Gödel Meets Einstein

Gödel Meets Einstein

Time Travel in the Gödel Universe

PALLE YOURGRAU

OPEN COURT
Chicago and La Salle, Illinois

This book has been reproduced in a print-on-demand format from the 1999 Open Court printing.

To order books from Open Court, call 1-800-815-2280.

The front cover photograph of Gödel and Einstein is used by courtesy of Richard Arens. The back cover photograph of Palle Yourgrau at Gödel's grave is by M.K. Sullivan.

Open Court Publishing Company is a division of Carus Publishing Company.

Library of Congress Cataloging-in-Publication Data

Yourgrau, Palle
 Gödel meets Einstein: time travel in the Gödel universe/Palle Yourgrau.
 p. cm.
 Rev. ed. of: The disappearance of time.
 Includes bibliographical references (p.) and index.
 ISBN 0-8126-9408-2 (pbk. : alk.)
 1. Gödel, Kurt—Contributions in concept of time. 2. Time—History—20th century. 3. Einstein, Albert, 1879–1955. I. Yourgrau, Palle. Disappearance of time. II. Title.
 BD638.Y68 1999
 115'.092—dc21 99-048706

If the world is beautiful, and its maker good,
clearly he had his eye on the eternal.

PLATO

. . . projecting directly from the developed parts of
mathematics to the whole world [Gödel] concludes
that it is also beautiful and perfect.

HAO WANG

Contents

Preface to the New Expanded Edition (1999)

At mid-century, Kurt Gödel and Albert Einstein, two of the greatest thinkers not just of the century but of the millennium, were colleagues at the Institute for Advanced Study in Princeton, New Jersey, and also the closest of friends. What, one wonders, would have happened if Gödel had taken the opportunity to cast a mathematical eye on Einstein's Theory of Relativity? Would not something amazing have resulted?

Well, fate sometimes smiles on us and as it happens Gödel did in fact turn his attention to Einstein's relativistic cosmology and the results were, predictably, astonishing. Within short compass Gödel discovered new and entirely unexpected solutions to the field equations of general relativity, bringing to light world models with disconcerting properties. In particular, he demonstrated the possibility, consistent with the laws of general relativity, of 'Rotating Universes', known today as 'Gödel Universes', in which, provably, there exist closed timelike world lines that permit, in a strict sense, *time travel*. In 1949, then, Gödel became the first thinker in the history of science to demonstrate rigorously the genuine possibility—consistent with the established laws of nature—of time travel. The mid-century meeting of minds of Gödel and Einstein gave birth, then, to a beautiful child of the scientific imagination.

Gödel, already in his twenties, had begun to establish himself as, in one colleague's words, "the greatest logician since Aristotle"[1]. Indeed, as the twentieth century draws to a close, it has become increasingly clear that Gödel's famous Incomplete-

1. This colleague went on to assert that this description constituted an underevaluation of Gödel!

ness Theorem for mathematical logic stands alongside Heisenberg's Uncertainty Principle and Einstein's Theory of Relativity as one the great mathematical achievements of this—or any other—century[2]. Indeed, these three milestones of twentieth century science have much in common. Although all three represent high water marks in the most rigorous of mathematical sciences, each constitutes at the same time a fountain of philosophical inspiration. In particular, although each is established by *formal* methods, each demonstrates, in its own peculiar way, a kind of *limitation* in principle of the relevant *formal science*. Heisenberg sets limits to our simultaneous knowledge of the position and momentum of the fundamental particles. Einstein, in turn, sets a limit to the speed of light and indeed to the velocity of any information-bearing signal in the universe. And Gödel establishes limits in the ability of any strictly formal, axiomatic mathematical system—in particular, of any computer program— to capture not only all mathematical truth, but even the totality of truths of *arithmetic*.[3] It is a further, striking fact that all three thinkers draw *ontological* consequences, about the nature of reality, from what are in effect *epistemic* premises.

Philosophically speaking, however, although a handful of Gödel's essays advancing his 'Platonistic' philosophy of mathematics have achieved, if not acceptance, then at least a kind of notoriety, it is rarely recognized that his writings on Einstein, in which he takes on one of the greatest and most elusive of philosophical questions—*the reality of time*—bear the unmistakable stamp of philosophical greatness. His argument proceeds in stages. 1. He argues forcefully that in the Special Theory of Relativity (STR) the relativity of the 'now' (of intuitive time) to an inertial frame[4] implies the relativity of existence.[5] But the latter is impossible.[6] Hence, if the STR is true, (intuitive) *time disap-*

2. When in 1952 Gödel was granted an honorary doctorate by Harvard University, the citation by the distinguished logician, W.V. Quine, described Gödel as "the discoverer of the most significant mathematical result of the century." Gödel, in a letter to his mother, explained that the citation should not be taken to mean that he is the greatest mathematician of the century, but rather that the phrase, "most significant" means here, "of the greatest General Interest outside of mathematics".

3. That is, of so-called 'higher arithmetic' or number theory.

4. It's an axiom of the STR that no inertial frame is 'privileged'.

5. ". . . [T]he idea of an objective lapse of time (whose essence is that only the present really exists) . . ." (Gödel 1949a, p. 202, Note 4).

6. "The concept of existence . . . cannot be relativized without destroying its meaning completely" (Gödel 1949a, p. 203, Note 5, in Feferman et al., Vol. II).

pears. 2. In the General Theory of Relativity (GTR), however, where matter affects spacetime curvature, some reference frames are 'privileged'—namely those whose motion "follows the mean motion of matter" (Gödel 1949a, p. 204). In our universe, these privileged reference frames can be systematically coordinated to determine a single, objective, 'cosmic time'. *Time reappears.* 3. a) Gödel discovered, however, world models for the GTR—the Rotating or Gödel Universes (GU's)—in which, provably, *cosmic time disappears.* b) Further, in certain nonexpanding GU's, there exist closed timelike world lines, permitting time travel. But if you can revisit the past, it never 'passed' from existence in the first place. So, once again, *time disappears.* 4. But the GU is a mere possible world. What about the actual world? By a daring 'modal' argument (from the possible to the actual), Gödel reasons as follows. Our world and the GU differ only in the global distribution of matter and motion. The two universes are described by the same fundamental laws of nature and, conceivably, provide for observers the same experiences (as of) time. If time is an illusion in the one world, therefore (as it provably is), it must also be an illusion in the other.[7] So, in the last analysis, *time disappears* even in the actual world.

Gödel's reasoning in 1.–4. is surely clear evidence of an extraordinary philosophical intelligence; yet his dramatic achievements in relativistic cosmology and the philosophy of time have themselves, one might say, 'disappeared' from view. Cosmologists, it is true, when Gödel first announced the existence of his new world models, were intrigued and were spurred on to discover other temporally anomalous world models for general relativity. Gödel had succeeded, at a minimum, in waking up general relativists to the fact that Einstein's theory by no means ruled out the possible existence of world models containing temporal and causal anomalies. Interest in the Gödel Universe as such, however, was primarily confined to demonstrations that the actual world is not such a universe,[8] as well as to queries as to whether the GU was after all a *physically realistic* solution to Einstein's Field Equations, as

7. "A lapse of time . . . would have to be founded, one should think, in the laws of nature, i.e. it could hardly be maintained that whether or not an objective lapse of time exists depends on the special manner in which matter and its impulse are distributed in the world" (Gödel 1946/49 B2, p. 238, in Feferman).

8. Gödel himself, however, seems never to have given up the attempt to discover

opposed to being a mere mathematical construct, consistent with the formal details of general relativity. Indeed, in the first edition of this book (Yourgrau 1991) I predicted (in Chapter 3) that it was only a question of time before some concerned general relativist would propose that ". . . we should recognize a new law of nature—an anti-Gödel law, as it were—that would rule out the embarrassing situation in which the R[otating]-universe turns out to be lawlike compossible with ours." And in fact exactly one year later no less a figure than Stephen Hawking confirmed my prediction when in 1992 he proposed his 'Chronology Protection Conjecture'—a hypothetical new law of nature to be added to the GTR, designed precisely to rule out temporally and causally anomalous world models like the Gödel Universe (Hawking 1992, pp. 603–611).[9]

The philosophical world, in turn, did not pay much more attention either to the Gödel Universes or to Gödel's philosophical essays, based on his results. A number of more or less 'popular' accounts of Gödel's cosmology have been written,[10] and a handful of philosophical discussions have appeared, but although some philosophers have accepted Gödel's demonstration of the possibility of time travel, almost no one has taken seriously his argument for the nonexistence of time—that is, for *temporal idealism*. It was in this philosophical climate, then, that I published in 1991 the first edition of this book. This book was then, and remains today, *the only serious, full-length philosophical investigation of Gödel's argument for the unreality of time*. Indeed, it is still the only book devoted to a sustained, sympathetic exploration of *any* aspect of Gödel's philosophy.[11] John Dawson's recent biography of Gödel, for example (Dawson 1995), expends only a few paragraphs on Gödel's cosmology and scarcely ventures into the

whether the actual world is in fact a rotating Gödel Universe. In his *Nachlass* were discovered two notebooks containing detailed calculations concerning the angular orientation of galaxies.

9. To date Hawking's conjecture does not appear to have received wide acceptance. M. Visser, however, maintains that "it [Hawking's Conjecture] should be taken to be an axiom, rather than attempting to prove it by calculation" (Visser 1994).

10. See the Anniversary Edition of Hawking's *A Brief History of Time* (Chapter 10), Paul Davies's *About Time: Einstein's Unfinished Revolution*, Robert Goldman's *Einstein's God*, and John Barrow's *Impossibility: The Limits of Science and the Science of Limits*.

11. Warren Goldfarb's assessment (forthcoming in *Synthese*) is, unsurprisingly, negative. See also E.P. James's review of a recent book by Charles Chihara: "Unfortunately, Chihara's account of Gödelian Platonism follows the common line of regarding Gödel as *a*

philosophical implications thereof.[12] He remarks only, on the final page of his study, that, "[t]o date only a single volume, *Yourgrau* (1991), has examined . . . the ramifications of [Gödel's] cosmological work for the philosophy of time . . . in any detail" (p. 269). Similarly, Hao Wang's posthumous book,[13] in which he records and reflects on the conversations he had with Gödel, devotes only a few pages to Gödel's philosophy of time,[14] concentrating primarily on Gödel's brief remarks on Husserl. And though both Wang and Dawson refer to my book, neither addresses the principal theses I proposed concerning Gödel's philosophy of time.

Among the primary theses I was concerned to advance are the following:

There is a deep and heretofore unremarked [15] *internal relationship between Gödel's Incompleteness Theorem and his discoveries in relativistic cosmology.* The Incompleteness Theorem proved by formalistically acceptable means the indefinability within the formal

logician par excellence . . . but *a philosophical fool*" (James 1992, p. 131; emphasis added). And John Earman asserts that the "correct response to Gödel" on the philosophy of time is to "brush aside the relation of GTR to idealistic philosophy" (Earman 1995, p. 200).

12. Dawson adopts a *psychoanalytic* approach to Gödel's philosophy: "Gödel['s] . . . *paranoia* may be seen as the culmination of a lifelong quest for a *consistent* world view." (p. 265; emphasis added) Further: "Gödel's choice of profession, [even] his *Platonism* . . . may thus be ascribed to a sort of *arrested development* " (p. 2; emphasis added).

13. Wang 1996. Professor Wang's widow, Hanne Tierney, asked Dr. Leigh Cauman and me to edit and proofread the final ms.

14. Wang told me that before reading my book he had tried to avoid this elusive topic, even to the point of cutting short Gödel's discussions with him. Similarly, Lawrence Sklar wrote to me: "Your analysis of Gödel's dialectical use of the 'no cosmic time' models of GTR which he cooked up is fascinating. . . . Like most others I avoid the puzzling issue of what Gödel really thought he was showing about time and stick to the easier stuff on closed timelike loops . . ." I had sent Prof. Sklar my account of Gödel after reading his 1984.

15. Giora Hon, in a series of articles, has reproduced not only my ideas but my very words, without, however, sufficient acknowledgement. See my response: 'Comments on "Did Gödel Surprise Einstein with a Rotating Universe and Time Travel?", by Giora Hon' (Yourgrau 1998). "This way of looking at Gödel's results," he writes, "suggests indeed the idea that Gödel's Incompleteness Theorem may imply a proof in physics which demonstrates that physics, as a formal theory, is as inexhaustible as mathematics" (Hon 1996, p. 515). My response: ". . . Prof. Hon has failed to understand the very concept of a 'limit case' that he has lifted from my text. A 'limit case' . . . constrains the possible intuitive content that can be expressed by . . . [a given] form . . . [For] Gödel . . . the mathematical 'formalism' of Einstein's relativity theory had precisely *succeeded in capturing* the essential properties of time. . . . As a consequence of this, [for] Gödel . . . those properties of time that *disappear* in the extreme geometrical context represented by the Gödel universe . . . are shown thereby *not to be essential to time itself.* A limit case, then . . . bring[s] to light . . . philosophical consequences not nearly so visible under less extreme geometrical constructions" (Yougrau 1998, pp. 1722–23; emphasis added).

system of *Principia Mathematica* of the 'intuitive concept' of arithmetic *Truth* (big '*T*'). Analogously, with his discovery of the Gödel Universe as a solution to the field equations of Einstein's general theory of relativity Gödel demonstrated by relativistically acceptable methods the inability of relativity theory to capture the 'intuitive concept' of *time* (little '*t*'). Having drawn attention to this analogy, I formulate a question that no one else has yet addressed, to wit: Why did Gödel conclude, in the case of *T,* intuitive arithmetic *truth,* that *the limitation lies with formalized mathematics,* whereas in the case of *t,* intuitive *time,* he concluded, not that *relativity theory* has intrinsic limitations, but rather that *intuitive time itself is an appearance or illusion?*

More generally, I bring to light two striking methodological patterns that characterize Gödel's great discoveries. First, *a preoccupation with probing mathematically the limits of formal methods in capturing intuitive concepts.* Second, *a tendency to move from the possible to the actual.*[16] Concerning the former, I argued that Gödel engages in the construction of ingenious 'limit cases'— 'extreme' formal constructions that *limit the possible contentful interpretations they can admit* (see Note 15). Concerning the latter, Gödel believes that in certain special contexts what is possible tells us much about what is actual. This emerges, for example in his formalization of the so-called 'ontological argument' for the existence of God, in which he tries to prove, following Leibniz, that if a 'divine being' possessing 'all perfections' (including necessary existence) is so much as possible, then it is actual. It also surfaces in his philosophical reflections on his cosmological discoveries, insofar as he argues from the mere *possibility* of the GU—in which, he maintains, time is demonstrably nonexistent—to the nonexistence of time in the *actual* world. More precisely, I argue that *with the discovery of the Gödel universe, Gödel has succeeded in constructing a limit case for the relativistic geometrization of time.*[17] (See Note 15.)

In a larger sense, this book makes a case for the thesis that, contrary to received wisdom, none of the *formal* sciences—

16. See, further, my entry, 'Gödel, Kurt', in *The Encyclopedia of Philosophy: Supplement* (Yourgrau 1996).

17. By the 'geometrization' of a manifold what is meant is not merely providing a geometry (as Schrödinger did for 'color space'), but rather a reduction of all essential

including relativistic *physics*, tense *logic*, and the *semantics* of so-called 'indexicals' like 'now'—has succeeded, to date, in bringing forth a successful analysis of time. *Gödel Meets Einstein* contains a sustained critique not only of attempts to defend the consistency of Einstein's relativity theory with 'flowing', 'intuitive' time, but also of the claim by Richmond Thomason[18] (et al.) that the so-called 'indeterminist tense logic' he has developed succeeds in capturing the logic of the 'open future' (demanded by intuitive time), and finally a detailed criticism of the attempt by the so-called New Theory of Reference, via the theories of context-sensitive indexicals by David Kaplan and John Perry, to account for the semantics of 'now'.[19] I argue at length that Gödel's argument for temporal idealism is far more powerful than anyone else has been willing to acknowledge, but I don't ultimately 'take sides' with Gödel[20] (or with Einstein). My purpose is not to carry a brief for Gödel but rather to show that Gödel's extraordinary writings on

properties to the geometrical. It was *Einstein* who, in the theory of relativity, had accomplished the geometrization of time. *Gödel's* contribution was the construction of a limit case for Einstein's geometrization.

18. Graham Nerlich, in his review (Nerlich 1996), complains that: "If I follow [Yourgrau's] objection [to Thomason], it rests on the fact that the model is static— . . . nothing singles out a model as representing the present. If the stakes are raised so high, no wonder the enterprise fails" (pp. 258–260). Should we, however, with Nerlich, simply refuse to 'police a formalism'—to test whether it *succeeds in achieving its stated philosophical purpose*? In the case before us, then, should not Thomason, whose tense logical 'indices' include not only 'points' of time but also (fully complete) 'branches', be taken to task when he defines 'necessity' *without invoking the very 'branches' he himself has introduced*, thereby begging the question at hand—to wit, finding a way *to acknowledge truth about the future without implying necessity*?

Again, Nerlich: "There is a long discussion of personhood, based on the premise that necessarily the dead are not persons" (p. 259). What I in fact argue, however, is exactly the opposite—that since death affects *whether*, not *what*, we are, it follows that the dead *remain* (not living, of course, but dead) *persons*. (We do not, when we die, *become another kind of being*—a concept, say, or a memory.) Nerlich again: "The consequences drawn from the plausible claim that persons are essentially living beings seem perverse, comparable to claiming that because, necessarily, bachelors are unmarried, then they are never married at weddings" (p. 260). What perverse consequences? How about: 'Since persons are essentially living beings, they never die'? But when I claim that we are "essentially living beings", I mean not that we are immortal (!), but only that we cannot exist without being alive. When we die, therefore, we cease to exist. (See also Note 22.)

19. Advertised as a theory of the 'essential indexical', Perry's account is widely accepted. Its essence is that, for example, 'now', used at *time t*, refers to *t*. Yet 'here', used at *place p*, refers to *p*. But no place is 'really' here; similarly, on Perry's account, no time is 'really' now. The *contextual* element of indexicals is here confined to a *semantic rule*; it reflects nothing in the objective order of things. Better to denote Perry's account as of 'the inessential indexical'.

20. George Schlesinger's review (Schlesinger 1993) is thus mistaken: "[t]he central aim of this book is to explicate and defend Gödel's view that time is 'unreal'" (p. 602).

Einstein have succeeded in raising the problem of the existence of time to an entirely new level. I defend neither McTaggart's A-series[21] nor his B-series,[22] neither Einstein and Gödel nor Bergson and Husserl, but rather attempt to bring to light the insufficiently appreciated relationships between these thinkers' ideas, and thus to point to *the true depth of the philosophical problem of the existence of time.*

All of this remains essentially unchanged in this new edition of my book. I have made, however, a number of stylistic improvements in the original text. There will also be found here a new chapter and two new appendices, which, unlike the original text, contain footnotes. If the reader finds some of this new material demanding, my advice is simply to skip over those sections that may appear daunting. There are after all a great many ideas here, and the reader should by no means feel compelled to master all of them. Though the ideas are indeed closely inter-related, in no case does the appreciation of one presuppose a mastery of all. Further, it is my strong belief that most of the fundamental ideas here are in fact accessible to anyone with a serious interest in the philosophical problems associated with the nature and reality of

Nathan Oaklander, by contrast, in his review (1994), quotes appropriately—though not approvingly—from my book: "time seems at once to demand and to resist a reconciliation between its subjective, intuitive, manifestations and its appearance in the best models that have been offered to date to incorporate its peculiar being into the fabric of the objective world." Adriano Palma, alone, however, in his review (Palma 1992), captures not only the letter but the spirit of the book.

21. For McTaggart, the A-series characterizes the shifting 'now' of 'flowing' time. Thus, 'past', 'present', and 'future' represent A-theoretic categories. In contrast, the B-series is constituted by the fixed, 'geometric' relations between times, represented by 'before' and 'after'. Fixed dates for events characterize the B-series.

22. According to Schlesinger in his review (1993): "Yourgrau . . . argue[s] that just as (according to Lewis) all worlds are equally actual relative to themselves and thus no single possible world is, objectively speaking, privileged, so all moments of time are present relative to themselves, and hence none is to be singled out as privileged (and present)" (p. 603). My claim, however, is only that it is a consequence of special relativity that all times turn out to be merely present-relative-to-themselves, and further that such a 'relative A-series' is equivalent to the B-series. (Howard Stein et al. who claim to have reconciled the A-series with special relativity have conflated the genuine with the relative A-series.) Further, contra Schlesinger, I do not defend David Lewis. I do, however, take Robert Stalnaker, a critic of Lewis, to task for his assertion that possible worlds are not really *worlds* at all (but merely *concepts*). Possible worlds are after all *really worlds*—albeit merely *possible* worlds, just as possible persons (including past and future people) are *persons*, not *concepts*—albeit merely *possible* persons. *An expectant couple is expecting to have a baby, not a concept of a baby.* (See also Note 18.) The same is true, of course, when we look forward to future times: "If you were to ask: 'Do I expect the future itself, or only something similar to the future?', that would be nonsense" (Wittgenstein 1975).

time. Whereas it is almost a 'point of honor' of many writers on the foundations of spacetime theories and the foundations of mathematics to scare off the mathematically unsophisticated reader, my intentions in this book are exactly the reverse. My ideal is the same as Gödel's, as recounted to Hao Wang: to be precise, without being technical.

In this second edition of the book, then, there is a new chapter, 'From Kant to Star Trek: A Philosopher's Guide to Time Travel',[23] in which I explore in much greater depth the question of 'time travel'. In particular, I probe more deeply into the details of Gödel's 'modal' argument from the mere *possibility* of the Gödel Universe—in which the very *existence of 'time travel'* implies the *nonexistence of time*—to the nonexistence of time in *the actual world*. I try to shine some light on the most puzzling features of Gödel's writings on Einstein by responding in detail to John Earman's important critique[24] of both Gödel's argument and my account of Gödel's reasoning. I pay close attention, further, to the analogy Gödel is at pains to draw between the role of 'time' in relativity theory and in Kant's 'idealistic' philosophy, and I pursue the question of Gödel's ultimate stance on the reality of time in light of his preoccupation not only with Kant but with Husserl's phenomenology of internal time-consciousness.

This new edition contains also two appendices on *potential versus actual* infinity. In the first edition, I began to explore the internal relationship between potential infinity and intuitive time. In the new edition there is an appendix—'Brouwer and the "Revolution": The Philosophical Background of "Temporal Mathematics"'—exploring the relationship between L.E.J. Brouwer's 'intuitionist' mathematics—which acknowledges only the potential infinite—and his conception of intuitive time needed for his reconstruction of mathematics. I pursue the question of the relationship between Brouwer's intuitive time and the 'time' of relativity theory and compare what Brouwer has to say about

23. A distant ancestor of this chapter, abridged and in German translation, appears as 'Philosophische Betrachtungen zu Gödel's Kosmologie' in W. Schimonovich, B. Buldt, E. Köhler, and P. Weibel, eds., *Wahrheit und Beweisbarkeit: Leben und Werk Kurt Gödels*. Wien: Hölder-Pichler-Tempsky, forthcoming, 1999.

24. Earman 1995. Steven Savitt, by contrast, in his 1994, acknowledges the force of Gödel's argument as I have reconstructed it.

time with similar observations by Husserl, Wittgenstein, and Gödel.

There is also a second appendix—'Zeno's Revenge: On the Mathematical Dogma of Infinite Divisibility'—where I take a fresh look at Zeno's Paradoxes, which have taxed the imagination of mathematical philosophers from Aristotle to the present. Aristotle's conception of *potential* (versus *actual*) infinity—an ineluctably *temporal*[25] notion, or so I argue—was, in fact, a direct result of his attempt to respond to Zeno. In this appendix, I explore, in particular, the relationship between Zeno's skepticism concerning infinite divisibility and two concepts, each essential to modern mathematics, but, arguably, in tension with each other: the definition, following Cauchy and Weierstrass, of *the sum of a convergent infinite series* in terms of the concept of the *limit* of an infinite series (which seems to rely only on *potential* infinity), and the definition of the *'sum' of a divergent infinite series* in terms of an *actually* infinite addition, employing the methods of Cantor's transfinite arithmetic. The discussion leads naturally to reflections on the attempt since Plato to *take time out of mathematics* and to Brouwer's radical attempt *to return time to mathematics*. I address, in addition, some observations of Wittgenstein's about the sum of an infinite series, as well as ideas from Brouwer, Bernays, and Gödel concerning *the arithmetization of the continuum*. In the end, I reach the somewhat radical conclusion that the apparent tension between the role of potential and actual infinity in the modern foundations of mathematics is in fact a *genuine* one, and that the received mathematical wisdom since Cantor, precisely opposed by Brouwer, that the totality of rational—not to say real—numbers constitutes an *actually infinite* collection may well have to be re-examined.

It may seem a long way from Gödel's meetings with Einstein in Princeton to our reflections on Cantor, actual infinity, and the arithmetization of the continuum—and in one sense this is true. One should recall, however, that Gödel is also the author of profound discoveries in transfinite set theory concerning Cantor's Continuum Hypothesis,[26] as well as being an outspoken propo-

25. Indeed, not just temporal, but in particular, A-theoretic.

26. Cantor's Continuum Hypothesis states that the cardinal number of the continuum or real number line, 2^{\aleph_0}, is in fact the second transfinite cardinal number, \aleph_1 (that is, the

nent of Cantor's Platonistic doctrine of actual infinity.[27] Indeed, the very fact that our study of Gödel's argument for the unreality of time moves naturally from Einstein's theory of relativity to Gödel's new cosmological models, to the question of the ontology of time and Gödel's—and Plato's—contributions to fundamental ontology or being-in-time, to the question of time and potential versus actual infinity, to the arithmetization of the continuum, testifies to the truly fundamental nature of the question of the reality of time. What could be more important, then, for those with a philosophical interest in time, than to come to grips with the full implications of Gödel's mysterious and beautiful writings on Einstein—the century's most profound thinker about the nature of time?

$$\ast \qquad \ast \qquad \ast \qquad \ast \qquad \ast$$

Special thanks are due to my editor at Open Court, David Ramsay Steele, both for his interest in bringing out this new expanded edition of my book and for his excellent advice and guidance on how best to make the new edition as 'reader-friendly' as possible. Thanks also to M.K. Sullivan for her excellent work in creating new, comprehensive index for this new edition.

first transfinite number greater than \aleph_0—the cardinal number of the natural numbers). Gödel proved the consistency of the Continuum Hypothesis with the accepted axioms of Zermelo-Fraenkel Set Theory. (Later, Paul Cohen proved the consistency of the negation of the Continuum Hypothesis, which turns out thus to be independent of the axioms of Z-F Set Theory.)

27. Gödel defends Cantor's doctrine of the Platonic existence of actually infinite sets in what is perhaps his most famous philosophical essay, 'What Is Cantor's Continuum Hypothesis?' (*Collected Works*, Vol. II). And of course Gödel also accepts Plato's doctrine that all genuine reality, 'in itself', is timeless.

Preface to the First Edition
(1991)

Of the three philosophical essays published by Kurt Gödel during his lifetime, only one is devoted exclusively to the study of time. Indeed, 'A Remark about the Relationship between Relativity Theory and Idealistic Philosophy' (Gödel 1949) is, from any point of view, a singular essay. Not only does Gödel announce his discovery of new solutions to the field equations of Einstein's General Theory of Relativity, which include the existence of closed, timelike world lines and permit, in a certain sense, time travel, but he goes on to advance considerations to the effect that his new results support the contention that time itself is merely ideal—that is, a subjective appearance or, more strongly, an illusion. As Gödel sees it, then, Einstein has not so much explained time as explained it away. What, however, can Gödel mean by such enigmatic pronouncements, and what force is it reasonable to attribute to them? Are they isolated and idiosyncratic observations, or do they occupy a natural position in his overall philosophy? Indeed, does Gödel, the logician, have a unified and comprehensive philosophy, or are his remarks on time, together with his better-known philosophy of mathematics, only fragments that fall short of the grand overall scheme of things one has come to expect of philosophers? Since Gödel's death in 1978, answers to these questions have begun to emerge. His *Nachlass* has revealed unpublished philosophical papers, including an extended presentation of 'Some Observations about the Relationship between Theory of Relativity and Kantian Philosophy'. In addition, some revealing new studies have appeared that shed light on Gödel as philosopher—Georg Kreisel, 'Kurt Gödel', in

Biographical Memoirs of Fellows of the Royal Society (1980); Solomon Feferman, 'Kurt Gödel: Conviction and Caution' (1984); and, most important, Hao Wang, *Reflections on Kurt Gödel* (1987), the last constituting, to my knowledge, the only full-length portrait of Gödel the philosopher in print. (Wang 1974, *From Mathematics to Philosophy*, benefited from contributions from Gödel himself.)

In addition to these more general studies, there have appeared in recent years works addressed specifically to philosophical issues raised by Gödel's contributions to the theory of time, most notably Howard Stein, 'On the Paradoxical Time-Structures of Kurt Gödel' (1970) and 'Introductory Note to K. Gödel 1949a' (1990), and Paul Horwich, 'Time Travel' in *Asymmetries in Time* (1981). Finally, the first three volumes of Gödel's *Collected Works* (1986, 1990, 1995) have now appeared, containing all of his previously published papers. It would seem, then, that the time is ripe for a more extended treatment of the philosophical ramifications of Gödel's writings on time. I have already, in a 'Review Essay: Hao Wang, *Reflections on Kurt Godel*' (1989), attempted to put into perspective Professor Wang's philosophical portrait of Gödel, emphasizing aspects of Gödel's thought that Wang had not focused on—for example, the close relationship of Gödel's mathematical Platonism to Frege's and the structural similarity of Gödel's thoughts on mathematics, time, and theology with respect to the thesis that the possible has strong implications for the actual. And in a volume on *Demonstratives* (1990) that I have edited, I have reproduced Gödel (1949a) in a setting that will, I hope, help to put Gödel's elusive thoughts into context.

This monograph is devoted to a philosophical consideration of Gödel's papers on Einstein and idealistic philosophy, and to an examination of various metaphysical questions concerning time to which his work gives rise. As will be seen, no attempt is made here to evaluate the purely technical side of Gödel's results. Much has been written, and continues to be written (see, for example, David Malament 1984 and Lawrence Sklar 1984), on the formal aspects of Gödel's ideas—that is, on those aspects that relate most directly to questions of physics or mathematics. I am, by training and inclination, not the one to add to that discussion. I believe,

however, that something is missing from discussions of the dramatic philosophical conclusions that Gödel was at pains to draw from his results. What follows is intended to help fill this in. Logicians and philosophers of space-time physics may well be taken aback by the introduction, in the pages that follow, of metaphysical issues associated with Parmenides, Kant, McTaggart, and others, concerning reality, idealism, becoming, and so on, but I make no apologies for this, since it is Gödel himself who has brought up these ideas. To shy away from metaphysical questions that Gödel himself raises would betray an inclination not to take him seriously as a philosopher.

In the completion of this project, I have greatly benefited from discussions over a period of years with Hao Wang, who has shared with me some of the fruits of his long association with, and reflections on, Gödel. In particular, his remarks have helped me to gain some insight into Gödel's philosophical worldview. I have also benefited from an extended correspondence with Michael J. White over issues related to the logic of time, with special reference to Aristotle and temporal indeterminism, as well as from his detailed comments on earlier versions of this manuscript. And I would like to thank Charles Parsons for his helpful comments on Chapter 7, Robert Tragesser and James Van Cleve for valuable suggestions about the manuscript, David Pitt for preparing the index, and an anonymous referee for Cambridge University Press for a number of helpful suggestions and comments. Finally, I wish to thank Elliott Shore, librarian at the Institute for Advanced Study, for granting me permission to quote from Gödel's unpublished papers, and the Special Collections Department of Princeton University's Firestone Library for providing me with a reproduction of the drafts of Gödel's papers, which I have done my best to assemble into a working manuscript. These drafts have proved especially illuminating, since by Gödel's indications it appears that much of the most interesting philosophical material may have been destined by him to be eliminated in the final draft. One must therefore bear in mind, when I provide excerpts from these unpublished manuscripts in the pages ahead, that the material quoted may well—for whatever reason—not have been intended by Gödel for publication. Hao Wang has reassured me that the

inclusion, nevertheless, of this material would not represent a violation of Gödel's wishes on such matters.

At various points in the book I have drawn on previous works of mine published elsewhere: Yourgrau 1985c; Yourgrau 1986; Yourgrau 1987c; and Yourgrau 1987b.

Chapter 1
The Reception of Gödel's Results

I would like to say first that I don't consider my work a "facet of the intellectual atmosphere of the early 20th century," but rather the opposite.

Kurt Gödel

In the 1940s, Kurt Gödel, having already achieved striking and fundamental results in foundations of mathematics, turned his attention to the universe. The occasion for the publication of these new reflections was an invitation to honor Albert Einstein, whose own work, decades before, had ushered in the era of relativistic cosmology. The result of this auspicious occasion was the beautiful and enigmatic "A Remark about the Relationship between Theory of Relativity and Idealistic Philosophy" (Gödel 1949a). An even more suggestive essay survives, unpublished, in his *Nachlass*, 'Some Observations about the Relationship between Theory of Relativity and Kantian Philosophy'. In these papers Gödel cast a philosophical eye on the ancient riddle of time, "that mysterious and seemingly self-contradictory being, which, on the other hand, seems to form the basis of the world's and our own existence" (Gödel 1949a). By Gödel's lights his new solutions to the equations of general relativity lend themselves to a philosophical interpretation that is in a strong sense "idealistic," providing support from an unexpected quarter to those thinkers, from Parmenides to Kant and McTaggart, who had all along been skeptical of the ultimate significance of time.

1

Now it has been some time since Gödel died, but the riddle of his enigmatic remarks has yet to be resolved. Indeed, the very first commentator on Gödel (1949a), namely, Einstein himself (Einstein 1949), simply brushed aside the second half of Gödel's title ("Entirely aside from the relation of the theory of relativity to idealistic philosophy . . ."). In fact, we read in Wang (1987) that Einstein tended to find such interest in the relationship of Kant to relativity theory rather amusing: "Kant's much praised view on time reminds me of Anderson's tale of the emperor's new clothes, only that the form of intuition takes the place of the emperor's clothes!" (p. 74). Other commentators are divided on the question of what to make of Gödel's assertion that in the so-called rotating universes he discovered (the R-universes, in Gödel unpublished) that "it is possible ... to travel into any region of the past, present, and future, and back again, exactly as it is possible in other worlds to travel to distant parts of space." Čapek (1961) and Popper (1982), for example, chide Gödel for entertaining the senseless idea that "time travel" could really be possible, Čapek attributing Gödel's mistake to his excessive "spatialization" of time (i.e., likening time to a 'geometrical space'). Howard Stein (1970), David Malament (1984), Lawrence Sklar (1984), and Paul Horwich (1987), on the other hand, take Gödel's results to have serious implications for the theory of time, and with considerable care investigate the formal and philosophical ramifications of these results. As Malament puts it: "We do have good evidence that the Gödel model does not describe our universe. I am only proposing here that it cannot be ruled out a priori. Neither can any other cosmological model just because it allows for the possibility for time travel" (p. 99).

Now what I find disturbing about the current state of this debate is that the primary philosophical point of Gödel's 1949 paper seems to have been lost or downplayed—namely, that the deduction, from the General Theory of Relativity (or GTR), of the possibility of time travel shows that time is ideal—a mere appearance imposed on reality by a kind of "optical refraction" of the subjective lens of the mind but reflecting nothing objective in the nature of things. Of course, philosophers could hardly have failed to acknowledge that Gödel's purpose in his 1949a was to defend an idealistic view of time. What is puzzling, however, is that some writers will, in the same breath, continue to reaffirm

(with approbation or without it) Gödel's commitment to time travel. But one cannot have it both ways. Yet Horwich (1987), a forceful defender of the possibility of time travel, sees Gödel as his precursor: "It has been claimed by Kurt Gödel (1949a) that time travel is in some sense physically possible . . . my aim in this chapter is to defend Gödel's claim" (p. 111). Stein (1970), by contrast, shows a more subtle appreciation of the logic and substance of Gödel's position and makes it clear that "[t]he paradoxical character of the time-structure of his model is emphasized by Gödel in (1949a), where his chief aim *is to put in question* our ordinary notions about time" (p.591). Stein himself, however, is less impressed than Gödel is by the paradoxical implications of time travel, and after asking us to "[n]ote Gödel's . . . implied acknowledgement that 'actual feasibility' of time-travel *would* constitute grounds for rejection of such structures a priori," he goes on to suggest that "[i]n my view, this concession is not warranted" (p. 594).

What must be admitted, of course, is that Gödel believes he has shown the compatibility with the GTR of universes permitting time travel—in Stein's words, a situation in which, "[i]f 'decisions' can be taken and 'free actions' performed in such a universe—and if adequate energy-sources are available—then a person in such a world can decide, at any point in his career, to visit the space-time vicinity of any epoch of his own past" (1970, p. 591). But it is this very fact that Gödel takes to indicate that t, the standard variable for time, should not be read here as standing for genuine, successive time. But if there is no genuine *time*, there can be no genuine time *travel*. This somewhat confusing situation is in certain respects comparable to a similar difficulty in the interpretation of Berkeley—an idealist in a different (though related) sense. Berkeley was always at pains to insist that his idealism about the physical world did not commit him to the view that ordinary physical objects like tables and chairs fail to exist. He insisted that chairs really do exist but went on to remind us that by his philosophy this does not imply that matter outside the mind exists, since he wishes us to interpret all talk of tables and chairs and other physical objects in terms of mental ideas. Similarly, Gödel describes the R-universe as permitting time travel, but only if we do not read "time" here as designating genuine, successive time, but rather as denoting a relativistic formal simulacrum of the real thing.

We must be careful, however, to distinguish Gödel's idealism from Berkeley's in the following two respects. First, Gödel means only to assert that time is an 'appearance' or illusion, not that it is mental. (Indeed, if the mental realm admitted genuine temporal succession, Gödel would surely have concluded not that time as such is an illusion, but only that its sphere of application is limited.) Second, Gödel's idealism applies only to time, not to space or to space-time. (An adequate explication of Gödel 1949a must explain this fact. We will come to it later.)

It is easy to see, then, how Gödel's deduction of the possibility of time travel could come to overshadow his use of his results to conclude the ideality of time. The reasons for this reversal of emphasis, however, in my opinion, run deeper. Gödel has always been sparing of the details of his overall philosophy, which, moreover, he has stressed, goes very much against the temper of the times. Indeed, only now have we begun to see the extent to which Gödel suppressed in his (already very sparse) published writings the heuristic philosophical background against which he himself believed it necessary to place his formal results in order for their true implications to be realized. Already in *From Mathematics to Philosophy* (1974, p. 9), Wang had reported how Gödel had even suppressed, in his published exposition of his early Incompleteness Theorems, that "the heuristic principle of my construction of undecidable number theoretical propositions in the formal systems of mathematics is the highly transfinite concept of 'objective mathematical truth' as *opposed* to that of demonstrability" (whereas the printed text of his 1930 used only the notions of consistency and ω-consistency). It is clear that Gödel feared that the philosophical climate, under the large shadow cast by Hilbert, in which the concepts of truth and of the transfinite were held in suspicion, made it advisable for a prudent man to isolate his formal results from such philosophical contamination.

More recently, Solomon Feferman, in 'Kurt Gödel: Conviction and Caution' (1984), has mused on "the tight rein [Gödel] placed on the expression of his true thoughts" (p. 559). After remarking the fact mentioned previously, Feferman points out, in addition, that "Gödel never did state publicly (until his communications to Wang reported in 1974) what he thought of the views of the Vienna Circle" (p. 560), although the evidence shows that "it is safe to say that Gödel already had firm general platonistic

views by the time he came in contact with the Vienna Circle" (p. 560). Feferman even speculates that Gödel's excessive caution in regard to (what he considered) the dominant "blindness (or prejudice), or whatever you may call it" of the times may have kept him from going ahead with fundamental research, for example, on computable (λ-definable, general recursive) functions (as Turing did), or on truth (as Tarski did). (This last claim, however, raises an issue I cannot go into here, namely, Gödel's anticipation of Tarski's results on the undefinability of truth. See Wang 1987, pp. 85, 273.) "Gödel's spreading fame," says Feferman, "should have reassured him that he would not be laughed off-stage if he were to go beyond the purely (logico-)mathematical formulation of his results" (p. 559).

The striking picture that emerges from Feferman's essay is reaffirmed by Wang's revealing new study, *Reflections on Kurt Gödel* (1987). Gödel's quarrel with the zeitgeist, it turns out, was far more considerable than even Feferman had suggested. Strongly influenced by Plato and Leibniz (and, later, by Husserl), Gödel had devised his own 'ontological argument' for the existence of God ("my belief is *theistic,* not *pantheistic,* following Leibniz not Spinoza", Wang 1987, p. 8), disliked the *Tractatus* ("because it purported to show that philosophy is not possible," p. 77), and believed that "there is mind separate from matter" (p. 197). In light of such views, it is perhaps a bit unfair to characterize Gödel's caution as "excessive."

Formalism

Especially striking is Gödel's resistance to the contemporary bias toward 'formalism' (in a broad sense), the tendency to recognize nothing in a domain beyond those features captured and represented in some chosen mathematical formalism. Already in his Incompleteness Theorems, of course, Gödel had provided formal evidence (!) against the most precise and well-formulated program of formalism of this century, the so-called Hilbert program, which identified (or replaced) mathematical truth with provability in a formal system, where the latter notion was given (relatively) precise mathematical sense—only fully precise, for Gödel, after the work of Alan Turing on computability. As Gödel wrote to Wang, "formalists considered formal demonstrability to be an

analysis of the concept of mathematical truth and, therefore, were of course not in a position to *distinguish* the two" (Wang 1974, p. 10). Gödel's results, and his essays on the philosophy of mathematics (1944 and 1964), suggest that formalisms do not "speak for themselves" as to their full significance, but require something more, something informal or 'intuitive', if you wish, for their proper interpretation. A striking contemporary example of extreme formalism (to continue to use the term in a broad sense) is the employment by Hilary Putnam (1985) of the Löwenheim-Skolem Theorem to argue that the formalization of Cantor's proof of the existence of nondenumerable sets subverts Cantor's intentions, since the formal proof can always be reinterpreted to prove the existence of at most a denumerable totality. This effect—the 'Skolem Paradox'—is achieved precisely by refusing to put the chosen formal system into a wider interpretive context, thereby, in effect, forcing the formalism to speak for itself. (For a reasonable response to this paradox, with special reference to Putnam 1985, see Paul Benacerraf 1985, who associates his approach explicitly with Gödel's.)

The Skolem Paradox represents an extreme version of mathematical formalism insofar as it combines two salient features of the late nineteenth- and early twentieth-century rigorization of mathematics—axiomatization and formalization (representation in a first-order formal system in the technical sense). In a broader sense, however, the attempt to capture the essential features of a domain by purely mathematical-structural means (at the expense, for example, of the qualitative or intuitive) represents the fundamental idea of formalism. Most important for our purposes is the mathematization (in the broad sense) of nature in the historical development of natural philosophy, especially physics, from Descartes's geometrical method (and reduction of matter to pure extension) and arithmetization of geometry to the geometrization of time itself in Einstein's Special Theory of Relativity (STR) and GTR. In fact, the historical (as opposed to the mythical) Descartes was not so pure in his geometrization and arithmetization as in the modern development culminating in Einstein. As David Lachterman has argued, "for Descartes graphic constructions [of geometric figures] are the outward counterparts and sensible signs of the inward activity of mind" (1989, p. 148). Not so, surely, for David Hilbert (1902). And not so for Einstein.

Indeed, "[t]he primary object of Einstein's profound researches on the forces of nature," writes G.J. Whitrow, "has been well epitomized in the slogan, 'the geometrization of physics', *time being completely absorbed* into the geometry of a hyper-space" (1980, p. 4; my emphasis). To what, however, can we attribute Gödel's interest in the geometrization of time?

We have already mentioned the official occasion for Gödel's reflections on Einstein's treatment of time, but it should not be thought that his concern with this subject was merely fortuitous. Wang (1987) affirms that Gödel attributed his interest in time to his early work on Kant and Leibniz. Perhaps, then, we can offer the following as a kind of 'rational reconstruction' of Gödel's interest in time, whether or not Gödel himself consciously saw himself this way. (And as Imre Lakatos has observed [1987, p. 4], if such rational reconstructions strike some as mere caricatures of history, "one might equally well say that both history and the way things actually did happen are just caricatures of the rational reconstruction"—a point of view that would surely have appealed to the arch-rationalist Gödel.) All along, then, Gödel viewed his well-known mathematical-logical work as the investigation of an objective 'platonic' domain that does not depend on the empirical. "Logic and mathematics," he wrote, "(just as physics) are built up on axioms with a real content which cannot be explained away" (Gödel 1944, p. 132). It was natural, therefore, for Gödel (as Frege had done before him) to make a sharp distinction between epistemology and ontology, thought and object of thought, proof and truth (distinctions that must be more blurred for other philosophers of mathematics, such as Hilbert, Brouwer, and Wittgenstein, who reject such platonism).

Time: An Ontological Suspect

With Plato, moreover, Gödel also shares the recognition of another crucial distinction, that between the temporal and the timeless or 'eternal' (in Plato's sense), where the realm of pure mathematics is confined to the latter, whereas the former applies only to the empirical—'sensible' realm; for, as Whitrow has written, "although Plato regarded time as an essential feature of the sensible world, he rigorously excluded it from the science of pure geometry which he associated with, and only with, the eternal

world of ideal forms" (1980, p. 179). Gödel, with Plato, also
regarded the world of time as somehow 'ontologically suspect', as
I will argue in due course. With Plato, finally, Gödel, I suggest,
attempted to integrate the two realms, the eternal and the tempo-
ral, to 'save the phenomena', though Gödel's final result turned
out to be far more negative than Plato's. A crucial reason, clearly,
for Gödel's negative result (his failure, as it were, to save the phe-
nomena) is that he faced the problem of integration in the con-
text of the extreme mathematization of the temporal represented
by Einstein's Relativity Theory.

To be clear, now, on the extreme sense in which Relativity
Theory represents a mathematization of time, we should recall
earlier systematizations by Aristotle and Newton (developed by
Kant). Aristotle and Newton had, of course, applied mathematics
to time, Aristotle, famously, defining time itself as "the number
[i.e., the numerable aspect] of motion with respect to before and
after," and Newton's discovery of the calculus was especially
designed to provide a measure of continuous motion (in time).
Yet, for all that, the characteristic 'mode of being' of time,
namely, its 'flux', was considered representable, at best, intuitively,
or by analogy, so that the idea of the 'geometry' of the one-
dimensional time line was clearly seen as, at best, a highly useful
(if potentially deceptive) *metaphor*.

Kant, in his philosophical reformulation of Newton, is explicit
on just this point: "Time is nothing but the form of inner sense,
that is, of the intuition of ourselves and of our inner state . . . and
just because this inner intuition yields no shape, *we endeavor to
make up for this want by analogies*" (1965, p. B50; my emphasis).
As Mary Tiles puts it, "philosophy of time cannot proceed simply
by conceptual or linguistic analysis, but must go via intuitions,
nonverbal representations . . . rhetorical devices other than those
of logic and argument (1989a, p. 182). For Kant, the central
analogy was that of a line continuously being generated: "we can-
not obtain for ourselves a representation of time, which is not
[itself] an object of outer intuition, except under the image of a
line, which we draw, and . . . by this mode of depicting it alone
could we know the singleness of its dimension" (1965, p. B156);
moreover, "one represents a line as generated through fluxion
and thus generated in time" (1902, vol.14, p. 53).

For Aristotle, too, there is a guiding and irreducible metaphor or analogy for time: "[Aristotle's] operative simile is that of the 'now' and its present-past to a moving object and its trajectory or to a geometrical point and the [partial] line generated by its 'fluxion'. This dynamic model of time leaves the past fixed but continuously supplemented, and the future at least partially indeterminate" (White 1985, p. 22). What Gödel found, however, in Relativity Theory, was an account of time where the mathematical-formal element completely dominated the intuitive or analogical, an account in which the Einstein-Minkowski geometry of time is now no longer only metaphorically a geometry. And as the future was to bring out, once the notion of the geometry of time was taken literally, the door was open to someone like Gödel to introduce the question of a nonstandard geometry of time—much as Einstein had earlier employed a nonstandard geometry for space or space-time.

Precisely those features at the heart of the analogies of time of Aristotle and Kant disappear in Einstein's 'geometrization of the temporal':

> It appears therefore more natural to think of physical reality as a four-dimensional existence, instead of as hitherto, the evolution of a three-dimensional existence. This *rigid four-dimensional space* of the special theory of relativity is to some extent a four-dimensional analogue of H.A. Lorentz's rigid three-dimensional aether." (Einstein 1961, pp. 150–51; my emphases)

Again, Louis de Broglie:

> In space-time, everything which for each of us constitutes the past, the present, and the future is given in block, and the entire collection of events, successive for us, which form the existence of a material particle is represented by a line, the world-line of the particle. (Schilpp 1982, p. 114)

Geometrization and Spatialization

Note the difference between the Einstein-Minkowski world line and the continuously generated line of Aristotle and Kant. As Einstein and de Broglie bring out clearly, what Relativity Theory

seems to offer us is in fact a 'spatialization' of time, to borrow
Čapek's term from his 1961. What constitutes time as 'spatial'
here, and thus susceptible to a purely geometrical treatment, is
what is the essence of any 'space' in the most general sense of this
term—namely, not extension, but rather *the ontological neutrality
of all the positions defined by such a manifold*. By this I mean that
something's *location* in a genuine space (whether it be physical
space or the 'mathematical space' of the natural number
sequence, construed platonistically) has no effect on the status of
its existence. This more general definition of a space also makes
better sense of Gödel's conception of *sets* as "quasi-spatial" (Wang
1987) than the classical notion of a physical space. Gödel presum-
ably meant that a set is a paradigmatic *platonic* object whose
members do not come into being successively. This is then to be
contrasted with the 'temporal mode of being' (construed pre-rela-
tivistically), in which to exist *is*, precisely, to exist *at* a designated,
or privileged, *temporal location*—namely, *now*, or in the present.
To 'spatialize time', then, is to collapse the latter mode of being
into the former, as Einstein and de Broglie would seem to be
doing in the quotations we have cited.

Whether this spatialization of time is indeed forced on us by
Relativity Theory, however, has been questioned, as we will see in
due course. Gödel, though, did not question it, and by exploiting
the mathematization of time to introduce a kind of extreme or
'limit case', he believed he had made the implications of Relativity
Theory, vis-à-vis spatialization, inescapable. Now the significance
of Gödel's having before him, in Einstein's theories, such an
advanced mathematization of time can be appreciated if we recog-
nize the surprising unity that underlies some of Gödel's most star-
tling formal-mathematical discoveries. A clue to this unity can be
found if we consider a nice distinction introduced by John Myhill
(1951). A formal question let us say, asks us to supply the content
of its answer, whereas an informal one demands of us that we sup-
ply both form and content. Further, "there is no way of knowing
whether an informal question is objective or subjective until the
question is answered" (p. 42). Gödel, I suggest, has a peculiar
genius for transforming previously informal questions into formal
ones and then settling the remaining question of content by
introducing formal constructions that limit the possible content-
ful interpretations that they can admit. I call this the introduction

of a 'limit case', by analogy with powerful limitation results like the Löwenheim-Skolem theorem. This way of looking at things allows us to tie together Gödel's dramatic formal-mathematical results concerning Frege, Hilbert, and Einstein, as well as to begin to see why these proofs are of such enduring, if ambiguous, philosophical significance.

In the case of Frege, indeed, Gödel's Completeness Theorem actually provided the reverse of a limitation result, since what he demonstrated was that on the level of the formalization of first-order predicate logic with identity, first presented in Frege's *Begriffsschrift*, the formal (or syntactic) property of being provable was coextensive with (and so, formally indiscernible from) the contentful (or semantic) property of being valid (or true under all interpretations). Here, then, proof can indeed simulate truth, and thus one cannot impose a limit on either interpretation of the formalism. In contrast, for Hilbert's ideal, the complete formalization of each branch of mathematics and the replacement of the concept of mathematical truth with that of provability in a suitable formal system (itself to be proved consistent by finitary means), Gödel's result was genuinely limitative. The Incompleteness Theorem showed that here proof could not simulate truth. In particular, Gödel demonstrated an intrinsic limitation on the semantic or contentful interpretation that can be imposed on the syntactic predicates in Hilbert's formal systems. No predicate, T, can consistently, in this context, bear the semantic interpretation 'is true'. In effect, then, Gödel showed, by purely formal means, that here Hilbert could not replace (nonfinitary mathematical) content by paying attention only to form. This spelled the end, then, of Hilbert-style (mathematical) formalism. (To be fair, however, one should add that this orthodox view has been challenged of late. See Detlefsen 1979; 1986; and 1990a.)

These results of Gödel's relied on the very mathematization of logic and metalogic introduced, respectively, by Frege and Hilbert. Exploiting, next, Einstein's geometrization of time—itself a kind of formalization—Gödel was able to construct a mathematical model of a possible universe in which, by his lights, there are essential constraints on the possible contentful, intuitive interpretations the model can bear. In particular, since in such a universe there are closed, timelike world lines, and, in a certain sense, the possibility of time travel, Gödel concludes from

this that the standard interpretation of *t*, here, as denoting *time*—genuine successive time, which represents the objectivity of becoming—is clearly impermissible. This reading of the model relies on the fact that Einstein has provided not just a *time geometry*, but rather a *geometrization* of the temporal. The distinction is crucial. Many domains can be described as occupying a certain logical space, which, in turn, may have a distinctive geometric signature. The geometrization of such a domain, however, consists in the elimination or reduction of all qualitative features in favor of the geometrical or structural.

To put this distinction to work, consider Erwin Schrödinger's geometry of color space (see Moore 1989, pp. 120–29). Schrödinger had no intention of reducing the qualitative properties of colors to the purely formal, structural aspects of the geometry he wished to employ. He introduced a geometry, then, but he did not attempt to geometrize color. In contrast, the Einstein-Minkowski geometry of space-time *is* put forward precisely as a geometrization of time, that is, to replace or reduce the intuitive, qualitative features of time to the geometrical (recall the characterization above by Whitrow). Talk of the intuitive content of temporal intuition—the 'given', if you will, of time consciousness—gives way to a purely structural representation of the form of time. The parallel with Hilbert is obvious, as is brought out in the following passage from Hermann Weyl (1949):

> Intuitive space and intuitive time are thus hardly the adequate medium in which physics is to construct the external world. No less than the sense qualities must the intuitions of space and time be relinquished as its building material; they must be replaced by a four-dimensional continuum in the abstract arithmetical sense. . . . What remains is ultimately a *symbolic construction* of exactly the same kind as that which Hilbert carries through in mathematics. (p. 113)

Limit Cases

Now, clearly, this is also how Gödel reads the Einstein-Minkowski geometrization of time. Nevertheless, he is well aware that there are those who persist in maintaining the compatibility of relativity theory with the interpretation of *t* as successive, intuitive, unfolding time. *With the derivation of the world model of the Gödel uni-*

verse, however, as a solution to the field equations of General Relativity, Gödel has constructed a limit case for the relativistic geometrization of time. That is, he has produced a formal model that essentially limits the possible intuitive, contentful interpretations it can support (due, as we saw, to such features of the model as the presence in it of closed, timelike world lines). Thus, just as the Incompleteness Theorem demonstrated in regard to the Hilbert program that, in that context, intuitive mathematical *truth* cannot be simulated by formal *proof,* so, in regard to Einstein, the construction of a formal-mathematical model of the Gödel universe demonstrated, by Gödel's lights, that in this context, *t* cannot be given the *intuitive,* contentful interpretation of denoting that successive, unfolding *time* that ushers in *objective temporal becoming.* (As we will see in detail later, Gödel in fact goes further and constructs a delicate modal argument from the latter result to the effect that even in the actual world *t* cannot denote intuitive, successive time.)

Now a natural question arises at this point as to why Gödel did not reach the same conclusion in regard to Einstein's geometrization of time as he did for Hilbert's attempted formalization of mathematics, namely, that his surprising discoveries demonstrated *the limits of the formalism,* rather than the *disappearance of an intuitive content* not just as a possible interpretation of this system but, as it were, absolutely. We will address this issue in due course. What is to the point here, however, is that in his papers on Einstein—the technical and the philosophical—he appears to have brought a classic, and recalcitrant, informal question (here, the question of the objectivity of temporal becoming) to a sudden and dramatic formal resolution, and again by means of the construction of *an ingenious limit case* that *essentially constrains the possible intuitive content* that can be expressed by this *form.* Since the power of formalization (in this broad sense) is thus, in Gödel's hands, a tool not for the elimination or detraction of pure form (as in Brouwer) or content (as in Hilbert) (to simplify matters considerably), but rather for the illumination of each by the other, Wang's (1987) characterization of Gödel as engaged in a "dialectic of the formal and the intuitive" seems well said indeed.

The notion of a *limit case,* as I have introduced it, can be usefully compared with that of a 'limit concept' as this arises in tradi-

tional philosophy. The philosopher as such, one might say, attempts to limit or delimit conceptually a complete domain or universe of discourse, which enables him or her to subject this very domain or 'whole' itself to the further manipulations or delimitations of pure thought (if perhaps subject now to new rules of manipulation). The mathematician, in turn, follows this line of development with even greater purity or abstractness. Frege, the seminal figure in the mathematization of logic, completed or delimited, in pure thought, the domain of all (quantificational) validities by means of the (first order part of the) formal system of his *Begriffsschrift*. This, then, paved the way for Hilbert to introduce the discipline of metalogic, or the formal manipulation of systems of logic as themselves objects of mathematical investigation. Indeed, to take the simplest example, one of the basic steps in mathematics, the move from the finite natural numbers to the single, definite, infinite series that contains all the natural numbers (which Gödel calls the decisive "first infinite jump" [Wang 1987]), is a particularly pure instance of the employment of a limit concept (here, the concept of '*all* natural numbers'). One leap of idealization leads to others. Cantor introduces the pure limit concept of 'actual infinity', thus delimiting the infinite series or infinite sets themselves, and proceeds to construct new rules for the manipulation of the corresponding transfinite numbers (cardinal and ordinal)—a transfinite arithmetic by analogy with classical finite arithmetic.

What emerges even from this brief consideration, I believe, is that limit concepts typically involve, implicitly or explicitly, a powerful universal quantification, or notion of 'all', that is always in danger, if unchecked, of leading to paradox. Aristotle himself, as we will see later, who first systematized logic and thus tried to capture or delimit the domain of all logical validities, quickly ran into paradox when he considered the application of one of his logical principles, the excluded middle, to another domain given by a limit concept, that of 'all future times'. And Kant, of course, devoted a good deal of attention in the "Dialectic" of his *Critique of Pure Reason* to such limit concepts as the limit of *all* time, of *all* space, of *all* causal chains, and so on, which, if employed 'uncritically' (in his sense), would, he argued, lead reason, itself, into antinomy (see Strawson 1985, p. 34). Clearly, cosmology, which, as a systematic science, treats the entire universe

as a complete, delimited whole, would thus be put very much into question. Actual antinomy, unfortunately, did arise, precisely in the rigorous domain of logic, when Frege, in attempting to derive the basic laws of arithmetic from the basic laws of logic, took the extension of a concept—that is, the totality that includes all things that fall under the concept—to be itself a completed whole, and thus an object. For, by Axiom V in 1967b, if two extensions are identical, then for *all* objects as arguments, the corresponding concepts yield the same values—even when the argument is the extension of the concept, itself. This, of course, leads to Russell's Paradox. Indeed, even today we have to take great care with our use of 'all' after Cantor's proof that even his powerful set theory cannot contain 'the set of all things', since there is no such set. In fact, the very *idea of Reality* itself can be seen as, so to speak, *the very limit of all limit concepts,* and so the most liable to lead, if treated 'uncritically', in Kant's sense, to antinomy—as will appear shortly when we come to discuss Parmenides, one of the thinkers Gödel (1949a) cites as having gotten it right about the relationship of time to Reality.

Gödel's construction of limit cases, then, is in the great philosophical-mathematical tradition of employing limit concepts to enable the mind to grasp or delimit the most distant reaches of reality. His formal constructions, though, are two-faced. In themselves, they are theorems in mathematics proper, and, as such, are no more subject to dispute than mathematics itself is. As we have seen, however, the results distinguish themselves by admitting alternative interpretations, both within and outside of mathematics, and it is these alternative readings that force the "philosophical-minded" (to use Gödel's term from his 1949a) to make hard choices on questions that would themselves have been considerably less visible under less extreme logical—or geometrical—constructions. In order to see, then, how Gödel has managed to force us to come to a hard decision about the nature of time, let us proceed to those cosmological results with which our discussion began.

Chapter 2
Gödel's Idealism

You ask me about the idiosyncracies of philosophers? There is their lack of historical sense, their hatred of even the idea of becoming, their Egyptianism. They think they are doing a thing honor when they dehistoricize it, *sub specie aeternitatis*—when they make a mummy of it.

Friedrich Nietzsche

In the simplest terms, the relevant details of Relativity Theory, as Gödel found it, are as follows. (Experts will no doubt wish to introduce complications, but for our purposes, what matters most is that we have in front of us a perspicuous and concise overview of those philosophically significant aspects of the theory that influenced Gödel's construction.) In the Special Theory of Relativity (STR) the relativity of (distant) simultaneity, and the absence of a distinguished or 'privileged' reference frame, prevent one from speaking, as in classical physics, of a nonrelative 'world-wide instant'. The 'now', in this new context, has only frame-relative significance. "The four-dimensional continuum," Einstein writes, "is now no longer resolvable objectively into sections, all of which contain simultaneous events; *'now' loses for the spatially extended world its objective meaning*" (1961, p. 149; emphasis added). The classical absolute notion of simultaneity, as a two-term, transitive relation, is replaced by a new three-term relation—simultaneous at an inertial frame. Nevertheless, there remains in the STR a measure between events that is frame invariant—namely, the interval. The equation for the interval, $ds^2 = dx^2 + dy^2 + dz^2 - c^2 dt^2$, establishes that for events with timelike separation, where $ds^2 < 0$, their temporal order is invariant—that is, the one precedes the other in all frames of reference. Since

timelike separated events are causally connectable, we can say that the STR preserves at least 'causal' time (order).

In the General Theory of Relativity (GTR), however, the global distribution of matter affects the overall curvature of space-time itself, so that from a cosmological point of view, it may be that certain inertial frames are privileged—namely, "those that follow in their motion the mean motion of matter" (Gödel 1949a, p. 263). In all the cosmologies projected from the GTR before Gödel, it was possible to fit these so-called co-moving frames into a single, consistent 'cosmic' time. So, from the perspective of the STR and the GTR, although absolute, 'equably flowing', *Newtonian time* has disappeared, one can still preserve, compatible with the equations, and given some luck in the distribution of matter, *causal time* as well as *cosmic time*.

Now one could well question whether the latter concepts are sufficiently close to what was meant, pre-relativistically, by time to justify the continued use of this term from classical physics, but we will reserve such considerations for later. In the present context, what is to be noted is that Gödel discovered that there is, compatible with the GTR, a nonstandard, 'unlucky' universe, the so-called rotating or R-universe, where the 'compass of inertia' rotates everywhere relative to matter and where one cannot fit together the co-moving frames into a single, consistent, cosmic time. In fact, he showed that in such worlds there exist nearly closed as well as closed, future directed, timelike curves—that is, world lines that, although everywhere timelike, eventually return near, or to, their starting points. In such worlds one can, in effect, 'travel' in time in the same way we can now travel in space, and, in particular, though always heading into our causal future, we eventually arrive at our past or present.

What can one say about the meaning of these results? On one level, these are purely mathematical deductions from the GTR, and hence unquestionable if the deductions are sound. (Some, including Einstein, have questioned their physical significance, but we will come to this later.) Gödel interpreted his discoveries, however, in a dramatic philosophical fashion, suggesting that (1) in the R-universe, the objective lapse of time is an illusion and (2) even though it is an empirical question whether or not ours is an R-universe, the collapse of the objectivity of genuine temporal succession in a universe differing from ours only in certain non-

lawlike features concerning the cosmic distribution of matter and motion shows that in our universe, too, time is merely ideal. In order to see why Gödel drew such striking philosophical conclusions from his formal results, it will be necessary to make an extended trip back to the dawn of philosophy, to the old quarrel that philosophers have had with time.

Is Time Compatible with Reality?

If we take our lead from Gödel and go as far back as Parmenides, we see that the problem seems to be a perceived incompatibility between the concept of being, or *reality*, and the concept of *time* (and so *change* and *motion*). Now the term 'reality' is often used rather loosely, sometimes even as a mere substitute for 'the world'. But to appreciate the power of such concepts for serious ontologists like Parmenides and Plato (and Gödel), it is useful to approach their full force gradually. In the primitive sense, reality, understood as the world, was taken to be the earth. Since the earth is soon seen to be but one part of the universe, however, 'the universe' replaces 'the earth' as the full generalization of the concept of the totality of the physical world. Yet even today, cosmologists are somewhat loose in their use of this term, speaking of a 'Big Bang' physical 'origin' of the universe, whereas they should in strictness speak rather of the origin of *the rest* of the universe (besides the Big Bang). (And a similar criticism could be made of talk of *multiple* universes.) Even this large concept is soon seen, however, not to be large enough, since the universe is, after all, only a large object, whereas reality, or what-is (in the broadest sense) seems to include what-is-the-case with this object (and what it contains—namely, us). In a word, "[t]he world is all that is the case. It is the totality of facts, not of things" (Wittgenstein 1974, 1, 1.1). The facts, however, might have been otherwise, and so if the actual world is the totality of facts that actually obtain, then surely we can speak also of other, merely possible worlds that might have obtained. But now that we have introduced the modalities of actuality and possibility, how can we resist the generalization of 'reality' into the 'modal space' containing (in some suitable sense of 'contain') all the possible worlds (including our own, the privileged or distinguished actual world)?

But we are not done yet. For we have still left out certain facts. That our possible world, the actual world (let's name it α), is actual is not a 'fact' that is 'internal' to α. Even if α contains a fact to the effect that α is actual, this is still merely one of the many *possible* facts that *constitute* α, and the question will still arise: Is *this* possible fact actual? Where, however, can this missing fact be found? If it is a 'superfact' about 'modal space' that in it α happens to be (the) actual (world), then it remains that since (theological scruples like Leibniz's aside) α might not have been actual, this superfact itself might not have obtained. Thus we seem to have arrived at a vicious infinite regress, and the concept of reality, as *all* that is the case, has eluded us. (See, further, Yourgrau 1986.)

The source of our difficulties is clearly the extreme sense of *totality* required of the concept of reality. We have focused on the problem along the dimension of *modality,* but there are equally disturbing considerations when we take into account the dimension of *time.* And this is where Parmenides comes in. He says, in *The Way of Truth*:

> There is only one Way left to be spoken of, namely that it *is.* . . . Nor was it ever, nor will it be, since it is now all at once. . . . Thus it must either be altogether or not at all. . . . And how could what *is* be *going to be* in the future?—For if it *came into being,* it *is* not; nor *is* it, if it is at some time *going to be.* Thus becoming is extinguished and perishing is not to be heard of. (1957, pp. 35–38)

As I read it, Parmenides's reasoning seems to proceed along the following lines. If reality, or being, is the totality of all there is, of "all that is the case" (as Wittgenstein puts it), then if time is real, and so also change, then when yesterday I said that reality is all there is, I misspoke, since I left out something—namely, what was not then but came to be. But if time is real, then I cannot simply modify my notion of reality to include, as well, what has been and what will be (the case), since *the real* (the existent) *in time* is (what is in) *the present.* Indeed, Gödel himself reaffirms this when he speaks of "an objective lapse of time (whose essence is that only the present really exists)" (1949a, fn. 4). In a word, if the 'is' in "*all* that there *is*" is *tensed,* it must always fail to apply to future times, for, as Richard Jeffrey puts it, "[If time and change

are real] Reality *grows* by accretion of facts" (1980, p. 253; my emphasis). Yet if the future is to add to the present, it must draw on, so to speak, what is (now) nothing, which is impossible, since "it is not possible for 'nothing' to be" (Parmenides 1957, p. 31), "nor shall I let thee say or think that it came from what is not" (p. 36). But if it is *tenseless,* we have already eliminated time as real, or objective, and the Parmenidean tension between time and reality has been 'resolved' only by dispensing with the former. (I am taking tense here as the semantic correlate of the 'objective lapse of time'.)

The only hope for the reality of time, then, would be to try, again, the first option. But at this point Parmenides would surely object: If reality is no illusion, it can hardly 'grow' (as Jeffrey suggests) or get bigger! And what of Wittgenstein's "all that is the case"? If this is a *serious* 'all' (as it is surely meant to be), how could it expand to include new facts? "[A]n expanding universe is one thing, an 'accumulation of Reality' (and thus of truth) another" (Yourgrau 1987b). Yet Gödel himself seems to represent reality as expanding if time is real when he says that "[t]he existence of an objective lapse of time, however, means (or at least is equivalent to the fact) that *reality consists* of an infinity of layers of 'the now' which *come into existence successively*" (1949a, p. 262; my emphasis). If he meant only that reality already contains all the 'nows', he would not have added that these come into existence successively. But if what reality consists of comes into being successively, then reality itself must come into existence successively (if time is real).

One should recall, at this point, Gödel's methodological employment of limit cases in his formal work and our earlier remarks on the concept of reality as the limit of all limit concepts. Kant's warning concerning the antinomies that may attend the 'uncritical' employment of such concepts should now, I think, appear to be justified. Still, if we are to engage in ontology at all, it is hard to see how reality can be an illusion, and so, it might seem, *time* must be, as Parmenides and Gödel would have it. Indeed, perhaps we can now understand an otherwise mysterious remark in Gödel (unpublished), where he suggests that his cosmological results only confirmed his suspicions about the legitimacy of the concepts of change and tensed existence, since tensed existence "entails that we can, at different times, rightly assert

about the same thing that it exists and that it does not exist." Here Gödel seems to be self-consciously turning Kant on his head, for Kant's famous remark is that "only in time can two contradictorily opposed predicates meet in one and the same object, namely *one after the other*" (1965, A32/B48).

At first glance, this remark of Gödel's might seem merely to be based on an unfair criticism of a *tensed* concept of existence by employing, in the reductio clause, precisely a *tenseless* use of 'exists'. If our reasoning has indeed been along Gödel's lines, however, we can see that the explanation is rather that he seeks a notion of *reality* as *what exists*, in the sense of *all* that exists, and that it is the force of the '*all*' (which derives from the force of 'reality') that drives his argument. The reply that tensed existence implies only that something exists *at one time* and does not exist *at another time* would surely not satisfy him, since he would then ask whether both *times*, in turn, really exist (are part of all that exists). If not, reality turns out to be an illusion (since it is *incomplete*). But if both do really exist, clearly *this* sense of 'exist' must now be *tenseless*, and we will have spatialized time (in the sense characterized earlier), since position in time will now carry no ontological weight. And, as should be clear by now, for Gödel, to spatialize time *is* to render it ideal (by robbing it of its characteristic mode of existence).

If this reconstruction of Gödel's reasoning has been along the right lines, we can see why he cites the temporal idealist McTaggart as a precursor, since McTaggart's argument for the unreality of time has strong affinities with the version we have attributed to Gödel. The elusive details of McTaggart 1908 need not be gone into here, but the analogy with Gödel's approach is clear enough. What is crucial for our purposes is the tension between the *completeness* implicit in the classical concept of reality (Wittgenstein's "*all* that is the case") and the *essential incompleteness* that seemingly attends tensed, or temporal, existence. A reconciliation here seems difficult indeed. There is always, as it were, something unfinished about the temporal. That is why it can never be complete, or completed, or completely described. Thus Michael Dummett can write, "McTaggart's argument shows that [if time is real] we must abandon our prejudice that there must be a complete description of reality" (1960, p. 357). And from an entirely different point of view, a relativistic one that yet takes the

'dynamic' of time seriously, Čapek asks, "to what extent does the concept of the totality of the universe remain meaningful after the denial of absolute simultaneity of distant events?" (1961, p. 271). If we are not led by such considerations to give up, with Parmenides and Gödel, on the concept of time (or, more radically, the traditional concept of reality itself—Nietzsche? Heidegger?), then it would seem, as we hinted earlier, that there will at least be something ontologically suspect about the temporal—a kind of falling away from the fullness of genuine 'being'. And this seems to be the approach adopted by Plato, who tried, unlike his great predecessor, Parmenides, to save the appearances.

From Plato to McTaggart

From three crucial dialogues, *The Sophist, The Parmenides,* and *The Timaeus,* we know that Plato was led by considerations like those we have discussed to distinguish (yet also to reconcile) the fundamental categories of *Being* (or Eternity) and *Becoming*—the former confined to the mathematical or formal realm (in Plato's sense of 'form'), the latter to the phenomenal, to the world of appearances. And Plato, too, had a fundamental analogy for time, which he described, in *The Timaeus,* as "a moving image of eternity." As indicated earlier, 'eternity', for Plato, stood not for a length of time, for 'everlastingness', but rather for a *kind of being*—namely, *genuine* being. "Eternity for Plato," as Harold Cherniss writes, "is not temporal duration; it is not a measure but a mode of being" (1962, p. 212). An "image," moreover, as Plato stressed in *The Sophist,* as a mere copy, can at most *resemble* and thus always fall short of its original. Temporal being is thus for Plato always a mere imitation of genuine being—what 'is' in time is always 'on the way to becoming' (what it really is). Thus, as J.M.E. Moravcsik puts it, "[g]iven Plato's views on the tenses, temporal being is not complete being; what is temporally both is and is not" (1973, p.11).

Plato's conception of time had a strong influence on Aristotle's. Aristotle, in turn, distinguished actual from merely potential being (which is always on the way to becoming actual), and associated the latter with matter. The very essence, indeed, of matter is its potentiality, which it expresses by the 'motion' of

'becoming' (including, as motion, as Plato had, both locomotion and qualitative alteration). *Time, then, is what, in effect, separates the potential, qua potential, from its realization (always partial) as actual, expressed in the form of motion* (see Kosman 1969). To be fully actual, impossible for a material being, would thus also imply being eternal or outside time, and so not in motion. Arguing from premises such as that all potential being presupposes, for it to 'awake' into its actualization, something fully actual, to move or awaken it, Aristotle concludes, in *Metaphysics XII*, that such a being does in fact exist. He calls it an "unmoved mover," or God.

These classical conceptions are, I would suggest, what Gödel presupposed as the background of (in his words) the "intuitive, pre-relativistic" idea of time against which he wished to place the limit case of relativistic space-time he had constructed. But the background will not be complete until we have sketched in an important idea of McTaggart's. McTaggart makes a considerable contribution to the analysis of classical accounts by introducing a fundamental distinction between two aspects of the temporal, which he calls the "A-series" and the "B-series." This distinction was implicit in classical philosophy, but McTaggart was the first to make it explicit and to give it a name. The B-series provides the fixed, immutable, indeed geometric relations between events in time in terms of *before* and *after*. The system of dates of events is B-theoretic, as are typical issues in the physics of time that are mathematically formulable, such as whether time is discrete or continuous, open or closed, and so on. The A-series, by contrast, characterizes events in terms of their shifting realizations as future, present, and past—that is, as *now*. Unlike the case with the B-series, an event's 'location' in the A-series is not fixed once and for all but is always in flux due to the *nunc fluens*—the 'flowing now'. Thus, whereas it is a B-theoretic fact that I am writing this in 1991, it is an A-theoretic truth that it is now 1991, so that I am writing it now. The former will still be true fifty years from now; the latter, however, will not.

The A-series must be strictly distinguished from what one might call the 'relative A-series'. The relative A-series characterizes events as now only *relative* to a position in time in the B-series. Thus, in the relative A-series, whereas my writing this is now-for-me-in-1991, McTaggart's writing (1908) is now-for-

him-in-1908. In a word, *every* time is *now* with respect to, or *relative to,* itself. With the relative A-series, then, no time is singled out as privileged—as the now. A moment's reflection reveals, however, that the relative A-series is in fact none other than the B-series! For 'now-with-respect-to-time-t' signifies, surely, no more than 'simultaneous-with-t'. To keep McTaggart's distinction intact, then, it is important not to confuse the genuine A-series with the relative A-series, and it will prove crucial, in the pages to follow, that we keep these series separate.

The Elusiveness of the A-Series

Having distinguished the A-series from the B-series, McTaggart argued forcefully that for time to be real, both series had to exist. He also believed he had an argument that it is impossible for this to be the case, and so he concluded that time is an illusion. I alluded to this argument earlier in connection with Dummett's elaboration and defense of it (1960), but it is the distinction itself I wish to draw attention to, not the particular use to which it was put by McTaggart. Now, the B-series, as was suggested earlier, is amenable to a straightforward formal treatment, as in mathematical physics. But the A-series is more elusive, and a natural suggestion is that it is this elusiveness of the A-series that is responsible both for the need we have pointed to, of Plato, Aristotle, Kant, and others to find an analogy for time, and for the ontological anomalies that seem to attend the temporal—in a modest form for Plato and Aristotle and in an extreme way for the idealists Parmenides, McTaggart, and Gödel (and also, in a certain sense, for Kant). Since the question of the A-series would thus seem to be decisive for our investigations, let us attempt to characterize it more fully by indicating certain *concomitants* that would attend it, if it were realized.

(1) One time is distinguished or privileged—the now—and this privilege 'passes on' to a succession of times, as time evolves or lapses. (2) Time evolves or lapses, irreversibly and in a certain direction—from the possible to the actual, from the future to the present to the past. (3) 'Positions' in time are not 'ontologically neutral'; the only location that confers the privilege of existence is that of the present, the now. (4) Although the past is (now) closed and fully determinate, hence (now) 'necessary', in the

sense of 'unavoidable', the future is still open. (5) Simultaneity is a nonrelative, two-term relation.

Now, if we consider just the Aristotelian conception discussed earlier, we can see why (1) to (5) would be seen as essential to the A-theoretic component of time. In fact, it is a rather delicate matter to separate out the A- from the B-theoretic components of time in Aristotle's account, but we need not dwell on such subtleties here. (See, on this point, the very helpful study by M.J. White, 'Aristotle on "Time" and "A Time"' [1989].) We see, from this Aristotelian perspective, why the A-series has ontological significance, since it represents the coming into actuality (that is, into actual existence) of the merely potential or possible. We see also why the A-series is successive and incomplete—since the material world, qua material, is always in the process of realizing itself—and also why it is 'branchwise asymmetric'—since although the past is always determinate, and thus unique and linear, the future is indeterminate, 'branching' into open possibilities. And as Aristotle also insists, the 'flow' of successive times must not be taken literally, but, as we would say, 'analogically', since literal motion or flow—say, of a river—occurs *in* time (and so at a determine *rate*). What, then, of the flow *of time*?

A Bias Toward the Spatial

Clearly, the notion of *nunc fluens,* to be made sense of at all, must be regarded as primitive, as sui generis. Time may be, in some sense, *like* a river, but it is just where the analogy falters that intuitive insight must step in (if it can) to complete the picture. "Hence Whitehead's conclusion that in analyzing time, an ultimate appeal must be made to intuition, that is, to our direct awareness of time" (Čapek 1961, p. 372). In a conceptual scheme, however, biased toward the visual and spatial, whose language (or logic, or *logos*) is *geometry,* how is one to recover what is not spatial but rather temporal? Not *sight* but *hearing* seems to be here the more appropriate sensory modality. Indeed, it is instructive to compare, on this point, the score of a musical composition, which is visually or 'geometrically' graspable, with its successive realization in the very different medium of sound. Note further the different explanation needed for the unity of a melody, successive in time, from the nonsuccessive unity of a chord con-

sisting of notes played, as it were, spatially—that is, together, non-successively. Indeed, in their attempt to provide a set-theoretic foundation for music analysis, R. Dipert and R. Whelden (1976–77) define a chord as a (quasi-spatial, as Gödel says) set of tones and a piece of music as an ordered *n*-tuple (sequence) of chords. (Later, we will discuss attempts to define ordered sets themselves in terms of [quasi-spatial] unordered sets, an issue raised in Dipert 1982. It will emerge that such definitions sacrifice the temporality implicit in the intuitive conception of an ordered set or sequence.) If we accept, then, that a piece of music, either in itself or in its realization in performance as a succession of sounds, is in essence temporal, it remains that it can be represented in a quasi-spatial musical score, and that one can, it seems, through a complete ('simultaneous') grasp of a score, *succeed in grasping a temporal entity tenselessly.* This puzzling situation is brought out nicely by Roger Penrose:

> Like Mozart, he [Bach] must somehow have been able to conceive the work in its entirety, with the intricate complication and artistry that fugal writing demands all conjured up together. Yet the temporal quality of music is one of its essential ingredients. How is it that music can remain music if it is not being performed in 'real time'? (1989, p. 445)

Penrose has, in effect, raised the question: *Can one succeed in representing time or music purely conceptually (via the 'geometry' of a score),* or must we, in the final analysis, construct (to use our earlier terminology) an 'analogy', in the form, perhaps, of a temporal model? (Compare Brouwer: Can one represent genuine mathematical activity by the merely conceptual-logical 'geometry' of a [tenseless] formal system, or must one actually construct something mathematical in 'real time'? We will come to this question in the final chapter. For discussion of the characterization of a formal system like Frege's *Begriffsschrift* as a kind of geometry, see Robert Tragesser (1984, p.54): "if one simply looks at the pages of the 'Begriffsschrift', they have the character of presenting a rather beautiful geometry of signs. It would be absurd to say that in exercising the logic presented in that work one was not relying on visual intuition.")

It is becoming clear, then, that there is a serious tension between the language of classical mathematics—with its logical

space (in the general sense of this term discussed earlier) of numbers, lines, points, and so on—and the successive reality represented by the A-series. In the classical mathematization of time, points give rise to 'instants', and in the relativistic mathematics, lines become world lines of particles; but *these* concepts are the natural means of capturing, rather, the *B-series*. This is, in fact, in part what underlies the problems with the reality of time brought out by Parmenides's student Zeno—for example, the paradox of the arrow in flight, which at no *instant* of its supposed motion is ever in an actual *state* of *motion*—which Plato discussed in his *Parmenides* and Aristotle in his *Physics*. We will see later how Russell (1956) handles this problem.

Time and Classical Logic

It would seem, then, that if one is to come to grips with the question of the reality or objectivity of A-theoretic time, one must, if a mathematization is sought, be open to a non-classical systematization. The manifold that is generated by the temporal succession of the A-series cannot be represented by the pointwise decomposable continuum of classical analysis, but must be something more along the lines of the intuitionistic continuum of Brouwer. Moreover, as Čapek writes, "[i]t is unfortunate that the term 'continuity' in the mathematical sense in fact means infinite divisibility, *that is, discontinuity infinitely repeated*—the very opposite of continuity in the dynamical sense" (1961, p. 373; my emphasis).

The 'now' of the A-series is thus not the problematic 'knife edge' of a mathematical point. Indeed, as White (1989) shows, Aristotle himself got into trouble here, since his conception of the generation of times by a point seems to conflict with his own doctrine that time consists not of pointlike instants but rather of 'lengths', which are limited on *two* sides by 'instants'. That Aristotle's mathematical perspective was in general closer to the intuitionistic has often been noted. (See, for example, Lear 1980; 1982). Indeed, Aristotle, with Brouwer, (1) believed the natural numbers themselves to be generated in time *(Categories*, chap. VI); (2) accepted only potential, not actual, infinity *(Physics*, Bk. III); and (3) in his logic, cast doubt on the universal validity of the principle of the excluded middle (in Aristotle's case, the ques-

tion of future contingent propositions caused him to reevaluate, if not to abandon, this principle) *(De Interpretatione,* chap. IX).

In sum, if the concomitants of the A-series are not merely to be dismissed out of hand, then one must resist the temptation to characterize them in a classical-geometrical sense. Čapek is correct to insist, then, in connection with consideration (2) and the so-called direction of time, that "[i]f we forget that the word 'direction' is borrowed from geometry and kinematics and therefore cannot be literally applied to time, we may thoughtlessly draw all the consequences of the deceptive analogy between 'movement of time' and 'movement in space'" (1961, p. 396). The direction of time—from potential to actual—cannot be captured in spatial-geometrical terms (which is why the question of the reversibility of time's direction is a nonstarter from the A-theoretic point of view—something cannot be 'de-actualized' or 're-potentialized'). A too literal-minded conception of the motion of time would then, as Čapek says, present us with the question (meaningless for the A-theorist) of whether the future is approaching the present, or rather, whether the present is approaching the future, "as every motion in *space* is relative and can be transformed into a rest by an appropriate change of the frame of reference" (p. 346; my emphasis).

Collecting, then, our preparatory observations on the history of the concept of time, we remind ourselves that the paradoxes that Parmenides is said to have discerned in the attempt to reconcile genuine temporal becoming with a robust conception of reality gave rise to the ontologically fragile accounts of such 'becoming' of Plato and Aristotle, from which McTaggart distilled the two dimensions of the A- and the B-series. Of these, it turned out, the A-series is the more formalistically elusive. Finally, not to render the A-theoretic conception immediately invisible, we insisted that the A-series not be conflated with the relative A-series, and that it also not be rendered meaningless by attempting an explication along the lines of classical analysis.

Relativity Theory and the Reality of Time

We can now state what lay behind Gödel's dramatic philosophical conclusions drawn from his formal results on the GTR. Gödel believes firmly, I suggest, that (entirely aside from questions about

the STR and the GTR, to invert Einstein's comment) if time is not to be a mere illusion, to be merely ideal, *it must include the A- as well as the B-series,* together with concomitants (1) to (5) of the A-series. Thus, Gödel's unpublished paper on Kant and Relativity states that "an objective lapse of time, such as is contained in the intuitive concept of time, is impossible in the R-worlds," as well as that "that passing of time which is directly experienced has no objective meaning in the R-worlds." Further, reinforcing the *ontological* and *nonrelative* character of A-theoretic time, he insists that, "[o]ne may say that . . . relativity theory has proved only the relativity of time not its subjectivity. . . . But it is to be noted that 1) the absoluteness (or uniqueness) forms itself an essential characteristic of intuitive time, and that 2) a *relative passing of time* (if any sense can at all be given to this phase) would be something radically different from the passing as described above; *for existence by its nature is something absolute"* (my emphasis). Thus, the mere existence of a B-theoretic structure, satisfying whatever complex geometric relations you want, would be, for Gödel, insufficient to establish the reality of what is intuitively meant by 'time': "[S]omething of this kind [which lacks the character of 'passing by'] can hardly be called time" (my interpolation).

If Gödel had meant by time, then, only B-theoretic time, his philosophical conclusions would be *incomprehensible.* In this respect, what Gödel demands of time in order for it not to be ideal stands in sharp contrast to the dominant perspective of contemporary philosophy of space and time. Among standard textbooks in the field, the A-series is either almost completely ignored, as in van Fraassen 1985 and Newton-Smith 1980, for example, or it is discussed only to be completely dismissed, as in Mellor 1981 and Horwich 1987. However, none of these writers draws the conclusion, as Gödel did, that time is ideal. Indeed, in Mellor's *Real Time* the conclusion is explicitly drawn that B-theoretic time alone is *real* time! And John Earman writes that "time does not 'go', or 'unroll', or 'flow'. All attempts to give a literal-minded interpretation to the notion of the flow of time have met with failure" (1967, p. 217).

Needless to say, Earman does not deduce from this proposition that time is merely ideal, an appearance or illusion. But Gödel does. "One may take the standpoint," Gödel writes, "that the idea of an objective lapse of time (whose essence is that only

the present really exists) is meaningless. But this is no way out of the dilemma; for by this very opinion one would take the idealist viewpoint as to the idea of change, exactly as those philosophers who consider it as self-contradictory. For in both views one denies that an objective lapse of time is a possible state of affairs, a fortiori that it exists in reality" (1949a, fn. 4). (I take it that Gödel's "lapse of time," as well as "passing by," from our earlier quotation, are equivalent to Earman's "go," "unroll," and "flow.") Note, further, that Earman is unhappy with the lack of a "literalminded" account of this A-theoretic notion. As we have seen, however, all A-theorists would in fact insist that an analogy is needed here. What is unclear is why Earman seems to reject out of hand any employment of analogical reasoning in this area. Is it that, for him, whatever is real *must* admit of only a literal-minded interpretation? Whatever the answer, it is sufficiently clear that Gödel imposes stringent requirements on time for it not to be ideal, exactly in the tradition of Parmenides, Kant, and McTaggart, whom he correctly cites as his philosophical precursors. What led him, then, to conclude from his formal results on relativity theory that it is doubtful that these stringent requirements on time can be met?

'Objectivation' and Science

Gödel's unpublished paper speaks of an increasing "objectivation" of the temporal in the history of the natural philosophy of time. More and more features attributed to time in the intuitive conception have been eliminated from the scientific world-view as having, at most, 'subjective' significance. Thus, as it were, the class of those intuitive features of time that have physical significance has been steadily shrinking as physics has progressed. Indeed, time is not unique in this regard. The road to the contemporary mathematization of nature was paved, after all, by Galileo's famous introduction of the distinction between primary and secondary qualities, which, by relegating the latter to the status of the merely subjective, freed the natural philosopher from the need to take them into account in his mathematical formalizations. Thus, Lawrence Sklar, in 'Up and Down, Left and Right, Past and Future' (1985, Chapter 12), in effect echoing Gödel, speaks of modern science proceeding via a "secondarization" of

the phenomena. How else, for example, could one be asked to accept identities such as Heat = Mean Kinetic Energy unless one distinguished heat, in this context, from the sensation of heat— that is, a mere secondary quality? Sklar questions whether this strategy will work in recent attempts to capture time in purely causal or entropic terms. The disanalogy occurs, for him, because although heat (as a physical process) is in essence independent of the sensation of heat, the experience of temporal succession is not similarly independent of the existence of genuine succession in time (at a minimum, even a succession of subjective experiences is a genuine, and hence objective, succession, and so implies the existence of time). And Saul Kripke (1980), it will be recalled, argued along similar lines, stating that a mind-body identity theorist who asserts that pain = c-fiber stimulation can hardly, in the spirit of Galileo, ignore the merely secondary qualities of pain, since the sensation of pain constitutes the very essence of pain itself.

Gödel's unpublished paper points out that by the time of Kant's reconstruction of the then contemporary scientific world-view, "these steps or levels of objectivation, each of which is obtained from the preceding one by the elimination of certain subjective elements," had proceeded to an advanced stage. "The 'natural' world picture, i.e., Kant's world of appearances itself," Gödel writes, "also must of course be considered as one such level, in which a great many subjective elements of the 'world of sensations' have already been eliminated." Kant, of course, was at pains to distance himself from the empirical phenomenalist Berkeley, who refused to relegate the secondary qualities of nature as experienced to a merely ideal status. Yet, for all that, as Margaret Wilson has argued, "Kant can be styled a phenomenalist not because he accords 'reality' to the ordinary 'image', but only because the scientist's sophisticated reductive explanation of that image is, on Kant's view, elaborated within the framework of merely ideal 'forms of intuition'" (1984, p. 170). This peculiarly Kantian 'transcendental' idealism, however, is too much for Gödel, who sees in it an overgeneralization of what is an otherwise useful distinction between secondary and primary qualities, or the subjective and the objective:

Unfortunately, whenever this fruitful viewpoint of a distinction between subjective and objective elements in our knowledge (which

is so impressively suggested by Kant's comparison with the Copernican system) appears in the history of science, there is at once a tendency to exaggerate it into a boundless subjectivism, whereby its effect is annulled. Kant's thesis of the unknowability of the things in themselves is one example." (Gödel's unpublished paper)

In fact, Kant's position on the question that is of particular interest here, the experience of time, is rather slippery. On the one hand, he insisted that the reason we have (or so he believed) an a priori insight into the fundamental features of time is that (as we saw earlier) "[t]ime is nothing but the form of inner sense." On the other hand, he insisted, in the Second Analogy, that our subjective time-consciousness is somehow grounded in our ability to order events in the world in a lawlike way in terms of cause and effect. "[T]he subjective succession by itself is altogether arbitrary" (1965, A193/B238). But is an arbitrary succession a succession? The delicacy of this question arises from the attempt to discern genuine, that is, objective, properties of the subjective realm, qua subjective, and the difficulty one has answering it brings to the surface the fragile nature of Kant's distinction between subjective and objective elements in experience. (We will come back to this question later.) It is no accident, then, that when these two strands in Kant's philosophy, already in tension, are pulled apart, as they are by recent advocates of the causal theory of time, no doubt inspired by the 'causal time' (in the sense we alluded to earlier) of Einstein's relativity theory, trouble ensues. (For some insight into these troubles, see Newton-Smith 1980, p. 204; Whitrow 1980, pp. 225, 323, 326; and Sklar 1985, pp. 256–58).

The Kantian level of objectivation is, for Gödel, exceeded by the STR, where, he suggests, time has become dramatically more spacelike. Absolute global simultaneity, in the non-frame-relative, intuitive, two-term sense, has disappeared. Gödel interprets this theory philosophically in the same way Einstein does, which we indicated earlier, as "replacing the *evolution* of a three-dimensional existence" with a "rigid, four-dimensional space." Some, however, as we will see later, including Čapek and Howard Stein, prefer a dynamic reading of the STR, in contradistinction to Einstein and Gödel. Whitrow (1980) is more circumspect. His view is that "the passage of time corresponds to the continual advance of the light cones" (p. 348), and he asks us to "visualize . . . a complex of advancing light cones in space-time, the track of

each vertex being the world-line of a potential observer" (p. 352). Nevertheless, he is careful to observe that "[a]s far as the theory of relativity is concerned, we can consider *either* the *set* of *all* these light cones *or* the *continual transition* from one to another" (p. 348; my emphasis). Gödel, however, as we have seen, attributes to the "passage of time" a strong ontological force that imposes on the *now* a strict requirement of uniqueness, and thereby conflicts with the relativity of simultaneity (and therefore of the *now*) in the STR. Therefore, he is already suspicious of attempts to introduce the passage of time into the STR, and his new model of the R-universe, by his lights, deals the *coup de grâce,* from the perspective of the GTR, to any possibility of reconciliation between relativity theory and temporal becoming.

Flux and Special Relativity

In relativity theory, then, as Gödel reads it, there is no objective correlate of the subjective experience of the passing of time. There is, to be sure, a spacelike 'trace' of the subjective, or intuitive, experience of temporal becoming in the definite, objective ordering of events 'from past to future' determined by the light-cone structure of Einstein-Minkowski space-time. But there is, as Gödel sees it, no objective *temporal becoming* correlate with (the) subjective (experience of) becoming. Time appears, rather, as a kind of fourth ('spatial') dimension, *distinguished,* to be sure, from the other three, but *only geometrically,* in terms of the world lines permitted by the light-cone structure of Minkowski space-time and so *not intuitively,* as Kant had distinguished time as a form of *intuition* distinct from space. Those, therefore, who base their opposition to the view that the STR spatializes time on the fact that, in the equation for the interval, the time variable is distinguished from the spatial by being preceded by a negative sign have not really addressed Gödel's concerns. Newton-Smith (1980), for example, unimpressed by the "range of alleged puzzles that some philosophers have thought to arise because of a *supposed tension* between the STR and our ordinary conceptions of past, present and future" (p.187; my emphasis), insists that "[t]he theory maintains an absolute distinction between space and time. This is reflected by the fact that the time coordinate in the semi-Euclidean Minkowskian metric has the opposite sign to the spatial coordinates: $ds^2 = dx^2 + dy^2 + dz^2 - dt^2$" (pp 186–87).

Gödel's conclusions, however, are unaffected by these facts about *the geometric constraints imposed on Minkowski space-time by this definition*—by the fact, as it were, that time here has a different *geometry* from space. His reading of Relativity Theory speaks not to these B-theoretic facts, but rather to the A-series of temporal becoming. Indeed, Newton-Smith seems insensitive to just this distinction—crucial to Gödel's thinking—since, as was seen earlier, after citing the above B-theoretic constraints, he goes on to cast doubt on the "supposed tension between the STR and *our ordinary conceptions of past, present and future.*" In fact, far from acknowledging the negative sign before the time variable in the above equation as the signature for the "absolute distinction between space and time," Gödel views it rather as "the last objective remnant of time," which he well expects to disappear as physics reaches yet another level of objectivation. "The one-dimensionality of time," he writes, "it is true, expresses itself also . . . in the fact that the fundamental quadratic form has one negative square, but . . . it would only be a straightforward continuation of the development from classical physics to relativity theory, if this last objective remnant of time too were to disappear". And Gödel's view of the matter, as opposed to Newton-Smith's, is echoed in the recent book by Penrose (1989, pp. 443–44):

> The way in which time is treated in modern physics is not essentially different from the way in which space is treated and the time of physical descriptions does not really 'flow' at all; we just have a static-looking fixed space-time in which the events of our universe are laid out! . . . It is hard to believe that what makes time 'actually flow' in our experiences of the physical world we know is merely the asymmetry between the number of space dimensions (3) and time dimensions (1) that our space-time happens to have.

In spite of the high level of objectivation that Gödel discerns in the STR, however, there remains that "last objective remnant of time," as well as the fact that from the perspective of the GTR, given an appropriate distribution of matter and motion in the universe, one can still define a 'cosmic time.' The objectivation of time, then, is not complete. To use our earlier terminology, in the theory of relativity we do not yet have a *limit case* in the mathematization of time. The result of this, for Gödel, is that the relationship of the formal to the intuitive elements of time is not yet

fully visible, which prevents us from being able to recognize the striking and counterintuitive philosophical consequences implicit in Einstein's theories. What Gödel achieved, however, in his rotating universe solutions to the gravitational equations of the GTR is precisely *a limit case for the relativistic mathematization of time.* For in the R-universe it is provable that no cosmic time is definable, and it becomes impossible, by Gödel's lights, to continue to maintain the existence of any semblance of an objective lapse of that (genuine, successive) time that one might have held out for in the STR. This derives from the fact that in the R-universe, by traveling always toward one's causal future, one can arrive eventually at one's local past, thus 'canceling', as it were, the effect of the passage, the objective lapse, of time.

In such a universe, one encounters circular or *closed* time, in contradistinction to *cyclical* time, in which a temporal process is *repeated* (n times). Even though the past is over, then, one somehow returns to it, thus making nonsense of the idea of a genuine succession of times, in the temporal (A-theoretic) sense, in which only the present member of a succession exists. In a temporal circle, as opposed to a temporal cycle, one does not *repeat* a series of processes, as a second hand completes the circuit of a dial so many times. For a temporal cycle, one can thus always ask how often the circuit has been completed, whereas such a question has no meaning with respect to the spacelike existence of a time circle. (Recall our earlier definition of a space in the general sense. If one can travel, at will, to any part of time, this must be because *all parts of time,* like all parts of physical space, *already exist* to be traveled to.) The crucial question, then, is whether one can sustain the philosophical consequences that Gödel derives from his new model for the GTR.

Chapter 3
Time Travel and the Gödel Universe

As we present time to ourselves, it simply does not agree with fact.
To call time subjective is just a euphemism . . . An entity corresponding
in all essentials to the intuitive idea of time . . . in relativity theory . . .
exists only in our imagination.

Kurt Gödel

The following two diagrams help us to grasp the significance of
nearly closed and closed timelike curves in the Gödel universe.
Figure 1 illustrates the successive stages in the advance of 'intu-
itive' time, and Figure 2 shows what would have to obtain if
closed time were possible. (A) in Figure 1 can be easily seen to

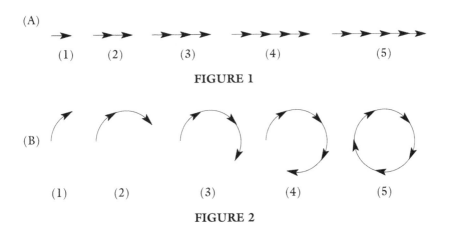

(A)

 (1) (2) (3) (4) (5)

FIGURE 1

(B)

 (1) (2) (3) (4) (5)

FIGURE 2

represent a succession of times. In the first place, it unfolds step-wise, successively. Further, when an earlier step has occurred, the later steps *have not* (they lie in the future, hence they are not yet actual or existent). Finally, it is always appropriate to ask, at any given step in the temporal progression, what stage *has now* been reached—and there will always be a definite, unique, answer.

None of these conditions, however, makes any sense when applied to (B), in Figure 2, considered as a representation of closed time. For in such a model of time, stage (5) no more comes about only after stages (1) to (4) have—that is, waits upon their completion for its own existence to be realized—than they wait upon its completion. Rather, it is entirely irrelevant, from an ontological point of view, how one chooses to describe the order of completion of the different steps, simply because they are all equally complete at all stages. If the step at stage (5) were not already fully complete at stage (1), for example, step (1) could never occur, since it occurs after step (5). *This is what it means to describe time as forming a circle.* In a world with closed, circular time, then, time could not but be spacelike—that is, temporal position in it could not have the ontological significance that attends a genuine, open succession of stepwise generated times. *And that was, of course, exactly Gödel's point.* That is why he believed that the new cosmological model he had discovered confirmed the idealistic conception that there is no 'objective lapse of time'. "[T]he decisive point is this," he writes, "that for *every* possible definition of a world time one could travel into regions of the universe *which are passed* according to that definition. This again shows that *to assume an objective lapse of time* would *lose every justification* in these worlds" (Gödel 1949a, p. 264; first emphasis Gödel's).

Further confirmation of Gödel's thesis comes from the fact that all five concomitants of the A-series, as we characterized them earlier, disappear in the closed time of the Gödel universe. Only a conflation of the A- with the B-series, then, could lead one to say, with Richard Sorabji, in 'Closed Space and Closed Time' (1986), that, "[d]espite the fact that each event could be seen as lying equally in the future and in the past, I see no reason why there should not be a direction for *the flow of time*" (p. 221; my emphasis). Consider, however, the concomitants of the A-series. (1) There would obviously be, in closed time, no unique, privi-

leged, *now.* (2) Time would not 'flow' or 'lapse', for the reasons given earlier. Further, although one could specify a geometric, B-theoretic 'direction' for time in such a world, this would not be the direction that characterizes A-theoretic time, which moves from the *possible* to the *actual.* For time travel to the past would be travel to what was already actualized and cannot, therefore, be *re-actualized.* Indeed, the very distinction between actual and possible times breaks down in the case of closed time. (3) Positions in circular time would be, as we saw, ontologically neutral. (4) *The future* would be as determinate and complete as the past, and therefore not open but *closed.* (And, as we will see later, in connection with Aristotle and the logic of indeterminist time, this would mean that if the past is '*necessary*', then so, too, is the future.) Finally, concomitant (5) clearly fails, since the closed time of the Gödel universe is part of a relativistic model that presupposes the relativity of simultaneity.

To drive home, further, the force of his conclusions from the peculiar properties of the R-universe, Gödel refers to certain paradoxes that he says would follow if it were feasible in such a universe for one "to travel into the near past of those places where he has himself lived" (1949a, p. 262). He proceeds to argue that in fact such travel would not be practically feasible, and so "[t]herefore it cannot be excluded a priori, on the ground of the argument given, that the space-time structure of the real world is of the type described" (1949, p. 264). We will come in a moment to the question of whether these 'paradoxes' of time travel to one's local past amount to actual antinomies. Gödel's point here, however, is that factors such as these should not lead us to rule out the R-universe as not containing physically realistic space-time structures, structures in which, nevertheless, no sense can be made of the objective passage of time. It is well, then, to remind ourselves of the two-faced nature characteristic of Gödel's formal results, which we drew attention to earlier.

Gödel cites certain mathematical results he has derived in relativistic cosmology concerning the possibility of the R-universe, results that would lead to the conclusion that *time* travel, in an intuitive sense, is possible in such worlds *if* we assume that *t* still has, in these contexts, the *standard* interpretation as *time.* Precisely this standard interpretation, however, Gödel rejects, arguing, as we have seen, that nothing corresponding to the pas-

sage of time (which he sees as essential to the existence of time and change) remains in such a universe. Thus, what could otherwise be correctly described as *time* travel—namely, the existence of nearly closed and closed, timelike world lines—cannot, in strictness, be said to satisfy this description, since exactly those conditions that *permit* us to describe these world lines as nearly closed or closed *prevent* us from also characterizing them as *temporal*. In a word, just because there is, loosely speaking, 'time travel' in such worlds, there is no passage of time, hence no time in the intuitive sense, and therefore no genuine time *travel*. (Indeed, there is no travel of any kind, in the intuitive sense, in such worlds.) Certain unexpected formal structures of space-time would exist, to be sure, but a certain interpretation of them—the standard one—is, for Gödel, definitely ruled out.

'Remaking' the Past

What remains to ask of such a model are B-theoretic questions, as well as issues concerning how physically realistic we should take this hypothetical universe to be. We will come to the latter issue presently, but let us focus for now on the 'paradoxes' of time travel that may seem to arise in the context of B-theoretic time. The first issue to be clear on is that a time traveler will not be *remaking history*. The very reason he or she will be able to visit the past is that in the spacelike B-theoretic time of a closed-time structure like the Gödel universe, all parts of time are equally real, existent, or actual. If it is correct, therefore, to say that one *will* visit the past, then it is equally correct to say that one *already has* visited it. As we saw earlier, a temporal circle is not a repeated cycle, and so one is not *revisiting* the past. One cannot 'undo', therefore, anything in the past; if it has already happened, it is a fact, and *nothing—including time travel—can alter the facts*. Indeed, the most prominent B-theoretic consequence of time travel in the Gödel universe is the symmetry of past, present, and future with respect to facticity. The asymmetric time structure of an A-series 'open' future, pregnant with multiple possibilities, is not applicable here, in a world containing only actualities, and so nothing can be *changed*—neither events in the future nor those in the past (even if one travels to it). Thus there is *no danger that the time traveler might,* by accident or design, *kill his or her par-*

ents and thereby *eliminate the conditions necessary for his or her own existence.* The very existence, rather, of the time traveler guarantees that no such result will come about—either because, as Gödel suggests, such a trip would turn out not to be feasible or because the time traveler on such a trip to his or her local past somehow, in fact, always fails to produce results that, if successful, would prevent his being there.

This last hypothesis brings out the fact that closed, circular time imposes strict constraints on what events *can* occur (past, present, or future), *consistent* with the fact that certain other events have happened. The 'beginning' presupposes the 'end', as it were (for whatever point in time we arbitrarily choose to call the beginning). What is 'possible' to do now, thus, depends on what was actual before. But, as we observed earlier, there are really no genuine possibilities in such a universe, and hence no free will in the traditional sense in which this implies the possibility of doing otherwise. In a universe of pure fact, containing only actualities, the most severe requirement is one of logical consistency—a requirement that reality, of course, unlike a formal system, cannot fail to satisfy. It remains to determine how best to characterize requirements such as that, if I try to kill my 'earlier self', I will fail. Either there would always be some ad hoc reason why such an action would fail (for example, the gun wonld jam, a bolt of lightning would startle me, etc.), or (Horwich 1987) there would be in such a universe ". . . the sort of initial conditions that will give rise to certain types of coincidence" (p. 126). Indeed, in the Gödel universe, with the consistency conditions mentioned earlier, the distinction between mere initial conditions and laws of nature may break down, for, as Sklar has observed, "[i]f there is, relative to the propositions we now countenance as the laws of nature (including the laws of general relativity) a lawlike constraint on 'initial conditions', if, that is, some specifications of the world 'at a time' are impossible since they are lawlike incompossible with themselves, what solid distinction is left between laws of nature and 'mere matter of fact initial conditions'?" (1984, p. 106).

In addition to these metaphysical-logical issues concerning the peculiar B-theoretic properties of time travel, however, there are certain epistemological anomalies to which Gödel has drawn attention. What troubles him is that if time travel to one's own

local past were possible, one could encounter one's own past self, and "[n]ow he could do something to this person which by his memory, he knows has not happened to him" (Gödel 1949a, p. 264). (Notice that Gödel does not say: 'he thinks he knows.') The problem here is not simply that our memories might prove to be fallible. This situation arises already in the actual world. Rather, Gödel is worried by the fact that our decision-intention to travel through time and create mischief can be the basis for the disconfirmation of even a confident first-person memory claim. My memory, it would seem, could then, in principle, if time travel to such regions were possible, be revealed as spurious because of what I now *decide* to do.

This is indeed awkward and unexpected, but Gödel does not specify if this is possible for any category of memory report (so that no class is privileged), or whether it is possible that by this means we could, in principle, choose to undermine most of our memory claims. Though such possibilities would not usher in explicit antinomies, they would raise serious questions about the epistemological status of memory in such a world. (And the relationship between time consciousness and memory, of course, is intimate. See, for example, Newton-Smith 1980, pp. 205–06.) The anomalous character of the situation Gödel envisages can be brought out more fully if we recall that, as Dummett has emphasized in 'Bringing about the Past' (1978a), normally we take it to be a mark of the difference between past and future, between memory and anticipation of the future, that only for the latter is it necessary to take into account, in forming our judgments, our intentions. That is to say, our knowledge of what will come about in the future, as opposed to what occurred in the past, may be influenced by what we presently intend to bring about. Of course, the reply may be made that such anomalies are to be expected here, since, as we have seen, in a Gödel universe permitting time travel, our traditional conceptions of past-future asymmetry would be inapplicable. Perhaps, then, there is a standoff here between a view like Gödel's, which points out the strain that certain trips to one's own immediate past would put on epistemological categories like memory, and the contrary conception that, in a time-anomalous world like the Gödel universe, it is to be expected that traditional epistemic notions like memory will not survive unchanged.

It remains to ask, however, given the close relation, mentioned earlier, between memory and time consciousness, whether what remains of time, in a world permitting Gödel's 'paradoxes' of memory during time travel to one's own local past, is close enough to our own conception to permit the continued use of the term 'time'. One is tempted to remark, with Earman, that "one must face up to the question as to what extent the concepts of time, causality, and identity which appear in a coherent account of time travel would resemble our present concepts" (1967, p. 221). As we have seen, however, it is precisely Gödel's point that time in the intuitive sense would not exist in such a world—not for the reasons Earman adduces, but rather due to the fact that (for Gödel) no sense can be made, in such a universe, of the objective lapse or passage of time (a consideration whose force must surely be lost on those like Earman, who, as we saw earlier, can in any case make no sense of the notion of the flow of time even for our universe). Thus, as should be clear by now, there is a sense in which Gödel was not suggesting the possibility of genuine time travel in the Gödel universe. His dialectical use of his nonstandard model of the GTR was intended, rather, to deliver the *coup de grâce* to the notion that relativity theory is in the end compatible with the intuitive conception of the temporal— according to which there exists an objective passing of time. "That at least *that* passing of time which is directly experienced has no objective meaning in the R-worlds *also follows from the fact* that it is possible in these worlds to travel arbitrarily far into the past and future and back again" (Gödel, in his unpublished paper; second emphasis mine). If he continues, nevertheless, to employ the *term* 'time travel', this is surely because he is confident that the reader will not forget his over-arching point that *all* temporal phenomena in the Gödel-universe are *ideal*.

The Fruits of Geometrization

In deducing the possibility of a universe permitting time travel, then, Gödel was, in effect, *generalizing the geometrization of the temporal* even to conclusions that Einstein himself was reluctant to draw. Einstein had always denied the possibility of 'sending wireless signals into the past', and in relativity theory, as it is usually understood, this is indeed impossible. The *reason* for this

impossibility, however, concerns *the structure of Minkowski space-time,* not, as in Kant, because of the *category distinction* between (the 'forms of intuition' of) space and time. This extreme *geometrical* approach to time *left the door open* to Gödel's unexpected proof that certain counterintuitive geometrical properties of time will obtain in universes consistent with the purely formal-mathematical constraints of the GTR. Thus Einstein can write, in response to Gödel, that "[t]he problem here involved disturbed me already at the time of the building up of the general theory of relativity, without my having succeeded in clarifying it. . . . Does it make any sense to provide the world-line with an arrow, and to assert B is before P, A after P? Is *what remains of temporal connection* between world-points in the theory of relativity an asymmetrical relation . . . ?" (Einstein 1949, p. 687; second emphasis mine).

Couldn't Einstein have replied, however, that one might be able to rule out the R-universe as realistic on the basis of purely physical considerations? He could have, and he did. "It will be interesting to weigh," he writes, "whether these [the Gödel solutions] are not to be excluded on physical grounds" (ibid., p. 688). This reply, however, does not address the modal force of Gödel's philosophical argument (alluded to at the opening of Chapter 2). Gödel seems to be arguing that the mere mathematical possibility of an R-universe, in which time *would* be ideal, shows that in our actual universe time *is* ideal. Indeed, as was mentioned in the Preface, I have suggested, in my 'Review Essay: Hao Wang, *Reflections on Kurt Gödel*' (1989), that this pattern of modal reasoning—namely that possible existence has strong implications for actuality—is typical of Gödel. In Wang's *Reflections on Kurt Gödel* (1987), for example, we read that Gödel had formulated his own version of the ontological argument for God's existence (whose characteristic logical form is that if God is possible, then He is actual). And for a mathematical Platonist like Gödel, the mere possibility of a formal structure would, I take it, imply its actual (mathematical) existence.

In the present instance, however, this characteristic pattern of modal reasoning is more elusive. To begin with, in order to have implications for the actual physical universe, Gödel's hypothetical cosmological model must be taken to have realistic, physical significance. On just this point, however, cosmologists have been

skeptical. Georg Kreisel, for example, reports, concerning one prominent cosmologist, that, "by Professor Penrose's account, the direct physical interest of Gödel's papers . . . is limited—in accordance with Einstein's comment on [Gödel (1949a)] . . . Professor Penrose emphasizes from his own work experience . . . [that] Gödel's work served as a cross check on mathematical conjectures and proofs in the modern global theory of relativity" (Kreisel 1980, p. 215).

How 'Realistic' Is the Gödel Universe?

It is tempting, then, to respond to the question at hand as Stein has: "Gödel's results concern a cosmological model; in assessing the eligibility of that model, one is up against the well-known difficulty that only one cosmos is given us (so that what other ones are 'physically possible' is moot)" (1970, p. 594). Although it can hardly be denied, however, that the question of physical possibility is "moot," it is not clear to me what force lies behind the suggestion that "only one cosmos is given us." It is certain that only our actual cosmos is given us via our sense experiences. But can we not grasp, conceptually, merely possible universes? In fact, does not the very enterprise of the theoretical scientist involve confronting the actual world with an ensemble of models of possible universes (often highly imaginative models—such as Einstein's), which it is the duty of the experimentalist to confirm or refute? Doesn't the experimentalist, then, by comparing, as it were, such models with the cosmos that is given us by sense experience, try to determine which universe is physically actual, as opposed to which are physically *possible*—the latter task falling, rather, to the theoretician? Although I have nothing new to offer the theorist concerning this general characterization of his or her task, it seems to me that something can be said concerning the specific question now before us—namely, the physical significance of Gödel's hypothetical world model.

The first thing to note about the Gödel universe is that it appears, to Gödel, at least (1949a, p. 265), not to violate the natural laws that obtain in the actual world. (Stein 1970, pp. 593–95, discusses this issue.) *One might, then, suggest that we should recognize a new law of nature—an anti-Gödel law, as it were—that would rule out the embarrassing situation in which*

the R-universe might turn out to be lawlike compossible with ours.
But the question is: What might *motivate* one to entertain such a
new law—except for the fact that the Gödel universe appears to
be *counterintuitive* in implying the existence of time travel? It is,
however, as we have seen, precisely one of Gödel's points that the
full counterintuitive implications of relativity theory have not
always been sufficiently realized—implications that his new mod-
els of the GTR were designed to bring out. Indeed, as we have
seen, Gödel viewed relativity theory itself as but one (advanced)
'level of objectivation' of time, to be followed, he suspected, by
other, higher levels—where, he conjectured, even the "last objec-
tive remnant of time" will eventually be "generalized away."
Although those who are skeptical of the physical significance of
Gödel's results, then (viewing them, perhaps, as Penrose suggests,
merely as "a cross check on mathematical conjectures and
proofs"), are arguing by *modus tollens* (against the physical signifi-
cance of Gödel's extrapolations from Einstein), Gödel surely sees
himself as proceeding by *modus ponens (bringing to light, as we
said earlier, philosophical consequences not nearly so visible under less
extreme geometrical constructions*).

To decide the issue between *modus tollens* and *modus ponens*
here, it is necessary to refer back to the various considerations we
have looked at in this book concerning Gödel's philosophical
interpretation of relativity theory. Earlier, with regard to his work
on the foundations of mathematics, we pointed out that he had
observed, in a letter to Wang about his incompleteness results,
that a contrary philosophical approach had hampered the formal-
ists (who "considered formal demonstrability to be an analysis of
the concept of mathematical truth and, therefore, were of course
not in a position to *distinguish* the two"). Here, I would suggest,
Gödel presupposes, for his formal results not to be robbed of
their full significance, the philosophical account of relativity the-
ory he has put forward. Concerning this account, we have already
tried to reconstruct some of Gödel's reasoning. Of particular note
is the fact that the problematic characteristics of time travel in the
Gödel universe that concern the canceling of the passage of time
by visiting the past, and belying the unreality of the future by vis-
iting it at will, as well as casting doubt on the notion of the asym-
metric direction of time, in the intuitive sense, all relate to
A-theoretic time. And if Gödel is right, philosophically, *this* has,

irrespective of considerations to do with time travel, already disappeared from the point of view of the *STR*. We will attempt to reinforce this reasoning soon, when we come to discuss those who, contra Gödel, have adopted a less counterintuitive interpretation of relativity theory. Assuming for now that Gödel's interpretation has force, and thus that his new mathematical model for the GTR has physical significance, I will now try to spell out the reasoning by which Gödel drew conclusions about the *actual* world from these results concerning merely hypothetical or possible worlds.

Possibility Implies Actuality

Gödel's modal reasoning seems to be as follows. Since the actual world is lawlike compossible with the Gödel universe, it follows that our direct experience of time is compatible with its ideality (assuming, with Gödel, its ideality in the Gödel universe). But if even *direct experience* is inadequate to establish the existence of intuitive time—that is, not merely (relativistic) causal or cosmic time, but genuine, successive time that lapses or passes—then *nothing further* will suffice. Thus there are, and can be, no grounds for asserting the existence of intuitive time, of temporal becoming. In a word, "if the experience of the lapse of time can exist without an objective lapse of time, no reason can be given why an objective lapse of time should be assumed at all" (Gödel 1949a, pp. 264–65). This line of reasoning shows a striking similarity to Kant's arguments in the Transcendental Deduction and Refutation of Idealism. In very simplified form, these arguments assert that if our possession of the basic categories of experience is compatible with the possibility that all our experience (as) of the external, sensible world of appearances is an illusion, then nothing further can establish that we are not subject to such an illusion. Thus, in effect, if there is no external, sensible reality in our world as we experience it, then there is none in any other world. (So, for Gödel, if there is no objective lapse of time in our world as we experience it, then there is none in any other world.) Kant claims, along these lines, to refute empirical idealism and to 'deduce' transcendental idealism.

Now, there would appear to be, for both thinkers, a movement from skepticism (both *p* and not-*p* are compatible with all

possible experiences) to idealism, and as Strawson (1985, p. 16)
notes, this kind of move rests, ultimately, on some sort of 'verifi-
cationist' bridge principle (Strawson speaks of Kant's 'principle of
significance'). In the case of the STR, Gödel's unpublished paper
makes such a principle explicit: ". . . in perfect conformity with
Kant, the observational results by themselves [on which the STR
rests] really do not force us to abandon Newtonian time and
space as objective realities, but only the observational results
together with certain general principles, e.g., the principle that
two states of affairs which cannot be distinguished by observa-
tions are also objectively equal" [my interpolation].

As J.S. Bell puts it (1989, p. 77):

> Since it is experimentally impossible to say which of two uniformly
> moving systems is *really* at rest, Einstein declares the notions 'really
> resting' and 'really moving' as meaningless. . . . Lorentz, on the
> other hand, preferred the view that there is indeed a state of *real*
> rest, defined by the 'aether', even though the laws of physics con-
> spire to prevent us [from] identifying it experimentally. The facts of
> physics do not oblige us to accept the one philosophy rather than
> the other.

For Gödel, then, what is 'timelike' (in the intuitive, not the
relativistic, sense) about relativity theory has, at best, only an acci-
dental correlation in the actual world with the intuitive features
that make time *time*. *By projecting pure 'Einsteinian time', how-
ever, into a universe where it survives, but where the accidental cor-
relations with intuitive time disappear, Gödel believed he had shown
that even in our world (where the obtaining of these correlations ren-
ders less visible the true temporal profile of relativity theory)
Einsteinian time is only a formal simulacrum of intuitive, successive
time.*

Shades of Kant

With this line of reasoning before us, then, we can begin to see
why Gödel's unpublished paper) is primarily a long philosophical
commentary on (in his words) the "insufficiently appreciated"
similarities between relativity theory and Kantian (idealist) philos-
ophy. (He is careful to add, however: "I wish to say right in the
beginning that I am not an adherent of Kantian philosophy in

general.") "Kant and Relativity Theory," Gödel writes, "go in the same direction, but Relativity Theory goes only one step." Thus, just as in the STR 'causal' time provides simultaneity relations only *relative* to each inertial frame—or, if you wish, to each observer—so, in Kant's philosophy, time as a mere form of our sensibility represents only *a relation* between us and things-in-themselves. In both, time is ideal in that it is not intrinsic to the facts, but rather is imposed on them by an observer. "[I]t [time] does not inhere in the objects, but merely in the subject which intuits them" (Kant 1965, A38). (Gödel remarks, however, on this difference, that for Kant time is relative to the universal human sensibility as such, not, as is the case with relativity theory, to particular inertial systems, or observers.)

Relativity theory "goes only one step," however, because (1) the time relative to the co-moving frames can, compatible with the GTR, be fitted into a single, consistent, 'cosmic' time (which then is not merely imposed by each observer in virtue of his local frame of reference), and (2) even in the STR, the relation of temporal succession between timelike separated events is invariant (and so, again, is not merely imposed by an observer). In Kantian philosophy, however, there is no higher perspective from which time can be seen not to be ideal. Beings with a different sensibility from ours, Kant affirms, would not experience the world temporally at all. Here Kant's idealism is closer to Gödel's, since for the Gödel universe (and hence, so the argument goes, for ours) nothing satisfying the intuitive (Kantian, as Gödel puts it) characteristics of time can be realized. Yet Gödel's idealism, of course, unlike Kant's, rests (in the present context) on an empirical physical theory—the relativity theory of Einstein—and, again unlike Kant's, applies only to time, not to space (or space-time). Can Gödel's employment of relativity theory, however, for these idealistic purposes be defended against those who find themselves able to reconcile the theory of relativity with temporal becoming? I have attempted to trace the lines of Gödel's modal argument from the GTR and cosmology. Next, I will try to evaluate Gödel's reading of the STR.

Chapter 4
Not Everything Can
Be Relativized

The concept of existence, however, cannot be relativized without destroying its meaning completely.

Kurt Gödel

Howard Stein, in his 'Introductory Note' (1990) to Gödel's 'Remark' (1949a), focuses on Gödel's idealism but finds an "apparent discrepancy" here between Gödel's 'Remark' and his unpublished 'Some Observations'. Stein suggests that in 'Some Observations', Gödel stresses the relativity of temporal relations in relativity theory to an observer, which does not, however, prevent such relations from being objective. But in his 'Remark', Gödel emphasizes the ideal or illusory nature of time. Yet, as Stein says, "to be relative is not to be illusory."

This is a crucial point, and it is important to be clear on it. The resolution of the "apparent discrepancy" consists in the fact that for Gödel, for *time* to be relative *is* precisely for it to be an *illusion*. We must never forget that for Gödel the A-theoretic component of time, with its characteristic of passing by, is essential, as well as the fact that he attributes to such A-theoretic passing by a serious and absolute (non-relative) ontological force. As Gödel states in 'Some Observations': "[S]omething of this kind [which lacks the character of passing by] can hardly be called time." Thus, the objective but relative temporal relations of Gödel's unpublished paper concern the B-theoretic structure of the Gödel universe, which Gödel believes "can hardly be called *time*" but

51

rather has to be called space or space-time. Further, in a passage that seems almost to have been written with Stein's comment in mind, Gödel says in 'A Remark':

> [I]t may be objected that this argument only shows that the lapse of time is something relative, which does not exclude that it is something objective; whereas idealists maintain that it is something merely imagined. A relative lapse of time, however, if any meaning at all can be given to this phrase, would certainly be something entirely different from the lapse of time in the ordinary sense, which means a change in the existing. The concept of existence, however, cannot be relativized without destroying its meaning completely. (1949a, fn. 5).

In a word: Some things cannot survive relativization.

That the intuitive conception of the now and of time's passage can survive in a relativistic context simply by being relativized to an observer or frame of reference was for Gödel precisely one of those misconceptions about relativity theory that prevent its revolutionary counterintuitive implications from being realized. A merely relative temporal succession, then, by Gödel's lights, is a contradiction in terms. If time were real, then by now the world-in-time would have advanced so far and no farther (recall our two diagrams at the opening of Chapter 3). This is surely what Gödel means when he says that "[t]he existence of an objective lapse of time, however, means (or, at least, is equivalent to the fact) that reality consists of an infinity of layers of the 'now' which come into existence successively" (1949a, p. 262). And, of course, it is precisely the existence of such absolute, non-frame-relative, instantaneous, worldwide cuts across space-time that is denied in relativity theory. If a merely relative succession is ruled out, then (as genuinely temporal), so too is a merely subjective succession. But this last point must be handled with some care, since it involves, seemingly, establishing objective truths about the subjective. On this point, Frege (1967a) advises us to stay entirely away from the subjective, lest we try to say what cannot be said. (Frege himself, however, may not have escaped getting into trouble on this point [Hacker 1972].) One might, then, with caution, be tempted to suggest that time does exist, even in a relativistic context, but only, as it were, subjectively. For there is a sense,

surely, in which even Gödel does not deny that there appears to be time. And in the case of Kant, in particular, whose idealism, as we have seen, Gödel at least in part identifies with, one might suspect that since time is, after all, the very form of inner representations, at least these representations—which Kant insists are always successive—are themselves really in time.

Time for Kant

This temptation, however, must be resisted. It would amount to violating Kant's prohibition never to take appearances as things-in-themselves. Kant himself, moreover, would appear to have been sensitive to just this misinterpretation of his views, for he says at A38, note a, that "I can indeed say that my representations follow one another; but this is only to say that we are *conscious* of them *as in a time-sequence,* that is, in conformity with the form of inner sense. Time is not, therefore, something in itself, nor is it an objective determination inherent in things" (my emphases). For Kant, then, it would seem that I am constrained only to *represent* my representations *as* (if) in time—to *think* them, as it were, as in time.

The idea that these representations of mine must somehow 'in themselves' be in time would constitute for Kant an impossible separation of my own representations from how I represent them to myself. In sum, *the 'appearance' of succession does not imply the (genuine) succession of appearances.* Or as Strawson has it in his book on Kant: "But what sort of a truth about ourselves is it, that we appear to ourselves in a temporal guise? Do we really so appear to ourselves or only appear to ourselves so to appear to ourselves? . . . I really do *appear* to myself temporally; but I do not really *temporally* appear to myself" (Strawson 1985, p. 39). For Kant, as for Gödel, although in some sense there 'appears' to be time, and so in this sense there is time 'relative to' our subjective sensibility, one cannot conclude from this that some things are, objectively speaking, in themselves in time, namely, the appearances themselves.

Although Gödel agrees with Kant, however, on the question of the ideality of time, he strongly rejects the overgeneralization of the fruitful 'Copernican turn' into what he calls the "boundless subjectivism" of Kant's universal transcendental idealism, which

brings with it the doctrine of the unknowability (by a receptive sensibility) of things (as-they-are)-in-themselves. On this point, however, there would appear to be a gap in Gödel's response to Kant.

Kant obtains his universal idealism from his doctrine that the mind has a form of its own, which it imposes on its object (of thought). In virtue of this fact, the mind can never claim to know its object (as-it-is)-in-itself, though it can know (indeed, a priori) the necessary form of its imposition (the primary forms, of course, being space and time). Gödel clearly rejects this picture, but what alternative picture does he propose to put in its place? He is silent here, but to see what a straightforward alternative would look like, we need only turn to Aristotle's account in the *De Anima*, which seems almost to have been written expressly to avoid Kant's conclusions.

For Aristotle the mind has no form of its own. It is a mere 'place' or 'form' of forms, and by 'containing' them, it can know them (as-they-are)-in-themselves. This view of the mind is, in fact, strongly reminiscent of the "receptacle of becoming," or space, of Plato's *Timaeus*, and we can thus characterize Aristotle's account as putting forward a conception of the mind as a kind of universal 'intellectual space' of forms that has no form of its own to impose on its contents. It would be good to know if it is to a doctrine like this that Gödel, with his strong interest in Greek philosophy, would turn in rejecting the Kantian paradigm of thought and its objects. It is to be hoped that the extensive philosophical Notebooks in the *Nachlass* will shed some light on this aspect of Gödel's thinking.

Whatever the basis of Gödel's rejection of Kant's universal idealism, it is clear that he restricted his own idealism to the doctrine of time. Gödel, after all, accepts relativity theory as, to date, the best account we have of the nature of space-time. (We set aside here the issue of the relationship of relativity theory to quantum mechanics, except to remark that for Gödel in his unpublished paper the "positivistic interpretation" of quantum mechanics is another example of an overgeneralization of Kant's 'Copernican turn': "Kant's thesis of the unknowability of the things in themselves is one example [of boundless subjectivism], another one is the prejudice that the positivistic interpretation of quantum mechanics must necessarily be the final stage of the theory."

Now, of course, a contemporary Kantian might also try to find room for relativity theory within his or her framework, but if we view Kant's philosophy and relativity theory from the same level of abstraction as competing overall accounts of the nature of the physical world, then they are clearly incompatible—and here Gödel sides with the latter against Kant. Note, further, that although Gödel agrees with Kant that there are certain a priori constraints on the conditions a form of being, or a form of sensibility, must satisfy if it is to be identified with time, unlike Kant he derives his conclusions regarding the ideality of time from what is after all an empirical physical theory—namely, Einstein's theory of relativity. One might wonder, then, how these two thinkers can derive the same results, with regard to time, from such (categorically) different sources. (We'll come back to this question later.)

Rejecting the Gödel Universe

We are beginning to see, then, why Gödel refuses to exchange his idealism with regard to time for a more conciliatory attitude, according to which temporal notions can simply be relativized to fit in with the new relativistic framework. The force of Gödel's position here, however, can be more fully appreciated if we look to those who have made a serious attempt to integrate into the framework of relativity theory the doctrine of temporal becoming. Among the leading proponents of such a view is Milič Čapek, who, in his imaginative study, *The Philosophical Impact of Contemporary Physics* (1961), plays Heraclitus to Gödel's Parmenides. Čapek, as we saw earlier, attributes Gödel's assertion of the possibility of time travel to his excessive spatialization of time. But although it cannot be denied that there is a sense in which Gödel does treat time as spacelike, it must also be recalled that he credits this point of view on time not to himself but to Einstein. Moreover, the construction within the GTR of world models permitting time travel does not presuppose but rather (for Gödel) proves the spacelike character of time, since such models bring out consequences implicit in relativity theory itself that, for Gödel, leave no reasonable alternative to viewing time as in fact spacelike.

Unlike Sorabji (1986), Čapek does not seek a way to introduce becoming into a model like that of the Gödel universe. His

response is to deny to such mathematical models any physical sig-
nificance, for the a priori reason that accepting them would mean
recognizing the possibility of time travel. If our suggestion
before, however, was along the right lines, the question of the
legitimacy—from a physical point of view—of Gödel's model,
derived in the GTR, is not unrelated to the issue of his philosoph-
ical reading of relativity theory. But although Čapek raises a num-
ber of objections to Gödel's reading of this theory, his own
attempt to integrate becoming with the theory of relativity runs
up against what seem to be insuperable difficulties, due especially
to the fact that he and Gödel agree on the ontological implica-
tions of (the passing of) time. "On each world-line," says Čapek,
"my present particular 'now' separates my past from my future"
(1961, p. 403). But exactly which 'now' is he referring to? It
can't be simply *the* now—the unique, absolute, worldwide instant
of A-theoretic temporal becoming—since, of course, there is no
absolute, non-frame-relative 'now' in the STR. Even for my own
reference frame, no unique now is singled out by the STR; rather,
every time, t, one could say, is now-relative-to-t. But this, the rel-
ative A-series, does not, as we have seen, discriminate between
times. Further, even if I choose one time as *the* now from my own
reference frame, the STR assures me that no one reference frame
is privileged—so that some other observer's choice of the now
from his or her reference frame has no less a claim to be *the* now.
If, however, we are generous and mean to include *all* these nows
as genuine, then it is unclear where in this account there is room
for the *nunc fluens*—that is, for the *transition* from one time to
another as the now, or the privileged ontological moment (since
all nows, on this conception, are already privileged).

 This difficult situation becomes even more uncomfortable
when Čapek denies the relevance of the fact that his now is in the
past light cone of some future observer. Merely future observers,
he suggests, are not presently observable, and hence are not real.
But this is true only from Čapek's perspective—here and now—
not from our future observer's, there and then, and the STR pre-
cisely denies that we are allowed to take any one reference frame
(or point at a reference frame), as privileged. On this point, rela-
tivity theory clearly separates itself from the classical framework.
As Gödel puts it, in relativity theory, "each observer has his own

set of 'nows' and none of the various systems of layers can claim the prerogative of representing the objective lapse of time" (1949a, p. 262). It would seem, then, that Čapek must mean that each reference frame constitutes its own separate 'river of time', its own *nunc fluens*. And indeed, he speaks of "this plurality of contemporaneous or co-becoming temporal series" (1961, p. 364). To employ Whitrow's image, we are being asked to imagine "a complex of advancing light-cones in space-time, the track of each vertex being the world-line of a potential observer" (1980, p. 352), a complex advancing not exactly simultaneously, but rather, as Čapek says, "contemporaneously." Now Gödel does not advance the complaint of Earman (1967) that he can make no literal sense of the advancing or passing of time, but objects rather that he finds senseless the idea that "time lapses in different ways for different observers" (1949a, fn. 5). For note that on the conception just entertained of multiple rivers of time, no definite sense can be attached to the question: How much time has flowed by *so far* (since we have no nonarbitrary point of evaluation of this question for each river or frame of reference)? As Gödel puts it, "A lapse of time, however, which is not a lapse in some definite way seems to me as absurd as a coloured object which has no definite colours."

Again, Čapek seems at one with Gödel that temporal becoming is an ontological notion—but then how can reality be 'growing' differently along (the) different lines (of the separate 'rivers of time')? "The lapse of time," as Gödel said, "in the ordinary sense . . . means a change in the existing. The concept of existence, however, cannot be relativized without destroying its meaning completely."

To sum up, there seem to be at least three challenges to those, like Čapek, who wish to include temporal becoming in a relativistic universe: (1) Can the STR recognize my set of nows as nonarbitrary (and can it even explain what it would mean for these nows to be nonarbitrary in the required sense)? (2) Do *my* nows establish a *universally valid* standard for how much time has (objectively) lapsed *to date*? (3), which we have not discussed: Does the worldwide instant of the now reflect, as some have contended, an irretrievably conventional element (that attends all determination of distant simultaneity)?

Can We Save Temporal Becoming?

I do not wish to state that it is impossible for these challenges to be met, but to my knowledge, no one has yet resolved all of them—not, at least, without seriously questioning the foundations of the STR itself. Thus, in 'Time, Reality, and Relativity' (1981), Lawrence Sklar suggests that the traditional doctrine of the (exclusive) reality of the present is not decisively ruled out by the STR—but his argument (as we will see in detail later) proceeds along the lines that this theory rests, *au fond*, on an epistemological basis that constitutes a variety of verificationism. And he concludes with the strong claim that in fact we seem to find here a verificationist slide that cannot easily be put an end to, short of a kind of point solipsism. Since Gödel, however, does not argue for, but rather presupposes, the epistemological basis of the STR, nothing he has said on these matters speaks directly to this particular suggestion.

But is there not some other way to save temporal becoming? At this point it may be useful to adopt a wider field of vision, and to compare the question of the privileged position of the now, in time (or, if you will, in temporal 'space'), with that of the actual world in the modal 'space' (of all possible worlds). For just as, intuitively, one time is privileged above all others in being now, or the present, only one among all possible worlds is actual—namely, ours, the real world. This point of view, however, has been challenged by David Lewis (1973), who argues for the indexicality of actuality—namely, that *actual* is a property that a world has only *relative* to itself—so that all worlds emerge as equally actual-relative-to-themselves and none as the (absolutely) actual world. This is strikingly similar to the relative A-series (= B-series) picture of the now, a picture of time, we have seen, that is difficult to avoid, given the STR. I have argued, moreover, in 'On Time and Actuality: The Dilemma of Privileged Position' (1986), that it is not so easy to refute Lewis's position as it has seemed to many. Nevertheless, it is certainly possible to dig one's heels in here, in opposition to Lewis, and insist, chauvinistically, that one possible world, or modal frame—namely, ours—is privileged and absolutely actual. The parallel doctrine, however, in regard to time—namely, the doctrine that one reference or inertial frame is privileged (*inertial chauvinism*, if you will)—is ruled out by the

STR. Thus, one cannot, even by brute force (as one could with modal chauvinism), compatible with the STR, maintain that one's own reference frame (or any other) is the universally valid standard for temporal becoming.

Bearing in mind, however, our earlier quotation from Bell in regard to the Einstein versus Lorentz philosophical interpretation of the STR, it should be noted that recent experimental results, by Aspect and others, in regard to Bell's theorem (in quantum mechanics), have been held to have a special relevance to the question at hand. The matter is controversial, but Karl Popper, for one, concludes that: ". . . should the result of these experiments (especially of the experiments of Aspect) be accepted, and interpreted as establishing physical action at a distance (with infinite velocity), then these experiments would have to be regarded as *the first crucial experiments between Lorentz's and Einstein's interpretations of the formalism of special relativity.* The reason for this assertion is that the mere existence of an infinite velocity entails that of an absolute simultaneity and thereby of an absolute space" ('A Critical Note on the Greatest Days of Quantum Theory' [1984], p. 54). Popper adds that ". . . as Newton anticipated, it may not be possible in this case to identify the inertial system that is absolutely at rest" (54).

Now Čapek, I believe, would probably agree as to the fruitlessness of such an attempt to save becoming (leaving aside the above considerations on Bell's theorem). For example, he himself insists that the now, though ontological in force and nonarbitrary, is yet not, given the STR, absolute. No doubt he would insist that the attempt to force a genuine now into a nonrelative worldwide instant is based on an excessively geometrical approach to the dynamic of becoming. I do not deny that this characterization fits. I do, however, wonder how Čapek intends to coordinate the *nongeometrically recoverable dynamic of becoming* with the *extreme geometrization* imposed by *relativity theory,* the epistemological basis of which he, unlike Sklar, has no wish to challenge (indeed, he seems to endorse explicitly the variety of verificationism he seems to find there). In fact, he goes further and suggests strongly that it is the very formal-mathematical details themselves of the STR that serve to strengthen and confirm the point of view of temporal becoming. On this point he seems to be in agreement with Stein 1968. So let's look at Stein's argument.

Stein suggests that we can recover temporal becoming from the formal structure of the STR. "The leading principle that connects this mathematical structure with the notions of 'process' and 'evolution'," writes Stein, "and *justifies* the use of our notion of *'becoming'* in relativistic space-time), is this:

> At a space-time point *a* there can be cognizance of—or information or influence propagated from—only such events as occur at points in the past of *a* (Stein 1968, p. 16)

He acknowledges that this 'becoming' cannot be considered absolute, but only *relative* to a (given) space-time point, *a*. In Stein's view " 'at a given time' is not a relativistically invariant notion," and "the question of definiteness of truth-value [about what has already happened, of what has become], *to make sense at all* for Einstein-Minkowski space-time, has to be interpreted as meaning 'definiteness at a given space-time point (or event)'—to be vivid, 'definiteness for me now'" (pp. 14–15; my interpolation). He finds this relativizing of the answer to the question "What has become (real or determinate)?", in the STR, analogous to the relativizing of the answer, in *pre*-relativistic physics, to the question "What has become (real or determinate) *now?*"

However, I believe that more needs to be said before we can conclude that the cases are indeed analogous. It is clear that for all space-time points, *a*, the STR tells us that, although what events are simultaneous with *a* is frame-relative, what events are *past* for *a*, that is, are in *a*'s past light cone, is frame-invariant. Thus the facts that Stein has alluded to, that he believes speak to the inclusion of temporal becoming in the STR, are *geometrical-structural,* concerning the light-cone structure of space-time as it affects *every* space-time point, *a*. In what sense, however, can it be said that such geometrical facts *themselves* introduce features such as *transition, evolution,* or *becoming?* Yet Stein not only says that the STR is compatible with such notions, but even that the formal structure he alludes to *"justifies* the use of our notion of 'becoming' in relativistic space-time." With regard to the strictly geometrical relationships he alludes to, however, we seem to need only the *relative* A-series, that is, what-is-past-*for*-space-time-point-*a*, for *all* points *a*. Where, here, do we find singled out that one privileged time, *the* now, whose flux constitutes becoming? In

fact, *what* exactly *is* becoming in the picture as Stein presents it? Do we not appear to have, again, the situation Gödel speaks of, where "time lapses in different ways for different observers," of which he could make little sense, or "a lapse of time that is not a lapse in some definite way" (1949a)? Again, Stein writes that "to be vivid" we can ask, in special-relativistic space-time, what has become for *"me* now." This does seem to make this conception resemble the A-series, in which the question 'What is happening?' could be paraphrased as 'What is happening *now,* from *my* present (point of view)?' But this apparent similarity vanishes as soon as we remind ourselves that Stein is, after all, talking about *any given* space-time point *a,* which he has picturesquely represented as saying to itself, "definiteness for me now." What has happened here to *the* now of A-theoretic, pre-relativistic, temporal becoming?

Geometry and Temporal Becoming

Let us try to bring these observations on Stein and Čapek together. Two problems stand out in their attempts to include becoming in the relativistic world picture: (1) An appeal is made to the light-cone structure represented by the geometry of Einstein-Minkowski space-time as what *justifies* the use of such terms as 'process' and 'becoming' in describing a relativistic universe. (2) Although such becoming is not taken to be merely subjective, but to represent (in Gödel's words) a change in the existing, the uniqueness of the now and the existence of a (non-frame-relative) set of events simultaneous with the now have been sacrificed. In regard to (1), however, let us ask: Suppose that Einstein and Gödel are right and that the universe is a rigid, four-dimensional 'space'. Would it not, for all that, *continue to satisfy* all the geometrical-structural constraints imposed by relativity theory? Since the answer is, clearly, that it would, we want to know: (a) How can it be correct, then, to assert that it is the *geometry* of space-time itself that justifies going *beyond* such a picture of a rigid, four-dimensional space? and (b) What exactly must be *added* to the mathematical formalities of relativity theory, as it is usually presented, to render visible the extra dimension of process or becoming? In regard to (b), note that Stein would appear to follow Earman 1967 in limiting himself to a 'literal-minded' representation of time (for surely nothing else is as

'literal' as mathematics), though he apparently draws different conclusions, vis-à-vis becoming, from the same equations. Čapek's position, here, however, is more elusive.

In Čapek (1961, pp. 398–99) we are told that the "visual-tactual imagination" is forever inadequate to represent the dynamic of space-time becoming and that "[a]bstract mathematical constructs seem to be today the only way, not to reach, but to *represent* the structure of the transphenomenal plane." Yet, as we have seen, such abstract, geometrical reasoning is entirely consistent with a purely spacelike conception of space-time. Recall Whitrow's comment that "although Plato regarded time as an essential feature of the sensible world, he rigorously excluded it from the science of pure geometry which he associated with, and only with, the eternal world of ideal forms" (1980, p. 179). Does not a similar sentiment lie behind Einstein's well-known comment that though "the Now means something special for man," "this important difference does not and *cannot* occur within physics" (this from the thinker who has taken the greatest steps, in the modern era, toward the geometrization of the temporal). What is surprising, however, is that Čapek is himself critical of the employment of classical geometry to represent time. *"[A]ll* geometrical analogies," he writes, "are intrinsically inadequate for expressing the nature of time" (p. 355). And he offers an important hint (which we will come back to later) along the same lines: "Only when succession and change are incorporated into the very foundations of geometry is there a better chance of expressing the dynamic nature of becoming" (p. 35). Clearly, then, a reconciliation is needed here, but not provided, between the view that it is the very *geometrization* achieved by the theory of relativity that has succeeded in 'justifying' talk of temporal becoming, and the other direction of thought, put forward by Čapek, that geometry itself is *"intrinsically inadequate* for expressing the nature of time."

Finally, in regard to problem (2) earlier, we stand in need of a new picture of existence if we are to accept both that the dynamic of temporal becoming has genuine ontological implications *and* that there are multiple rivers of time, all genuinely 'flowing' and all adding to existence. Indeed, as we saw earlier Čapek himself suggests that the very concept of reality, that is, of the whole world, is suspect in a relativistic context: "[T]o what extent does

the concept of *the totality of the universe* remain meaningful after the denial of absolute simultaneity of distant events?" (1961, p. 271; my emphasis). I cited this remark in Chapter 2, in the context of a discussion of the old quarrel, initiated by Parmenides, between the concepts of reality and time. Here, indeed, Čapek would seem to be playing Heraclitus to Gödel's Parmenides. What we need to know, however, is this: (a) What are we to understand relativity theory to be a theory *of* if not of (the totality of) the universe? (for it is surely not simply a theory of my set of nows, or the universe 'to date'); (b) How can one possibly have (as we do have) a *relativistic cosmology* if the very concept of the 'totality of the universe' is to be abandoned? (Kant in the 'Dialectic' of the *Critique of Pure Reason*, had indeed warned us against the use of this concept. But, as we have seen, Kant's philosophical perspective was in this regard precisely at odds with the relativistic one—that is, with the perspective that Čapek himself accepts and defends.) (c) How can we make sense of the genuine coming-into-being that constitutes temporal becoming if it is not unique and absolute but proceeds along parallel lines, so to speak, in different reference frames? We need an account of what Čapek calls "the *co-existence* or rather *co-becoming* or *co-fluidity* of world-tubes in relativistic space-time" (p. 377).

What problems (1) and (2) bring out, then, is a general question concerning the representation of time by a mathematical model. Without some illumination on this point, Gödel (and perhaps we should add, Einstein), on the one hand, and Stein and Čapek on the other, will seemingly be able to draw on the same formal details of relativity theory and yet reach, as we have seen, diametrically opposed conclusions. What is needed, then, is reflection on the very nature of formalization in the most general sense—including the use of mathematical models and formal systems—and representation. This we will take up in the next chapter. We conclude this discussion, however, with two revealing examples in which the pressure toward relativization, as well as toward localization, may become particularly acute.

The 'Now' and Special Relativity

In a well-known paper, 'A Rigorous Proof of Determinism Derived from the Special Theory of Relativity' (1966), C.W.

Rietdijk argued from the relativity of simultaneity in the STR to the conclusion that one can no longer consistently maintain the (A-theoretic) principle that the present alone is real. The situation he sets up is as follows. An observer, α, in inertial frame i_α, regards another observer, β, in inertial frame i_β, itself in motion relative to i_α, as simultaneous—indeed, coincident—with him, hence as real for him. Now consider an event e in α's future light cone. It is consistent with the STR that from β's viewpoint with respect to I_β, e is simultaneous with β, hence real for him. But what is real for someone who is real for me must, by transitivity, be real for me. Thus, as against the A-theoretic view of time, the future turns out to be as real as the present. Furthermore, if the future is thus, in a sense, already there, insofar as it is already fully determinate what are the truths or facts about the future, then what will be is not open. And so we must accede to temporal determinism. (Recall our earlier quote from Louis de Broglie to the effect that in space-time, past, present, and future are given 'in block'.)

How might one reply to Rietdijk if one were disinclined to abandon completely the original intuition that reality (in time) belongs only to the present? A natural response would be the one entertained by Sklar (1974) that since the transitivity of simultaneity has itself been given up in the STR, one should also be prepared to abandon the *transitivity of reality*. Once this is done, of course, Rietdijk's argument no longer holds. But is the price to be paid for this result acceptable? Either we would simply adopt a merely relative A-series (= B-series) or, as Sklar suggests, we could *relativize reality to an inertial frame*. Concerning the latter option, he writes:

> Now the traditional philosophical exponent of these claims [namely, that only the present is real] . . . can simply accept the consequence, surprising, no doubt, but by no means inconsistent or patently absurd, of relativizing his notions of reality and determinate reality at the same time that he relativizes his concepts of simultaneity. (1974, p. 275)

It is surely correct that no actual inconsistency arises from the suggestion that we respond to Rietdijk by simply relativizing reality itself (to an inertial frame). Yet, the following remains: (1) It

becomes difficult, indeed, to recover the motivation for the original doctrine that the future is not (now) real if what constitutes 'the' future is precisely a 'subjective' matter (since it is relative to a given inertial frame). (2) Does it make sense to relativize *reality*? (Recall again Gödel: "The concept of existence, however, cannot be relativized without destroying its meaning completely.")

Sklar (1981) broadens his response to Rietdijk by suggesting that the main result from the pressure of the relativity of simultaneity in the STR is in fact to lead us not to relativize reality, but rather to *symmetrize irreality* to what is spatially as well as temporally distant from us. Sklar has in mind the much discussed interpretation according to which the definition of distant simultaneity in the STR has an irreducibly conventional element, so that, in a strong sense, there really is no 'fact of the matter' as to which (spatially) distant events are simultaneous with (hence, real for) a given event—just as there is (now) no 'fact of the matter', for the A-theorist, concerning what is temporally distant from us in the future. Sklar sees this result as a consequence of the original epistemic motivation of the STR, based on the epistemic remoteness of distant events. Indeed, he claims to see no alternative basis for the STR other than the verificationism that seems to have been there from the start (in light of which the lack of a nonconventional principle of *measuring* distant simultaneity has objective significance). On this point, at least, Gödel would seem to be in agreement, for as Wang writes,

> Gödel points out that the fruitfulness of the positivistic [verificationistic] point of view in this case [the STR] is due to a very exceptional circumstance, namely the fact that the basic concept to be clarified, i.e., simultaneity, is directly observable, while generally basic entities (such as elementary particles, the forces between them, etc.) are not. (1974, p. 12)

For Sklar, then, the irreality of spatially remote events in the STR is consequent on the conventionality of distant simultaneity, itself a consequence of the epistemic remoteness of distant events (combined with an implicit verificationism that implies that the real coincides with the knowable or measurable). He finds here a generalization of the principle that lies behind the A-theoretic conception of the irreality of the future, founded also, he

suggests, on the epistemic remoteness of the future. The question of the conventionality of distant simultaneity in the STR, however, and of its basis in a kind of verificationism, is the source of considerable disagreement among experts in the philosophy of relativity theory, and I do not propose to engage in this debate here. I limit myself to pointing out that in Michael Friedman's *Foundations of Space-Time Theories* (1983; see especially pp. 309–320), a rather different approach is adopted to the issues raised by Sklar.

What is to the point, however, is the question of whether the foundations of the pre-relativistic principle of the irreality of the future lie, as Sklar suggests, in epistemology. I would suggest, rather, that the picture is just the reverse. It is precisely because the future is not 'really there' that there arises an epistemic distance between the present and the future. In other words, the foundations of the A-theoretic intuition of the future are not epistemological but rather ontological. It is not a question of *knowing*, but rather of *being*. That is why the past, too, though determinate, is now also 'unreal', from the point of view of the A-series. Consider, for example, our natural (pre-relativistic) attitudes toward someone's miseries in the distant past, as opposed to the present sufferings of those who happen to live in distant lands. I do not discount as unreal the sufferings of those too far away for me to reach, but I do consider as *now over* the grief of those swept away into the receding past. "Swift," writes W.B. Yeats, "has sailed into his rest. Savage indignation there cannot lacerate his breast" ('Swift's Epitaph'). Swift has sailed, for Yeats, not into a distant place, too far for us to reach him, but rather into a different mode of being—namely, nonexistence.

That past events no longer exist (and future events do not yet exist) is, I believe, the "natural ontological attitude" (to borrow, for my own purposes, a phrase from Arthur Fine), and this, rather than questions about knowledge or the flow of information (always at a finite rate in the STR), accounts for the asymmetric doctrine of the irreality of what is temporally (as opposed to spatially) remote. That people in the remote past—that is, the dead—do not exist is an intuition that, though natural, has been resisted on theoretical grounds—including considerations from the STR itself. We will come to this issue in Chapter 7. What matters now, however, is that we recognize that the grounds of the

irreality of the past and the future from the point of view of the A-series are ontological, in contrast (if Sklar [and Gödel?] are right) to the epistemic-verificationist foundations of the STR. Thus, the challenge posed by the STR to the A-theoretic view of the future remains twofold: Either (1) we *relativize* reality to an inertial frame, and thus threaten the integrity of the very concept of existence, or (2) we *symmetrize the irreality* of what is temporally remote to include what is spatially remote, introducing in the process a suspect analogy between the question of *epistemic remoteness*, which seems to some to lie behind the STR, and the concept of *existential distance*, which forms the basis of the A-theoretic attitude to the future.

Global Considerations

However, before concluding this discussion, we should consider a way to soften the force of Gödel's conclusions, namely, by considering our pre-relativistic intuitions about present-future asymmetry to be a matter of local rather than global significance. (Michael J. White has, in fact, suggested this to me as a possible response to Gödel.) I do not believe, however, that we can find here an avenue of escape from Gödel's reasoning. Although it is certainly true that space can be globally curved, while remaining locally, by approximation, flat, in what sense could *time*, in the Gödel universe, be 'globally curved' yet, from a local perspective, 'flat' (i.e., preserving the felt asymmetries between present and future)? Recall that Gödel's concern throughout is not with the spacelike time of the B-series (which would permit a local-global distinction), but with the time of the A-series, with all its concomitants. But as became apparent from the two figures in Chapter 3, the very concept of a closed curve in A-theoretic time leads to antinomy. That is surely why Gödel never entertained the hypothesis that there is, after all, an 'objective lapse of time', but that this 'lapse' occurs only locally. If he objects to a merely 'relative lapse', surely he will not be able to find a place in his philosophy for a merely 'local lapse' of time. To suppose otherwise, to suppose, that is, that the local-global distinction applies to time, as it does to space, would be precisely to liken time—A-theoretic time—too closely to space, that is, to spatialize time. The time of the A-series, then, is incompatible with certain cosmologies, and,

conversely, a proof of the soundness (or, if Gödel is right, even the possibility) of certain cosmologies would argue against the A-theoretic picture of time. Nothing similar, however, applies to *space* or to *space-time*. Here we have, then, in dramatic form, a line of reasoning that accounts for the fact, stressed earlier, that Gödel, unlike Kant, was an idealist with respect to time—but not to space (or to space-time).

The question of the relationship between Kant's idealism and Gödel's indeed furnishes a vital clue to the real meaning of the Gödel Universe. In fact, Gödel's longer, unpublished, more philosophical version of 1949a, is, as noted earlier, entitled 'Some Observations about the Relationship between Theory of Relativity and Kantian Philosophy'. In the next chapter we will look more closely at the Kantian roots of Gödel's employment of time travel in the Gödel Universe in his argument for temporal idealism.

Chapter 5
From Kant to Star Trek:
A Philosopher's Guide to
Time Travel[1]

Alterations are real and . . . [these] are possible only in time. [T]ime is also
therefore something real . . . Thus empirical reality has to be allowed to
time. . . [I]t is only its absolute reality that has to be denied. . . [I]t does
not inhere in the objects, but merely in the subject which intuits them.

<div align="right">Immanuel Kant</div>

[A]t least in one point, Relativity Theory has furnished a very striking
illustration, in some sense even a verification, of Kantian doctrines.

<div align="right">Kurt Gödel</div>

Gödel is rather unusual in taking Einstein to have verified Kant.[2]
Not all of Kant, to be sure. Gödel has in mind only the doctrine
of the ideality of time, not of space. Nevertheless, most thinkers
have presumably been more impressed with the negative implica-
tions of relativity theory with respect to such Kantian doctrines as
the apriority of our knowledge of space and time, the Euclidicity
of space, and the absoluteness of simultaneity. Moreover, given
the so-called 'fusion' (in some suitable sense) of space and time in

1. A distant, abbreviated, ancestor of this chapter, in German translation, entitled
'Philosophische Betrachtungen zu Gödels Kosmologie', is forthcoming, 1999, in W.
Schimanovich, B. Buldt, E. Köhler, and P. Weibel, eds., *Wahrheit und Beweisbarkeit: Leben
und Werk Kurt Gödels* (Vienna: Hölder-Pichler-Tempsky). Thanks to Eli Hirsch, Robert
Tragesser, Hao Wang, and Hidé Ishiguro for helpful discussions.
2. Gödel 1946/49 C1, p. 247.

Relativity Theory, emphasized by Minkowski, it may well strike one as nothing less than perverse to insist asymmetrically, as Gödel does, on the essential validity of Kant's idealism vis-à-vis time, but not with respect to space.

Yesterday's revolution, however, is today's orthodoxy, and Einstein's achievement is now old news, swept into the shadow of Bohr's and Heisenberg's quantum mechanics, which constitutes, arguably, the philosophical challenge *du jour*. Thus, whereas the interpretation of quantum mechanics is generally regarded as confronting us with a genuine dilemma, the former is usually viewed as requiring at most the clearing up of confusions harbored by those who have failed to grasp Einstein's new perspective. The most blatant expression of the latter occurs, perhaps, in Hilary Putnam (1979), p. 205: "Indeed, I do not believe that there are any longer any philosophical problems about Time; there is only the physical problem of determining the exact physical geometry of the four-dimensional continuum that we inhabit." The phrase, "any longer" suggests that there *used* to be philosophical problems about time. Who, then, is supposed to have resolved them? Presumably, for Putnam, Einstein. So the physics of relativity theory becomes, here, the knife that cuts the philosophical knot.

Putnam's sentiments should be compared with those expressed by Niels Bohr, that *anyone who is not shocked by quantum mechanics has not understood it* (Davies and Brown 1989, p. vii).[3] By implication, Gödel's estimate of the philosophical situation with regard to time in the light of relativity theory is closer in spirit to Bohr's comment than it is to Putnam's. In fact, Gödel apparently believed—as he confided to Hao Wang that time is *the* philosophical problem. Gödel refers to time as "that mysterious and seemingly self-contradictory being" (1949a, p. 202), and cites, as a philosophical precursor, Parmenides, whose doctrines are well known to clash violently with the deliverances of common sense. And Gödel's invocation of Kant is co-ordinate with

3. As Einstein put it in 1911 in Prague, pointing out the insane asylum in the park below his study: "Here you see that portion of lunatics who do not concern themselves with quantum theory."

his stress on the idealist strain in Kant's philosophy. In fact, those like Karl Popper (1982) and Milič Capek (1976) who have strongly objected to the philosophical conclusions Gödel drew from his argument—that his new solutions to the equations of the GTR demonstrate the possibility, in some sense, of time travel—have, in one respect, shown a real appreciation for his reasoning, insofar as they have insisted on the paradoxical clash between Gödel's thinking, here, and our direct experience (as) of the lapse of time. To echo Bohr's sentiments again, I would like to suggest that *anyone who is not shocked by Gödel's results about time has not yet sufficiently understood them.*

In contrast to Popper and Čapek, Paul Horwich (1987, p. 111–128), a vigorous proponent of Gödel's views on the possibility of time travel, ignores Gödel's employment of his formal results in the service of his (uncommonsensical) idealism, as well as his sense of the mysterious and problematic nature of time. Thus, an ironic situation: for Gödel, the mere possibility of time travel calls into question the very existence of 'intuitive time', while for Horwich, Gödel's achievement consists, rather, in demonstrating the unproblematic nature of the exotic notion of time travel! So, we have*: Čapek (but not Horwich) agrees with Gödel that if there were time travel, time would be ideal, while Horwich (but not Čapek) agrees with Gödel that time travel is possible.* Neither, however, appears to accept both propositions put forward by Gödel, that *time travel is possible , and that therefore time is ideal.*

Horwich's own philosophical perspective could not be further from Gödel's. He writes, for example, with evident sympathy:

> After the devastating attacks on a priori theorizing by Wittgenstein and Quine, it is now widely believed that the sciences exhaust what can be known and and that the promise of metaphysics was an intellectually dangerous illusion. An anti-metaphysical naturalism dominates philosophical research. (1990, p. 672)

Gödel, by contrast, "wished to do for metaphysics what Newton did for physics" (Wang 1974, p. 85). He summarized his philosophical perspective as: *"rationalistic, idealistic, theological,*

and optimistic" (Wang 1996, p. 290). He viewed his results on relativity theory as a contribution to the 'metaphysical', idealistic philosophical tradition of Parmenides, Kant, and McTaggart. His writings on Einstein, then, although developed from within the framework of natural science, no more point to any sympathy for a purely natural-scientific *Weltanschauung* than does his Incompleteness Theorem, developed from within the context of formalized mathematics, indicate any attachment to mathematical formalism, *à la* Hilbert.

It is interesting to compare Gödel's cosmological and philosophical results about time with some of his results in metamathematics. In response to an earlier essay of Wang's (1970), Gödel notes (Wang 1974, p. 8) that, "the completeness theorem, mathematically, is indeed an almost trivial consequence of Skolem 1922," but that there was ". . . a widespread lack, at that time, of the required epistemological attitude toward metamathematics and toward non-finitary reasoning" (p. 8); but, "the aforementioned easy inference from Skolem 1922 is definitely non-finitary, and so is any other completeness proof for the predicate calculus" (p. 9). Gödel went on to indicate the importance for his Incompleteness Theorem, of his own freedom from the "prejudice" that metamathematics should not employ non-finitary reasoning, and commented that ". . . *formalists considered formal demonstrability to be an analysis of the concept of mathematical truth and, therefore, were of course not in a position to distinguish the two*" (p. 10).[4] If we add that the concept of (full, non-finitary) mathematical truth is in some sense an 'intuitive' one[5] then we can perhaps draw an analogy here, to wit, that *those who consider the temporal component of relativistic spacetime to be an analysis of the (intuitive) concept of time are of course not in a position to distinguish the two and thus, not in a position to realize fully the shocking consequences—from a philosophical point of view—of Gödel's cosmological discoveries.*

What is perhaps most striking, in fact, in the various philosophical responses to relativity theory is that there is no apprecia-

4. For detailed discussion of the relation between Skolem 1922 and Gödel 1930, see Dreben and van Heijenoort 1986, pp. 50–56.
5. In contrast to a 'formal' concept—an issue considerably clarified by Gödel's Incompleteness Theorem (of which more below).

tion for the fact that even (I would say, especially) after Einstein, time still represents a mystery, a paradox. This lack of appreciation is shared by those who view the Special Theory of Relativity (STR) as compatible with—or as even reinforcing—the traditional conception of (to use Gödel's phrase) the objective lapse of time,[6] and by those who maintain that the STR in effect spatializes time.[7] It is shared also by those who reject outright the meaningfulness of the very idea of an objective lapse of time.[8]

The position, however, of the most important figure, here—namely, Einstein himself—on these philosophical issues is not so easy to discern. At best, it can be described as ambivalent. On one side, his response (1976) to Emile Meyerson suggests his unhappiness with attempts to read time in the STR as a mere fourth 'spatial' dimension. On the other side, in Einstein 1961 (pp. 150–51) he speaks of it appearing ". . . more natural to think of physical reality as a four-dimensional existence, instead of, as hitherto, the evolution of a three dimensional existence." And he speaks here of "this rigid four-dimensional space of special theory of relativity." In the same spirit, Popper writes of a conversation he had with Einstein in 1950:

> I tried to persuade him to give up his determinism, which amounted to the view that the world was a four-dimensional Parmenidean block universe in which change was a human illusion, or very nearly so. (He agreed that this had been his view, and while discussing it I called him 'Parmenides'.)" (Popper 1982, Note 2)

And in his final years, in a personal letter on the death of his old friend Michele Besso, Einstein writes that: "in quitting this strange world he has once again preceded me by a little. That doesn't mean anything. For those of us who believe in physics, this separation between past, present, and future is only an illusion, however tenuous."[9] (Bernstein 1991, p. 165) Finally,

6. Popper 1982, Čapek 1976, Stein 1968, (in one sense) Newton-Smith 1980, p. 187, and Craig 1990.
7. De Broglie 1982, Hawking 1988, p. 24, Putnam 1979, and Quine 1987, pp. 196–99—as well by Whitrow 1976, p. 529, who sees the STR as neutral, here.
8. Earman 1967, p. 217, Mellor 1981, and Wittgenstein 1974, 6.3611.
9. Robert Goldman (1997) reports that he actually called up Gödel on August 14, 1977, just months before Gödel's death, and asked for a reaction to what Einstein wrote

Rudolf Carnap remarks (1963, pp. 37–38) that: "Once Einstein said that the experience of the Now means something special for man, something essentially different from the past and the future, but that this important difference does not and cannot occur within physics."[10]

What Gödel Means by 'Time'

To understand Gödel's views on these matters it is essential to grasp exactly what Gödel means here by 'time'. What is crucial is to realize that he draws a sharp line between intuitive time and what is indicated by 't', the temporal component of relativistic spacetime. The latter, as we will see, turns out to be for Gödel in effect a mere *relativistic simulacrum* of the real thing—intuitive time. But how, precisely, does he understand the latter? Let us bring together the various characterizations he chose to employ for his notion in his 1949a and 1946/9. What Gödel refers to as "intuitive" time, then, he also calls "Kantian" time, "pre-relativistic" time, and "what everyone understood by time before relativity theory." The essence of time, in this sense, he says, is that it is "a one-dimensional manifold that provides a complete linear ordering of all events in nature," which, moreover, involves "the objective lapse of time," which, in turn, is "directly experienced" and, further, "involves a change in the existing." Time in this sense, he says, is something "whose essence is that only the present really exists." The objective lapse of time "means (or is equivalent to the fact) that reality consists of an infinity of layers of 'now' which come into existence successively." Finally, "something without these properties can hardly be called time." When Gödel speaks of the ideality of time, then, it is time in this, 'intuitive' sense he has in mind, not whatever is the referent of the time variable, 't', in relativity theory.

to Besso's family. Gödel's comment: "I think he meant it as some sort of joke" [!] (pp. 100–01). Goldman records Gödel as saying that Einstein believed that science could never explain consciousness, in particular that "the methods of science lead away from the life-world." (p. 100). According to Goldman: "[Gödel] then added that Einstein believed the concepts of space and time to be [a] human construction. Reality was something deeper."

10. Equally noteworthy is Carnap's response: "But I definitely had the impression that Einstein's thinking on this point involved a lack of distinction between experience and knowledge."

Since Gödel invokes the name of McTaggart in this context, it may be well to recall McTaggart's distinction, addressed on pp. 24–26 above, between two aspects of time, the A-series and the B-series. Whereas the A-series characterizes events in terms of their shifting realizations as past, present, or future (or, equivalently, as 'now'), the B-series indicates the fixed (in a sense, 'geometric') order of events in terms of the before/after relation. (It's a B-theoretic fact, then, that the American Civil War 'is' before 1999, whereas it's an A-theoretic fact that 'it is now' 1999.) Clearly, what Gödel means by intuitive time has close ties to the A-series, while the 'time' of Relativity Theory (and also, it may be urged, of current tense logic) has closer ties with the B-series. With McTaggart, then, Gödel appears to hold that the reality of time requires the existence of both the A- and the B-series, and, also with McTaggart (though for different reasons), that this situation fails to obtain.

We must be careful not to conflate A-theoretic time with 'subjective', 'inner', or 'mental' time. If I say it is presently snowing, snowing now, I am reporting on the presence of snow, not just on my mental state (though, of course the latter is significant from an epistemological point of view). I can also choose to report on my mental states, themselves, and if these are located in the A-series, then it would also follow that the A-series is exemplified. In short, the presence (or absence) of the A-series is something objective , and if what is at issue is the (mental) states of a 'subject', then, here too, it is no less an objective question whether or not a subject's (mental) states are located in the A-series than it is that the subject himself has an A-theoretic 'location'. Indeed, although Kant maintains that time is the "form of inner sense," he also stresses that time is in a sense more fundamental than space, the "form of outer intuition," since "all representations, whether they have for their objects outer things or not, belong, in themselves, as determinations of the mind, to our inner state; and since this inner state stands under the formal condition of inner intuition, and so belongs to time, time is an a priori condition of all appearance whatsoever" (Kant 1965, A34/B51). Thus, "all appearances whatsoever, that is, all objects of the senses, are in time, and necessarily stand in time-relations."[11]

11. As will be seen below, however, this conclusion must, in the end, for Kant—as a transcendental idealist—be considerably qualified.

Special Relativity and Temporal Idealism

Let us briefly recall Gödel's argument for temporal idealism. From the Special Theory of Relativity (STR) we have the relativity of simultaneity to an inertial frame, the observational equivalence of all inertial frames, and the principle that observationally indistinguishable frames of reference are also objectively equivalent. It follows immediately that there is in the universe no unique, privileged, non-frame-relative, 'now'. As Einstein says: "The four-dimensional continuum is now no longer resolvable objectively into sections, all of which contain simultaneous events; *'now' loses for the spatially extended world its objective meaning*" (1961, p. 149). Hence (by Gödel's characterization of intuitive time, recorded above) there is in the universe of special relativity no objective lapse of time. True, there remains in the STR an objective, non-frame-relative relation between events given by the definition of the so-called interval : $ds^2 = dx^2 + dy^2 + dz^2 - c^2dt^2$. Events with timelike separation, then, where $ds^2 < 0$, are causally connectable, and one might wish to refer here to 'causal time'. Gödel's conclusion could then be put thus: *causal, relativistic time cannot be identified with intuitive time.* At best, it could define a B-series—but even here, there could be no complete, linear ordering of all events in a single B-series of times. One could, however, construct a series of B-series relative to certain parameters. A natural choice for such parameters would be the timelike world lines. (See Shimony 1993, p. 283) There could be no reasonable objection to thus relativizing the B-series; with the A-series, however, as we will see, matters stand otherwise.

Various objections to this line of argument immediately come to mind. As we have seen, there are those who object outright to the very notion of an objective lapse of time, and so, of course, are not in a position to appreciate Gödel's demonstration of its absence from the framework of the STR. Gödel's response, as we saw earlier, is as follows:

> One may take the standpoint that the idea of an objective lapse of time (whose essence is that *only the present really exists*) is meaningless. But this is no way out of the dilemma: for by this very opinion one would take the idealistic viewpoint as to the idea of change . . . For in both views one denies that an objective lapse of time is a possible state of affairs, a fortiori that it exists in reality. . . . (1949a, p. 203, Note 4)

More frequent, perhaps, is the objection that the correct point of view to adopt is that in the STR time is relative, not that it is a mere appearance or illusion. This is the approach adopted by Howard Stein (1990), addressed earlier in this study. Stein insists, contra Gödel, that "to be relative is not to be illusory" (ibid). Gödel's reply:

> It may be objected that this argument only shows that the lapse of time is something *relative*, which does not exclude that it is something *objective* . . . A relative lapse of time, however, if any meaning at all can be given to this phrase, would certainly be something entirely different from the lapse of time in the ordinary sense, which means a change in the existing. *The concept of existence, however, cannot be relativized without destroying its meaning completely.* (Gödel 1949a, p. 203, Note 5)

But Stein goes further:

> The leading principle that connects this mathematical structure [Einstein-Minkowski spacetime] with the notions of 'process' and 'evolution' (and *justifies* the use of our notion of '*becoming* ' in relativistic space-time) is this: At a space-time point *a* there can be cognizance of—or information or influence propagated from—only such events as occur at points in the past of *a*. (1968, p. 16; emphasis added)

These considerations, however, apply equally to *all* space-time points. But if there is no unique, privileged 'now', then we have at most the *relative* A-series—in effect, the B-series. Hence Gödel's characterization of the STR: "Each observer has his own set of 'nows,' and none of these various systems of layers can claim the prerogative of representing the objective lapse of time" (1949a, p. 203).

Stein's mistake is to adduce a *structural* property as what "justifies the use of our notion of '*becoming*' in relativistic space-time." The facts alluded to in the above passage from Stein's 1968 are, after all, physical expressions of the geometry of Einstein-Minkowski spacetime. But how can such *geometrical* facts be the basis of the *transiency* of the 'now'—in other words, for 'temporal becoming'? Indeed, even Abner Shimony (1993, p.

285), who believes, like Stein, in the compatibility of the STR with A-theoretic time, notes that "that *structure* [viz. the structure of Einstein-Minkowski space-time] is *neutral* with respect to the status of *transiency*" (emphasis added). Curiously, however, although Shimony praises Stein 1968, he fails to note that his own remark is at odds with Stein's approach to temporal 'becoming'. Shimony's own account, in turn, of the A-series begins with the phenomenological given of the transient 'now'. Since we will address phenomenological questions below, let us focus here on the issue of combining the A-series with the STR. Shimony maintains that the 'now', even in the context of the STR, is non-relative. He imagines two observers, on different timelike world lines, whose paths intersect at a (space-time) point, *P*. At *P*, if one observer takes *P* to be now, so will the other. "The conclusion is that A-determinations must be ascribed to the point *P* itself, not to *P* as associated with one or another world line" (1993, p. 284–85). But how does this show the 'now' to be non-relative? After all, given the relativity of simultaneity in the STR, our two observers, with diverging world lines, will in general not agree on the 'now'. As Shimony himself stresses, if *P* and *Q* lie outside each other's light cones, one cannot correlate any of their A-determinations: "if an A-determination of a space-time point P implied an A-determination of a space-time point outside its light cone, then the structural properties of Einstein-Minkowski space-time would be violated, even though that structure is neutral with respect to the status of transiency" (p. 285).

It is unclear, then, what exactly Shimony's picture is of relativistic 'becoming'. He seems to be saying that the 'now' is non-relative—yet he clearly cannot be suggesting the existence of a unique, objective, world-wide 'now', consistent with the STR. It must be, then, that each observer has his own 'now', which is nevertheless somehow non-relative—each of these 'nows' objectively 'becomes' (not exactly simultaeously , but, in a way that is, as Čapek says, as quoted above on p. 57, "contemporaneous or co-becoming"). But then Gödel's observation is again to the point: "each observer has his own set of 'nows', and none of these various systems of layers can claim the prerogative of representing the objective lapse of time" (1949a, p. 203). (Recall also his remark that, in effect, he can make no sense of the idea that "time lapses in different ways for different observers.")

In addition to such attempts to reconcile 'temporal becoming' with the STR, there have also been more direct assaults on Gödel's line of reasoning. A particularly interesting one comes from Čapek (1976, p. 507), who writes that Gödel has failed to recognize that just as the concept of space can be generalized beyond the Euclidean, the concept of time can be generalized beyond the Newtonian: "What Gödel and modern neo-Eleatics do not consider at all is the possibility that the Newtonian time may be only a special case of the far broader concept of time or temporality in general in the same sense that the Euclidean space is a special instance of space or spatiality in general." Curiously, although Čapek is at great pains to distinguish time from space, this remark of his has the effect precisely of treating time as if it were a 'space', in the general sense introduced earlier in this study[12]. For *Gödel does not for a moment deny that Einstein-Minkowski spacetime is a valid generalization . . . of 'space'!* Indeed, he goes even further in this direction: as against those (such as Newton-Smith 1980, pp. 186–87) who see in the definition of the interval the clue to the preservation of time in the STR (since the time variable is singled out by being preceded by the minus sign), Gödel (1946/49) describes this as "the last objective remnant of time," and remarks that:

> The one dimensionality of time, it is true, expresses itself also. . . in the fact that the fundamental quadratic form has one negative square, but . . . it would only be a straightforward continuation of the development from classical physics to relativity theory, if this last objective remnant of time too were to disappear.[13]

As we saw earlier, however, Gödel in effect denies precisely that intuitive time constitutes a 'space', in the general sense, since the objective lapse of time, in his words, "means (or is equivalent to the fact) that reality consists of an infinity of layers of 'now'

12. Earlier in this study, on p. 10, we characterized a space, in the most general sense, as: a manifold, positions in which are characterized by ontological neutrality. It follows that where something exists in *space*—as opposed to *time*—has no effect on whether it exists.

13. This quotation appears in a *ms* from Gödel 1946/49, a xerox copy of which was supplied to me by the Special Collections Department of Princeton University, Firestone Library, with the permission of Eliott Shore, Librarian at the Institute for Advanced Study. I have been unable to locate these lines in the versions of Gödel 1946/49 reproduced in Feferman 1995.

which come into existence successively." For Gödel the absence—indeed the incompatibility in principle—of such an objective lapse of time with respect to the STR means that there is no alternative, for him, to viewing 'causal'/relativistic time as in effect 'spatial'—which, like any other 'space', permits the kinds of generalization that Čapek has in mind.

In sum, for Gödel, time, in the intuitive sense (which is what concerns Čapek), cannot be generalized without at the same time *generalizing away* the essential features that distinguish time from space. Indeed, as will be seen below, Gödel gives the matter an added twist when he constructs new cosmological models for the GTR where he generalizes to a new, closed geometry for 'relativistic time', providing thereby additional support for his thesis that 'relativistic time' is not identifiable with genuine, intuitive time. Čapek, however, without noting the tension this creates in his own views, rejects this particular generalization. It would seem that for him this last generalization of Gödel's violates what is essential not just to intuitive time, but, as it were, to (what is for Čapek) the spirit of relativistic time (the spirit, not the letter—since Gödel's results are achieved within the formal framework of the theory of relativity.)

General Relativity and Temporal Idealism

It is time, then, to devote some attention to the second part of Gödel's argument for temporal idealism, which draws not on the STR but on the GTR. We began to address this issue earlier in this study, but here we will probe more deeply. Recall that it is basic to the STR that all 'observers', all inertial frames, are equivalent. Gödel notes, however, that in the general relativistic context the existence of matter and the curvature of space-time induced by this "largely destroys the equivalence of different observers and distinguishes some of them conspicuously from the rest, namely, those which follow in their motion the mean motion of matter" (1949a, pp. 203–04). Further, in all cosmological solutions of the gravitational equations of GTR before Gödel proposed his own (in his 1949), it was possible to fit together the local times of these privileged observers into a kind of distinguished 'cosmic time', which, if one is generous, one could choose to identify with

that intuitive time that objectively lapses. Gödel cites James Jeans (1936) as a proponent of such a view.[14]

Cosmic Time

The concept of cosmic time is in the background of all contemporary discussions in relativistic cosmology of the *evolution of the universe*, the *age of the universe*, the big bang *origin* of the universe, and so forth. It is fair to say, however, that the majority of people who are aware that contemporary cosmologists now believe that the *current state of the universe* is the result of an evolution that originated in a spacetime singularity—known, since Gamow, as the 'big bang'—have not reflected on the fact that these ideas—*the current state of the universe* , *the origin of the universe*, and so forth—are the very notions that are *ruled out* by Einstein's Special Theory of Relativity! Such notions, as we have seen, have no objective significance in the STR, given the relativity of simultaneity and the equivalence of all inertial or reference frames. In the context of the *General* Theory of Relativity, however—which is the theory that describes the actual universe (whereas the STR can for our purposes be viewed as a matter free idealization of the latter), in which matter gravitationally determines the geometry of spacetime, the question arises whether there exist reference frames, represented by the major mass points (galaxies and clusters of galaxies), which, in Gödel's words (1949a, pp. 203–04), are "distinguish[ed] . . . conspicuously from the rest, namely those which follow the mean motion of matter."[15] If so, then these major mass points, the so-called

14. According to Jeans: "If the theory of relativity [i.e. the STR] was to be enlarged so as to cover the facts of astronomy [i.e. the GTR], then the symmetry between space and time which had hitherto prevailed must be discarded. Thus time regained a real objective existence, although only on the astronomical scale. . . . Meanwhile, mathematical analysis has shown that an infinite number of . . . types of universe are possible [compatible with the field equations of the GTR]. And these all have two properties in common. In the first place, in every one of them space is either expanding or contracting. . . . The second property . . . is that every one of them makes a real distinction between space and time. *This gives us every justification for reverting to our old intuitional belief that past, present, and future have real objective meanings . . . In brief, we are free to believe that time is real*" (pp. 22–23; brackets and emphasis added).

15. Gödel comments, additionally, that: "Of course, according to relativity theory all observers are equivalent in so far as the laws of motion and interaction for matter and field

'fundamental particles', will be in some objective sense 'privi-
leged' or 'fundamental' frames of reference.

We need, next, to introduce a few basic notions in general rel-
ativistic cosmology, before we provide an account of cosmic
time.[16] A cosmological model of EFE (Einstein's Field Equations
for the GTR) is temporally orientable just in case the light cones
of the spacetime can be divided into past and future light cones.[17]
Further, given temporal orientability, one says that spacetime
point x chronologically precedes spacetime point y—i.e. $x \ll y$—
just in case there is a smooth, non-degenerate, future-directed
timelike curve from x to y. Finally, a map $t: M \to R$ is a global
time function just in case: $t(x) < t(y)$, whenever $x \ll y$. How,
then, does one construct such a global time function? Consider
the series of spacelike hypersurfaces orthogonal to the worldlines
determined by a 'fundamental particle'. These constitute the
"simultaneity slices", or planes of simultaneity, relative to the
worldlines characteristic of such a frame. Suppose, then, that there
exists a congruence of all the fundamental particles that is 'twist-
free'—that is, where there exists a one-parameter set of slices
which is everywhere orthogonal to these worldlines. Insofar as all
these sets of planes of simultaneity can be globally synchronized,
this unified temporal frame will constitute in effect an objectively
determined global time function—a 'cosmic time', so-called
because the combined set of fundamental frames will represent
the mean global distribution of matter and motion and thereby

are the same for all of them. But this does not exclude that the structure of the world (i.e.
the actual arrangement of matter, motion, and field) may offer quite different aspects to
different observers, and that it may offer a more 'natural' aspect to some of them and a dis-
torted one to others" (1949a, p. 203, note 6). Concerning "the mean motion of matter",
Gödel notes: "The value of the mean motion of matter may depend essentially on the size
of the regions over which the mean is taken. What may be called the 'true mean motion' is
obtained by taking regions so large, that a further increase in their size does not any longer
change essentially the value obtained. In our world this is the case for regions including
many galactic systems. Of course a true mean motion in this sense need not necessarily
exist" (1949a, p. 204, note 7). Given the fact that in general relativity matter determines
spacetime curvature, Gödel presumably intends by "mean motion of matter" something
like "mean curvature of spacetime".

16. I follow here the characterization of "cosmic time" given in Gödel 1946/49,
Malament 1995, and Earman 1995.

17. To further elucidate the notions, here, of "past" and "future" light cones would
require discussion of the so-called "direction of time". Clearly, "past" and "future" should
not, here, be assumed to indicate what is meant by the *intuitive* notions of past and future,
as in McTaggart's A-series.

represent the large-scale geometry of spacetime. Think of the family of worldlines as being like the fibers of a rope. If the rope is everywhere twisted, at no point can one make a slice of the rope that will be orthogonal to every fiber. In Malament's felicitous words (1995, p. 263): "orthogonal sliceability is equivalent to fiber untwistedness." Fiber untwistedness, in turn, is equivalent to global non-rotation. The actual world, then, in which the world-lines of the fundamental particles are 'twist free', appears to be a non-rotating universe[18] in which cosmic time can be defined. Hence, *if we follow Jeans, a case can be made that there is after all a sense in which in the actual world a single, non-arbitrary world time "objectively lapses".*

Absolute Time and the Gödel Universe

Would Gödel's suggestion, then, that relativity theory provides new evidence for Kant's temporal idealism lose force in the broader context of general relativity, given the fact that in certain cosmological models for GTR—including, in particular, the actual universe—one can construct a 'cosmic time', which may be taken to reintroduce the idea of a unique, objective time order for the universe at large? Gödel offers three primary reasons why this conclusion should not be accepted. To start with, he announces that in the new cosmological models for the GTR he has presented in his 1949, the so-called 'Rotating-Universes' (R-Worlds) or 'Gödel-Universes' (henceforth, GU), it is *provably impossible to fit together all these 'privileged' local times into a single 'cosmic time'.* For, in the (Rotating) Gödel Universe (GU),[19] the condition of the congruence of the major mass points being 'twist free' is precisely unsatisfied. It is impossible, therefore, to define a cosmic time in the GU. (Indeed, in the GU, $p \ll p$, for all spacetime

18. If, however, the rotation of the universe were very slow, the limits of precision of measurement, given current technology, would make it difficult to rule out the possibility of rotation with complete confidence. Gödel, indeed, seems never to have relinquished his belief that the actual world may turn out in the end to be a rotating Gödel Universe. His *Nachlass* includes two notebooks containing calculations of the angular orientations of galaxies.

19. It is natural to ask: With respect to what is the GU rotating? The answer is that it is not rotating relative to anything outside the universe (there is nothing, by hypothesis, outside the universe). Rather, the GU rotates with respect to "the axis of a completely free gyroscope" (to use Gödel's formulation), within the universe.

points, *p.*) Further, he makes the dramatic announcement that in such a rotating GU *there exist future directed closed, and nearly closed, timelike curves which permit, in a strict sense, time travel!* In particular, "by making a round trip on a rocket ship in a sufficiently wide curve, it is possible in these worlds to travel into any region of the past, present, and future, and back again, exactly as it is possible in other worlds to travel to distant parts of space" (1949a, p. 205). This demonstrates, for Gödel, in effect, that *spacetime in (this) GU cannot but be a 'space'*, since the 'passing of time' in such a universe cannot carry any ontological force. For *how can one 'revisit' the past, if it is no longer 'there' to be 'returned to'?*

> [T]he decisive point is this: that for every possible definition of a world time one could travel into regions of the universe which are past [i.e., already lapsed] according to that definition. This again shows that to assume an objective lapse of time would lose every justification in these worlds. (1949a, p. 205)

Again, "that at least that passing of time which is directly experienced has no objective meaning in the R-worlds also follows from the fact that it is possible in these worlds to travel arbitrarily far into the past and future and back again" (Gödel 1946/49, p. 251). This last comment is of special interest, since it brings out the fact that for Gödel even the direct experience (as) of the passing of time is compatible with the absence of an objective lapse of time. Indeed he remarks that, "if [even] the [direct] experience of the lapse of time can exist without an objective lapse of time, no reason can be given why an objective lapse of time should be assumed at all" (1949a, p. 206); that is, in the GU under consideration, where *'cosmic' or 'absolute' time is absent, time-travel is possible, and even the direct experience (as) of the passing of time is no guarantee of a suitable objective correlate, nothing at all remains of the objective lapse of time.*

These considerations, however, concern only a certain GU— as it turns out, one given by a non-expanding, rotating solution. What about our own universe, which appears to be an expanding one? Gödel remarks that there are also expanding rotating universes, and that here, too, an 'absolute' time might fail to exist, and that our own world may be such a universe. But his most

FIGURE 3

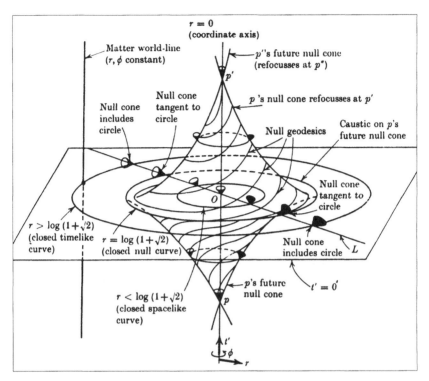

Spacetime Diagram of the Gödel Universe (From S. Hawking and G. Ellis, *The Large Scale Structure of Space-Time*. Cambridge: Cambridge University Press, 1973)

striking observation is his last one—the final argument for temporal idealism. Here he puts forward the remarkable suggestion that even if our world is no kind of GU, the mere relation of ours to a GU suffices to cast doubt on the existence of (intuitive) time in our own universe:

> The mere compatibility with the laws of nature of worlds in which there is no distinguished absolute time, and in which, therefore, no objective lapse of time can exist throws some light on the meaning of time also in those worlds in which an absolute time can be defined. For, if someone asserts that this absolute time is lapsing, he accepts as a consequence that whether or not an objective lapse of time exists (i.e., whether or not a time in the ordinary sense of the word exists) depends [not on our intuitive awareness of intuitive

time, but rather] on the particular way in which matter and
its motion are arranged in the world [that is, on non-lawlike, episte-
mologically-remote phenomena]. This is not a straightforward con-
tradiction; nevertheless a philosophical view leading to such
consequences can hardly be considered as satisfactory. (1949a, pp.
206–07; the parentheses are Gödel's, the brackets added)

Earman's Critique of Gödel

This last argument of Gödel's is no doubt the most controversial
and the least convincing element of the philosophical analysis he
constructs concerning what remains of time given the new cos-
mological models he has derived from Einstein's field equations
(EFE) for general relativity. Earlier in this study, however, I tried
to make the case that Gödel's argument is in fact far more subtle
and powerful than has heretofore been suspected. Steve Savitt, for
one, seems to have been convinced. In Savitt 1994, 'The
Replacement of Time', he reconstructed, in a somewhat weak-
ened form, the argument I gave, and found it to have consider-
able force.[20] John Earman, however, in *Bangs, Crunches,
Whimpers, and Shrieks: Singularities and Acausalities in Relativ-
istic Spacetimes*, is unpersuaded both by Gödel's reasoning and by
my account of Gödel's argument. After an extended discussion of
the "logic" and the physics of "time travel", including time travel
in the GU, Earman introduces an Appendix devoted to an evalua-
tion of Gödel's argument for the ideality of time. This Appendix
deserves our most serious attention.

Earman begins by noting the "relative neglect of the philo-
sophical moral Gödel (1949a) himself wanted to draw from his
solution to EFE" (Earman 1985, pp. 194–95). This is a curious

20. Savitt takes exception, however, to Gödel's temporal idealism, according to which
time is a mere appearance or illusion. According to Savitt, the correct conclusion is, rather,
that time does not exist. What exactly the difference is between Savitt's view and Gödel's,
however, is difficult to fathom. According to Savitt: "All over the world people arrive at
meetings, performances begin, buses arrive, all more-or-less on schedule. Could an illusion
coordinate this intricate choreography?" (p. 470). "Since," he continues, "I maintain
[intuitive] Time does not exist, do I maintain the even more absurd thesis that nothing is
responsible for this organization . . . ? Of course not. I do maintain that it is not Time
which is responsible, but watches and clocks do not measure Time; they measure space-
time" (p. 470). The puzzle here is why Savitt thinks Gödel's thesis that time is ideal or an
illusion (which, of course, implies that time does not exist!), prevents him from adopting
the same point of view with respect to what clocks measure.

comment given the fact that he is about to discuss the first edition of the present book, which was devoted precisely to putting an end to this neglect. A clear difference emerges immediately, however, when Earman proceeds to comment that "the neglect has been benign," implying that it was entirely appropriate for philosophers to have neglected, for half a century, Gödel's philosophical discussion of time. Why then does Earman feel moved himself to remedy a neglect that is, by his own lights, so richly deserved? "A deeply held conviction of someone of Gödel's stature deserves serious consideration" (p. 195). For Earman, then, it appears, it is by no means Gödel's philosophy that deserves our attention, but rather Gödel the man—a man of "stature"—who merits our attention, even with regard to a philosophy that in itself merits neglect. It is a curious kind of 'piety', then, that motivates Earman's discussion. Indeed, that he has come 'to bury Caesar, not to praise him' emerges clearly at the end of his discussion, when he recalls Einstein's published response to Gödel's essay, in which the great physicist, in Earman's words, "brushes aside"[21] the relationship of the GTR to idealistic philosophy: "This seems to me," says Earman, "the correct response to Gödel" (p. 200). So much for the "attention" due to "a man of Gödel's stature".

Earman opens his discussion by recalling Gödel's reaction to the STR in which he insists that the relativity of simultaneity cannot be blithely accepted if one continues to accept time as a genuine ontological aspect of reality. Gödel, as we saw earlier, insists that if time is real, then the "flow" of time constitutes the flow or evolution of reality, but that reality itself cannot be relativized (to an inertial frame). Earman, however, is unimpressed: "This is a pretty piece of ordinary language philosophizing. But like most of

21. This is one of the few signs that Earman has actually read (at least a few pages of) the first edition of the present book, since these are the very words I use to describe Einstein's reaction to Gödel. Another sign is Earman's comment, p. 164, that: "One could object that Gödelian time travel does not deliver time travel in the sense wanted since Gödelian time travel so-called implies that there is no time in the usual sense in which to 'go back'. . . . I feel that there is a good deal of justice to this complaint." This is a point I stressed in Chapter 1, p. 3: "Gödel takes it [his argument] to indicate that *t*, the standard variable for time [in physics], should not be read here as standing for genuine, successive time. But if there is no genuine *time*, there can be no genuine time *travel*." The obvious point I was making here is, curiously, rarely acknowledged. It is strangely absent, for example, from Paul Horwich's 1987 "defense" of Gödelian time travel.

its ilk, it leaves one up in the air: even if one shares the linguistic intuitions, one can wonder how such intuitions can support weighty philosophical morals" (p. 195). But Gödel was no friend of so-called "ordinary language philosophy", pioneered by Wittgenstein, Austin, Strawson, et al., and prominent in Anglo-American philosophy since World War II.[22] In particular, unlike Wittgensteinians and positivists (who surrounded him in his years in Vienna[23]), Gödel acknowledges the existence of *conceptual intuition*: "We *perceive* objects and *understand* concepts. *Understanding is a different kind of perception . . .*"[24] (Wang 1996, p. 138; emphasis added). With regard to science: "The analysis of concepts is central to philosophy. Science only combines concepts and does not analyze [them]. Einstein's theory [of relativity] is itself not an analysis of concepts . . . Physical theories . . . are not the correct metaphysics . . ." (p. 237). And against Kant: "A good English rendering of Kant's term "*Anschauung* " is . . . 'concrete intuition'. . . . [There] is a ground for rejecting Kant. Our intuition tells us the truth not only of 7 plus 5 being 12 but also [that] there are infinitely many prime numbers and [that] arithmetic is consistent" (p. 217). With regard to positivists: "Intuition is not proof; it is the opposite of proof . . . [B]y intuition we see something without a proof. . . . We do not distinguish between intuition *de re* and *de dicto*; the one is contained in

22. When Gödel lamented to Wang that most contemporary philosophers remain, in essence, positivists, Wang inquired about Saul Kripke. "Kripke," Gödel replied, "is, though not a positivist, still doing linguistic philosophy" (Wang 1996, p. 138). (One can imagine, then, how Gödel would have reacted to Earman's description of his reasoning as constituting a "pretty piece of ordinary language philosophizing"!)

23. Indeed, his own thesis adviser, Hans Hahn, is the author of a famous essay which attacks the very concept of mathematical intuition. See Hahn, 'The Crisis in Intuition' (1933), of which the final line is: ". . . [I]t is not true, as Kant urged, that intuition is a pure a priori means of knowledge, but rather that it is a force of habit rooted in psychological inertia" (p. 101).

24. This remark of Gödel's is strikingly similar to what Alonzo Church wrote in (1951): ". . . [T]he preference of (say) *seeing* over *understanding* as a method of observation seems to me capricious. For just as an opaque body may be seen, so a concept may be understood or grasped." Anthony Anderson (1998, p. 135) has also noted this resemblance. What he does not note, however, is the similarity of both to what Frege (whose ideas Church has done much to champion) wrote in 'The Thought' (1967a, p. 29, Note 1), having argued forcefully for the need to recognize a "third realm" (of Platonic entities like [the contents of] thoughts): "One *sees* a thing, one *has* an idea, one *apprehends* or *thinks* a thought" (emphasis added). In my 1989 review of Wang 1987, I draw, pp. 402–03, an extended comparison between Gödel's and Frege's views on our cognitive access to the 'third realm'.

the other . . . The positivists attempt to prove everything from nothing. This is a basic mistake shared by the prejudices of the time . . . To be overcritical and reluctant to use what is given hampers success" (pp. 304–06).

Gödel's sympathies thus lay more with Edmund Husserl (for example, with his idea of conceptual intuition or "intuition of essences") than with Wittgenstein; and it is well known that he recommended to his colleagues that they study the writings of Husserl. Gödel was at pains to emphasize the importance of mathematical intuition in his philosophy of mathematics, with special reference to the consequences of his Incompleteness Theorem, and in his philosophical discussions concerning Einstein and time he drew heavily on certain primitive and crucial 'intuitions' concerning *the concept of time* and *the concept of reality* or existence. Such intuitions were by no means, for Gödel, a substitute for detailed formal investigations in the sciences themselves— whether in logic, mathematics, or physics—but by the same token Gödel argued forcefully that the formal theorems of these sciences themselves rest, ultimately, on a small set of (correctable, but) fundamental intuitions of the basic concepts.

Positivism

Insofar, then, as Earman dismisses recourse to intuitions about fundamental concepts he is in effect associating himself with positivism, whereas it was an overarching goal of Gödel's to bring down positivism in whatever realm it may haunt—from physics and mathematics to philosophy and theology. Now Warren Goldfarb, it is true, has taken Gödel to task for as it were finding a positivist under every bed: "Gödel, it appears, took positivism to be a more widespread and longer-lived orthodoxy than it was" (Goldfarb forthcoming). But I cannot agree with Goldfarb's assessment.[25] The spirit of positivism—if I may be permitted to

25. I also cannot agree with Goldfarb (forthcoming) when he states: "[Gödel] provides no evidence that *observation of one's stream of consciousness* while thinking of mathematical concepts will give insight into those concepts . . ." (emphasis added). But Gödel does not have in mind passively attending to one's stream of consciousness while entertaining a mathematical concept. "*Understanding*," says Gödel—not *daydreaming*—"is a form of perception [of concepts]." Goldfarb continues: "The muddled results of bare phenomenological examination with respect to mathematics . . . were pointedly . . . criticized

use this expression—is very much alive. Thus the noted physicist, Stephen Hawking: "I . . . am a positivist" (Penrose 1997, p. 169). Thus the noted philosopher of science, Nancy Cartwright: ". . . [P]ositivist that I am, [I] am opposed at once both to metaphysics and to transcendental argument" (p. 161). And recall Paul Horwich, another prominent philosopher of science: "After the devastating attacks by Wittgenstein and Quine, it is now widely believed that *the sciences exhaust what can be known* and that *the promise of metaphysics was an intellectually dangerous illusion . . .*" (1990, p. 672; emphasis added).[26]

By "positivism", clearly, I mean here a broad intellectual tendency—including but not limited to rejection of 'metaphysics', skepticism about the reality of conceptual intuition, skepticism, indeed, of conceptual realism and other forms of 'Platonism', and so on, not a narrow set of precise, 'technical' postulates. The latter conception constitutes, rather, if I may put it thus, *a positivistic conception of positivism*. Michael Friedman, for example, writes, that: ". . . [A]s a consequence of Gödel's Incompleteness Theorem . . . there is no philosophical metaperspective with which Carnap's distinctive version of [mathematical] conventionalism can be coherently articulated, and *it is precisely here . . . that the ultimate failure of logical positivism is to be found*" (1991, p. 518; emphasis added). Without disputing the force of Friedman's claim—cf. indeed Gödel's own 1953/9 'refutation' of Carnap—I wish nevertheless to reject his narrow conception of positivism (shared, apparently, by Goldfarb forthcoming). A better perspective is provided by Gödel (1961/?), in which he isolates two basic philo-

by Frege, in his review of Husserl . . ." (op. cit.) But Frege's exaggerated fear of "psychologism" no doubt misled him here. In *The Foundations of Arithmetic: A Logico-Mathematical Enquiry into the Concept of Number* (1980), it is clear that Frege is as much a *conceptual realist* as is Gödel. True, Frege warns us not to observe what floats in our imagination when, for example, we seek to grasp the concept of infinity, but what enabled Frege himself to discover that the first infinite number is the extension of the concept: 'equinumerous with the concept: "is a finite natural number"' if not something like *conceptual intuition*? Indeed, Frege's own words belie his skepticism of mathematical intuition: "In arithmetic we are not concerned with objects which we come to know as something alien from without through the medium of the senses, but with objects given directly to our reason and, as its nearest kin, utterly transparent to it" (p. 115). (Hans Sluga, it is true, has given this passage a Kantian [idealist] cast, but a more accurate comparison would be with the first Platonist, viz., Plato, in the *Phaedo*. See Yourgrau 1997, p. 144, Note 17.)

26. See Bealer 1987 and 1994, however, on the incoherence of a scientific empiricism which abjures all recognition of conceptual intuition.

sophical worldviews: one with a 'leftward' direction, toward *skepticism, materialism*, and *positivism*, the other inclined to the 'right', toward *spiritualism, idealism,* and *theology* (or *metaphysics*). He puts empiricism on the left and a priorism on the right, and points out that although mathematics *qua* a priori science belongs "by its nature" on the right, it too has followed the spirit of the times in moving to the left—as witnessed by the rise of Hilbert's formalism. (See, further, Yourgrau 1996.) Indeed, Wang (1996, p. 173) records Gödel as saying that, "[t]he spirit of the time always goes to positivism and materialism; for instance, Plato was followed by Aristotle."

Returning, then, to Earman, we must ask him whether he wishes *seriously to dispute* Gödel's statement that "the concept of existence cannot be relativized without destroying its meaning completely."[27] *This is a test.* Is Earman a positivist? A Wittgensteinian? Does he find Gödel's ontological thesis too *unclear* to be debated, or perhaps too *metaphysical*, or too *ordinary language*? Is he waiting to receive the latest results from the Hubble Telescope about the motion of distant galaxies, better to resolve complex issues in relativistic cosmology concerning, say, the cosmological constant or the large-scale structure of space-time, before taking a stance with regard to Gödel's thesis? Or would this get things exactly backwards, making the answer to a perfectly simple, clear question about a primitive concept rest on disputed issues at the very frontier of the most complex of mathematical and physical sciences? Gödel's position is clear: *"The notion of existence is one of the primitive concepts with which we must begin as given. It is the clearest concept we have. Even 'all', as studied in predicate logic, is less clear, since we don't have an overview of the whole world"* (Wang 1996, p. 150).

27. As noted above (p. 72), Gödel's reasoning would apply to Lawrence Sklar's proposal: "Now the traditional philosophical exponent of these claims [that only the present is real] . . . can simply accept the consequence, surprising, no doubt, but by no means inconsistent or patently absurd, of relativizing his notions of reality and determinate reality at the same time that he relativizes his concepts of simultaneity" (Sklar 1974, p. 275). Quentin Smith 1995 adopts a similar position: "The defender of the tensed theory of time will hold that *reality is relative* in the very same respect that presentness is relative. . . . The defender of the tensed theory of time will point out that Einstein's Special Theory of Relativity may be taken as implying that *reality is relative* to an observer" (p. 183, italics added; see also pp. 208–09 where this reasoning is employed in an account of time travel in the context of the GTR). Smith appears oblivious both to Gödel's objections to this line of reasoning and to my account of Gödel's defense.

The Possibility of the Gödel Universe

The issue immediately before us, however, is Gödel's discussion of time in the context of the General Theory of Relativity (GTR), in particular with regard to the (physically) possible Gödel Universe (GU). Gödel makes a number of claims about the GU. In the first place, he claims it represents a physically realistic model of Einstein's Field Equations (EFE). Next, he claims that the existence in GU of closed temporal curves (CTC's), the possibility in the GU of time-travel, and the non-existence in the GU of a global time function (which rules out a definition of cosmic time) demonstrates conclusively the nonexistence of (intuitive) time in this world model. Third, Gödel reasons backwards from the mere (physical) possibility of the GU to the ideality or nonexistence of time in the actual universe. What allows Gödel, however, to argue that *if time is ideal in the GU then it is also ideal in the actual world?*

Earman claims that Gödel's argument has a missing premise, which he endeavors to fill in. Here is his first suggestion: "The existence of an objective lapse is not a property that time can possess contingently" (p. 197). He rephrases it thus: "$L \to N(L)$ [that is, if time has the property of lapsing, then necessarily so]; $\sim N(L)$ [lapsing is not a necessary feature of time], therefore $\sim L$ [time does not lapse]" (p. 198). Further, "$P(\sim L)$ is established by showing there is a physically *possible* world—the Gödel universe— where $\sim L$ is true." He comments on this argument that: "Gödel's essentialist intuitions here are not easy to fathom." Earman's reconstruction of Gödel's argument, however, contains an ambiguity. Is he attributing to Gödel premise (A): "If time lapses in ours, or in any universe, it lapses necessarily—i.e. lapses in all (physically) possible universes"? Or is he attributing to Gödel premise (B): "If time lapses in ours, or in any universe, then time lapses necessarily, in the sense that *it lapses in all universes in which time exists*"? (Compare: if pain hurts in our universe, then in any universe in which people have pains, these pains will be felt to be hurtful by these people.) Clearly, Gödel is concerned to assert (B); there is no indication that he has any sympathy for (A). Attention, therefore, should only be paid to premise (B). Gödel is asserting that lapsing or passing is essential to, is a necessary feature of (intuitive) time, in the sense that: *Necessarily, if time exists, it lapses.*

The question becomes, then: why does Gödel find it philosophically unsatisfactory to claim that whereas time exists (and thus lapses) in our universe, it does not lapse, and thus fails to exist, in the GU? Gödel's concerns are focused on *the philosophical significance of the close similarity* of our universe with the Gödel Universe. The two universes are governed by the same fundamental laws of nature—in particular by EFE—and the denizens of both worlds can be presumed to have the same direct experiences (as of) time. *Same laws of nature, same phenomenology of time consciousness.* All that *differentiates* the two worlds, then, is *the global distribution of matter and motion*, and Gödel (1946/9 B2, p. 238) believes that: "*A lapse of time . . . would have to be founded, one should think, in the laws of nature*, i.e. it could hardly be maintained that whether or not an objective lapse of time exists depends on the special manner in which matter and its impulse are distributed in the world." But what exactly is the conceptual insight Gödel is adducing here? Earman is no doubt correct that others will agree him that "Gödel gives us no guidelines for judging superiority of conceptual insight" (p. 198). Earman adds, further, that: "This game of using an inner sense to perceive conceptual truths is a dangerous one, for others claim to perceive the nonexistence of CTC's [closed temporal curves] as essential to the concept of time, and therefore, that . . . the Gödel model can be ruled out on a priori grounds" (1995, p. 198).

Note, however, that Gödel agrees that the nonexistence of CTC's is essential to *the concept of intuitive time*. His point is rather that their nonexistence is *not* essential to *the concept of relativistic spacetime*, which, one must never forget, is for Gödel but a *formalistic simulacrum* of the real thing. Indeed, it was on the basis of the consistency of the Gödel model with the accepted principles of relativity theory that I predicted (pp. 45–46) that it would not be long before some physicist would come forward to correct this embarrassing situation by proposing what would amount to an '*anti-Gödel*' *law of nature*, to be appended to the accepted principles of the GTR, precisely to rule out the present lawlike compossibility of the GU with the known laws of nature. And, as it happened, less than a year after the first edition of this book appeared, there came forward such a physicist. For in

1992 Stephen Hawking[28] proposed his 'Chronology Protection Conjecture', designed precisely to add a new law of nature to ensure that world models like Gödel's could no longer be claimed to be physically possible.[29]

Returning, then, to Earman's complaint that "Gödel gives us no guidelines for judging superiority of conceptual insight," we should note that Gödel is not concerned here with providing *a foundation for the theory of conceptual intuition*, but rather with invoking a *particular* intuition in attempting to resolve the question of the '*completeness*' of a particular 'formal' system—in this case, relativity theory—just as he invoked, in the course of proving his Incompleteness Theorem, an intuitive arithmetic truth undecidable in the formal system of *Principia Mathematica*, in his attempt to resolve the question of the *completeness* of that particular formal system.[30] The question remains, however, what the intuition is, concerning intuitive time, that Gödel is invoking in his writings on Einstein, and the answer to this question seems to be that he believes that *time is simply not the kind of thing concerning whose existence the testimony of direct experience, combined with the fundamental laws of nature, could be irrelevant.* Compare, again, the case of pain: one might urge that pain is simply not the kind of thing concerning whose existence the testimony of direct experience, combined with the fundamental laws of nature, can be irrelevant. In the case of time, moreover, there is the further consideration that the presence or absence of time

28. Hawking wrote an 'Introduction' to Gödel 1949 in Feferman et al. 1990.

29. It behooves physicists like Hawking, however, to explain how they can consistently accept the basis of the GTR and yet feel the need to rule out the GU. (Gödel, of course, accepts the GTR, but not as an account of *intuitive time*.) Appending, as Hawking does, an ad hoc physical condition to EFE, with the express purpose of ruling out world models like Gödel's, must have some defensible philosophical or physical motivation; yet it is hard to see what this could be, once one accepts Einstein's (four-dimensional) *geometrization of spacetime*. To be sure, Hawking advances detailed physical considerations to support his 'conjecture'. But these have not received wide acceptance. Those who live by geometry, one is tempted to say, must be prepared to die by it.

30. There arises, however, the question of why, in the case of his Incompleteness Theorem, Gödel concluded that the formal system of arithmetic is essentially *incomplete* (with respect to 'intuitive arithmetic'), whereas in the case of the 'formal' system of relativity theory he concluded, rather, that it is the fundamental *intuition* of time that lacks an objective correlate. We will address this question below, but note for now that those like Earman who simply dismiss the question of the intuition of time, uncapturable in relativity theory, are in no position *even to recognize the existence* of this problem.

does not seem to be the kind of thing that is sensitive to the global/local distinction. Compare: whether or not the water in a river is flowing is not the kind of thing that can be determined globally, whatever the facts are locally (a river cannot flow locally but not globally).

The Epistemology of the Gödel Universe

One has to visualize the situation Gödel considers paradoxical or philosophically problematic—namely that time exists in the actual world, but not in the GU. Empirical observations (concerning the lack of perceived rotation of our universe and the expansion of the universe) seem to rule out the possibility that ours is a GU. What is crucial here, however, is the *epistemic remoteness* of these observations. Absent some subtle measurements made by powerful telescopes (combined with long chains of delicate theoretical interpolations), it is entirely compatible (or epistemically consistent) with our everyday temporal experiences that our world turn out, in the end, to be a GU. But that means that it is conceivable that at the end of a long life filled with anticipations and regrets, a life filled with the joys and sorrows attending the flow of time, I may learn, as a result of some subtle astronomical observations performed with the Hubble Telescope concerning the distribution of matter and motion in the most distant reaches of the visible universe, that my entire life has been an illusion: time does not in fact flow, and time itself, therefore, does not exist in our universe. (Whereas, if I were to receive the next day a telegram informing me that the observations made with the Hubble Telescope had been misinterpreted, I should then be able to conclude that time does after all exist, and that my entire life has not been, after all, an illusion.)

This situation may be usefully compared with a similar one concerning the co-called 'direction of time'. David Malament, in a review of Sklar 1974, discusses theories that attempt a 'reduction' or analysis of the direction of time—to which we seem to have some sort of direct epistemic access—in terms of esoteric, *epistemologically-remote*, physical processes: "Is it at all plausible that our only means of determining whether the dessert comes after the soup is by first determining patterns of weak interaction

in particle physics? Surely not.[31] [As Sklar 1974, p. 399, puts it:] 'Surely, there is something implausible about a philosophical analysis that makes the existence and knowability of *an obviously present feature of the world* hinge upon the existence of other features that may, in fact, not exist and that, even if they do exist, have *observational consequences only under the most unusual of situations*'" (Malament 1976, p. 322).

Neither Malament nor Sklar makes here an explicit reference to conceptual intuition, but their reasoning seems, nevertheless, to depend as much on such intuitions as does Gödel's. If, for example, we substitute, in both of their above remarks, for the concept of the direction of time the (closely related) one of the objective lapse of time (and in place of facts in particle physics substitute results in astronomy and cosmology), we obtain, I believe, sentiments in considerable sympathy with those expressed in Gödel's argument. Thus, Gödel seems to have it in mind that: if (even) direct experience (as) of the objective lapse of time would *not* testify to its presence, then *nothing else* (including epistemologically-remote cosmological data) *would*. Hence, if neither direct experience nor the laws of nature suffice to establish the existence of time in the GU, the global distribution of matter and motion could not by itself suffice to establish the existence, in that world, of time.

Now, it turns out that the very considerations that render problematic the reality of time in the GU also demonstrate, for Gödel, the problematic nature of the existence of time even in the actual world. But for Gödel the geometry of the actual world does not, in itself, rule out the existence of time. So, argues Earman, "[According to Gödel] time in the actual universe lacks some non-geometrical feature necessary for time lapse. What is this missing feature?" (Earman, p. 198). The missing feature, surely, is precisely the lapse of time! But for Gödel the objective lapse of time amounts to the fact that "reality consists of an infinity of layers of the 'now' which come into existence successively." Once again, however, Earman finds the very concept of objective

31. Yet, by analogy, Earman seems willing to countenance this kind of possibility—with respect to epistemologically-remote physical conditions in the universe—when the question at hand concerns not the 'direction' but rather the very existence of time.

time lapse problematic: "it would be difficult to make any non-psychologistic sense of shifting nowness" (p. 199).[32] The proper response to this comment of Earman's, however, is to recall our earlier analogy with the case of Gödel's Incompleteness Theorem and Gödel's comment that formalists, who took formal proof to be an *analysis* of the concept of intuitive arithmetic truth, were in no position to *distinguish* the two. As we remarked then: those who consider the temporal component of relativistic spacetime to be an *analysis* of the intuitive concept of time are not in a position to *distinguish* the two and thus not in a position to realize the shocking consequences of Gödel's cosmology.

At this point in his argument, however, Earman refers to the account of Gödel's argument given in my book and cites a line from Gödel that I included: "If the experience of the lapse of time can exist without an objective lapse of time, no reason can be given why an objective lapse of time should be assumed at all". "Let it be granted," says Earman, ". . . that some observers in the Gödel universe are under an illusion—they experience a time lapse . . . even though in fact there is no objective lapse of time" (p. 199). It remains, according to Earman, that: "*Apart from our experiences of time lapse we have all sorts of other experiences that lend strong support to the inference that we do not inhabit a Gödel type universe but rather a universe that fulfills all of the geometrical conditions necessary for an objective lapse of time*" (p. 199; emphasis in the original). It is tempting to respond to this line of reasoning by adducing the fact that even if the geometry of our universe fulfills the necessary conditions for the flow of time, this does not suffice to establish the actual existence of objective time flow: a *necessary* condition must be distinguished from a *sufficient* one. And the question then arises: what is *left*, beyond the geometry of the actual universe, to establish the existence of the objective lapse of time?[33]

Savitt, indeed, offers just such an argument in response to considerations like those advanced by Earman. Savitt cites "Yourgrau's presentation of 'Gödel's modal reasoning' [from the

32. Earman's position here stands in sharp contrast with Čapek 1983, Stein 1968, and Shimony 1983.

33. *Pace* Stein 1968, spacetime geometry by itself never suffices to establish temporal becoming. Shimony 1983 and Savitt 1994 are quite clear on this point.

non-existence of time in a possible universe, to its nonexistence in the actual world]" (Savitt 1994, p. 466), and quotes the following passage from my book: "Since the actual world is lawlike compossible with the Gödel universe, it follows that our direct experience of time is compatible with its ideality . . . But if even direct experience is inadequate to establish the existence of intuitive time . . . then nothing further will suffice." He imagines, however, a "blunt challenge" to this line of reasoning: "no modal facts show that our direct experience of our time is inadequate to establish the existence of objectively lapsing 'intuitive' time" (p. 467). This blunt challenge is, however, in Savitt's view turned back by "Yourgrau's epistemic argument." "This argument," says Savitt, ". . . decisively shifts the burden of proof with respect to the existence of objectively lapsing time. If the inhabitants of a Gödelian universe can have experience like ours of time . . . then why should our experience be taken as any indication that in our world time does objectively lapse?" (p. 467) "To the 'blunt challenge'", he continues, "raised above to Yourgrau's version of Gödel's argument, that in our world our experience is in fact of objectively lapsing time, we simply respond, 'How do you know that?' The challenger must respond with grounds other than (what we seem to) experience. For instance, we presumably have in our universe (and the Gödelians lack in theirs) a global time function and global time slices, but these structures, we recall, are only necessary conditions for objectively lapsing time. The other condition, the successive coming into existence, is precisely what is at issue" (p. 468).

This counter-argument of Savitt's, though well put, still leaves room for a reply by Earman. Consider an analogy with seeing a stick looking bent when placed in a glass of water. The possibility of this happening proves that even direct experience (as of) a stick looking bent is not a sufficient condition for a stick actually being bent. But might one not claim that, if the 'standing conditions' are 'favorable'—for example if light rays are not bent by refraction by the water in a glass—then in these conditions direct experience (as of) a stick looking bent does suffice to establish that the stick is bent? Similarly, might not Earman claim that when the large scale geometry of the universe is 'favorable' to time flow (does not rule it out), then in these conditions the direct experience (as of) time does suffice to establish objective time flow?

The True Meaning of the Gödel Universe

How might Gödel respond to this counter-argument? One should remind oneself, to begin with, of the fact that the situation Earman is envisaging is the following: in the actual world, in which cosmic time can be defined, time exists, whereas in a universe with the same basic laws of nature as our own but lacking the mean global distribution of matter and motion found in the actual world, cosmic time cannot be defined, and so time does not exist. Concerning the latter world, one is tempted to remark, matter and motion are not sufficiently 'co-ordinated', in a global sense, to allow the definition of a single, objective, cosmic time. *This remark, however, would precisely miss the true paradoxicality of the situation Earman evisages.* For, by Gödel's reasoning, in a general relativistically possible universe lacking cosmic time, *time* itself does not exist, and so *neither does motion* (that is, change of spatial position *over time*). In the GU, then, the mean motion of matter is not simply *different* than it is in the actual world; rather, there is *no motion at all*. Let us describe this scenario so that its most paradoxical aspect becomes fully visible. We can say that when matter and motion exhibit the pattern they enjoy in the actual world, time exists, but when they exhibit the pattern characteristic of the GU, then the so-called 'motion' of matter is really an *illusion*; for without *time* there can be no *motion*. In a word, when the 'motion' of matter assumes the pattern of motion of the GU it ceases to be *motion* at all! NB: it is not that Gödel is denying that there can be a possible world in which matter is not in motion. The Gödel Universe, however, is not specified as such a 'frozen world', where nothing moves. On the contrary, the Gödel, or Rotating, Universe is characterized precisely by a peculiar *pattern of motion*—namely *universal rotation*. The *puzzle*, then, is how the question of the mere *pattern* of something's movements can determine whether or not it is *really moving* at all.[34] As Gödel says, "a philosophical view leading to such consequences can hardly be considered satisfactory."

34. Compare: there are possible ballets where the dancers simply stand on stage, 'frozen' in their assigned positions. But are there possible ballets, similar to familiar ones like *Swan Lake*, where the *pattern* of the dance steps *alone* ensures that no dancer is really moving? But the GU is just such a possible world where the pattern of the 'ballet' of the motion of matter ensures that nothing is really moving.

Further, it is well to remind ourselves of Gödel's emphasis on the directness or epistemic intimacy of our contact with the phenomenon of time. He is at pains to remind us that (it is in the 'nature' or 'essence' of intuitive time that) we have direct, unmediated contact with (the flow of) time. Time would seem to be, for Gödel, similar to the phenomenon of consciousness—for example, pain—in that if these phenomena represent genuinely possible modes of being, then if we so much as *think* we are experiencing them, then, 'by definition' (or 'by nature or essence') it follows that we *are*. Unlike strictly 'mental' phenomena, however, time also constitutes a (perhaps *the*) fundamental aspect of empirical reality itself. It is these two aspects of time that make it so peculiar and so fundamental, both to the 'life-world' and to the 'objective' world (under the purview of physics). (Recall Gödel's description of time as "that mysterious and seemingly self-contradictory being which, on the other hand, seems to form the basis of the world's and our own existence.") That's why Arthur Eddington was moved to write (as cited earlier) that: "we have direct insight into 'becoming' which sweeps aside all symbolic knowledge as on an inferior plane" (1958, p. 97). And recall Gödel's remark to Wang, in the context of relativistic physics, that "the fruitfulness of the postivistic [verificationistic] point of view in this case [in relativity theory] is due to . . . the fact that the basic concept . . . i.e., [non-distant] simultaneity, is directly observable, whereas generally basic entities such as elementary particles . . . are not" (Wang 1974, p. 12).

Gödel's basic idea here, then, is that if even the direct experience of time (in the GU) turns out to be insufficient to establish the existence of the objective lapse of time, then, since time is precisely *the kind of phenomenon for which it is not possible that direct experience not be decisive evidence for its presence,* it follows that time is *essentially ideal* or an illusion, and so ideal or illusory even in the actual world—in spite of our direct experience in this (geometrically accommodating) world (as) of time. Now Earman seems to be to some extent aware of the kind of argument Gödel is offering here, and toward the end of his discussion he remarks on the fact that there may be a GU that is "observationally indistinguishable from models that fit current astronomical data" (p. 199). He remains reluctant, however, to draw any conclusions from the possibility that objective time flow might

thus prove to be, in effect, 'verification transcendent'. "Gödel", he comments, "would seem to need an additional premise asserting something like a verifiability theory of meaning in order to reach his conclusion. I take it that few people will be attracted by such a premise" (p. 200). [35] Now, we have just seen, above—and the point was also stressed earlier in this study—that there is a sense in which Gödel subscribes to a kind of verificationism with respect to time, a verificationism, however, that he attributes to *Einstein* and the Theory of Relativity. Though generally hostile to verificationism in science and mathematics, Gödel, as we have seen, credits Einstein with the insight that with respect to the role of time in relativity theory a kind of verificationism is merited, insofar as the theory emphasizes the fundamental role played by the measurement of time, in particular the measurement by clocks of simultaneity. Earman's complaint about Gödel's verificationism should, therefore, by rights, be aimed rather at Einstein. Further, as we have seen, Gödel goes beyond even this degree of verificationism insofar as he seems to be suggesting that intuitive time presupposes a peculiar epistemic intimacy that must, in the nature of things—if time is a genuinely possible mode of being—serve as sufficient guarantee of its existence.

Local versus Global Properties of Time

Earman to the side, however, one might note that Gödel's conclusion is addressed specifically to the question of the existence of 'intuitive time' in our own universe and that it brings to bear both global considerations in the actual universe as well as modal

35. This is another sign that Earman may have read (some pages from) my book, since the relationship between Gödel's 'modal argument' for the ideality of time and a version of verificationism is explored here at length. In particular, I stress (pp. 47–48 above) that the move from *skepticism*—i.e. that, as Savitt (op. cit.) has it, there is nothing left to demonstrate that time exists in our world—to *idealism* (i.e. that time does not exist in our world) relies on a kind of 'verificationist bridge principle'. I emphasize, further, that the situation here is analogous to Kant's 'transcendental deduction' (a point also made by P.F. Strawson)—which is in effect designed to show that if the world is not, as a matter of fact (empirically) as we perceive it to be, then there never will be such a world. And of course, Kant combines his 'empirical realism' with what he calls "transcendental idealism." (For more on the relationship of Gödel's idealism to Kant's, see below.) I point out, further, that *Einstein too* employs some such verificationist bridge principle in the STR—a principle, however, that John Bell, in an insufficiently appreciated study, has called into question (Bell 1989: 'How to Teach Special Relativity', p. 77).

facts—that is, world to (possible) world relationships. It seems appropriate to ask, therefore, whether the distinction between local and global properties within our world could not be invoked to soften the force of Gödel's reasoning. Thus, it might be urged that whatever the large-scale properties of the world in regard to the distribution of matter and motion (relevant to cosmological time), or to the existence of closed future directed timelike curves (relevant to the possibility of time travel), it is another question whether the local properties of time may not still be as they are 'perceived as being'—that is, as of something 'objectively lapsing'. After all, speaking geometrically, given a large curvature in space, local conditions can still be, by approximation, 'flat'. (Not only does the round earth *look* flat, locally; it really *is*, by approximation, locally flat.) So, why couldn't similar considerations be brought to bear on Gödel's reasoning in terms of closed timelike curves in spacetime? The answer, surely, is that since what is at issue here is *intuitive* time, he would object as strongly, here, to the suggestion of a merely '*local* (objective) lapse of time' as we saw him objecting, earlier, to a merely "*relative* (objective) lapse of time."[36]

In sum, if it is so much as possible that, compatible with our direct experience as of the lapse of time, there exists, known or unknown to us a large-scale closed timelike line in this very space-time—that is, if we assume that the time dimension in Minkowski spacetime is that very time we directly experience, locally, as lapsing—then it follows (by reductio) that the experienced lapse as of time is actually (not just possibly), and locally (not just globally), (an appearance or) an illusion, since *the '(ontological) effect' of the lapsing of local time is precisely 'annulled' by the mere possibility of a 'return' to the present,* at some time (no matter how distant), in the future. In other words, an objective lapse of time has ontological consequences, and these would conflict with the ontological consequences of closed timelike lines in space-time, no matter how great the

36. Although Malament 1984, p. 92 remarks that "[t]hough, in a sense, notions of past and future break down in the Gödel model, they do not do so locally," he presumably does not have in mind the A-theoretic notion of past and future. In relativity theory the so-called 'future light cone' is defined in terms of the relativistic concept of the 'causal future'.

radius of curvature. ("The radius of the smallest time-like circles," says Gödel, "in the solution given in this paper, is of the same order of magnitude as the world radius in Einstein's static universe" [1949, p. 198].) To assume otherwise would mean to abandon the ontological dimension of the objective lapse of time—to reject Gödel's assumption that "the lapse of time in the ordinary sense . . . means a change in the existing"—and thus, in effect, to treat spacetime as a 'space', in the general sense (thereby conceding to Gödel the ideality of time, in the intuitive sense).

Analogies and Disanalogies

Another objection, however, to Gödel's argument can be raised along quite different lines. It may be asked, then, whether the heavy-handed detour through the GU is really necessary to refute Jeans. Sklar (1984, p. 106) remarks: "I don't think Gödel really needed such a cosmology to 'refute' Jeans, since conceptual reflection shows us, I think, that even if such a cosmological time exists it is hardly a restoration of an 'absolute time' in anything like the pre-relativistic sense of that notion." This comment, on the face of it, is reasonable enough, but it is well to recall the reaction of Ernst Zermelo (as well as L.E.J. Brouwer) to Gödel's Incompleteness Theorem, to wit, that, in effect, the heavy-handed detour through the manipulation of formal systems and the arithmetization of metamathematics were not really needed to 'refute' formalists like David Hilbert—since 'conceptual reflection' alone shows us that proof in a formal system is no substitute for the ('intuitive') notion of mathematical truth.[37] And, indeed, there are a number of analogies (as well as disanalogies) between the two cases. It should be noted first that in both contexts, rather than engaging in a brute affirmation of the results of his own 'conceptual reflection' (unlikely, as Earman has remarked, to convince his opponents), Gödel chose to employ the very methods favored by these 'antagonists' (the definition of a 'cosmological time' in the case of Jeans, the use of formal systems, in Hilbert's case) to provide a proof that would be simultaneously within the accepted methodological framework while nevertheless demonstrating, or

37. See, for some discussion, Kreisel 1980, pp. 209–210.

at least strongly pointing in the direction of, the results Gödel was concerned to emphasize. Just as Hilbert could easily ignore Gödel's (realist) intuitions, but not so easily his Incompleteness Theorem(s), so Jeans would not be able so easily to ignore the actual proof of the undefinability of cosmological time in the GU as he could Gödel's unadorned conceptual reflections about time.

In the case both of Gödel's Incompleteness Theorem and of his cosmological results, Gödel is well aware that the formal results alone, without any philosophical presupposition or 'intuition', are insufficient to 'prove' the philosophical conclusions he seeks. Recall Gödel's remark: "The positivists seek to prove everything from nothing." It remains, then, that the final step in each argument is in some sense more philosophical or 'intuitive', and thus leaves some room to resist Gödel's conclusions. In the one case, concerning the (*not fully precisely stated*) *Hilbert program*—about which Gödel himself was always rather guarded in his judgments—in the other, with respect to the actual universe and the (*not fully precisely stated*) *objective lapse of* (*intuitive*) *time*—concerning which Gödel is remarkably *less* guarded in the conclusions he is willing to draw. (Indeed, with regard to the former, Hilbert himself, did, at least initially, put up some resistance.[38])

Gödel's Theorem and Gödel's Cosmology: Mathematical Realism versus Temporal Idealism

A disanalogy, however, between the two cases, that is also of relevance to Sklar's objection, is that whereas the Incompleteness Theorem was taken by Gödel to *support* his belief in the concept of objective mathematical truth, his cosmological writings were interpreted by him as a *challenge* not only to Jeans's attempt to

38. According to Paul Bernays, "[a]t first [Hilbert] was only angry and frustrated, but then he began to try to deal constructively with the problem" (Wang 1987, p. 87). Indeed, in his 1931 Hilbert added to a formal system of arithmetic a new rule of a "semi-infinitary" character, with an eye on completeness. The relation of this new approach to Gödel's Incompleteness Theorem(s), however, is uncertain. (See Solomon Feferman 1986, pp. 208–213). In a review of Hilbert's paper, Gödel (1931c) says, cautiously, that this approach "offers a substantial supplement to the formal steps taken thus far," and that this rule "structurally, is of an entirely new kind." Carnap, however, notes in his diary for that year that Gödel said that "Hilbert's program would be compromised by acceptance of this rule" (Wang 1987, p. 87).

employ cosmological time to reintroduce (the) objective (lapse of) time into the universe, but rather to any attempt (in a relativistic context) to reintroduce "time, in the ordinary sense." After all, Gödel is a mathematical *realist* (or platonist), but a temporal *idealist*. He wishes to challenge not only Jeans's (use of) cosmological time, but as well the very existence of (the) objective (lapse of) time Jeans's analysis was intended to support. And one should bear in mind that this (temporal) idealism of Gödel's (which he associates with Kant) is derived by him from what might be called 'Einstein's idealism'. Thus, Kreisel (1980, p. 209) writes: "In conversation, at least with me, [Gödel] was ready to treat [realism and idealism in philosophy] more like different branches of the subject, the former concentrating on the things considered, the latter on the processes of acquiring knowledge about these objects or about the process." If, then, one accepts, with Kreisel, that, "[i]n mathematics, the idealist tradition is involved, in one form or another, in constructivist foundations which stress the use of definitions and proofs [as with Hilbert's program] in the process of acquiring mathematical knowledge," then one can view the Incompleteness Theorem(s) as using (mathematical) *idealist methods* to argue for (mathematical) *realist conclusions*. In the case of relativity theory then, Einstein's focus on the *measurement* ("the process of acquiring knowledge") of time—where, as Gödel (1946/49) makes explicit, "time is defined by direct measuring with clocks," and one is asked to accept "the principle that two states of affairs which cannot be distinguished by observations are also objectively equal"—can also, with some justice, be called a kind of *idealism*. What Gödel has done, then, is to argue that *(temporal) idealism in Einstein's sense leads to (temporal) idealism in Kant's.*

This way of looking at things, however, leads to the following question: *Why didn't Gödel, in his writings on time, conclude to the limitations of the formalism (here, the mathematics of relativity theory), vis-à-vis the intuitive concept of time (little 't'), as he had earlier drawn the conclusion, in his Incompleteness Theorem, that the purely formal methods (in the metamathematical sense) of the Hilbert school were (provably) inadequate to express the concept of intuitive arithmetic Truth (big 'T')?* Amazingly, I find no evidence that any other thinker has answered this question, or that anyone else seems even to have posed it. Now, to make

the parallel suggested in this question sharper,[39] we can say that in both cases a result is achieved concerning the relation of *form* to *content* —in the one case about the big 'T' of truth, in the other, the little '*t*' of time. In the case of the Incompleteness Theorem and Hilbert's program, Gödel succeeded in constructing a formal system (in the strict metamathematical sense) for which it was provable that no predicate, 'T', could bear the interpretation or have the (intuitive, mathematical) content, 'is true' (briefly, that in this essentially richer context, unlike that of the Completeness Theorem, *proof* cannot take the place of, or 'simulate', *truth*). With the (demonstrable part) of his cosmological writings, in turn, concerning the GU, he succeeded in producing a 'formal' structure (in the relativistic-mathematical sense) concerning which it was provable that '*t*', the variable for time, could not have the standard interpretation, or content, '(intuitive) time', since it is provable that in this context Jeans's cosmological time cannot be defined, and that (in the non-expanding GU) closed and nearly closed timelike lines occur, permitting time-travel. But, in the case of Hilbert's program, he concluded only to the limitations of the form (of formalism [in Hilbert's strict metamathematical sense]) to express the content (of mathematical truth). *Why, then, did he not conclude, with regard to Jeans's 'program' and Einstein's 'idealistic' methodology, only that the 'form' (of Relativity Theory, as standardly interpreted) was limited in its abil-*

39. It is also interesting to note a parallel between Gödel's Incompleteness Theorem and Aristotle's dilemma—discussed at length in the next chapter—that truth about the future seems to bring with it 'necessity' (since what is now true about the future *cannot fail* to come about). Stein 1968 and Horwich 1990 are inclined to dismiss this dilemma. Thus Stein: ". . . I do not see that the adoption of this notion [of truth as a 'timeless' predicate]—as a manner of speaking—says anything about the world" (Stein 1968, p. 21). Aristotle and Aquinas, however, and, as will be seen in Chapter 6, contemporary tense logicians like Thomason (1970), et al., take the problem more seriously. Aristotle's proposed solution, we will argue, was, in effect, to preserve the principle of excluded middle, as, so to speak, a 'theorem', while rejecting the principle of bivalence (that every statement is either determinately true or determinately false). In effect, then, Aristotle maintains:

$\vdash (p \vee \sim p)$, but not $\vdash (p)$ or $\vdash (\sim p)$; where '$\vdash (p)$' can be read either as '*p* is determinately true' or as '*p* is necessarily true' (in Aristotle's special, tense-logical, sense of 'necessary', according to which what is [now] determinately true is [now] necessary). ("[I]t is necessary for there to be or not to be a sea battle tomorrow, but it is not necessary for a sea battle to take place tomorrow, nor for one not to take place . . ." (Aristotle, *De Interpretatione*, 19a.)

But this is exactly the form of the conclusion Gödel reaches in his Incompleteness Theorem, if we read '$\vdash (p)$' as 'p is provable' (in the formal system at hand), and put for 'p' the formula he proves undecidable! (Myhill 1952, p. 166, Note 3, has also noted this parallel.)

ity to represent the sought for 'content' (i.e. intuitive time), instead of viewing his results as a kind of 'verification' of Kant's idealism— i.e., of the nonexistence of this intuitive content?

I don't think we really know enough, at present, to resolve this question satisfactorily. One can observe, of course, that in the case of Gödel's Incompleteness Theorem, the result is achieved in the context of full, 'intuitive' (i.e. non-formalized, in Hilbert's sense) classical number theory, in which the 'unprovable' (in the formal system at hand) Gödel formula is seen to be true. But in the case of the cosmology papers, it seems, there is no comparable uncontroversial, well-developed, theoretical context in which it can be seen that there is—though invisible to Relativity Theory— an objective lapse of time. (Indeed, in the special relativistic context things are really even worse than this, since by Gödel's earlier reasoning concerning the STR and the relativity of simultaneity, it appears that there is an outright conflict between that theory—on its standard, Einsteinian interpretation—and the proposition that there is an objective lapse of time—i.e., of the 'now').

What gives one pause, here, however, are the following considerations. As mentioned above, Gödel, in his discussions with Wang, made it clear that he thought of time as *the* philosophical problem. Since, moreover, as is well known, Gödel read Edmund Husserl on the phenomenology of internal time-consciousness, perhaps, it was to Husserl (1991) that he turned for the "well-developed theoretical context" sought for above, to provide the background and foundation for the content of 'intuitive time'. If so, however, the disanalogy with his Incompleteness Theorem(s) and the limitations of mathematical formalism remains. For, as will be seen below, it is precisely one of Husserl's fundamental methodological principles that we are not permitted to draw any ontological conclusions about the existence of an objective lapse of time from purely phenomenological investigations.

For some insights into Gödel's relationship to Husserl's investigations concerning temporal consciousness one turns naturally to Wang, *A Logical Journey* and also 'Time in Philosophy and Physics', where he records the conversations he had with Gödel on Husserl and time consciousness.[40] One note of caution,

40. See also Appendix A: 'Brouwer and the "Revolution"'.

however: Wang hints at various places that it is far from clear whether Gödel believed that Husserl ever succeeded in breaking through to important insights about the nature of time.[41] Gödel comments, indeed, that: "What remains in Husserl's approach is the observation of the working of the mind: this is the way to make the concept of time, etc., clear—not by studying how [such concepts] work in science" (p. 228). In general, what emerges from Gödel's conversations with Wang is that Gödel thinks that there is indeed a genuine intuition that lies behind our ordinary concept of time, but that this intuition points to a concept, indeed a conceptual frame, foreign to contemporary physical science—in particular, foreign to relativity theory. Gödel refers to the "mind" but he clearly is not thinking of the subject of contemporary empirical psychology, but rather of something more like 'transcendental psychology' in the sense (whatever it is) of Kant and of Husserl. Gödel also hints that in point of fact this alternative conceptual framework does not exist at present, and thus one is in no position to assess its relationship to that of an established empirical science like relativity theory. It is also fairly clear, moreover, that Gödel thinks that physics itself should be rethought, in particular to include not time or some simulacrum thereof (like 'cosmic time'), but rather what he calls, somewhat misleadingly, 'real time'. As his comments to Wang indicate, he thinks this amounts to something like the 'causal structure of the world'—with the proviso that 'cause', here, is to be freed from its classical associations (stressed, for example, by Kant) with time and change. Gödel hints that in the sense of 'cause' he has in mind, an axiom 'causes' the theorems it implies. He seems thus to be harking back to the notion of 'formal cause' (i.e. formal '*aitia*') developed by Aristotle, following Plato.[42]

41. In this regard, see Note 53 below, for some skeptical observations about a recent attempt by Izchak Miller (1984) to revive Husserl's account of time.

42. Gödel's invocation of "formal causation" is another example of his sympathy with Greek philosophy, especially with Plato (and Parmenides)—a sympathy stressed in this book but insufficiently addressed elsewhere in the literature on Gödel. Indeed, in *A Logical Journey* (p. 300) Wang notes that Gödel once singled out a passage in Plato's *Republic* to which he was especially attached (Book 6: "Do you not know that although they [students of geometry] make use of visible forms . . . they are thinking not of these but of the Ideas they resemble . . . ?"). Gödel comments further (Wang, p. 235): "I am for the Platonic view. If there is nothing precise to begin with, it is unintelligible to say that we somehow arrive at a precise concept. Rather, we begin with vague perceptions of a concept, as we see an animal from far away . . ." Further, although clearly more sympathetic to Plato than to

A further consideration that gives one pause with regard to Gödel's ultimate acceptance of the conceptual framework of relativity theory, at least in the matter of Gödel's earlier discussion of the STR, is the fact that he is careful to preface his remarks on Einstein's methodology with a caveat. The fuller quotation, excerpted above, is: "*if* time is defined by direct measuring with clocks and Einstein's concept of simultaneousness" (my emphasis). Gödel's own attitude toward this methodology, however, is not easy to discern from the available evidence. Gödel 1946/49 is carefully noncommittal on just this point, but elsewhere the evidence seems to point in different directions. As we saw earlier, Wang 1974, pp. 12–13 records that, in the case of the STR,

> Gödel points out that the fruitfulness of the positivistic point of view in this case is due to a very exceptional circumstance, namely the fact that the basic concept to be clarified, i.e., [presumably local] simultaneity, is directly observable, while generally basic entities (such as elementary particles, the forces between them, etc.) are not. Hence, the positivistic requirement that everything has to be reduced to observations is justified in this case.[43]

On the other hand Wang pointed out to me, in conversation, that Gödel was very interested in the question of the Lorentz versus Einstein interpretation of the formalism of the STR. And in his 1946/49 B2, pp. 245–46, Gödel writes:

> . . . in perfect conformity with Kant, the observational results by themselves [on which the STR rests] really do not force us to abandon Newtonian time and space as objective realities, but only the observational results together with certain general principles, e.g.,

Aristotle, he is not averse to invoking the latter: "Already in Aristotle [*De Anima*] *noûs* is a causal affair: the active intellect works on the passive intellect" (Wang, p. 235).

43. Gödel goes on to resist what he sees as the positivistic bias of quantum mechanics: "That, generally speaking, positivism is not fruitful even in physics seems to follow from the fact that, since it has been more or less adopted in quantum physics (i.e. about 40 years ago) no substantial progress has been achieved in the basic laws of physics . . ." (Wang 1974, p. 13). Einstein, of course, shared Gödel's concern over the direction taken in quantum mechanics. All the more ironic, then, is Werner Heisenberg's report of an early encounter with Einstein. When Heisenberg's attempt to defend his approach was treated to a cold reception, he fought back: "And when I objected that in this I had merely been applying the type of philosophy that he, too, had made the basis of his special theory of relativity, he answered simply: 'Perhaps I did use such philosophy earlier, and also wrote it, but it is nonsense all the same'" (Heisenberg 1983, pp. 113–14).

the principle that two states of affairs which cannot be distinguished by observations are also objectively equal.

Compare these sentiments with those (mentioned earlier) expressed by J.S. Bell (1989, p. 77):

> Since it is experimentally impossible to say which of two uniformly moving systems is really at rest, Einstein declares the notions 'really resting' and 'really moving' as meaningless . . . Lorentz, on the other hand, preferred the view that there is indeed a state of real rest, defined by the 'aether', even though the laws of physics conspire to prevent us [from] identifying it experimentally. The facts of physics do not oblige us to accept the one philosophy rather than the other.[44]

It seems best, then, to leave it up in the air for now just what Gödel's final attitude was to the relativistic background he took for granted in his writings on time, and, therefore, also to leave undecided how one should approach the lack of parallel, noted above, between the final conclusions Gödel wished to draw from the Incompleteness Theorem(s) (in regard to intuitive arithmetic truth) and the conclusions reached in the cosmological writings (in regard to intuitive time), with respect to judgments concerning *the limitations of the formalism.*

Time Travel: Time Circles versus Time Cycles

Methodological questions aside, however, there remains an important component of Gödel's argument, employing the GU,

44. Popper, in turn, comments on the recent results of Alain Aspect and others concerning Bell's theorem: ". . . should the result of these experiments . . . be accepted, and interpreted as establishing physical action at a distance (with infinite velocity), then these experiments would have to be regarded as the first crucial experiments between Lorentz's and Einstein's interpretations of the formalism of special relativity" (1984, p. 54). By contrast, Shimony (1993, p. 286) remarks, concerning these results: "quantum-mechanical nonlocality 'peacefully coexists' with special relativity theory, because quantum-mechanical correlations between spatially separated systems cannot be exploited for sending messages faster than light." Popper, in turn, responds to this line of reasoning: ". . . even if signals cannot be transmitted with infinite velocity, the mere idea of infinite velocity requires the existence of a Lorentzian-Newtonian absolute space and absolute time, although, as Newton anticipated, it may not be possible in this case to identify the inertial system that is absolutely at rest" (Popper 1984, p. 54). This is obviously not the place to attempt to resolve this dispute. (Stein, however, one should note, in his 1991, pp. 154–55, Note 3, has offered some rather pointed remarks on the prospects of reviving the Lorentz "aether-compensatory" theory.)

that bears closer examination. I have in mind what is no doubt the most dramatic element in Gödel's reasoning, that in a certain (non-expanding) GU, due to the presence of closed, and nearly closed, timelike curves, 'time travel' is possible. To simplify, let us take such a closed timelike curve to be a (time) circle. The first point I wish to emphasize, then, is that one should not conflate circular with cyclical time. Cyclical time implies a process repeating itself over and over again, *n* times. One must be careful, here, of course, to distinguish proper from coordinate time, local from global time (order), but what I want to focus on is the fact that for a cyclical process, one can always ask: how often has it (now, in some appropriate sense of 'now') occurred? For a time circle, by contrast, such a question makes no sense. Unfortunately, however, in the famous 'time travel' episode from the *Star Trek* television series, this distinction is conflated; the ship's crew, supposedly traveling back to the past in a time *circle*, in fact repeats, *n* times, a time *cycle*.[45]

By a time circle one means a *completed* circle, not one in the process of being 'inscribed'. Whatever point one considers in such a circle, it has no more right to be considered objectively privileged or 'now' than any other. Unlike the 'open' line of A-theoretic time, where the future is, at any given moment, yet to become actualized, to become present, with a time circle *all* points of time are *fully actualized*; nothing merely potential remains. It follows, of course, that the (space-)time in the GU which permits a time circle must be a 'space' in the general sense we have introduced (insofar as the positions in a time circle bear no ontological weight). But since, as Gödel insists, "the lapse of time in the ordinary sense . . . means a change in the existing," it follows that, in a GU with a time circle and the possibility of time travel, there can be no genuine (A-theoretic) succession of times, no objective lapse of time. For as Gödel says, "the decisive point is this: that for *every* possible definition of a world time one could

45. The writers make another mistake insofar as the crew in the show quote their orders to under no circumstances do any thing that will change the past (and thus change the [past] future—i.e. the time period at which the time trip "originated"). This is, of course, the famous time travel 'grandfather paradox' (if you time travel and kill your grandfather, you will not have existed in the first place to make the trip). As we insisted earlier (pp. 40–41), the past is a *fact*, and *nothing*, including time travel, *can change what is already a fact*.

travel into regions of the universe which are past [i.e., already lapsed] according to that definition. This again shows that *to assume an objective lapse of time would lose every justification in these worlds*" (1949a, p. 205; second emphasis added).

Since Gödel (1946/49 C1, p. 251) insists that "something of this kind [which lacks the character of 'passing by'] can hardly be called time," it follows that the correct way to put things is that precisely because the GU permits 'time travel', it does not really contain time at all (intuitive time—that which deserves to be called time); hence there is also no genuine travel (namely, movement over time) at all, and thus *nothing that can really, in a precise (and intuitive) sense, be called 'time travel'*![46] Thus, the picture conjured up by 'time travel' in the GU—of a rocket ship moving at extremely high velocities ("the velocity of the ship must be at least $1/\sqrt{2}$ of the velocity of light"—Gödel 1949a, p. 205, Note 11)—will very likely mislead us, since, as Gödel reads it, such a universe 'verifies' Kant's idealism, that is, it lacks time, in the intuitive sense. Of course, there will be (the possibility of) such a rocket ship trip in the GU, as there are ordinary rocket trips in our universe—but the correct philosophical approach to these situations, according to Gödel, is Kant's.

The almost irresistible picture conjured up by time travel (in the GU or any other universe) or, more generally, by closed or *circular* time, has in fact mislead many thinkers, who cannot resist the temptation to invoke a *cycle* of times (thereby precisely missing the force of *time travel*). A *time circle* is a closed timelike world line, represented as such in a *Minkowski spacetime diagram*. The latter represents not just the *spatial* path on which one travels, over time, but rather the very *spacetime journey* itself. A Minkowski spacetime diagram, then, represents not just the *path*, but the *journey*. Yet, in *Einstein's Dreams*, a popular work by the physicist Alan Lightman, we read: "Suppose time is a *circle*, bending back on itself. The world *repeats* itself, precisely, *endlessly* . . . Politicians do not know that they will shout from the same lectern *an infinite number of times* in the *cycles* of time" (pp. 8–9; emphasis added). Similarly, John Wheeler writes in his recent book,

46. Earman (1995, p. 164), as mentioned in Note 21 above, has expressed similar sentiments.

Aeons, Black Holes, and Quantum Foam: A Life in Physics, that in the Gödel Universe, ". . . there could exist world lines . . . that closed up in loops. In such a universe, one could in principle *live one's life over and over again*" (p. 310; emphasis added). Popper, in turn, writes of "the existence of a closed world-line (which, for the sake of consistency, must be infinitely and absolutely *repetitive)*" (1982, p. 59, Note 2; emphasis added)—from which, given certain principles about causal traces or records, he derives a contradiction. And consider Čapek [1991], who remarks that, "[f]or such a [time] traveler time would obviously cease to exist as its 'successive' phase would co-exist simultaneously, i.e., would not be successive at all" (331). This is correct insofar as it notes the absence of the succession of times when time travel is at issue, but wrong in employing the expression, "co-exist simultaneously." To be simultaneous is to be at the same time—but, as Gödel has it, it's not that in this situation things happen 'all at once'. Rather, here one cannot speak of (intuitive) time at all. But Čapek goes on: "[time travel] was a contradiction: while time was excluded from the universe, viewed as becomingless and without succession, the tiny piece which was the time machine retained its moving, its succession, and therefore its temporality" (1991, p. xii). He is referring here to H.G. Wells, *The Time Machine*; but whatever pictures Wells's novel may conjure up, there is nothing in Gödel's argument to suggest that he entertained the view that somehow the time machine itself "retained its moving, its succession." In fact, a movie was made of Wells's novel, and in it the kind of illusion Čapek refers to is apparent. One might wonder, then, whether a better movie of this could not be made, or whether the medium itself—the 'motion picture'—is intrinsically inadequate to this (philosophical) task. To indulge in the latter concern, however, would be to perpetuate the confusion. One does not need 'special effects' to capture the 'look' of the GU. Simply look around yourself and you will, if Gödel is correct, already be witnessing a universe no less 'timeless' than the GU.

Not only, however, is there a temptation to form a misleading image of time travel in the GU—there is also a tendency to misconstrue its causal/ontological structure. Consider, again, Čapek: "Gödel's time-traveler, by his capacity to interact causally with past events would make envious even the medieval God whose omnipotence was restricted by St. Thomas by his incapacity to

undo the past . . ." (1976, LIII). But 'time travel' does not imply the capacity to 'undo the past'. On the contrary, as we have insisted, the most striking ontological consequence of closed time is the symmetry, in regard to facticity, of past, present, and future. Thus, there are no potentialities in such a time structure—everything is 'already' fully actual. Everything in a universe with closed time would resemble the way we view the past in our universe, as (now) closed, fully complete—indeed, as now 'necessary', as Aristotle says in *De Interpretatione*—and thus as unchangeable. It is as true to say that the time traveler is 'already' in the past, as that he or she is 'returning to it'. Of course, the time traveler might well, from a subjective point of view, 'feel' free to intervene in and 'undo' the past. But this subjective state would conceal an illusion, for in a universe with closed time no one would be 'free', in the sense of freedom that is incompatible with determinism.[47]

One must be careful here, however. The timelessness, or ideality of time, of the GU leads to full determinateness, or determinism—but this is in conjunction with the presence (or non-ideality) of space-time, as a 'space'. In contrast, for Kant, who maintains the (transcendental) ideality of both space and time, there remains the question of 'noumenal freedom'.[48] How is it, then, that Gödel manages simultaneously to enlist Kant's (temporal) idealism in support of his own and, in effect, to split apart Kant's doctrines on time and space?

47. Horwich (1987, p. 116), however, states, about the GU: "We may grant that the possibility of time travel implies that Charles *may* return to 1066, and . . . that he *could* attend the battle. But this conclusion is perfectly compatible with the supposition that he *did not* attend it. . . . From the fact that someone *did not* do something, it does not follow that he was *not free* to do it" (my emphases). Recall, however, that in the GU there is complete symmetry in terms of facticity (hence, of determinateness) of past, present, and future. There is thus no 'earlier' point in time at which an event that 'has' happened in the 'past' was not 'already then' fully determinate (or not 'free' to happen or not). But if the facts (whether we know them or not) rule out that a certain event happens, in what sense is one *free*, in that world, to initiate this event? (See also Stein 1990, p. 199, Note 9.)

48. Since the *noumenal*, for Kant, as the sphere of freedom is the domain of ethics, the question arises how he can combine his (transcendental) idealism with respect to time with our ordinary experience of our moral development over time. Allen Wood (1984, p. 99) offers the following suggestion, echoing the Platonic 'idealism' of the *Timaeus*: "Temporal striving and moral progress are the moving images of our eternal moral attitude, which we cannot conceive directly but to which we can relate only through such temporal images or parables. Kant thus hopes to preserve our ordinary experience of moral struggles in time and moral progress through time not as literal truth, but only as the best way we have of representing to ourselves a truth we cannot directly experience or literally comprehend."

Kant and Relativity Theory

The first point to emphasize is that Gödel by no means subscribes to Kant's universal idealism. It is thus misleading for Popper to write that: "The reality of time and change seemed to me to be the crux of realism . . . and it has been so regarded by some idealistic opponents of realism, such as Schrödinger and Gödel" (1982, p. 3, Note 2). On the contrary, Gödel (1946/49 C1, p. 257) speaks of Kant's "conviction of the unknowability (at least by theoretical reason) of the things in themselves," and comments that, "at this point, it seems to me, Kant should be modified, if one wants to establish agreement between his doctrines and modern physics; i.e., it should be assumed that it is possible for scientific knowledge, at least partially and step by step, to go beyond the appearances and approach the things in themselves." The equations of relativity theory, then, for Gödel, succeed in describing the world (as it is) in itself. He is thus *a realist* vis-à-vis *spacetime*. His idealism comes, rather, from his refusal to identify time in the intuitive sense with the temporal component of relativistic spacetime.

Again, however, one must ask: with what right does Gödel draw attention to the ideality of time, but not space, in a relativistic context? "One may wonder," Gödel says,

> why in the foregoing pages only time was spoken of . . . [given] the symmetry which subsists in relativity theory between time and space . . . [T]here are some essential points [however] where the analogy does not go through . . . 1. the passing of time has no analogue for space and 2. the symmetry between space and time in relativity theory is not complete, if the existence of matter is taken into account. For matter entails the existence of a 3-parametric system of physically distinguished one dimensional time-like subspaces (namely, the world lines of matter), whereas there exists in general no one parametric system of physically distinguished 3-dimensional space-like subspaces . . . This has the consequence that there exist no possible worlds in which the structure of absolute space-like relations would be so greatly different from intuitive space as is the case for time in the R[otating] worlds. (1946/49 C1, p. 253)

But things may still seem confusing. For Gödel, as we have seen, refers to intuitive or Kantian time. Thus, to put the matter

as paradoxically as we can, we have: *Kant claims that 't', for Newton, represents 'Kantian time'*, while *Gödel has it that 't', for Einstein, does not represent 'Kantian' (or 'intuitive') time.* Yet Gödel says: *'Einstein verifies Kant'*!

To help sort things out, it is important to have before us the fundamental analogy Gödel discerns between Kant and Relativity Theory:

> For Kant, time exists only 'in' the realm of appearances (itself a relative notion—things appear to us), and thus represents only a relation to the (universal, receptive) human sensibility, and so is not an 'absolute' property that 'inheres in' or is intrinsic to the things (as they are) in themselves (= *noumena*).

> For the STR, time exists only relative to an 'observer', or a reference or inertial frame, and thus is not an absolute or intrinsic feature of the things themselves (viz. the world-lines of bodies; as a special case, the body of a being with human sensibility) (= "*noumena*").

Gödel's analogy comes thus not from a superficial, literal comparison of Kant's views with Einstein's, but rather from a deeply thought out, systematic realignment of the two doctrines in a form calculated to be maximally perspicuous. Indeed, in his 1961/? he says: "I believe it to be a general feature of many of Kant's assertions that literally understood they are false but in a broader sense contain deep truths" (p. 385). Given this, one must be careful to take note of the role played by both the dissimilarities and the similarities in the comparison. To begin with, then, we note that of course *noumena*, for Kant, insofar as they represent things (as they are) in themselves, present them as in principle unknowable by (the theoretical reason of beings like) us (with a receptive sensibility), as are also their (objective) relations to us (although he does permit himself to speak of the latter in quasi-causal terms, and does claim at least to be able to rule out certain properties as belonging to *noumena*—for example, being in space and time). In contrast, (what play the role of) '*noumena*' in the STR are precisely elements of the world that theoretical reason can grasp, including their objective relations to us. Further, for

Kant the world of appearances, the phenomenal world, is essentially in time (though, see below), while, by Gödel's lights, this same phenomenal world (of Kant's) is precisely not in time (in the Kantian, intuitive, sense).

A Subtle Reading of Kant

In point of fact, however, Gödel, in a subtle reading of Kant, speaks of the "world of appearances" in several senses. (1) The world "as it appears" to an "observer," or relative to a reference or inertial frame, in the STR, is (as if) temporal, in something like Kant's sense (although, while Kant speaks of the [whole] world of appearances—and of the universal human sensibility as such—in the STR one speaks of the various "worlds" determined by the different "observers" or reference/inertial frames). (2) The STR also goes beyond the "world of appearances," relative to inertial frames, and theorizes about the world (as it is) in itself. And this "*noumenal*" world (as a whole) is not in time—"in perfect accord with Kant" (on what he took to be the "noumenal" world), as Gödel 1946/49 likes to say.[49] (One should add, moreover, that this world is "*noumenal*", for Gödel, not just because its properties are not merely relative to [relativistic] observers, but because, "Newtonian physics, except for the elimination of secondary qualities . . . is only a refinement of [that 'natural' picture of the world which Kant calls the world of 'appearance']; modern physics, however, has an entirely different character. This is seen most clearly from the distinction which has developed between 'laboratory language' and the theory, whereas Newtonian physics can be completely expressed in a refined laboratory language" (Gödel 1946/49 C1, p. 258). (3) Yet this "*noumenal*" world of the STR remains, for all that, as Gödel points out, the world as cognized by "observers" with human sensibility, no matter how formal or abstract this cognition may be, and thus it is still, in the most general (Kantian) sense, a world of appearances. Hence,

49. Of course, there are several approaches extant concerning the question of how one ought to read Kant's distinction between *phenomena* and *noumena*, in particular whether it represents a division in some sense between 'two worlds', or rather a distinction between two 'aspects' under which we may conceive the world. I do not think any considerations in the present chapter hinge on the question of which interpretation is the right one. (For a particularly useful discussion of this issue, see Parsons 1992, pp. 62–100.)

contra Kant, the "world of appearances," in this sense, is after all not in time.

A further point of dissimilarity is the obvious fact that while for Kant our knowledge of the 'forms' of space and time are a priori, in the STR they are a posteriori. This causes, moreover, the further problem that while Gödel's temporal 'idealism' is untroubled by this a posteriority, Kant's idealism was heavily influenced by his conviction that this knowledge is a priori. (See Parsons 1992, on Kant's idealism.) Thus, the very epistemological reorientation of the STR that lies at the basis of Gödel's (temporal) 'idealism' threatens the foundations of Kant's. If this seems somewhat ironic, even more so must be the fact that not only does Relativity Theory, according to Gödel, show, contra Kant, that one can go 'beyond the appearances'—the basis for the theory's ability here comes from empirical experience derived from physical experiments, while "[d]oubtless Kant would least of all have held an overstepping of the world of appearances to be possible, on the basis of conclusions drawn from experiments" (Gödel 1946/49 C1, p. 259).[50] It may seem, however, somewhat peculiar for Gödel to base his "epistemological optimism" (to borrow a term from Goldfarb forthcoming) on what is, after all, a kind of limitation of human reason—to wit, that our knowledge of (the fundamental forms of) space and time is not a priori but ('only'— as a philosopher might say) a posteriori. But any felt strangeness, here, I think, will disappear when one reflects on the fact that if the form of the world is not 'imposed by the knowing subject', yet is, for all that, still known by us, then the result is, precisely, epistemological optimism—since we now have no reason to insist on a division between the (form of) the world (as it is) in itself and as it appears to us.

50. To be sure, as we noted earlier, in the most general sense, even relativity theory does not "overstep the world of appearance," if all that is meant by the latter is "the world as cognized by us, in however abstract or formal a way." But the thrust of Gödel's thinking, here, in regard to physics, is still that, contra Kant, we have no reason to contrast the world as it appears (to us) and the world (as it is) in itself. Thus, Gödel (1946/49 C1, pp. 257–58, Note 27) writes: "Unfortunately, whenever this fruitful viewpoint of a distinction between subjective and objective elements in our knowledge (which is so impressively suggested by Kant's comparison with the Copernican system) appears in the history of science, there is at once a tendency to exaggerate it into a boundless subjectivism, whereby its effect is annulled. Kant's thesis of the unknowability of the things in themselves is one example." Compare Einstein: "In a certain sense . . . I hold it to be true that pure thought can grasp reality, as the ancients dreamed" (Frank 1982, p. 283).

Kant and the Appearance of Time

Dissimilarities exist, then, between Kant and the STR even in the framework of Gödel's comparison; but he is at pains to stress that the fundamental analogy, given above, remains valid, and thus that there continues to be an important sense in which 'Einstein verifies Kant'. There is, however, another aspect of these doctrines of Kant's, not exploited by Gödel, that may seem to point in the opposite direction. A closer look at the analogy as presented above reveals that for Kant there is a sense in which time does exist 'in' the world of appearances—or if you wish, that there really does appear to be time. Indeed, Kant insists that all our own representations are successive, in time. "Alterations are real," he says, "this being proved by change of our own representations—even if all outer appearances, together with their alterations, be denied. Now alterations are possible *only in time,* and *time* is therefore something *real*" (Kant 1965, A37/B54; my emphases). And in fact this line of thinking is still with us, whether inspired by Kant or just parallel to his thoughts. Popper, for example, in his conversation with Einstein alluded to earlier, says:

> I argued that if men . . . could experience change and genuine succession in time, then this was real. It could not be explained away by a theory of the successive rising into our consciousness of time slices which in some sense co-exist; for this kind of 'rising into consciousness' would have precisely the same character as that succession of changes which the theory tries to explain away. (1982, pp. 2–3, Note 2)

Similarly, Peter Geach writes that, "I am arguing that the variety of states each person experiences must really be, as it appears to be, a change in his experience, because these states are combinable only in succession, and not simultaneously" (1972, p. 306). William Lane Craig, in turn, has argued that, ". . . no B-theorist has successfully defended that theory against the incoherence that if external becoming is mind-dependent, still the subjective experience of becoming is objective, that is, there is an objective succession of contents of consciousness, so that becoming in the mental realm is real" (1990, p. 485). And, finally, Shimony writes that: "Something fleeting does indeed traverse the world line, but

that something is not subjective; it is the transient now, which as a matter of objective fact is momentarily present and thereafter is past. Without this minimal amount of objectivity there cannot even be an illusion of transiency" (1993, p. 284). Again, "[n]owness must either be more than an illusion or less than an illusion. If it is less, then no justice has been done to the phenomenology of time" (ibid, 279).

One could raise the question of whether these thinkers have an independent reply to the kind of reasoning Gödel has put forward (or whether they believe reason is here in tension with itself), as well as how they propose to explain the temporal relationships (for instance, with regard to simultaneity) between one subject's 'inner' experiences and those of others, and of both to the events in the 'outer' world that is the province of relativity theory. Further, in regard to the last quoted remark of Shimony concerning whether "justice has been done to the phenomenology of time," one could point out that Husserl, who presumably knew something about phenomenology—and to whom Gödel seems to have turned in this regard—precisely denies the validity of the kind of approach adopted by Shimony.[51] "Inherent in this, as in any phenomenological analysis," Husserl writes, "is the complete exclusion of every assumption, stipulation, and conviction with respect to objective time . . ." (1991, p. 4). Indeed, according to Husserl, "the ordered connections that are to be found in experiences as genuine immanencies *cannot be met with in the empirical, objective order, and do not fit into it*" (p. 6; emphasis added). (See further, Appendix A, below.)

With these remarks in mind one can perhaps better understand the comment Gödel made to Wang (1995, p. 228), that "time is the only natural frame of reference [for the mind]." The surface similarity of this remark to those expressed above, by Popper, et. al., in defense of the existence of objective time flow, should not, now, mislead us. 'Time', here, for Gödel, is clearly

51. NB: As indicated in the Preface to the Second Edition, I do not wish to deny the force of the considerations advanced by Shimony, et al. My point here is rather to deny both that the existence of an objective correlate for our intuition of the flow of time is *consistent* with relativity theory, and that our intuition suffices to *refute* relativity. (It may, however, signal the 'incompleteness' of relativity theory, but in a problematic way, as Einstein-Podolsky-Rosen suggested an 'incompleteness' in Bohr's conception of quantum mechanics—which led, however, to Bell's Theorem.) As Gödel put it: "As we present time to ourselves, it simply does not agree with fact. To call time subjective is just a euphemism for this failure." (Wang 1996, p. 320) In my view then, *we are doing an intellectual disservice if we deny that time—even after Einstein and Husserl—still represents an enigma.*

not that quasi-spatial time (in his words) "defined by direct measuring with clocks," associated with relativity theory, but rather Husserl's "phenomenology of the consciousness of inner time" (not to be conflated with the data studied by *empirical* psychology). Indeed, Husserl himself remarks that "the time we assume is the immanent time of the flow of consciousness, not the time of the experienced world" (1991, p. 5). To forge a language and a conceptual frame adequate to this 'immanent time' from within a culture biased, one might argue, from its inception toward the 'spatial' (or geometrical)—without, in the process, transforming what is essentially temporal into something 'spatial'—was presumably one of Husserl's tasks. Thus, Gödel's results, here, were no doubt viewed by him not as the last word about time, but rather as the first—and possibly the cleanest and most amenable to demonstration.

We have seen, then, how Kant's words might give rise to the conceptions expressed by Popper, Geach, Craig, and Shimony. Recollection of the 'Second Analogy', however, should already give one pause, since there Kant, in effect, attempts to 'found' inner time-consciousness on outer, causal relations: ". . . we must derive the subjective succession of apprehension from the objective succession of appearances . . . [T]he subjective succession by itself is altogether arbitrary . . ." (A193/B238). More directly to the point, however, is Kant's own response to those words of his alluded to, above. For he immediately adds the following remark: "I can indeed say that my representations *follow one another;* but this is only to say that we are *conscious* of them as in a time-sequence, that is, in conformity with the form of inner sense. Time is *not* therefore, something *in itself,* nor is it *an objective determination* inherent in things" (A38/B55, Note a; emphases mine). For Kant, then, insofar as I make myself an object of thought, my representations to myself of my own representations must themselves be in conformity with the form of inner sense—viz. time. As Gödel himself remarks: ". . . according to Kant the psychic realities in us are for our self-consciousness also a kind of outer world which we know only as an appearance, i.e. incompletely and indirectly through the medium of sensations" (1946/49 A, p. 428). *I am constrained, therefore, to represent my own representations as (if) in time.* To go further, and ask if the latter are 'really', 'in themselves', in time would be to violate Kant's prohibition never to take appearances as things (as they

are) in themselves.[52] To adopt a Kantian idiom, then, one might say (as suggested earlier in this study): the (mere) *appearance* (as) *of a succession* (of anything—including my own representations) should not be confused with a (genuine, or intrinsic) *succession of appearances*.[53]

Gödel's invocation of Kant, then, in support of his own (temporal) idealism, cannot be turned against him. It serves, moreover, as a reminder of the extent to which the philosophical perspective he has put forward represents a genuine challenge to naive common sense. And if his enlisting of the empirical theories of Einstein in defense of the philosophical views of Kant seems inappropriate, it should be remembered that Kant himself, of course, built his own philosophical system on the physical and mathematical foundations of Newton and Euclid. Indeed, if we recall Gödel's distinction between the 'leftward' and the 'rightward' directions in philosophy, then we can cite his cosmological results as yet another example of the Janus-faced quality of his thinking (presaged already in his arithmetization of metamathematics)—*contributing mathematically to the "left"* while simultaneously, as he sees it, *pointing to the "right"*. His results, alone, surely, will serve as adequate testimony to the fruitfulness of his methodology.

52. Wayne Waxman (1991) has recently devoted a book to defending an approach to Kant that seems to be in the same spirit as the one I am suggesting. He, too, questions "the thesis that Kant's transcendental idealism is compatible with the existence of relations of juxtaposition, simultaneity, and succession among the sensory contents (i.e., affections) of the mind" (p. 13). Again, in 1962 he writes: "For Kant, the 'flux' of inner sense exists only in and through the imagination. . . . as givens of sense outside imagination, individual states of consciousness . . . are devoid of temporal relation of any kind . . . " (p. 181). (Compare what Gödel says in our epigraph to Chapter 3, p. 37. See also Appendix A, pp. 209–210.)

53. Izchak Miller [1984], *Husserl: Perception and Temporal Awareness*, p. 108, makes just the reverse point: "A succession of presentations, however, must be distinguished from a presentation of succession." His point is phenomenological while mine is ontological. I disagree, however, with his claim that: ". . . it must be the case that an awareness of succession derives from *simultaneous features* of the structure of that awareness" (p. 109; emphasis added). True, the mere existence of a succession of experiences does not account for my awareness of that succession *as* a succession. But it is *also* true that the obtaining of 'simultaneous features' in the structure of an experience does not, in itself, explain the possibility of awareness of succession. *Structure, after all, is a 'geometrical' concept*, and as we have stressed, *geometry cannot account for succession*—either in the events themselves or in our consciousness of these events.

Chapter 6
Formalization and Representation

> Ultimately formalism in its private aspect is an expression of fear. But fear can lend us wings and armor, and formalism can penetrate where intuition falters, leading her to places where she can again come into her own.
>
> John Myhill

We have seen how Gödel has succeeded in exploiting the mathematical formalism of relativity theory to achieve results contrary to the spirit of Einstein's enterprise, much as earlier, via his Incompleteness Theorem, Gödel was able to exploit the formal account of number theory put forward by Hilbert (via Frege, Dedekind, and Peano) to achieve results contrary to the spirit and the letter of the so-called 'Hilbert Program'.

Concerning Einstein's 'Program', a useful way of viewing the recalcitrance of relativity theory to a reconciliation with the A-theoretic conception of an objective lapse of time is that it results from our desire both to adopt a (limited) perspective from *within* time and also to regard time itself *sub specie aeternitatis*—that is, from a position of timelessness, or eternity, in Plato's sense.

That the same mathematical model of time—namely, the relativistic one—can be put to such different uses by Einstein and Gödel, on the one hand, and Stein and Čapek, on the other, suggests that we are in the presence of that "dialectic of the formal and the intuitive" that, for Wang, as we saw earlier, characterizes so much of Gödel's work. Let us recall that what Gödel achieved with his construction of a model of the Gödel universe from within the framework of the GTR was in effect a translation into a formal problem (which he then proceeded to resolve) of what had

123

hitherto been an intuitive one (concerning the existence of an objective lapse of time in general, and in particular, within a relativistic context). Indeed, Wang (1987) speaks of the "transmutation," in Gödel's hands, of one problem into another, "cleaner," one. In fact, Gödel himself seems to have believed that Einstein had already accomplished this transmutation for the case of intuitive time. Yet, as we have seen, Einstein's translation of the problem into a formal mathematical one still left room for alternative interpretations (of the mathematical equations of the theory of relativity). To be sure, Gödel already considered some of these interpretations to be very much against the spirit of the theory; but to find something more conclusive, he derived (what we have called) a limit case for the relativistic mathematization of time—a formal result that, by his lights, *no longer left any room for such non-Einsteinian interpretations.*

This characterization will help confirm the remarkable resemblance between Gödel's work on relativity theory and his better-known results on the incompleteness of formal systems. The famous Incompleteness Theorem, of course, accomplished the translation of the intuitive question: 'Does there exist, even for the most powerful (consistent) axiom system, formalized along reasonable lines and designed to be adequate for number theory, an undecidable number-theoretic proposition?', into a perfectly precise formal question (which Gödel then proceeded to resolve, positively). Indeed, this translation of intuitive questions into formal ones may have been part of what so troubled Wittgenstein about the great significance attributed to Gödel's Incompleteness Theorem. "It might justly be asked," Wittgenstein remarks, "what importance Gödel's proof has for our work. For a piece of mathematics cannot solve problems of the sort that trouble us" (1978, VII, §22). Whatever the case may be, however, regarding Wittgenstein and the Incompleteness Theorem, it should be clear by now that Gödel's "piece of mathematics" concerning relativity theory can speak to the problems concerning the ideality of time that trouble *us.*

From Formalization to Mechanization

One can, indeed, go back even further and trace the source of (what might be called) 'Gödel's program' to Frege's ideal of

translating our intuitions of logical consequence into a formal-axiomatic system in order "to prevent anything intuitive from penetrating here unnoticed" (1970, p. 5). (However, we must be careful not to go too far and identify the precise modern conception of a formal system with Frege's. See Goldfarb 1979). This replacing of intuition by the formal manipulation of a syntactic system leads, from Frege to Gödel to Turing, to a distinct path in the history of the concept of reasoning—the path *from the formalization of logic to the mechanization of thought*. Indeed, there would appear to be an irony here, or perhaps an instance of what Hegel called 'the cunning of reason', in the fact that although Frege sharply distinguished *genuine mathematical thought* from the mere mechanical manipulation of formal symbols, his goal in the *Begriffsschrift* was precisely to enable us *to dispense with the need to invoke genuine mathematical intuition* in the presentation of a proof. As he puts it in the *Grundlagen*:

> It is possible, of course, to operate with figures mechanically, just as it is possible to speak like a parrot: but that hardly deserves the name of thought. It only becomes possible at all after the mathematical notation has, as a result of genuine thought, been so developed that it does the thinking for us, so to speak. (1980, p. IVe)

But the very success of Frege's program pointed the way to later thinkers, like Turing, to identify mathematical thinking with mechanical computation. And Gödel himself who writes that "[for] formal systems in the proper sense of the term, [the] characteristic property is that reasoning in them, in principle, can be completely replaced by mechanical devices" (1931, p. 195, note 70), has not been untouched by the 'cunning of reason'. Webb (1980), for example, argues that the formal results of (the arch-anti-mechanist) Gödel lend powerful support to mechanism. Unlike Turing, however, Gödel was not tempted to leave intuition completely out of account. (See Wang 1987 and Yourgrau 1989.) We will see later in this chapter that Frege is himself in need of an intuitive element to hold his semantics (insofar as he offered a semantics) together, and that this intuitive element has a special relevance to time. Here, however, we can note a further point of agreement between Gödel and Frege in their interpretation of the axioms of a formal system. Whereas Hilbert and the

Formal School view such axioms as implicit definitions that hold by mere stipulation within the system, and that apply to any system of elements that satisfy them, Gödel, with Frege, rejects this approach (Wang 1987, p. 247) and regards axioms as having a real, extrasystemic content, which, if the axioms are true, correctly describes a genuine (extrasystemic) reality. (This is one aspect of their shared Platonism. For more on their affinities, see Yourgrau 1989.)

In sum, the dialectic of the formal and the intuitive leads, in Gödel's work, not to the replacement of the intuitive by the formal, but rather to a translation of an intuitive problem into a formal one that, in Myhill's words, "lends us wings and armor," so that we may "penetrate where intuition [unaided] falters." The results of such an enterprise, however, have only as much plausibility and significance as does the original translation. The question of *the formalization of our intuitions of time,* however, presents especially acute problems in regard to the issue of representation, since *the very language of the formal*—namely, *mathematics* and *logic*—has in effect been *designed expressly for the tenseless.* Perhaps, then, it can help us make some progress with the problem of the geometrization of time in physics if we broaden our horizons to consider the issue of the adequacy of the representation of time in logic and semantics. Specifically, we look at an attempt to model, in current tense logic, that concomitant of A-theoretic time that regards the past as closed but the future as (now) open. After this, we come to the semantics of the crucial A-theoretic term 'now' (which, we have seen, Gödel employs forcefully in his characterization of intuitive time) and discuss its resistance to accommodation within the classical semantic framework of Frege.

Modeling the Open Future: Aristotle and Modern Logic

Aristotle, who, as we have seen, adopts an A-theoretic view of the moving now of temporal becoming, derives, in *De Interpretatione*, IX, a formal result that seems to contradict a concomitant of this conception of time. Having adopted, as a basic principle of logic, the 'excluded middle', $pv{\sim}p$, and as a principle, in effect, of tense logic, the 'necessity of the past'—namely, that

what is now past is unalterable and thus (now) 'necessary'—he considers propositions in the past that speak of the (then) future. But of two such opposed predictions of the future, one (by excluded middle) must obtain, hence (by necessity of the past) be *necessary*. Hence, paradoxically, the future (including any aspect that we would normally take to be contingent and thus open to chance or deliberation) turns out to be as necessary as the past. Indeed, as he says, "there is nothing to prevent someone's having said ten thousand years beforehand that this would be the case, and another's having denied it; so that whichever of the two was true to say then, will be the case of necessity" (1979, 18b 26). Unlike Gödel, however, Aristotle takes the philosophical implications of his formal result to be a kind of reductio, and so, applying *modus tollens,* he proceeds to re-examine the formal result itself so that the future can be seen to be, indeed, open.

Now the exact outcome of Aristotle's reappraisal has been the source of much dispute. It is not necessary, however, I believe, to enter into this controversy in great detail in order to propose the following theses, which seem clear enough from Aristotle's own words. They will help us take our bearings in the discussion that follows concerning recent attempts to model Aristotle's approach to the open future in the logic of branching time.

0. What is (true, or the case), now that it is, is (now) necessary. ("What is, necessarily is, when it is; and what is not, necessarily is not, when it is not" [19a 23].)

1. What is now *true* about the future is (now) *necessary.* ("For what anyone has truly said *would* be the case *cannot not* happen" [19a 7; my emphases].)

2. *Excluded middle* holds, necessarily, for all propositions. ("Everything necessarily is or is not, and will be or will not be; but one cannot divide and say that one or the other is necessary" [19a, 23].)
 That is:

 a. Nec $(p \vee \sim p)$,

 and

 b. Nec $(Fp \vee \sim Fp)$,

but not

c. Nec (Fp) v Nec (~F*p*).

(Read 'F*p*' as '*p* will obtain'.)

3. *Bivalence* does *not* hold for *all* (especially future-tensed) propositions. ("Clearly, therefore, not everything is or happens of necessity: some things happen as chance has it, and of the affirmation *and* the negation, *neither* is *true* rather than the other" [19a 7; my emphases].)

4. There is a *tense-logical modification* required of the 'correspondence theory of truth', namely (a) that truth comes from correspondence with the *actual* (present) facts and (b) that (the contingent part of) the future is not now a fact. ("[S]tatements are true according to how the *actual* things are" [19a 23; my emphasis]; "[I]t is not necessary that of every affirmation and opposite negation one should be true and the other false. For *what holds of things that are does not hold for things that are not* but may possibly be or not be" [19a 39; my emphasis].)

 a. It follows that we must *reject* the principle that: if, in the course of time, *p* obtains, then it *was already true* earlier to say that *p* *would* obtain.

These logical and tense-logical principles, 0 to 4, reflect the Aristotelian picture, or analogy, of time we encountered earlier, as generated by the 'moving point' of the now, a picture in which the past is always *fixed* and *determinate* but *growing*, whereas the future remains always (partially) *indeterminate* (until it arrives). Recently, an attempt has been made to provide a formal account of time along these lines, in terms of asymmetric branching models. The seminal contribution here, I believe, is Richmond Thomason's "Indeterminist Time and Truth-Value Gaps' (1970), with important papers along similar lines by John Burgess (1978), Richard Jeffrey (1980), and Michael J. White (1980). It is instructive to take a somewhat close look at the details of Thomason's formal approach. Although this book is not intended as a contribution to technical issues in the formal study of time,

some important lessons can be learned by taking a look at the fine structure of one particularly elegant and suggestive formalization. (*N.B.* The reader who wishes to remain innocent of these formal details can simply skim the next few pages and pick up the philosophical thread from the section-heading 'Aristotle Undefeated'.)

What is the basis of Thomason's approach? We are to consider a model containing a set K, of times, ordered by a relation, $<$. This relation is *not* to be *linear.* So we will not have, for all times α, β, where $\alpha \neq \beta$, $\alpha < \beta$, or $\beta < \alpha$. Rather, $<$ will define a treelike structure, with the following conditions: (1) for all α, β, $\gamma \in K$, if $\beta < \alpha$ and $\gamma < \alpha$, then, where $\beta \neq \gamma$, $\beta < \gamma$ or $\gamma < \beta$; and (2) for all α, β, $\gamma \in K$, if $\alpha < \beta$ and $\beta < \gamma$, then $\alpha < \gamma$ (transitivity). The intended model, then, will have an asymmetric branchlike structure like that of Figure 3.

Notice that although, for any time α, there will be alternative possible futures, there will always be a unique path back through the past. There are many possible futures but only one past. For any time α, we define a *branch*, or *history*, through α as a subset h of K such that (1) for all α, $\beta \in h$, if $\alpha \neq \beta$, then $\alpha < \beta$ or $\beta < \alpha$; and (2) *if g* is any subset of K such that for all α, $\beta \in$ g if $\alpha \neq \beta$, then $\alpha < \beta$ or $\beta < \alpha$, then $g = h$ if $h \in$ g. (Thus a branch will be a maximal linear subset of K.) We let H_α be the set of branches through α. In addition to K and $<$, a model will contain a function V, a valuation that assigns the truth values T or F to formulas. What is distinctive about such a valuation in tense logic is that it assigns a truth value to a formula only *relative to* a 'point of reference'. What is distinctive, in turn, about *Thomason's* tense logic is that two sorts of points of reference are employed, and there are, correspondingly, two sorts of valuations. The valuation V_α

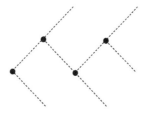

FIGURE 4

assigns a truth value to a formula relative to a time α, and V_α^h assigns a value relative to a history h through α. A formula that contains no tense operators is assigned either T or F by each valuation V_α. These valuations are thus *bivalent* over such tense-free formulas.

For the valuations V_α^h, however, the conditions are as follows:

1. a. $V_\alpha^h (A) = V_\alpha (A)$ if A contains no tense operators.

 b. $V_\alpha^h (FA) = T$ if $V_\beta^h (A) = T$ for some $\beta \in h$ such that $\alpha < \beta$.

 c. $V_\alpha^h (FA) = F$ otherwise.

 d. $V_\alpha^h (PA) = T$ if $V_\beta^h (A) = T$ for some $\beta \in h$ such that $\beta < \alpha$. (Read "(PA)" as "A did obtain.")

 e. $V_\alpha^h (PA) = F$ otherwise.

These valuations V_α^h, bivalent over *all* formulas, seem altogether plausible. Relative to a branch h/α, 'p will occur', or 'Fp', should be true just in case 'p' is true at some time β such that $\alpha < \beta$. But what of the truth value of a formula 'FA' relative simply to a time α? Here we are not given a *particular future* for α; remember, too, that the picture is of a tree where α has alternative possible futures.

It is at this point that the indeterminist makes his move. The valuations V_α are designed to resemble Bas Van Fraassen's 'supervaluations':

2. a. $V_\alpha (FA) = T$ iff, for all $h \in H_\alpha$, there is a $\beta \in h$ such that $\alpha < \beta$ and $V_\beta^h (A) = T$.

 b. $V_\alpha (FA) = F$ iff, for all $h \in H_\alpha$, there is no $\beta \in h$ such that $\alpha < \beta$ and $V_\beta^h (A) = T$.

 c. $V_\alpha (FA)$ is undefined otherwise.

The valuations V_α are thus *not bivalent* over all formulas. In particular, some future-tense propositions, *relative* only to a *time* α, will be truth-value-indeterminate. Nevertheless, as Thomason points out, the class of valid formulas on valuations V_α coincides with that for valuations V_α^h. (A formula A is *valid* just in case, for

all model structures M, for all points of reference α (or h/α) V_α (A) = T for all valuations V on M.) Of special interest to the indeterminist are formulas containing the necessity, or inevitability, operator, 'L'. The truth conditions for formulas containing this operator are as follows:

3. a. V^h_α (LA) = T iff V^g_α (A) = T for all $g \in H_\alpha$.

 b. V^h_α (LA) = F otherwise.

('L' will be a modal operator satisfying the conditions of S5.) With this characterization of necessity, we are now in a position to evaluate the indeterminist results that Thomason derives from his logic of nonlinear time, a logic that, he says, "puts these alternatives [the possible futures] into the ontological structure of time" and succeeds "in developing a rigorous form of the traditionally popular view that 'future contingent' statements can be neither true nor false" (1970, p. 265).

The results Thomason would like to derive are those that A.N. Prior (1967) has called "Ockhamist." The past and the present are now necessary, for it is too late to alter what is already the case. But this applies only to past and present facts that have no trace of the future in them. This is reflected in the following validity in Thomason's system: ‖ p ⊃ Lp. Given that p contains no tense operators, it is easy to see that, for any V^h_α, if V^h_α (p) = T, then trivially, for any $g \in H_\alpha$, V^g_α (p) = T. (Recall from 1a that V^h_α (A) = V_α (A) when A contains no tense operators.) This is as it should be. From the point of reference of time α, if p is true at α, then it is too late to alter this truth value—too late from the viewpoint of α or from any branch through α.

But what about Fp ⊃ LFp? A glance at (3) reveals that this will not be valid. Even if, from the perspective of some V^h_α, V^h_α (Fp) = T, it doesn't follow that this future is necessary—for it may well be that, for some g ∈ H_α, V^g_α (p) = F. Further, PFp ⊃ PLFp will not be valid either. For suppose that V^h_α (PFp) = T. Then, for some $\gamma \in h$, where $\gamma < \alpha$, p is in the future. But it may well be that, for some alternative branch g through γ, p will not be in the future. Thus, V^h_α (PLFp) = F. This fact, that it is not the case that PFp ⊃ PLFp, together with the fact that ‖ p ⊃ Lp, appears to vindicate Thomason's claim to have produced an Ockhamist

resolution of Aristotle's concerns about tense-logical determinism—that is, fatalism. The result is the more convincing in that the model structure on which Thomason bases his logic is not simply ad hoc, but rather represents a plausible construction of time. Appearances notwithstanding, however, I will argue that although Thomason has indeed produced an elegant formal reconstruction of a large part of the content of Aristotle's A-theoretic intuitions about the open future, there remain some serious questions about what the formal model has *not* succeeded in capturing.

Future Truth Without Future Necessity

A key question is whether Thomason succeeds in achieving *truth* about the future without admitting *necessity*. Note, first, that his results in fact contradict Aristotle's, if our earlier characterization of Aristotle is correct. Recall Aristotelian principle 1: What is now *true* about the future is (now) *necessary*. Has Thomason found a way out? I don't think so. The source of my concern is his condition 3, stated earlier. What he has in effect done there is to use the index of V_{α}^{h}, that is, a *branch*, in defining *truth* about the future, but then to ignore this very index in the relevant clause for *necessity* in regard to V_{α}^{h}. For he states that $V_{\alpha}^{h}(LA) = T$ not, as we would have expected, when A is unavoidably true *from the perspective of the relevant index,* namely, h/α, but rather, in effect, from the point of view *of time α alone.* For we are told that V_{α}^{h} (LA) = T just in case V_{α}^{g} (A) = T for all $g \in H_{\alpha}$. Thus, the very branch h/α that forms the index of our valuation, V_{α}^{h}, is ignored, and we are, in effect, reduced to considering the necessity of A from the point of view *merely of time α!*

But have we not slighted Thomason here? Might not someone defend clause 3 and insist that, in acknowledging that h is the way things *will* go, we do not *ipso facto* acknowledge that things *must* go that way. Indeed, Michael J. White has emphasized to me that (a) "so long as there are *multiple* branches 'to the right' of a time α, it is *possible* to distinguish, in terms of the model, between what will (actually, as a matter of fact) take place in the future relative to α and what must take place in α's future," and (b) "[t]he terms 'fixed', 'definite', 'determined', 'already a fact' certainly *may* be interpreted as having a modal force, in other words as connoting some form of necessity; but they *may* also be interpreted as connoting simply ('assertoric'—not 'apodictic') *actual-*

ity. Thomason's models (as standardly interpreted) allow us to draw the distinction with respect to the future but not the past."

With regard to (a), however, we must ask what the relevance is of the multiple branches to the right of (time) α. These represent possible future histories of the world (or, if you will, possible worlds) that, *by hypothesis, will not become actual* (recall that we are considering now whether *truth* about the future entails necessity). Now a true proposition about the future, F*p*, is not now necessary just in case ~F*p* is now still possible. The crucial question, then, is whether the fact that there are alternative future histories from time α, including ~*p*, shows that ~F*p* is still, at α, possible. It all turns, of course, on the relevant sense of 'possible' here. But since Thomason's goal is, in effect, to formalize *Aristotle's* intuitions, we must look to *his* use of this modal term. Clearly, as we have seen, the modalities of necessity and possibility, as Aristotle is here employing them, are *relative* to an index—whether to a time or to a branch/history—and concern what is *unavoidable* or *unalterable, not subject to chance, or yielding to deliberation* from the perspective of the relevant index. He writes, for example that *if* "everything is and happens of necessity . . . there would be no need to deliberate or to take trouble (thinking that if we do this, this will happen, but if we do not, it will not)" (1979, 18b 26). What is now possible, then, in Aristotle's sense, is what can still yield to my deliberation, to my choice of action. But, by hypothesis, F*p* is true, and thus ~F*p* is *not* subject (now) to my control or deliberation; it is *not* now possible.

Recall, again, our background for Aristotelian principle 1: "For what anyone has *truly* said *would* be the case *cannot not* happen." The fact that ~F*p* is not now possible in this *Aristotelian* sense is clearly unaffected by the fact that there remain branches/histories, or possible worlds, which by hypothesis *will not* obtain, in which ~F*p* would be true. In a word, the future is not open (to my deliberation and control) if it is already *true*, or *a fact, what will happen*, tomorrow, just because there are possible histories, or possible worlds, in which the future *would* be different. These histories/branches or worlds are possible *not* in the sense that they are (now) subject to my deliberation and control, but *only* in the sense that though they are not actual, they might have been. Two senses of 'possible', then, are being run together here. The fact that the Thomason model 'branches out' with these possible histories only toward the future suggests here a false picture—an artefact of the formalism—concerning the

multiple possibilities that seem to remain in the open future, even on the assumption that it is already a fact, a truth, what will happen in the future.

Future Possibilities versus Past Facts

With this line of reasoning, then, we are brought back to White's remark (b). The problem here is quite subtle. The force behind this remark is that Thomason's asymmetrically branching model shows that there are always many (possible) futures but always only one past, so that one cannot, on the basis of the model, *distinguish* past truth from past necessity. But the situation is otherwise with regard to the future. Here it is important to recall that we are considering the question of whether *truth* about the future entails necessity. So, *ex hypothesi,* we are now assuming that the future is as much a fact as the past. (Recall our discussion of the symmetry, with respect to facticity, of past and future times in a model of closed, circular, time—a model, we argued, incompatible with the A-series.) There are then, as we saw in our discussion of remark (a), *no more* alternative possible *futures,* in the *relevant* sense of 'possible', than there are alternative possible *pasts.* In a word, the assumption of the (present) facticity of the future has the effect of collapsing all the future-directed branches into the *one* true history of the world—a *linear* history. Further, one can now ask: Given the *appropriate* sense in which these alternative branches represent possible but not actual future histories of the world, do there not also exist alternative possible but not actual past histories? Could I be myself if I had had a different past?

The Thomason model suggests that there are no such alternative possible pasts in this restricted sense of 'possible'; but I think there is no *basis* for this feature of the formal model once it is given this reading. Insofar, then, as the branches were to represent the possibilities in *Aristotle's* sense of the open future, the asymmetric, treelike structure of the model had a sound intuitive basis. For although it seems intuitive that various possible futures are now subject to my deliberation, the past is now closed and forever beyond my control. But once we assume the symmetrical facticity of past and future, the only *remaining* sense for such possible branches/histories is, as we saw, as possibilities in a different sense—mere ways-the-world-could-be-but-in-fact-won't-be. But

then we *no longer* have any *intuitive* basis for the claim that in *this* sense there are many possible futures but only one possible past. We will have to bring to bear *other* considerations to settle this issue—considerations irrelevant to modeling the open future. For example, one suggestion along these lines is Kripke's thesis (1980) concerning the necessity of origin, for example, that something could not be this very desk if it had had a different historical origin—say, if it had been made from a different tree. But apart from such considerations, there is nothing in the Thomason model, given the new, restricted interpretation of the branches imposed by the hypothesis about facts concerning the future, to help settle the question about the possibility, in this sense, of alternative pasts.

Aristotle Undefeated

Aristotle's principle 1—that the (present) truth of the future brings with it necessity, in the relevant sense—has not, then, really been philosophically defeated, by Thomason's formal model. Rather, in this regard, the branches appear only as artifacts of the formal model that can deceive us. Indeed, Aristotle's original intuition seems clear enough. If the past is now necessary because it is, all of it, a big, unalterable fact to which present truths about the past correspond, then if there are truths about (all of) the future, then the future, too, is a big, unalterable fact, and so it, too, is, in this sense, necessary. I detect here no sign of the modal fallacy that some have attributed to Aristotle.

Aristotle, however, as we have seen, in fact rejects the assumption that there are now truths concerning all of the future. Does Thomason succeed in modeling this open aspect of the future? Note, first of all, that Thomason's formal system contains, as points of reference, both individual times and branches, where the latter are, in effect, total (linear) world histories, and that, although truth-value gaps appear from the limited perspective of points in time, nothing *in* the model *prevents* the recognition of one *branch* as privileged, as representing 'the' truth about all of the past, present, and future. Given Aristotle's principle 1, however, which we have just defended, the existence of such a privileged branch would, of course, rule out an open future. It is true that Thomason does not in fact go so far as to recognize a privi-

leged branch. (His system is designed, rather, to map the subtle interplay that arises between the different perspectives of points and branches.) But the fact that the existence of such a branch is not ruled out in the formal model indicates that he has not gone far enough in formalizing Aristotle's intuition of the open future. The situation here is, I would suggest, analogous to certain attempts to resolve the liar paradox through recourse to formal systems. For, just as one must be able to block the possibility of constructing, within the system, a 'superliar' paradox—as in 'This sentence is either false, or neither true nor false'—one must be able to block the possibility of construing one branch, from within Thomason's formal framework, as 'the' total course of history (thus reintroducing temporal determinism and the closed future).

A further problem is that nothing in Thomason's formal model shows that only what is in the present really exists, although this is a crucial feature of A-theoretic, Aristotelian time (and one that, we saw, Gödel also stressed). As far as the model goes, each individual time constitutes its own point of reference, which leaves its future open (from *its* perspective). But such relational facts constitute, so far, at most, a *relative* A-series. Thus, the failure of bivalence for valuations at a time, though necessary to reflect the Aristotelian picture, does not go far enough. For there to be an open future, it is not enough that if we choose to restrict our perspective to that of an individual time, the future will thereby not be reflected; rather, it is necessary that we *not be able to widen* our perspective to include (all the) facts about the future. And this negative result, we have seen, Thomason, with the availability from within his system of the (total) branches as points of reference, has not been able to establish.

Indeed, one can remark of the branching model, as we did of Stein 1968, that if the world were entirely static—reflecting no A-theoretic temporal becoming at all—it could still satisfy the formal requirements of Thomason's structure. In fact, White (1989) admits that "if such a model is to come at all close to capturing Aristotle's idea of the 'developmental' character of time, we must envision the model as being viewed from a (dense and continuous) succession of nows along one linear (but not predetermined) branch of the model" (p. 223). This seems to me correct, but what it shows, surely, is that the formal model itself represents at

best a *spacelike trace* of time. But is it not asking too much of a formal model to do more than provide such a spacelike trace? Perhaps, but then one has to acknowledge that representation here must go beyond formalization and to acknowledge the ineliminable role, in this context, of *analogy* or, perhaps, *intuition*. (Indeed, as we will see later, Brouwer insists that even in the case of pure mathematics, formal logic—even if modified along intuitionistic lines—is inadequate to represent genuine mathematical intuition or activity.) One might begin to wonder, then, whether the formal-mathematical method, as such, is not sufficiently out of place here to be doing a disservice to those very intuitions about time that it was intended to capture. Arthur Eddington, for example, writes, along these lines, that "[w]e have direct insight into 'becoming' which sweeps aside all symbolic knowledge as on an inferior plane" (1958, p. 97). We have already seen, however, that Einstein seems to reject such qualifications on the ability of mathematical formalism to represent time, or space-time. For now, however, we should remind ourselves that even as a formal model of time, Thomason's branching system—for all its undeniable virtues—suffers from the drawbacks to which we have been drawing attention.

Truth and Correspondence

The most serious limitation, however, in the model of branching time we have before us is its failure to account for Aristotelian principle 4—that there is a tense-logical modification required of the correspondence theory of truth—although this is, arguably, the central issue concerning a correct model of the open future. Nothing in Thomason's model, however, shows why we should *accept* Principle 4, although the principle itself is nicely reflected within the system. Specifically, although $V_\beta\,(p \supset \mathrm{PF}p) = \mathrm{T}$ for all β, it is still the case that if (contingent) p obtains at β, it remains that, for $\alpha < \beta$, $V_\alpha\,(\mathrm{F}p)$ is undefined. (This is well brought out by White [1985, pp. 192–202], who dubs the former "Cicero's principle.") The question, however, is how the formal model can account for this fact. For it follows from it that someone who predicted *correctly* (as it turns out), yesterday, that it will rain today did not, for all that, *speak truly then*. Thus, even if what I say *will* happen, *does* indeed come to happen, what I said was not *true!*

This is a glaring exception to the classical correspondence theory of truth, introduced, of course, by Aristotle, himself. But no basis for it occurs in the formal branching model of time, and so one could well object that in this regard the model merely represents a partial reflection of the complete truth about time, leaving it open that in a more comprehensive, philosophically perspicuous, systematization this as yet unexplained exception to the classical theory of truth will disappear.

What Thomason has done is to provide an elegant model of Aristotle's Principle 4a, that truth comes from correspondence with the *actual* (or *present)* facts, and of Principle 4b, that (the contingent part of) the future *is not now a fact.* (Or, at least, he has reflected these principles *from,* or *relative to,* the perspectives of the relevant indices.) Principle 4b, I believe, underlies 4a. For an A-theoretic proponent, like Aristotle, of the open future, reality literally (as Jeffrey puts it) "grows by accretion of facts." Thus, at the present moment, that is, now, the future is simply *not there to correspond to.* By the very nature of things, then, a future contingent proposition will, for Aristotle, always be put forward at a time that cannot 'contain' all the reality required for it to correspond to, to be true. A true statement, then, for Aristotle, states how things *are,* where 'are' here has essentially the *present* tense. (What, then, of the past? Aristotle seems to have in mind that the past is [now] fully determinate and that there exist, in the present, facts about the past. These facts will have to speak to properties possessed by some objects that no longer exist—for example, the dead. We will come, in the final chapter, to the question of how there can be, in the present, reference to, and truths about, nonexistent objects like the dead.) The (contingent) future, then, can never confirm the past. If it rains today, it *now* becomes true to say that yesterday's prediction became true. But it remains that yesterday, before today arrived (with its rain), the prediction, lacking any actual, existent, factual correlate, was without a truth value.

How plausible, however, is this principle of Aristotle's, which lies at the heart of his conception of the open future? We will, unfortunately, find nothing to help us decide this by contemplating the formal model of branching time, for the crucial question is whether the future existence of a fact entails the (present) truth of a proposition that predicts the existence of this fact. But how

does one decide an issue such as this? White (1985, pp. 195–97), who calls the truth condition according to which, what I *now* say will obtain, is *true now,* if it comes to obtain *in the future,* the "truth-value link" condition (following Dummett 1969), argues that this truth-value link condition itself presupposes the B-theoretic conception of time (and thus, in effect, begs the question against Aristotle). I cannot agree with this assessment, however. To my mind, the truth-value link condition is based on purely *semantic* (Aristotelian!) intuitions about truth and correspondence. Since what I say (here) about New York is made true by what obtains in New York, what I say about the past is true (now) depending on how things are in the past, what I say about other possible worlds depends for its (actual) truth upon how things are in those worlds, and so on, symmetry surely suggests that what I say about the future is made true (now) by what the facts are *in the future* (entirely aside from the question of whether a fact that will obtain in the future is somehow contained in or reflected in a present 'metafact' about the future).

The Very Existence of the Future Tense

In itself the question at hand is probably unresolvable. It forces us to adopt as exclusive either a perspective from within or one from outside time, although each perspective individually is natural and unavoidable. Thus, we seem to be in the presence here of a genuine antinomy. One can see, then, why Gödel was so suspicious of the notion of tensed existence and why he chose, on this point, to adopt the Kantian resolution of such antinomies—namely, idealism. For to reject the correspondence theory of truth just here is difficult indeed. If we can think of and *refer to* the future (which Aristotle can hardly deny), then how can we fail to think *truly* when what we say will be *will be?* Why should truth be confined to what exists *now* if the statement in question refers precisely to what will exist *in the future?* We do, after all, have the future tense, and this device seems to be able to lift us, *in thought,* out of our *existential* confinement to the present. ('Antactualists' appear to deny this. For discussion of the formalization of antactualism, and a comparison with intuitionism, see Yourgrau 1985c, pp. 556–57.) On the other hand, however, on the A-theoretic view, time is always an incomplete totality, and, as we will see in

Chapter 6, there are other domains, such as the foundations of set theory, where incomplete totalities have also been invoked, and where a modification has also been suggested for the correspondence theory of truth (see Parsons 1983, p.289). Further, if the A-theoretic picture of reality growing over time is coherent, then it is plausible to maintain that there really is no fact now, in the present, corresponding to a future contingent state of affairs, and so there is nothing in reality (as it has progressed so far) for a future-tensed proposition to correspond to. Thus, the tension between these two points of view seems to offer no hope of resolution.

Now, the question arises as to what value resides, from an ontological point of view, in purely formal models. In the dialectic of the formal and the intuitive, the formal must always be read against the background of the intuitive, rather than the reverse. Thus, even as regards the most rigorous formalism, that of metamathematics, we must always bear in mind, as Myhill (1951) says, that "metamathematics must be in the final analysis informal; for the process of discussing formalisms by means of another formalism must either terminate in a formalism which is not discussed, or be informal" (p. 42). Of particular interest to us here is the difficulty of capturing the concept of an ontologically significant privileged position, whether in time (the now) and modality (the actual world) or in semantics (the true), from within the confines of a formal model. Let us look at some examples of those features of reality that are thus 'formally diaphanous'.

What a Formalism Cannot See

Consider, first, truth tables, especially n-valued tables, for arbitrary n. We take as an example S.C. Kleene's so-called strong table (Figure 5) for the propositional connective, 'v' ('or') (1962, p. 334). (The modern three-valued logic of Łukasiewicz originated in his attempt to formalize Aristotle's way out of the problem of temporal determinism.) Here t and f represent the designated—in our terms, *privileged*—values truth and falsity. From within the model, however, this can only be reflected by labeling these values the designated ones. From a formal point of view, however, this label is a mere mark without substance; all the values, considered as mere formal objects within the model, are on the same level.

		Q	v	R
R		t	f	U
Q	t	t	t	t
	f	t	f	U
	U	t	U	U

FIGURE 5

Indeed, this problem arises already for classical, two-valued truth tables, which are, after all, a natural reflection of Frege's initial move in taking truth and falsehood to be sentential referents—hence, to be (formal) objects. As Dummett has written, however, "it is part of the concept of truth that we aim at making true statements; and Frege's theory of truth and falsity as the references of sentences leaves this feature of the concept of truth quite out of account" (1967, pp. 50–51; see also Yourgrau 1987a).

Indeed, the problem runs even deeper than this, for once one formalizes semantic notions one can always proceed to treat the semantic values as themselves mere formal, syntactic objects; and thus the crucial distinction between syntax and semantics threatens to disappear. As Alonzo Church puts it,

Semantics begins when we decide the meaning of the well-formed formulas by fixing a particular interpretation of the system. The

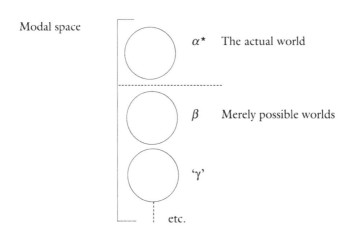

FIGURE 6

distinction between semantics and syntax is found in the different significance given to one particular interpretation and to its assignment of denotations and values to the well-formed formulas; but *within the domain of formal logic,* including pure syntax and pure semantics, *nothing can be said* about this different significance *except to postulate it as different.* (1956, pp. 65–66, fn. 143; my emphases)

A similar problem in regard to designated or privileged values within a formal model arises for the popular 'possible worlds' models for modal logic. Here the actual world is considered as merely one among other, merely possible, worlds in 'modal space', although, to be sure, the actual, or real, world is singled out by being labeled 'real'. Thus Saul Kripke says: "Intuitively, we look at matters thus: K is the set of all 'possible worlds'; G is the 'real world'" (1963, p. 64). We can model modal space, then, as in Figure 6. Once again, however, it appears that what constitutes one world as privileged—here, actual, or real—cannot be expressed from within the formal model (except that, in Church's words, "we postulate it as different"). Worse, as we observed earlier, one also cannot express the metafact that although our world, the actual world, α, happens to be actual, it need not have been so (Leibniz and modal theology to the side).

It is thus doubly misleading for Robert Stalnaker (1976) to suggest that "the actual world" has the same force as "Reality." In the first place, although Reality must obviously contain *all* the facts, including the fact that α is actual, α itself obviously cannot express this fact, for each possible world can only express, as it were, *intrasystemic* facts about the way things are if it obtains or is actual, whereas what is needed here is the *intersystemic* fact that among all the possible worlds, α alone does obtain—that is, a fact *about* world α, as a whole, and so not *internal* to it. (Wittgenstein calls this intersystemic fact "mystical": "It is not *how* things are in the world that is mystical, but *that* it exists" [1974, 6.44].) In addition, however, as we have just seen, α also cannot express—and, indeed, neither can the entire model in Figure 5, of modal space—the metafact that α might not have been actual. And a symmetrical treatment of such metafacts leads immediately to an infinite regress: world α obtains in superworld S, let's say, but fails to obtain in superworld T. But then superworld S itself obtains,

but might not have. So, *S* obtains in supersuperworld *W*, but not in *X*, and so on.

A further question arises, moreover, concerning how seriously to take the ontological symmetry among the possible worlds suggested by the model. Are all the possible worlds genuinely *worlds* like ours? On the one side, David Lewis (1973) insists on the genuineness of this symmetry to the extent that he considers the actual world itself *not* to be privileged, absolutely speaking, in relation to the other, merely possible, worlds. 'Actual', he suggests, is an indexical, like 'here', so that *each* world is actual *relative* to itself. In effect, then, Lewis's modal series of worlds is akin to the *relative* A-series of times. Actuality and 'nowness' (or being the present), on this conception, turn out both to be merely relative characterizations of worlds and times (see Yourgrau 1986).

On the other side, Stalnaker (1976) argues for a kind of *modal chauvinism,* insisting not only that ours is, absolutely speaking, *the* (only) actual world, but that the other so-called possible worlds are not really *worlds* at all, like ours, but rather complex concepts or properties. Can one steer a course between the Scylla of Lewis and the Charybdis of Stalnaker? The formal model itself is, once again, silent. Indeed, even Kripke, whose name is perhaps most closely associated with the possible-worlds model of modal logic, has had little to say on this question. Besides dismissing (1980) Lewis's modal realism, he has done little more (in print) than to warn us not to take his formal-mathematical models of possible worlds too literally. But just how literally should we take them? What we need here, I would suggest, is a distinction between *being* and *existence* (and its correlate for time, *being present,* and for modality, *being actual).* We will develop this theme in Chapter 7, but for now, we note that one can recognize the opposition between actual and possible *worlds,* between actual and possible (including past and future) *people,* and, finally, between present and future (or past) *times,* not as one between different *kinds* of objects, or *beings,* but rather as one concerning the *existential status* of such beings (existent vs. nonexistent, actual vs. possible, present vs. past or future) (see Yourgrau 1987b). This way, one can admit an ontological symmetry in each case concerning category of being, but also adopt, if one chooses,

an attitude of chauvinism that recognizes only one member of each opposed pair as privileged (in existential status).

The Ontology behind Space-Time Diagrams

Let us conclude, then, this discussion of privileged position in formal models with two attempts to model time. Consider, first, the model of a world line in relativistic space-time given by a Minkowski space-time diagram (Figure 7). The dotted lines represent the paths of light rays, which thus mark out the light cones (for the diagram represents a four-dimensional space, although we have, for simplicity, collapsed the three spatial dimensions into one), within which are the permissible paths of particles. The origin of the two axes represents the time *now*, but this designation is only *relative* to the frame provided by this particular diagram. Most important is the fact that the *history through time* of a particle is represented in the model as a *world line*. By the method of Cartesian coordinates, this world line, in turn, can be represented as a set of ordered quadruples of real numbers, and this, in turn, employing the Frege-Russell definition of numbers and the Wiener-Kuratowski definition of ordered sets, can be reduced to a large, complex, unordered set of sets. The formal model, that is, represents the *history in time* of a moving particle in a *completely tenseless* way. For Minkowski did not intend us to interpret a world line in a Minkowski diagram as a path a particle *moves along*. Rather, he was suggesting a *definition* of motion in terms

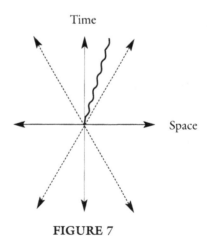

Time

Space

FIGURE 7

of a *geometrical* figure—as a world *line* in a four-dimensional geo-metric space. (For a comparison of the problem of 'privileged position'—that is, of the 'now'—in the context of Einstein-Minkowski space-time with the analogous problem in the meta-physics of modal logic [that is, of being the actual world] via the introduction of a combined, five-dimensional 'modal-Minkowski space-time diagram', see Yourgrau 1986.)

The approach Minkowski is offering by representing motion in time by a space-time diagram is in the spirit of one put forward by Bertrand Russell: "People used to think that when a thing . . . moves, it is in a state of motion. This is now known to be a mistake. When a body moves, all that can be said is that it is in one place at one time and in another at another" (1956, p. 1582). (It's clear that "is," here, is meant to be tenseless.) In a Minkowski diagram, then, with a world line interpreted as a defin-ition of motion, as in the passage just given by Russell, we have an extreme example of the geometrical mode of representation. All that is left within the formal model is a spacelike trace of time. If for Plato, as we have seen, time is but a moving image of eternity, could one not say that a world line in a Minkowski space-time diagram represents a mere frozen image of time? Indeed, not only is the flux of temporal becoming, as well as the lack of privileged status for any chosen now, not represented in the Minkowski model, but, as we saw in a previous discussion, it is far from clear whether it is even possible to supplement these features of A-theoretic time, with the aid of intuition or imagination, given certain formal characteristics of the STR, such as the relativity of simultaneity.

The Ontology behind the 'Trees' of Branching Time

In this regard, it seems, the branching model of time in Thomason's tense logic fares better. For although it has problems similar to those of the other formal models we have considered, in regard to the difficulty of doing justice, within the model, to cer-tain privileged moments or positions, it remains that (1) the branching, treelike structure captures an important component of the A-theoretic open future and (2) if we bracket the question of relativity theory, it seems as if we can, as White suggested, if we so choose, read into the model a dynamic conception of temporal

becoming. A more accurate version of the model would then be that shown in Figure 8. Here the solid line represents the *nunc fluens*, and where its moving edge rests represents the extent that time has advanced so far. We note, then, that (a) a new diagram must be drawn to represent this feature of time, 'every moment'—or else a moving diagram set up (in which case the standard, set-theoretic formulation of tense logic would need analogical supplementation); (b) the progress of time would still be represented *linearly* by the gradual, stepwise generation of a partial *line*—always (= at all times) unfolding, always incomplete; (c) the model itself still cannot be appealed to for help in deciding on the crucial questions about the open future, to wit: (1) Does truth about the future entail (temporal) determinism (= fatalism)? (2) Is a future-tense proposition now true if it corresponds to a fact in the future? and (3) Can it be ruled out that one (complete) branch is privileged and thus (already) represents the total course of history?

It should be clear, then, that in attempting to illuminate and rigorize our intuitive conceptions of privileged position, including and, perhaps, especially for the case of time, the employment of formal models cannot always be counted on to lend us, in Myhill's words, "wings and armor." It is of special note, then, that Gödel's construction of such models *stands apart as being of unusual philosophical significance*. For example, in regard to Church's remarks about the difficulty of maintaining, within a formalism, the significance of the distinction between syntax and semantics, we note that one of the most dramatic results of Gödel's Incompleteness Theorem is precisely to establish that one *cannot collapse* the (semantic) notion of mathematical truth into that of the (syntactic) concept of proof within a given formal system. And we recall that Gödel insisted that one of the dramatic

FIGURE 8

consequences of his model of the Gödel universe, permitting time travel, was that it *ruled out* an interpretation of *t* as that time that objectively lapses. With Gödel, then, the construction of a formal model takes on a special significance for philosophy—a significance, with regard to time, we have tried to bring out in previous chapters.

We have traced, then, some of the challenges to A-theoretic time posed by formal models in physics and (tense) logic. There remains, however, a serious problem concerning the very terms we use to characterize time from an A-theoretic point of view— namely, 'now' and 'the present'. 'Now' is a member of a family of terms, including 'I', 'here', 'this', and (more controversially) 'actual', that are called 'demonstratives' or 'indexicals'. These terms are, in a strong sense, context sensitive. 'I', for example, used by me, refers to me; used by you, to you. The semantics of such demonstratives, however, including the crucial term 'now', has caused serious difficulties for classical theories such as Frege's. (See, for example, the readings collected in Yourgrau 1990, which reflect also the metaphysical issues—including, specifically, the question of reality and 'the now'—that must be addressed in a proper account of demonstratives.) We need, then, to see what Frege, as well as his recent critics, can teach us about 'now' and, hence, indirectly, about *time*.

Frege and the Decontextualization of Thought

The moving force behind the intense concern with the philosophy of language in this century in the analytical school is the great logician Gottlob Frege—widely neglected in his own day but seminal through his influence on Wittgenstein, and thereby on Ryle and Strawson, and along different lines, on Russell and Carnap, and thereby on Quine. Frege himself, however, by training a mathematician, by inclination a philosopher, was occupied primarily in an attempt to secure the logical and epistemological foundations of arithmetic (in the broad sense), the most certain part of the most certain science. Frege's principal concern was thus with the timeless domain of pure mathematics and logic, a realm (for a Platonist like Frege) that in itself is entirely free from any contextual parameters that touch the human sphere. What distinguished Frege's conception of mathematics and logic, more-

over, was his insistence that we are concerned here not merely with a calculus for achieving certain results but also with a language for expressing truth—in other words, with a science, in the old and proper sense of the word. If in mathematics and logic we have to deal with language, then, in these disciplines one employs sentences and expresses thoughts and, if fortunate, attains knowledge. In this, Frege stood apart from a great many of his contemporaries, and indeed, still stands apart from many of his successors—notably, Wittgenstein ("A proposition of mathematics does not express a thought" [1974, 6.21].) and, equally notably, not Gödel—who in this, as in so many respects, is at one with Frege.

If then, Frege likened arithmetic and logic to natural language, he also construed logic along the lines of arithmetic. Indeed, the title of his seminal formalization of logic reads *Begriffsschrift, a Formula Language, Modeled upon that of Arithmetic, for Pure Thought*. Further, Frege introduces an analogy from another direction, likening natural language to the system of equations in arithmetic. Thus he dethrones subject and predicate from their traditional place of honor in the decomposition of the logical-grammatical form of sentences, replacing them with the mathematical categories of argument and function. Truth and falsity, then, emerge as the (truth) values of sentential functions (which he calls "concepts"), given, as arguments, the objects referred to by singular terms. We saw earlier that Dummett (1967) has expressed reservations about this construction of truth as a truth value—that is, as the value of a function, hence, as an object, in just the sense as are the arguments of a function. (For a reconstruction of a formal proof that, in a Fregean context, the designation of a sentence must be its truth value, see Gödel 1944. For an argument that this formalization could not be used by Frege to establish his thesis, see Yourgrau 1987a.) For Frege, then, no line separates (natural) language, logic, and arithmetic insofar as each provides, in a suitable manner, for the systematic expression of thought.

In regard to logic, in particular, Frege insists that it concerns truth in the most general way—indeed, that its end or purpose is to expose the very laws of truth (or truth-preservation, in inference). He makes, further, a bold transcendental assumption, in the spirit of Kant, that the truth bearer, the thought, must be true

in itself and so not merely true relative to context—whether we include as context time, place, or speaker. (Recall Kant's insistence that if ethics is not to be an illusion, something must be capable of being good in itself—namely, the will.) In this, as in his conception of logic as a science as opposed to an *organon,* he takes exception to Aristotle, who views the truth bearer as precisely context *relative.* ("Suppose, for example, that the statement that somebody is sitting is true; after he has got up *this same statement* will be false" [Aristotle 1979, 4a 22; my emphasis].) In contrast, Frege writes: "But are there not thoughts which are true today but false in six months' time? . . . [F]or example, that the tree there is covered with green leaves. . . No, for it is not the same thought at all" (1967a, p. 37).

Mathematics as a Science: Philosophical Consequences

If then, mathematics is a science, which pretends to knowledge, we must demand a justification for its claims. With Kant, Frege sharply distinguishes the (causal-psychological) origin of our beliefs from a 'deduction' or demonstration of legitimacy. Only the latter concerns him. Further, with Plato, he requires of knowledge of a domain that one know the objects whose structure is being investigated—that one recognize, as it were, the fish one has trapped with his net. But how does one go about justifying a vast enterprise like mathematics? Here Frege takes a leaf from Descartes's book and seeks out the least foundation on which the enterprise as a whole can be found to rest. He divides the task into the question of geometry, on the one hand, and arithmetic (including number theory and analysis), on the other. The former he takes to have been settled already by Kant, as resting on the basis of a (synthetic) a priori intuition of the pure form of space. The latter task is made propitious by the fact of the gradual arithmetization of mathematics, culminating in the nineteenth-century arithmetization of analysis. (Descartes's arithmetization of geometry is, of course, of no use to the geometric Kantian, Frege.) The effect of such arithmetization is the gradual shift in mathematics from the qualitative to the quantitative. More specifically, the multiplicity of categories of mathematical being—natural numbers, negative numbers, rationals, irrationals, imaginaries, and so on—is replaced by diverse manners of grouping (via sets, or

classes, or extensions) a single kind of object—namely, the natural numbers. Whence Kronecker's famous remark that "God created the integers, and man has made the rest." (For René Thom, however, "this maxim, spoken by the algebraist Kronecker, reveals more about his past as a banker who grew rich through monetary speculation than about his philosophical insight. There is hardly any doubt that from a psychological and, for the writer, ontological point of view, the geometric continuum is the primordial entity" [1971, p. 74]. He adds that "perhaps, even in mathematics, quality subsists, and resists all reduction to sets" [p. 77]. We will return later to the issue of the reduction of intuitive mathematical ideas to the set-theoretic.)

The possibility thus opens up of actually being able to solve, in brief compass, the problem of foundations (beyond geometry), if only the following specific tasks can be accomplished: (1) The natural numbers themselves must be defined—and not just distinguished from other categories of mathematical being. (For the language of mathematics is, we recall, construed here as referring to a definite reality—and we need to know which. Thus, as Frege says, we require that it be settled, for example, whether 0 = the Moon!) (2) We must explain the possibility of cognitive access to such objects as the natural numbers. For Frege notes that the paradigmatic form arithmetic knowledge takes is the equation, which, by his analogy with natural language, he takes to be a statement of *identity*, flanked on both sides by singular designations—numerals (i.e., proper names) or definite descriptions (since '2 + 3' becomes '*the* sum of 2 plus 3')—which thus designate *objects*. But Kant had insisted that our only method of access to genuine objects was by intuition, and Frege, unlike Kant (as well as Aristotle and Brouwer), denies that we have (synthetic) a priori knowledge of the numbers via our intuition of temporal succession. Thus he must either relinquish his claim that numbers are genuine objects or provide for some other, nonintuitive, mode of access. (3) The permissible rules of deductive inference by which we derive the theorems of arithmetic must be made explicit and justified, as well as the deductive reasoning required by arithmetized domains like analysis. (4) The basic laws of arithmetic must be exposed and justified or else derived from yet more basic laws. (5) An account must be provided of those groups or sets by which the arithmetization of mathematics is accomplished.

How Close Frege Came to Succeeding

Now what is remarkable is that Frege had good reason to believe he had actually accomplished all five tasks required for foundations.

(1) In his *Grundlagen* and *Grundgesetze* he provides explicit definitions of the natural numbers as logical objects. This is made possible by the fact that his logic is in fact higher order, containing both "concepts" and "extensions" (his version of the 'groups or sets' needed for this enterprise), exploited in his definitions. Thus, what Kant never dreamed of, pure logic shows itself to contain its own objects. (That such Frege-style definitions of the natural numbers in terms of extensions, or, in Russell's case, sets, are unavoidably arbitrary, and thus unsuccessful, is argued for in Benacerraf (1965). Yourgrau (1985a) suggests that the problem with Frege's definitions lies deeper than this.)

(2) Since, on Frege's account, numbers turn out to be logical objects, our cognitive access to them will be via the logical faculty itself which Frege takes to be one of the three 'Sources of Knowledge of Mathematics and Natural Sciences' (1979), the other two being the geometrical source of knowledge and sense perception. Frege, however, never, to my knowledge, speaks of the faculty of logic delivering logical *intuitions*. Indeed, he has very little to say about this faculty, since, for him, its proper place of investigation lies not in logic (which investigates only the relationships between *truths)*, but in psychology. Again and again, he seems to characterize what is clearly epistemological as psychological (and thus to dismiss it).

(3) In *Begriffsschrift*, Frege had accomplished the formalization of quantification logic (whose first-order part Gödel proved complete), which for the first time permitted the systematization of the principles of deductive reasoning required for the nineteenth-century rigorization and arithmetization of mathematics. Further, Frege claimed to have reduced all peculiarly arithmetic modes of reasoning—such as mathematical induction—to the purely logical, made possible by his definitions in task (1). (Indeed, this was only to be expected, given his insistence on the universal applicability of arithmetic—a trait it clearly shares with logic.)

(4) In *Grundgesetze* he attempted to derive the basic laws of arithmetic from the basic laws of logic. (For the relations between

Frege's formulation of the basic laws of arithmetic and those of Dedekind and Peano, see Gillies 1982.) Here, again, Gödel provided the relevant metamathematical proof—only this time, surprisingly, in the negative, demonstrating via the arithmetization of metamathematics that any reasonable, formal, axiom system for arithmetic must (if consistent) be *incomplete* (and this for the most certain part of the most certain science).

(5) In *Grundgesetze,* Frege provided a formal account of the groups or extensions required for the completion of his project. In particular, his (infamous) Axiom V established the relationship between a concept and the extension (or class) it determines. Unfortunately, for a third time, a problem arises, since Bertrand Russell showed, via the 'Russell Paradox', to which we referred in Chapter 1, p. 15, that Axiom V leads to inconsistency. Indeed, the problem here is especially interesting, since it consists, at least in part, in the desire we have already met with several times in this study to adopt simultaneously a perspective within and outside of a totality. In Frege's case, a quantifier was permitted to range over, as a member of its domain, the extension of a predicate that falls within the scope of that quantifier. (For a discussion of Russell's solution to this problem via his 'vicious circle' principle, see Gödel 1944.)

The Problem of Identity

Having accomplished, then, as he believed, all five tasks required to secure for arithmetic, and so for the rest of mathematics, a firm foundation, Frege addressed himself to a final task that even then remained unfulfilled. For it will be recalled that arithmetic truths take the fundamental form of identities. "Identity, however," Frege writes, "gives rise to challenging questions which are not altogether easy to answer." With these opening lines of 'On Sense and Reference' (1892), a new chapter commences in the philosophy of language, or (as Frege sees it), the philosophy of thought. But what are these challenging questions identity gives rise to? A true identity seems somehow to be about, to concern, two things, but also, in another sense, to be about *one.* But as Wittgenstein, a close student of Frege's thought, puts it, "to say of *two* things that they are identical is nonsense, and to say of *one* thing that it is identical with itself is to say nothing at all" (1974, 5.5303). Such

difficulties led Wittgenstein to abandon the concept of identity entirely. They led Frege in *Begriffsschrift* to interpret a statement of identity, 'a = b', to be, in terms of its logical grammar, about the signs 'a' and 'b' themselves. Now, however, in 'On Sense and Reference', he finds this artificial translation unsatisfactory. To begin with, it introduces an unjustified change of subject matter. 'Mark Twain is Samuel Clemens' is clearly about Mark Twain the man, not 'Mark Twain' the name. Further, that two signs—that is, ink marks or sounds—happen to be used (somewhere, by someone) to designate the same object is of little interest, since "[n]obody can be forbidden to use any arbitrarily producible event or object as a sign for something" (1892, p. 57). But identities like that just given can be of considerable interest.

Reversing our tack, however, produces no improvement. If we take identity to concern not the signs but rather what they designate or represent, then all true identities turn out to be trivialities (of the form that a given object is itself). But, again, many identities are so far from being trivialities that in fact they represent great advances in our understanding—as in the famous example of Hesperus being Posphorus. Further, if all identities are trivialities—and indeed, on this account, are knowable a priori—the same would hold of all propositions, since all statements can be re-expressed as identities. (Thus, for an arbitrary statement, 'Fa', we have:

'Fa .\equiv. $a = \imath x\,(x = a\cdot\mathrm{F}x)$'.

Indeed, Gödel relies on this equivalence in his reformulation of Frege's argument that the designation of a sentence is its truth value [Gödel 1944, p. 122, Note 5].) One can see why Wittgenstein was inclined to give up identity entirely rather than to seek its elusive explication. His position, here, moreover, has special relevance for mathematics, where equations are essentially employed. "It is the essential characteristic of mathematical method that it employs equations. For it is because of this method that every proposition of mathematics must go without saying" (1974, 6.2341). Yet, as we have just seen, any arbitrary statement can be recast as an identity. So, along these lines alone, the response to be made is surely that if the propositions of mathematics do not express thoughts, or "go without saying,"

the same applies to all other propositions! Frege, however, chooses a different path. He accepts the apparent logical form of the equations of arithmetic as genuine and seeks a deeper analysis of identity.

Thought versus Thought Content

The problem, he now discovers, is that we have not yet recognized the need to split up the meaning—or "content," as he put it in *Begriffsschrift*—of a term or sentence into two components. Words do not simply *represent* objects, but rather *present* them in one way as opposed to another. This mode of presentation by which we introduce items into our thought is a matter for cognition. Meaning is here a question of *"cognitive* value." This is then to be sharply distinguished from the question of the *truth* value of a sentence, or the issue of designative value, or reference. We can then lay it down: Whereof there are *two* in an identity is material for *cognition;* whereof there is *one* concerns *truth and reference.* Frege calls this mode of presentation, which raises a mere sign to the level of a representation, a "sense," and he says that the sense of a sentence is a "thought." A proper name, then, designates its referent via its sense, and a sentence designates its referent—a truth value—via the thought it expresses. The subject of logic, then, is thoughts, not sentences, and the cognitive value of mathematics as a branch of knowledge lies on the level of sense, not reference.

What exactly are senses, however? Frege proceeds to derive their nature from their functional characterization. An empirical object as such, and also a mental-psychological object, does not, he insists, point beyond itself. A sentence, after all, is a mere picture in words, but even a picture that obviously resembles its object—say, a realistic drawing of a pipe—does not thereby represent it. Something else must be added, some principle of projection, to connect this one object with another. Without this we face, one might say, the 'Magritte problem'. I have in mind here Magritte's famous painting 'The Use of Words, I', in which a lifelike drawing (as of) a pipe has painted under it the very words: *Ceci n'est pas une pipe.* If we restrict ourselves to the domain of images ('ideas', in Frege's terms), the painting can never be seen

to point beyond itself unambiguously to (represent) a pipe. For as much as the drawing points (by resemblance, via an *assumed* principle of projection) to a pipe, the painted title erases (by its assumed meaning, as another kind of painting or image) the customary or assumed meaning of this very painting.

By cutting loose from their safe, ordinary contexts such typical vehicles of representation as a realistic drawing and a simple sentence, and by letting each challenge the other's referential credentials, Magritte has succeeded in undermining our presupposition that somehow the mere painted images themselves succeed in referring. For here the images seem to be quarreling with each other, and *confined to the level of images* alone, no resolution of this quarrel is in view. Thus, considered as a mere painted object, including as a part a painting of a sentence (for a sentence just *is* a painting of a sentence), the picture never succeeds in pointing beyond itself. A mere picture, as such, always stands in need of an interpretation (Frege 1967a, p. 18). But where does this leave us? Is anything true in itself or does everything stand in need of an interpretation? Frege's answer is clear. Unless there is something that is literally true, true in itself, there can be no truth at all, and rational thought threatens to disappear. There must, then, be such a truth bearer, true in itself. Frege calls it the "thought." The thought, for Frege, is intrinsically articulate: It says what it means. He concludes that it would have to occupy neither the empirical nor the mental-psychological realm (since the same considerations would apply to mental images). Rather, "[a] third realm must be recognized" (1967a, p. 29). Frege would surely not have been surprised that the resolute commitment of W.V. Quine *not* to follow Frege down the path to this 'third realm' (of senses, or, in modern terminology, 'intensions') has led to the so-called 'indeterminacy of translation' and the abandonment of analyticity (see Katz 1988).

Thinking and Time

Senses, then, including thoughts, turn out, from an ontological point of view, to occupy a timeless, abstract, Platonic third realm, also occupied by concepts and numbers. Functionally speaking, they satisfy a variety of roles. They serve to present an object in a

definite manner in our thoughts and so to account for the cognitive value, or 'information', contained in our sentences. By determining specific objects as referents, moreover, they also help determine the truth value of sentences. Finally, they provide the indirect or oblique referents in sentential contexts where what is at issue is not (ordinary or nonoblique) truth and reference. For example, in so-called propositional attitude contexts, such as 'I suspect that Mark Twain is Samuel Clemens', the sentential component, 'Mark Twain is Samuel Clemens', refers in this context not to its ordinary reference—a truth value—but to its ordinary sense—namely, the thought that Mark Twain is Samuel Clemens. Finally, from a logical point of view, we note that Frege makes no attempt to formalize his account of senses. This has been done, however, by Church (1951; 1973), though serious problems remain even with these formulations.

What is of most concern here, however, is the role of context in the expression of thought via language. Although "[t]houghts are independent of our thinking" and "whoever thinks it encounters it in the same way, as the same thought" (Frege 1979, p. 127), and indeed, "[i]t is thus of the essence of a thought to be non-temporal and non-spatial" (p. 135), it remains that words alone do not always suffice for the expression of a thought. It is exactly here that context comes into play. "If a time indication is needed by the present tense one must *know when* the sentence was uttered to apprehend the thought correctly. Therefore the *time* of utterance is part of the *expression* of the thought" (Frege 1967a, p. 24; my emphases). Frege is sensitive to the fact that mere words may well stand in need of contextual supplementation for a complete thought to be expressed or apprehended. The thought itself cannot always be put completely into words. Nevertheless, one can attribute to Frege here a 'principle of exportation': The pragmatic contribution of *context* can always be completely exported into (not necessarily *words*, but) semantic *thought content*. (See Yourgrau 1983 for an epistemic formulation of such a principle.) In this sense, Frege has brought about a *de-contextualization of thought*. Indeed, when the relevant contextual parameter is time, one may have to change one's words, over time, to keep expressing the same thought. "If someone wants to say the same today as he expressed yesterday using the word 'today', he must replace this word with 'yesterday'" (p. 24).

Tracking the 'Now'

This example of Frege's, however, has inspired Gareth Evans (1985) to offer a very different account of the relation of Fregean thought to context demonstratively indicated by words like 'today' and 'yesterday'. On Evans's proposal, the Fregean thought expressed by 'Today is fine' today is a tensed thought, which one can grasp tomorrow by using the word 'yesterday'. "Might Frege not have had in mind an idea of a thought the grasp of which, on a later day, requires just as specific a way of thinking of a day as does its grasp on an earlier day—namely as the preceding day?" Further, "the grasp, at [time] t, of a thought of the kind suggested by the passage from Frege, a *dynamic* Fregean thought, requires a subject to possess at t an ability to keep track of a particular object over time" (p. 87).

As an interpretation of Frege, however, Evans's reading appears to miss the mark doubly. In the first place, from our previous discussion, it should be clear enough that there is no such thing as a *dynamic* Fregean thought. Recall only that "[i]t is of the essence of a thought to be non-temporal and nonspatial" and that "[w]hoever thinks it [a thought] encounters it in the same way, as the same thought." In the second place, Evans's 'dynamic Fregean thoughts' are not even genuinely dynamic. For Aristotle, for example, the thought expressed by 'Today is fine', though true today, may be false tomorrow. For Evans, however, this same thought remains true tomorrow, no matter what the weather, only tomorrow it is expressed by the words 'Yesterday was fine'.

Is Thought Part of Nature?

Assuming, then, that our reading of Frege is not undermined by Evans, it emerges that Frege draws a sharp line between thought content and the process of thinking. Not only is it true, as we saw earlier, that for him "thoughts are independent of our thinking," but thinking itself as a mental-psychological process, would appear to have, for Frege, no internal relation to thought (content). But how can this be? Isn't thinking, after all, in the sense of 'having thoughts', a natural mental process? Well, is it? Perhaps it is simply a highly evolved biological process, like digestion? But my digestion cannot contradict yours. Must the process of

thinking contain its objects? Must I 'absorb' this tree in order to think it? Senses and 'concepts' (in Frege's sense), no more than trees, are absorbed into the mental process. Thus, in the Preface to the *Grundlagen*, Frege clearly places *both* concepts and objects on the side of the objective, while mental ideas belong to the subjective. The problem here is that the categories proper to thought— namely, truth, implication, validity, and so on—do not seem to have any internal relation to the empirical or psychological realm, which knows only motion, contiguity, resemblance, causation, and so on. Hence the clash between Fregean semantics and the recent causal-genetic theory of reference of Kripke, Donnellan, Kaplan, Putnam, and others (addressed in detail in Yourgrau 1987c).

Here we should recall our discussion of Magritte's painting and the inability from within the empirical realm, which includes the relation of resemblance, to provide a basis for an account of the representational function of Fregean sense. Indeed, Frege goes to great pains in 'The Thought' to distinguish the relation 'thought → truth value' from the relation 'picture → object (depicted)'. The strain this produces between the perspective within nature and the point of view of pure thought (*sub specie aeternitatis*) makes it tempting to adopt a kind of 'dual aspect' view of the world—the phenomenal aspect and the transcendental—in the manner of Kant. Frege, it would appear, has nothing new to offer here to relieve this strain, and shows no inclination to adopt, under such pressure, a merely forced synthesis. Indeed, if anything, he tends to draw attention to the irreconcilability of the two perspectives. His integrity here, however, puts enormous stress on his ability to avoid outright paradox, as when he writes that "still the grasping of this law [of gravity] is a mental process! Yes, indeed, but it is a process which takes place *on the very confines of the mental* and which for that reason cannot be completely understood from a purely psychological standpoint" (1979, p. 145; my emphasis). It is, I take it, a mystery what could constitute being on "the very confines" of the mental realm (short of a dangerous spatial-geometrical metaphor).

Dressing up Thought in Linguistic Clothing

Frege, however, further destabilizes an already unstable position by insisting that thought, in itself immaterial, can make itself

apparent to us only by wearing a 'garment' of (sense-perceptible) words. "I have to content myself," he writes, "with presenting the reader with a thought, in itself immaterial, dressed in sensible linguistic form" (1967a, p. 26, fn. 1). The choice of metaphor, surely, is not a happy one and renders his task more difficult and mysterious than it need be. Just as my body does not *clothe* but rather *embodies* my soul, it would be more suggestive for Frege to say not that language 'dresses up' thought, but rather that it embodies it. The thought is the soul of the words, what gives them life and meaning. What is clear, however, is that Frege resists the tendency, since the 'linguistic turn', to remove the tension here and to simply identify the thought with the words (in context). For Frege, we must *resign* ourselves to the fact that we can only, given the kind of beings we are, encounter thought in an alien medium. Nevertheless, he insists that we can, via words, grasp thoughts. Indeed, we read in 'The Thought' that each of the three realms—the sensible, the mental, and the third realm— is accessible to us by the appropriate mode of cognition. We *sense* a physical object, *have* a (mental) idea, and *grasp* a thought.

What is peculiar to the latter mode of cognition, he insists, is the lack of reciprocal action so typical of the natural world. To grasp a thought is very different from holding on to, say, a hammer. "How different the process of handing over a hammer is from the communication of a thought. The hammer . . . is gripped, it undergoes pressure and on account of this its density . . . is changed in places. There is nothing of all this with a thought" (1967a, p. 38). Like an Aristotelian unmoved mover and (I would suggest) a Platonic Form, a Fregean thought moves by being apprehended, though remaining itself unmoved. "How does a thought act? By being apprehended and taken to be true There is lacking here something we observe throughout the order of nature: reciprocal action" (p. 38). For Frege, if thinking, grasping a thought, somehow disturbed it or put it into motion then the objectivity of thoughts would be lost, as would their constancy and stability. In a passage strongly reminiscent of Plato's *Theaetetus,* he writes that "[i]f everything were in continual flux, and nothing maintained itself fixed for all time, there would no longer be any possibility of getting to know anything about the world" (1980, VII). Thus, grasping a thought, knowing something, must not imply affecting the thought in any essential way.

In a word, "[i]f knowing is to be acting on something, it follows that what is known must be acted upon by it, and so, on this showing, *reality when it is being known* by the act of knowledge must, in so far as it is known, be *changed*" (Plato, *The Sophist*, 1973, 248e; my emphases). (It is hard not to think here of Heisenberg's Uncertainty Principle.)

A difference emerges, however, as soon as it becomes a question of that being that is not changeless, of the flux of time and human experience, of 'reality in motion'. Here Plato comes closer to saving the phenomena. "But tell me, in heaven's name, are we really to be so easily convinced that *change*, life, soul, understanding have no place in *that which is perfectly real* . . . ?" (1973, p. 249; my emphases) Frege's extreme separation of thinking from (what is) thought (in his strict sense), his preoccupation with the logic of mathematics—or 'reality at rest'—leads him, in spite of strong contrary inclinations, to a kind of cognitive cul-de-sac, where we somehow cannot *put into thought* what we can nevertheless *grasp in experience,* and so to neglect the very *form* of that other reality, the reality in motion, namely, *time.* For recall that Frege recognizes, in 'The Thought', three categories of cognitive access, each suited to an appropriate category of being: We *have* (mental) ideas, *experience* sensible objects, and *grasp* thoughts. Yet the official doctrine he puts forward is that all reference is only via senses (the components of thoughts); all thinking that attains to *truth* and *knowledge* is constituted *only* by grasping (eternal, changeless, third realm, Fregean) *thoughts.* It seems that we cannot, for Frege, succeed in having objective thoughts that are directly about what we directly experience—either the ideas we have or the sensible objects we see or touch. It is more, then, than the fact that we cannot always succeed completely in putting what we experience *into words.* This Frege acknowledges even for a complete *thought.* Rather, it is a question of what can be *put into a thought,* and *so known*—in the sense of knowledge that implies truth.

A Tension in Frege's Thought

There is, then, in Frege's own account of reference and thought a tension that demands resolution. For even his own thesis in 'The Thought' concerning the three modes of cognition, each proper to its own ontological realm, is rendered incomprehensible given

his official doctrine of no reference without sense, no thinking without *thought* (in his sense of this term). Thus his thesis implies that we have, but do not see, an idea of the color red. Yet this thought cannot contain this experienced idea, but only a sense, a conceptual correlate (in the intuitive, not Frege's, sense) that determines this idea. So, the direct deliverances of experience are, as such, invisible to Fregean conceptual thought. But the problem is even worse than this. For if the only means of "introducing an item into our thought" (to borrow a phrase from Strawson 1963) is by *designating* it via a *sense*, then *this* sense, too, must be introduced into our thought by itself being designated by a new $sense_1$. But $sense_1$ must then itself be introduced by a new $sense_2$, and we are landed in a (vicious) infinite regress. To avoid it, however, we need only bring in the other half of Frege's theory, the half that acknowledges that we can *grasp* thoughts and other senses—as opposed to only *designating* them via other senses. But once we recognize this, nothing prevents us from continuing in the same direction, and thus from also acknowledging that we can introduce into our thought the deliverances of immediate experience, simply by having such experiences (ideas, in Frege's sense), without going through the conceptual intermediary of a designating or referring *sense*—which, moreover, must, by its very nature, miss precisely what is peculiar and proper to the world of direct experience of ideas. For the mode of presentation of the experience of red *as* that very experience is essential to it. (Recall our earlier discussion of Sklar on the secondarization of the phenomena as science—or, in general, abstract, conceptual thought—advances, and also Kripke's important reminder that when it is a question of the mental experiences themselves, their mode of presentation—for example, of a pain *as* painful—is essential.) Thus, if we are not to change the subject when attempting to think about the deliverances of experience and to capture, instead, a mere sense that happens to designate or refer to that experience, we must acknowledge having an experience as a legitimate mode of presentation of a *referent,* along with designation via *sense*.

I maintain that Frege cannot but acknowledge that all three direct modes of cognitive access to the three realms—having, sense experience, and grasping—are as legitimate modes of presentation of our referents as is designating by a sense (which, alone, is recognized by the official doctrine). For the case of

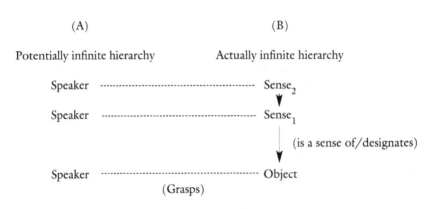

(A) (B)

Potentially infinite hierarchy Actually infinite hierarchy

FIGURE 9

grasping senses, we can represent the situation diagrammatically in Figure 9. Column B represents a metaphysical hierarchy of senses in the realm of pure thought. Column A, however, represents an epistemological (Frege would say, mental-psychological) domain ('hierarchy' is not quite the right term), which shows us how we grasp the elements of Column B. (For details, see Yourgrau 1982, including the question of 'grasping a grasping' and the issue of the hierarchy of iterated 'oblique' or 'indirect' senses in propositional attitude contexts, made famous by Church 1951 and considered by Davidson [1968, p. 99], to be a reductio of Frege's theory.) It is not necessary here to go into the fine points of the nature of this relation of grasping, but it is important to note that it, together with the cognate relations of having and of sense experience, are cognitive relations. An analogy would thus be Russell's notion of *acquaintance,* not the causal-genetic relation employed by the causal theory of reference, alluded to earlier. (For details on why these Fregean relations must be cognitive, see Yourgrau 1982; 1987c. For a comparison of Russell, acquaintance, and the Theory of Descriptions with Frege, grasping, and the theory of sense and reference, see Yourgrau 1985b.)

Is Thinking about Time Possible?

Depending upon whether the object at the base of Column B in Figure 8 is an idea or an empirical object, the diagram will represent either the relation of having an idea to designating/denoting

such an idea by a sense, or the relation of the sense experience of an empirical object to designating/denoting such an object via a sense. In each case, Column A represents a kind of direct, nondescriptive, nonconceptual mode of cognitive access to the relevant ontological realm. But when the realm in question is temporal becoming—given, perhaps, with Kant, through the "form of inner sense"—may not Column A represent something more pertinent to our present concerns, namely, a kind of *tensed access to a tensed reality?* Indeed, in naming it *"Column A,"* I have tried to suggest just such a kinship with *the tensed reality of A-series time*. One would here, then, bring Frege into line with Plato, whose attempt to save the phenomena of cognition, time, and change in *The Sophist* we have already alluded to, and which Iris Murdoch has well characterized by saying that Plato "here conjures up *a moving knower to follow a moving known"* (1978, p. 49; my emphasis).

If this suggestion is along the right lines, then it becomes understandable why the only form of reality directly visible to Fregean thought is tenseless—namely, because our access to tensed reality, reality in motion, is not via the conceptual hierarchy of pure thought, represented by Column B, but rather through the direct, nonconceptual, epistemic (or, for Frege, mental-psychological) channels of cognitive access represented by column A. For, as Bertrand Russell has put it in 'On the Experience of Time', "Thus introspection is necessary in order to understand the meaning of 'past', because the only cases in which this relation is immediately given are cases in which one term is the subject [of experience]. Thus 'past', like 'present', is a notion derived from *psychology"* (p. 192; my interpolation and emphases). (And recall Capek 1961, p. 372, on Whitehead and the "direct awareness of time.")

Even if our proposed reconstruction of Frege is successful, however, it does not, of course, establish the objective existence of the tensed reality of the A-series, but rather creates some semantic breathing room for the recognition of A-theoretic facts, should they exist—in particular, should they survive the challenges posed by Gödel and Einstein. But without such a reconstruction, and assuming, as we have suggested, that Evans's dynamic Fregean thoughts are the result of a misinterpretation, it would be a consequence already of the *semantics* of temporal dis-

course—without any help from Einstein and Gödel—that the A-series is an illusion. And, indeed, this result *has* been claimed on behalf of semantics alone—not, however, by an unreconstructed Fregean, but rather by the severest of critics of Fregean semantics. How did this come about?

A New Semantics for 'Now': Problems and Consequences

Coordinate with the criticism of Frege advanced by the causal-genetic theory of proper names, there is a critique centered on the study of demonstratives, inspired by the non-Fregean theory of such terms put forward by David Kaplan. (See, for example, Kaplan's 1978 and 1990.) Bringing an analysis like Kaplan's to bear on Frege's remarks on demonstratives, like 'now', John Perry, in 'Frege on Demonstratives', argued that Frege could not adequately account for both the dynamic aspect of such referential devices (each time you use 'now', a different time is indicated) and the apparent *constancy* of meaning that underlies such shifts in reference (for in some sense, 'now' is being used in the same way across these changes in reference). For Perry, Frege, using only the theoretical devices of sense and reference, cannot explain this apparent constancy through diversity. Perry therefore puts forward a theory of demonstratives more in the spirit of Kaplan. He distinguishes the *content* that is expressed by a demonstrative statement from the *expression* of such thoughts. The content, for example, of 'Today is fine', asserted on day t, is the ordered pair consisting of the actual day, t, and the property of being fine: $<t$, (being fine)$>$. Thought *content* gives us the *information* carried by such assertions and grounds *truth value*. The expression of such content, by contrast, is determined by what Perry calls the "role" of the demonstrative. The role of 'today', for example, is to refer, when used on day t, to t. The role of a demonstrative explains our psychological states, hence our actions, when employing such devices. Thus, when you *entertain* the role of 'today', on day t, in asserting 'Today is fine', you refer to t and adopt the psychological attitude to day t that inclines you to put away your umbrella. In contrast, entertaining the role of 'yesterday', on day $t + 1$, to assert 'Yesterday was fine', ushers in the same content, $<t$, (being fine)$>$, but expresses a different psycho-

logical attitude: You don't yet know whether or not to bring along your umbrella when going out.

Though neither Perry nor Kaplan drew the consequences of such a semantic account of demonstratives for the question of A- versus B-theoretic time, D.H. Mellor, in *Real Time*, applying Perry's analysis to the crucial temporal demonstratives 'now' and 'today', argued that the B-series alone constitutes 'real time', the A-series being a kind of semantic hallucination produced by an incorrect account of the crucial terms. Indeed, I would suggest that a strict employment of the Kaplan-Perry theory of demon- stratives, or, as they are sometimes called, 'indexicals', must inevitably usher in a kind of *spatialization,* in the sense intro- duced earlier, of the relevant domain. Thus, the indexical account of 'actual' advocated by Lewis, which we alluded to earlier, is a kind of *spatialization of actuality* based, in effect, on a Kaplan- Perry approach to this term. Since, for Lewis, the complete truth is given by the fact that 'actual', used at possible world *w*, refers to *w*, it follows that no single possible world is singled out as privi- leged—as *the* actual world. Rather, all worlds turn out to be actual *relative* to themselves. Similarly, Mellor argues that the A-theo- retic notion of *the* now is based on a (semantic) misconception, since *all* times are now *relative* to themselves. Thus Mellor, along semantic lines, finds no reason to recognize anything but the rela- tive A-series—that is, the B-series. Unlike Gödel, however, he does not conclude that time is ideal, but rather, as we have seen, that time, though real, is characterized exclusively by the B-series.

We will not repeat Gödel's reasoning that, in effect, the nonexistence of the A-series would imply the ideality of time. Rather, I wish to focus on the adequacy of Perry's theory itself as an account of 'now', as well as on Mellor's pragmatic account of the illusory intuitiveness of the A-series. The crucial question for Perry's account concerns the entertaining of a role. What exactly is a role? A role, it would seem, is a semantic rule. The role for 'now', then, would be of the form: 'For all times *t* and speakers *s*, if *s* employs 'now' correctly at *t*, he or she refers to *t*'. Now a rule is no good unless you can use it, but if you attempt to employ this semantic rule, it becomes apparent that, in grasping it, you get a handle not on any *particular* time, but only on a *universal condi- tional* on times and speakers. The problem, then, is that to actu- ally put this rule into effect, you must *instantiate* the universal

quantifier. Yet, to accomplish this, you must already have a partic-
ular time, t, in mind. *But how do you get to have it in mind?* By
describing-denoting it, for example, with a B-theoretic time speci-
fication—say, July 31, 1990, 8:00 P.M.—that is, in effect, via a
Fregean sense that designates its object timelessly? But this would
be a throwback to Frege and is, accordingly, solidly rejected by
Perry. How about simply taking t to be the present moment, that
is, now? This, of course, would be circular, for it is the role =
semantic rule itself that was to explicate our use of the term
'now'. One is soon forced to the conclusion that Perry has mis-
taken a necessary constraint on a mode of presentation, or mode
of designation, of a time with 'now'—that, whatever this mode of
presentation may be, it must be such that, employed at time t, it
determines t—for the mode of presentation itself.

I conclude, then, that Perry has failed to provide an account
of temporal demonstratives alternative to the Fregean, and there-
fore, that the door remains open, from a semantic point of view,
to a recognition of the A-series if a reconstructed Fregean theory,
like the one we gave earlier, is sound. But if Perry's account fails
of its purpose, then so must Mellor's employment of it as a
semantic critique of A-theoretic time. Mellor also has, however, a
positive account of the relative A-series that he puts forward as an
attempt to soften the paradoxes that might otherwise seem to be
consequent for the human experience of lived time, if an objec-
tive, nonrelative 'now' proves an illusion.

An important aspect of the seeming significance of the pre-
sent, the now, is that present experiences have a different value in
our lives than do those in the past or future. Thus, in a famous
essay, 'Thank Goodness That's Over', A.N. Prior argues forcefully
that it is difficult to account for our relief when, for example, a
present pain is *now over,* if tense and the non-relative now of the
A-series are mere illusions. (Recall again Einstein's statement that
"the *experience* of the Now means something special *for man.*")
Mellor (1981) suggests that what is crucial in the kind of example
Prior raises is the (B-theoretic) relationship between the time of
the experience and that of the utterance of a token of the appro-
priate sentence. Thus, 'Thank goodness that's over' is uttered
immediately after the painful experience has ended, and 'I wish
this pain would end' is uttered simultaneously with the pain.

Is this, however, a plausible explanation of the phenomena Prior adduces? Recall that without the A-series time is spatialized, so that positions in time bear no ontological significance (and this applies to all events, including the mental). Thus, all my pains, past, present, and future, are, by this account, equally real. But why, then, would it be such a fundamental feature of human existence that we attribute great significance to the fact that a pain (or a death—as we will see in the next chapter) is simultaneous (or not) with the utterance of a particular sentence of ours? After all, although the pain is simultaneous with this utterance, it is not for that reason more real than any other pain of mine, past or future. It merely has a particular location in (B-theoretic) time, just as, say, a pain in my foot has a particular location in space. One might, of course, have a foot fetish and pay special heed to pains in that location, and similarly, one might have, I suppose, a temporal fetish and be especially concerned with pains occurring at certain temporal locations, such as being simultaneous with certain sentences I utter. But we seem in any case not to have come to grips with the essence of the phenomenon of lived time Prior has drawn attention to—the human significance of the present moment.

Thus it seems that if the A-series is an illusion, it will not be so easy to avoid paradoxical implications. Gödel, moreover, seems rather to insist on these paradoxical consequences than to attempt to soften or sidestep them, and Einstein, as we have seen, senses here a dilemma. It remains, however, that even if the challenges to the objectivity of A-theoretic time, and hence to time as such, from the side of tense logic and semantics are not conclusive, the problems raised by Gödel, from the point of view of physics, are considerable. Rather than press on, however, in further consideration of the challenges to the reality of time, I suggest that we consider next what happens if we follow Gödel and adopt an idealistic conception. In short, what exactly must we give up if we abandon A-theoretic time? Too high a price, here, may incline us to a *modus tollens*, against Gödel, rather than a costly *modus ponens*.

Chapter 7
Being and Time

If, with Gödel, we maintain the ideality of time—that successive time which unfolds into an open future—we abandon not only our overtly temporal intuitions (which Gödel recognizes), but also certain otherwise clear, natural, and intuitive distinctions of a mathematical, as well as of a more general, human, significance. There is, to begin with, the traditional association of time with potential infinity.

Time and Infinity

Every infinity . . . is made finite to God.

St. Augustine

All finite cardinal numbers are distinct and simultaneously present in God's intellect.

Georg Cantor

It has been the custom in foundations of mathematics, at least since Aristotle, to distinguish *actual*, or completed, infinity from infinity that is merely *potential*, or always incomplete. Potential infinity, however, held the field among mathematicians (the other variety being restricted by the theologians to God) until the work of Georg Cantor in the late nineteenth century. Indeed, as late as 1831, Gauss himself could write that "I protest above all against the use of an infinite quantity as a completed one, which in mathematics is never allowed" (Dauben 1979, p. 120). A quantity is potentially infinite if it increases without limit or if it goes on

forever. With the latter formulation we see time enter the picture, and it must clearly be successive, forever incomplete, A-theoretic time. Thus Kant writes that "the infinity of a series consists in the fact that it can never be completed through successive synthesis. It thus follows that it is impossible for an infinite world series to have passed away" (1965, p. 396). And Cantor says that "the potential infinite is mostly witnessed where one has an undetermined, *variable finite* quantity which . . . increases beyond all limits (here we can take as an example that so-called time which is counted from a definite initial moment)" (Hallett 1984, p. 12). Finally, Mary Tiles sums up the matter well, leaving no doubt that it is A-theoretic time that is here at issue: "Potential infinity is opposed to the sort of completeness required of the universe, just because the universe consists of what is, of what is *actual,* whilst the potentially infinite is never fully actual but always in the process of becoming. *It is an inescapably temporal notion*" (1989b, p. 28; second emphasis mine).

One could thus say that the set-theoretic Platonist, Cantor, by introducing actual infinity (indeed, as we will see later, as the primary concept), was in effect breaking the historical tie between time and infinity, as Plato had separated time from geometry. And it is clear that Cantorian infinity is opposed specifically to A-theoretic time. For suppose, employing the latter concept, that time is infinite—that is, goes on forever. Could it have gone on even longer? This obviously makes no sense for this sort of infinity. Yet, distinctive of Cantorian infinity is that it is extendable: for any infinite cardinal, α, Cantor proves that $2^{\alpha} > \alpha$.

The Epistemology of Potential Infinity

Thus, if Gödel is to be believed that (A-theoretic) time is an illusion, it follows that, at most, B-theoretic structures characterize the universe. But nothing essentially incomplete survives in the B-series. Thus one can put forward a characteristically Gödelian disjunction: Either time is not ideal, or the only permissible mathematical infinity is the actual. For if time is ideal, then, assuming, with Kant, that it is the very form of inner sense, it follows that not only are there no potential infinities in the natural world, but even the mathematical imagination will be unable to fashion such a concept as objective. This result about the epistemology of

infinity, if sound, would clearly threaten the approach of intu-itionistically inspired philosophers, like Dummett, for whom "it is quite literally true that we can arrive at the notion of infinity in no other way than by considering a process of generation or con-struction which will never be completed" (1978b, p. 56). (Of course, one must be careful, as we have already stressed, not to conflate Gödel's idealism with Kant's. Thus, Gödel's idealism applies only to time, *not* to relativistic space-time, *or* to mathemat-ics—especially with regard to Cantorian, set-theoretic, actual infinity.) That such results in *pure* mathematics seem to follow from considerations on the nature of time derived from the *empirical* theory of relativity may give us pause. Yet, in retrospect, this was to be expected. For the internal relation between A-theo-retic time and potential infinity is an indication that here mathe-matics is not being cut free from its human context—that it is not being de-contextualized—and thus that the thinking *process* is here not disconnected from (mathematical) *thought*. (This becomes especially clear in the conception not just of potential infinity, but of mathematics in general, advocated by L.E.J. Brouwer, to be discussed later.)

Is there any direct mathematical evidence that counts against the second disjunct in our Gödelian proposal—and so favors the existence of potential infinity? What, after all, is a genuine *witness for potential infinity*? Jonathan Lear, in 'Aristotelian Infinity', sug-gests that a temporal process of dividing, though incomplete at any finite stage, can be a witness to Aristotelian potential infinity.

> [A]n actual process of division, which terminates after finitely many divisions, is all that a witness to the existence of the potential infinite could consist in. While such a process is occurring, one can say that *the infinite is actually coming to be.* (1980, pp. 191–93; emphasis added)

Lear goes on to suggest a translation of a crucial line in Aristotle, *Metaphysics*, VIII.6 (1048 b, 14–17): "The division not being exhausted ensures that this activity (of dividing) *is*, poten-tially, but not that the infinite exists separately." Lear glosses this: "On this reading it is precisely because there are possible divisions that will remain unactualized that the line is potentially infinite" (Lear 1980, p. 193).

Now I cannot see how, for Aristotle or Lear, any actual temporal process of only finitely many stages can itself bear witness to the existence of the *infinite*. We need a firmer basis for, as Gödel puts it (Wang 1987), "the first infinite jump" (which Gödel sees as the decisive leap of idealization here). Indeed, Lear seems to be in some sense aware of this when he adds that it is "because there are possible divisions that will remain unactualized" that such a finite process can serve as a witness to infinity. But it remains that (1) there will always, for *all* finite possible divisions, remain new possible divisions to be made, and (2) we must have some *epistemic access* to this modal fact—namely, that we *could* always make (in some merely possible world) more divisions than we ever in fact (in this strictly finite, actual world) will. How, then, can "an actual process of division, which terminates after *finitely* many divisions" provide one with the needed epistemic access to this modal fact?

Further, as Frege wrote, in a review of Cantor, "many mathematicians and philosophers only acknowledge the potential infinite. Cantor now succeeds in showing that this infinite presupposes the actual infinite, that the 'receding limit' *must have an infinite path,* if it really is to recede ever and ever further" (1979, pp. 68–69; my emphasis). Indeed, it is instructive to compare Frege's remarks here with our earlier discussion of branching time and with the question of whether the ever-diminishing open future also presupposes an actually infinite path, or branch, along which this diminishing takes place. In any case, we must have another form of access to such an infinite path than the (A-theoretic) temporal one (which can bring us, at most, an incomplete or potential totality). Thus, if Cantor and Frege are correct, the advocates of potential infinity must resolve not only the previous epistemic problem but also the question of our access to actual infinity (the very question, no doubt, they were trying to avoid).

Whether or not, however, Lear or Aristotle can adduce a witness to potential infinity, and thus, if our disjunction is valid, cast doubt on the thesis of the ideality of time, it remains that Gödel's commitment to Cantorian set theory and actual infinity is untouched by any results about time. For Gödel combines his Platonism in mathematics with a strong commitment to mathematical intuition, which he refuses to identify with a Kantian-

Hilbertian concrete space or time intuition. (See, for example, Gödel 1964, and Yourgrau 1989, p. 395.) In a word, Gödel harks back to a kind of purely noetic or intellectual intuition, reminiscent rather of Plato than of Kant. It would be instructive to compare this conception with Charles Parsons's (1980) more Kantian account of mathematical intuition. Indeed, Gödel is explicit that such intuitions appear precisely to lift us out of the realm of the merely empirical into a kind of contact—an *analogue* of sense perception—with the mathematical world. But if Gödel is correct about time, and if we are then not to occupy the untenable position of failing to recognize any category of mathematical infinity, it would seem that he has found surprising new evidence concerning his, to date, far from influential conception of mathematical intuition.

The 'Direction' of Time and the 'Direction' of Infinity

Epistemological issues to the side, however, one should note two ontological aspects of A-theoretic time brought to the foreground by the issue of potential infinity: its *directionality* and its *incompleteness*. Recall Cantor's remarks in which he relates the potential infinite to "that so-called time which is counted *from* a definite initial moment." A potentially infinite series, then, has a definite origin and a direction from this origin. And this direction (from, one might say, the potential to the actual) is not reversible. A putatively potentially infinite series whose direction is toward the past, with a present member of the series as the origin, would, of course, be rather an actually infinite totality (since, for the present moment to have been reached, the former moments—all infinitely many of them—must have already elapsed, or become actual). Thus we have Kant's famous argument, in the First Antinomy, that the infinity of time can only be a feature of its future, not of its past (since, as we have seen, he recognized only the potentially infinite). Here, it would seem, mathematics and cosmology meet again, the direction of influence this time, however, coming from permissible mathematics to permissible cosmology. On this point, a vast debate has raged, over 'Kant versus Cantor'. (See, for example, Huby 1971; Whitrow 1978; and Craig 1979.)

With regard to the infinite past, I would suggest that, in order to maintain a clear view of the logical picture, we must keep in mind the following relationships: (1) (From the mathematical point of view) There is no strictly mathematical reason not to maintain the existence of both (a) potential and (b) actual infinities, so long as the epistemological basis of each is sound—for the case of (a), A-theoretic temporal intuition, for (b), if Gödel is correct, intellectual intuition. Thus the cases here are independent of each other, and are dependent on cosmological considerations only to the extent that these may speak to the validity of these epistemological bases—as we have suggested that Gödel's views on the ideality of (A-theoretic) time cast doubt on the legitimacy of the appropriate intuition of the potentially infinite. (2) (From the cosmological point of view) If time is, indeed, A-theoretic, then the past (unlike the future) cannot be infinite. But this fact would have no relevance, if Gödel's epistemology is sound, to the question of Cantor's set-theoretic conception of actual infinity. It would, however, be highly relevant to the question of the interpretation of relativity theory, if Gödel's arguments in this regard are sound.

But the connection of the directionality of time to questions in the foundations of mathematics involves more than the issue of the irreversibility of the direction of potential infinity. Let us distinguish the order of a series from its *direction*. Following Russell (1903, p. 210), let us say that a series of elements is *ordered* by a relation, R, if and only if, for each x, y $(x \neq y)$, either xRy or yRx (i.e., R is connected), and R is asymmetric (hence, irreflexive) and transitive. The *direction* of relation R, in turn, is from x to y if xRy. Further, one speaks of *the* direction of a *series*, which is thus unique and 'privileged'. Thus, for example, the series of natural numbers (construed Platonistically) is ordered by the relation 'less than', but also by 'greater than'. Unless one direction, then, is singled out as privileged—for example, by the A-series of time—there will be no such thing as *the* direction of this series. Indeed, Hans Reichenbach remarks (1958, p. 139) that the STR seems to require only that time be *ordered* in the preceding sense. And, I would suggest, recent attempts to analyze the 'direction of time' in terms of entropy are in fact more relevant to the question of *order* than to that of *direction*.

Now let us recall, with this distinction in mind, two recent reductions of intuitive mathematical notions to strictly logical/set-theoretic ideas. (1) Intuitively, in the ordered pair <*x*, *y*>, *x* comes before *y* in terms of direction. But modern standards of rigor (that is, of formalization) demand an explicit definition of such pairs in terms of (unordered) sets. The criterion of adequacy of such a reduction is usually given as <*x*, *y*> = <*w*, *z*> if and only if *x* = *w* and *y* = *z*. This, then, is satisfied by the now standard Wiener-Kuratowski definition: <x, *y*> = {{*x*}, {*x*, *y*}}. Indeed, W.V. Quine calls this a "philosophical paradigm," since it illustrates so well that "the question 'what is an ordered pair?', is dissolved by showing how we can dispense with ordered pairs in any problematic sense in favor of certain clearer notions" (1979, p. 260). It's clear that what Quine means by "clearer notions" are the logical/set-theoretic replacements for intuitive (here, temporal) ideas.

In terms of our earlier distinction, however, we observe that the Wiener-Kuratowski definition of an ordered pair preserves at most order, not direction. For an equally valid definition along the lines of this kind of reduction would be <*x*, *y*> = {{*y*}, {*y*, *x*}}. The intuition, then, that in the ordered pair, <*x*, *y*>, *x* comes first or precedes *y* has now been lost. And there is an additional problem here, analogous to that raised by Benacerraf (1965), for Frege's set-theoretic definitions of the natural numbers (more strictly, definitions in terms of extensions of concepts): to wit, that although an ordered pair is supposed to *be* an unordered set, there seems to be no nonarbitrary way to determine just which *particular* unordered set the ordered pair is supposed to be identical with. (See Dipert 1982, and Kitcher 1978.) (One should also note here that Cantor himself, the seminal figure in—'quasi-spatial', as Gödel says—set theory, took the notion of ordinal, or ordered sequence, as basic (see Hallett 1984, p. 8). If, then, the preceding remarks are to the point, we would seem to have *intimations of the temporal* in the very heart of the 'space' of Cantor's sets.)

Along the same lines as this kind of problem—that is, preservation, through reduction to logic/set theory, of order but not direction—lies Frege's purely logical reconstruction of the natural number series. His definition of the successor of a natural number is, as he insisted, of a purely logical/set-theoretic nature, with

nothing of the temporal remaining. Yet just this temporal (A-theoretic) element in the notion of the successor of a natural number was insisted on by Aristotle, Kant, and Brouwer. The replacement, however, of this unformalized, intuitive-mathematical conception by what Quine calls the "clearer notions" of logic/set theory leads to the preservation of the order of the intuitive, preformalized, natural number sequence, but not of its direction. And it is, of course, no accident that Frege, contra Aristotle, Kant, and Brouwer, considers this series to be actually infinite. If he, too, recognized it as only potentially infinite, then he would not have been able to disregard the question of the direction of this series—since, as we have seen, the direction of a potentially infinite sequence is not reversible (on pain of relinquishing its status as potential). (And, of course, *the*—actual—*infinite* enters Frege's formalization of logic and mathematics in the form of polyadic *quantification*. What Aristotle and Kant could only represent in terms of *iteration in time*, Frege can express in terms of *quantifiers*. See Friedman 1990, pp. 233–34.)

It seems, then, that the direction of modern work in foundations of mathematics toward formalization and thus toward the *detemporalization* of notions that seem otherwise to have an intuitive, A-theoretic basis may be leading us to lose sight of features of the mathematical world more visible to those less inclined to divorce *the process* of mathematical *thinking* from its thought *content* (in Frege's sense)—that is, to those who have no wish to decontextualize mathematical thinking. (See Wang 1961.) Often, indeed, when attempts have been made to banish all traces of time from foundations of mathematics, something temporal manages, nevertheless, to slip back in unnoticed. We conclude this discussion with an example of this phenomenon of special relevance to our concerns.

Complete versus Incomplete Totalities

Another familiar mathematical distinction that threatens to disappear along with (A-theoretic) time is that between *complete* and *incomplete* totalities. The potential infinity of natural numbers constitutes one such incomplete totality (closely related, clearly, to the incompleteness of the A-theoretic open future). But there are others. Cantor himself pointed out that the collection of all (in

themselves complete) transfinite ordinals does not constitute a complete totality—namely, a set. Indeed, he identifies completed mathematical totalities with sets and appears to regard mathematics as the science of such completed totalities. He writes, for example: "When . . . the totality of elements of a multiplicity can be thought without contradiction as 'being together', so that their collection into 'one thing' is possible, I call it a *consistent multiplicity* or a *set*" (Hallett 1984, p. 34). But, he adds, "[a] collection can be so constituted that the assumption of a 'unification' of *all* its elements into a whole leads to contradiction, so that it is impossible to conceive of the collection as a unity, as a 'completed object'. Such collections I call *absolute infinite* or *inconsistent* collections" (Dauben 1979, p. 245). The problem, however, is that the metatheory of set theory will clearly have to have recourse to just such "inconsistent collections," since, for example, the universe of *all* sets is not a set. (The proof is due to Cantor himself, who shows that although the 'universal set' would have to contain *all* sets, its own power set would be still larger, since, if the cardinal number of the universal set is a, the cardinal number of its power set is 2^α—and we have already seen that $2^\alpha > \alpha$.) The metatheory must employ, then, collections that are not sets—that is, incomplete totalities, known since Gödel as 'proper classes'. The question, then, is whether the metatheory of Cantor's paradigmatically Platonist, nontemporal theory of completed totalities, or sets, can itself be intuitively grounded without invoking those temporal (A-theoretic) ideas that we have found to lie behind other incomplete totalities, such as potential infinity and the open future.

The Incompleteness of the Universe of Sets

A case in point is Charles Parsons's discussion of the intuitive basis of set theory in 'What is the Iterative Conception of Set?'. At issue is the so-called iterative conception of set, favored by Gödel, who writes that "this concept of set, however, according to which a set is something attainable from the integers (or some other well-defined objects) by iterated application of the operation 'set of', not something obtained by dividing the totality of all existing things into two categories, has never led to any antinomy whatsoever . . ." (1964, pp. 258–59). A set, on this conception,

presupposes, for its existence, the 'prior' existence of its members (from which it is 'obtained'). As is perhaps already apparent, however, this 'genetic' conception may suggest to the imagination ideas of time and process (a set 'emerging' from the collecting together of 'prior' members), and Parsons argues that in his attempt to provide an intuitive picture of this conception Wang (1974), Chapter 6, comes too close to actually employing such notions. After all, "set theory," as Parsons says, "is the very paradigm *of a platonistic* theory" (Parsons 1983c, p. 273). Seeking, then, to avoid the (on the surface) temporal and the (more deeply) 'idealistic' strain, he finds (p. 268) in Wang's intuitive model, Parsons urges that "what we need to do is to replace the language of time and activity by the more bloodless language of potentiality and actuality" (p. 293). Drawing on Cantor's idea that the elements of certain ("inconsistent," as Cantor puts it) multiplicities (such as the 'universe' of all sets) cannot all 'exist together' and thus do not constitute a set, Parsons suggests that elements that exist together *can* constitute a set (p. 293). Further, for Parsons, this holds for any multiplicity of objects that can "exist together," where the latter appears to mean, or to imply, that they exist together in some possible world. "I assume," he says, "that in any possible world, $\{z: Fz\}$ is the set of existent z such that Fz in that world" (p. 286, Note 25). Clearly, moreover, no one possible world can be 'maximal', or closed under set formation, since "there is for any world i possibly a set of all objects existing in i that are not elements of themselves, and that set cannot exist in i" (Parsons, 1983d, p. 330). Finally, he invokes modal notions again in his account of 'inconsistent multiplicities' themselves. The "universe of all sets," he suggests, cannot presuppose the prior existence of all its members, since there is no such "prior existence." Rather, it is, for him, a so-called proper class, something essentially potential. A proper class, moreover, for Parsons, is something "predicative," kin not to an extension (of a predicate)—which has closer historical and conceptual ties to *sets*—but to an *intension*, "if we think of an intension in the traditional way as a meaning entertained by, and in some sense constructed by, the mind . . ." (1983c, p. 285).

Now, I cannot hope in the present context to do full justice to the richness of Parsons's account (which, moreover, seems to have developed from 1983c to 1983d), but I do want to advance some

considerations that suggest, to my mind, that here, too, temporal (A-theoretic) ideas are still in the background, and, further, that it is not clear that Parsons's own line of approach is as close to Cantor's as one might wish. To begin with, then, how can one reconcile Parsons's own characterization of set theory as a very paradigm of platonism with his conception of the 'universe', itself, of all sets (a proper class) as essentially potential and, moreover, akin to intensions seen as, in some sense, constructs of the mind? *How can sets themselves be platonic objects if their 'totality' is not?* Further, has he not leaned, himself, in the very direction of 'idealism' he was concerned with on Wang's part, with his own invocation of meanings constructed by the mind? Indeed in this regard, it seems even not quite appropriate to continue to speak of 'the universe' of all sets. *Is a 'potential-universe' a universe?* Recall that Kant's idealism leads him to be suspicious of talk of the (here, physical) universe (as an absolute totality). Parsons, of course, is well aware of all this, and recognizes that when he chooses to characterize talk of all sets as "systematically ambiguous," this itself threatens the very idea of *the* universe of all sets (p. 296). What is not clear, however, is what has happened, at this point, to set theory as paradigmatic platonism, and to the avoidance of idealism.

The One and the Many

A further question that naturally arises for Parsons's modal conception of set existence concerns the 'totality' of the possible worlds themselves. Clearly, he would not accept the notion, introduced earlier in this monograph, of 'modal space'. Indeed, in his 1983d account of modal set theory, he espouses a metatheoretical perspective that operates not with the classical set-theoretic account of possible worlds, but rather with a primitive modal language. What I wish to focus on at this point, however, is the question of the totality of all sets. Parsons moves too quickly, to my mind, from the fact that this multiplicity is "inconsistent"— from the fact, that is, that it does not constitute a set—to the conclusion that it is not, strictly speaking, a *totality* at all (which presupposes the existence of all its elements), but rather a mere *'potentiality'*. After all, for Cantor the 'absolute infinity' of an 'inconsistent multiplicity' is not potential but *actual* (Hallett

1984, p. 41). Wang, it seems to me, comes closer to Cantor's original conception. "[T]he multitude V of all sets . . . presupposes for its existence (the existence of) all sets and therefore cannot itself be a set. . . . The universe of all sets is the extension of the concept of set and is a multitude (many) and not a unity (one)" (1977, pp. 310–11). If a set is a 'class as one', then the universe of sets is a 'class as many' (to borrow Russell's terminology from 1903, §70) or a 'manifold'. A manifold, for example, of sheep, is not some *one* thing (viz., a set) that represents a 'collecting-together' of the sheep ('in thought', that is—the collection of sheep in the meadow, of course, is a flock), but rather *many* things—that is, *the sheep!* (See Sharvy 1980; Simons 1982; Boolos 1984.) To be, then, though it is always to be (the same as) *something*, is not always to be *one,* or a *'unity'.* Indeed, as (Plato's) Parmenides says: ". . . the character of unity is one thing, the character of sameness another. This is evident because when a thing becomes 'the same' as something, it does not become 'one'. For instance, if it becomes the same as the many, it must become many, not one" (Plato, *The Parmenides,* 139d; drawn attention to in Simons 1982).

The advantages of viewing the universe of sets as a many, a manifold, are several. For one thing, one need not give up the idea of this as a genuine universe, a totality, that is not merely potential, and that does indeed presuppose the existence of all its members, for nothing prevents the members of a manifold from enjoying ontological parity, that is, from having, all of them, the same ontological status—a characteristic we attributed, earlier, to a 'space', in the general sense. This would agree, then, with Gödel's idea of sets as 'quasi-spatial' (extending the meaning we attributed earlier to this phrase, from the 'quasi-spatial' being of all the members of a set to the quasi-spatial being of all the sets themselves). In addition, we would avoid the troubling question of how one can conceive of a multiplicity as potential without invoking, implicitly, temporal (A-theoretic) notions. It is not clear, that is, how the collection of sets, on Parsons's reading, can be merely *potential,* if it is not becoming *successively completed* (over time). For what is needed seems to be something in between being merely a limited and extendable domain and being a fully completed, unextendable, 'platonistic' domain; and this in between mode of being has traditionally been viewed as that of

successive coming-into-being—that is, the very mode of being of time and 'activity' that Parsons was trying to steer us away from in providing an intuitive basis for set theory.

Further, we would avoid, by invoking manifolds, essential use of Cantor's dangerous idea that the members of an 'inconsistent multiplicity' cannot 'exist together'. This phrase seems to be temporal/spatial in origin (thus evoking ideas out of place in set theory), and I remain uncomfortable with what seems to be its modal interpretation by Parsons (existing together in a possible world). To my mind, either we have here something tautologous (the members of a non-setlike multiplicity cannot all exist-together-*in-a-set*), or I am inclined to protest, as Dedekind did to Cantor, that "I don't know what you mean either by the 'being together of all elements of a multiplicity' or its opposite," (letter to Cantor, August 3rd, 1899; quoted in Hallett 1984, p. 34). Finally, this conception of a manifold would also enable us to conceive of the 'totality' of possible worlds as a quasi-spatial many. This idea, however, raises a new problem. If, as we suggested, the members of a manifold of possible worlds enjoy ontological parity, this still leaves us with the question: What exactly is this ontological status they all equally enjoy? From our earlier discussion of Lewis, it should be clear that this will not be existence. We will come, shortly, to the issue of just what it will be. We turn first, however, to another, crucial, employment of modal reasoning by Parsons, a consideration of which will enable us to draw a number of strands together.

A 'Modal' versus Temporal Account of Potential Infinity

Parsons advances a modal, as opposed to a temporal (A-theoretic), conception of potential infinity. He suggests (1983a, p. 47), as a representation of potential infinity, a model for a modal logic containing S4, in which the possible worlds are all finite, but where for each world there is always one possible relative to it which contains one more member. And in 1983d he continues, in this vein, to suggest that for "conversion of a 'potential' infinity into an 'actual' infinity . . . in terms of a set-theoretic semantics for the modal language, the possible worlds containing finite segments of ω need to be collected into a single one" (pp. 295–96).

Now, it should be immediately clear how far this modal concep-
tion of the potential/actual infinity distinction is from the tempo-
ral (A-theoretic) one of Aristotle, Kant, and Brouwer (if our
reconstruction of the ideas of these thinkers has been along the
right lines). But let us consider, explicitly, some of the questions
that arise for the modal conception of potential infinity. One
peculiarity that comes immediately to mind is that we would seem
to have before us, now, *two different 'sizes' of potential infinity.*
On the one hand we have the potential infinity of the series of
possible worlds representing all the finite segments of ω, and on
the other the (presumably) potential infinity of the (essentially)
potential multiplicity of (the 'universe' of) all sets. Here, we must
face the prospect that although it is difficult to see how one is to
compare two different, merely potential infinities, the first is intu-
itively the 'smaller' of the two—it 'precedes', as it were, Cantor's
ascending sequence of actual infinities—while the second not only
cannot be 'converted into' an actual infinity, but it seems to 'tran-
scend' the entire hierarchy.

A further problem is that, from a certain point of view, the
first model is precisely one of an *actual* infinity (even before the
'conversion'), for does it not present us with an infinite sequence
of possible worlds—that is, an *actually infinite* sequence (if it is
really to represent *all* the finite segments of ω)? (It is becoming
even clearer why Parsons suggested [1983d] that strictly we
should give up the set-theoretic possible worlds approach to
modal logic—to fulfill the program of modal set theory.) To deny
this implication, it would seem necessary to view the sequence of
possible worlds as itself a merely potential multiplicity. But this
would seem to bring with it a doubling of modalities (that is, a
potential totality of *possible* worlds)—and what could this mean?
(One must be careful not to conflate what is at issue here with the
fact that in classical semantics of modal logic, as in Kripke 1963,
we have a clear representation of iterated modal operators, e.g.,
'possibly possibly p' (or $\Diamond\Diamond p$). Here, $\Diamond\Diamond p$ is true in a possible
world α, just in case $\Diamond p$ is true in a possible world α', accessible
to α, and $\Diamond p$, in turn, is true in α', just in case p is true in a possi-
ble world α'', accessible to α'. We thus have clear truth conditions
for *formulas*, like $\Diamond\Diamond p$, without needing to invoke such things as
'possible-possible-worlds'.)

Indeed, to connect this issue with our earlier discussions of temporal series, we observe that Parsons's modal model for potential infinity employs, as it were, only 'B-theoretic' (to speak figuratively), 'structural-geometric', features of a manifold, as opposed to the A-theoretic (to speak literally) properties of potential infinity of Aristotle, Kant, and Brouwer. Parsons's model is B-theoretic, or relative-A-theoretic, insofar as the salient feature that we are to read as limiting the infinity in the model to the potential is that we are only permitted to assess the size of the segments of ω present in the model *relative to*, or from the perspective of, individual possible worlds. He does, in fact, say elsewhere that "the alternate possibilities that our modal operators envisage are simply those in which possibilities of set formation have been realized that as yet have not been realized. The logic will then be somewhat like the sort of tense logic in which everything past is necessary (unalterable by later events)" (1983d, p. 316). But this quasi-temporal talk of 'realization' is only figurative. Clearly, nothing is really 'happening' in his model: All is, as it were, 'static, geometric, relational'. Our response to the model clearly violates, then, the way we are intended to read it, namely, from the perspective of the individual possible worlds (hence, the significance, in 'converting' a potential into an actual infinity, of 'collecting together' all finite segments of ω into a *single* possible world). (Recall our similar problems with the Thomason model of indeterminist time, which, it turned out—or so we claimed—was indeterminist only if one always limits one's 'perspective' to individual times.)

The 'Space' of Possibilities

Once again we have a disagreement with Parsons over what is required in order to have before us a truly spacelike multiplicity. As before, Parsons appears to require that all the elements be 'collected together' in a single possible world (where they can all 'exist together', or all 'be actual'—relative to that world), while on our account the presence of all the members in a manifold— that is, as a many—suffices for us to be presented with a 'space' (here, a 'modal-space'), in which the members enjoy ontological parity. But now, since the manifold in question must span possible worlds, the ontological status shared by all the worlds (and,

.

hence, by all the finite segments of ω) must be, not existence or actuality, but rather possibility.

But what business do we have quantifying over a domain of mere possibilities? Must there not, after all, be something there to quantify over? Precisely, but that's why we hinted, in our earlier discussion of Lewis and Stalnaker, that we must distinguish *being* (something) from *existing* (being actual, being present), and why we will insist, in the following section, that the existential quantifier, '∃*x*' or 'there is something *x*', be read not, as with Quine (1969, p. 97), as expressing existence, but rather, *'being'*—that is, being something that (if a contingent being, like us) can come to, as well as cease to, exist. Indeed, it is perhaps worthwhile to point out that this conception of (possible) objects (including possible worlds) should not be viewed as *Meinongian*. Parsons, unfortunately, in characterizing the free variables in (one of) his modal constructions of set theory as ranging over all possible objects, expresses concern lest this aspect of his approach be thought "too Meinongian" (1983c, p. 286, note 25). And Kripke, it will be recalled, already got into trouble on just this point, in his seminal 1963, when he incautiously asserted that although Sherlock Holmes does not exist, he might have. Such a claim really does appear to invoke a naive Meinongian semantics that all proper names, including those in fiction, refer to genuine objects. At issue here, however, in letting one's variables range over all possible objects is not a Meinongian semantic thesis about *names*, but a 'Parmenidean' ontological proposal about *objects* (as I put the matter in Yourgrau 1987b). Thus, as Kripke wrote in his 'Addendum':

> I could no longer write, 'Holmes does not exist, but in other states of affairs, *he* would have existed.' . . . This change affects my view of the linguistic status of fictional names in ordinary language but does not affect the model-theoretic issue involved in the text, namely (1) some of the entities which actually exist might not have existed, and there might have been entities other than those which actually exist. (Kripke 1963, p. 172).

If, then, distinctions like these are sound, I remain skeptical that the modal approach to potential infinity can succeed in capturing the intuitions that, I have argued, lie behind the classic,

temporal (A-theoretic), conception (unless, that is, implicit temporality is smuggled into the proposed model). Thus, here, as with the modal approach to set theory, one finds yet more evidence of *the difficulty of doing justice to* (what one takes to be) *a genuinely non-spacelike,* essentially incomplete *'totality' while restricting one's formal methods to the 'geometric-spatial'* (in the general sense). Indeed, I think Parsons's work, here, can be seen, in part, as a strong response to just this dilemma. What our worries have centered on is the question of whether one can succeed, as would appear to be Parsons's intention, in developing non-'geometric-spatial' formal methods that yet "replace the language of time and activity by the more bloodless language of potentiality and actuality." *The price of abandoning (A-theoretic) temporality may be a high one, indeed.* Things become even worse, however, once we turn from mathematical to more general, ontological concerns, where (A-theoretic) time, it turns out, appears to be essential to marking the distinction between human-being and human-existence.

Being-in-Time: Birth and Death

> Like a running grave,
> Time tracks you down.
>
> Dylan Thomas

It is an unpleasant but unavoidable deliverance of intuitive time that, since we are not gods, there lies in our future the consequence of our mortality—namely, death. "The Coming of death is the inescapable result of the irreversible flow of time. . . . The fear of death is thus transformed into a fear of time" (Reichenbach 1956, p. 4). This is one of the phenomena that any philosophy that hopes to be taken seriously must, in Plato's terms, save. And when we are dead, what then? Do we, somehow, become nothing? Hardly, since the very real grief of our survivors turns on their ability to still think of or refer to us (without thereby thinking of nothing). But who exactly will my survivors be grieving over? Well, me, except myself as dead, gone, nonexistent. For past individuals have not merely changed their residence, having simply 'moved into the past'. (Although this is how Harry Silverstein 1980, fol-

lowing Quine and the alleged spatialization of time in the STR, chooses to view things.) Rather, as Aristotle puts it, "[f]or living things, it is living that is existing" (1983, 415 b12).

Can the Dead Be Buried?

But if, for us, existing means living, then not living—that is, being dead—means not existing. Thus, we have it that (1) The dead don't exist. When I announced this result in 'The Dead' (Yourgrau 1987b), it seems to have produced something of a shock. Not everyone, however, seems to be shocked by this proposition. Kaplan, for example, writes in 'Afterthoughts' (1989b) that "[p]ast individuals are also, in my view, nonexistent." In any case, as we have seen, it follows by exactly one logical step from Aristotle's reasonable observation, which is itself a straightforward deliverance of the intuitive conception of time and of living-in-time (and what other kind of living is there for those of us who are not gods?). But let me shock you even further. It follows immediately from (1) that (2) The dead cannot be buried. For what does not exist is obviously not there to be shoveled under the ground. You will certainly bury something, only it will not be *me*. This is a point that continues to elude the Critos of this world:

> 'But how shall we bury you?' said Crito. 'Any way you like,' replied Socrates, 'that is, if you can catch me and I don't slip through your fingers.' . . . 'I can't persuade Crito that I am this Socrates here who is talking to you now . . . ; he thinks that I am the one whom he will see presently lying dead . . . [but] when I have drunk the poison I shall remain with you no longer'. (Plato, *The Phaedo*, 114A-115D)

The Dead Aren't Memories

Once we have extended our ontological horizons, however, to recognize the dead as nonexistent objects, we are free to acknowledge other nonexistents: the unborn (i.e., future people), those who will, alas, never be born (merely possible *people)*, merely possible *worlds,* past and future *times,* and so on. Thus, we propose an ontological symmetry here in terms of *categories of being:* Future people are *people* (not *concepts, names,* etc.), past people

are *people* (not *memories,* etc.), possible worlds are *worlds* (not sets of *concepts*—Stalnaker 1976—sets of *sentences,* etc.). And we thus satisfy Kant's famous dictum that "the real contains no more than the merely possible. A hundred real dollars do not contain the least coin more than a hundred possible dollars" (1965, A599/B627). We do *not,* however, thereby commit ourselves to a *spatialization* of these categories of being—in the manner of Lewis's extreme and literal 'modal realism', since we continue to distinguish the *mode of being* of these beings, namely, *existence* (of present or actual people, times, worlds), from *nonexistence.* Thus, along the lines of our discussion of the metaphysics of modal logic in the previous chapter, we continue to steer a course between the Scylla of Lewis (spatialization) and the Charybdis of Stalnaker (ontological asymmetry).

We thus *take individuals seriously.* Physics is not ontology. The logic of (human) *beings* is not the logic of *bodies.* We are not bodies but are embodied. (As we saw, in our Frege reconstructed, the sentence is not the thought, but rather its embodiment.) What we are in need of, then, to understand human existence is not more physics or biology, but rather a systematic *logic of embodiment.* (For some important first steps in this direction from an Aristotelian perspective, see P.F. Strawson 1963. For more advanced Aristotelianism, see Montgomery Furth 1988. For Platonism, my own sympathies lie with Harold Cherniss 1962.) Even today, however, and even among modal logicians and meta-physicians, individuals are not, in general, taken fully seriously. In addition to the dilemmas of Lewis and Stalnaker, already addressed, one can point to Kripke, in many respects (as we said), the seminal figure in modal metaphysics. For although Kripke correctly insists, in his 1980, as against Lewis (and possibly Leibniz; see Ishiguro 1972, p. 123), on "transworld identity"— namely, that the selfsame individuals exist in different possible worlds—when it becomes a question of the ontological status of the possible worlds themselves, he backs off. Fearing, it would seem, to sail his ship toward the Lewis-Scylla or the Stalnaker-Charybdis, he declines to set sail at all. As we saw earlier, we are merely warned, with Lewis in view, not to take the model of possible worlds too literally, but we are not told just how literally we *ought* to take it.

To be blunt, it too often appears that the modal logician (or the tense logician) is inclined to back away from the perilous metaphysics toward which his or her mathematical models would appear to point. And when the charge is: *metaphysics!*, the reply is: *mathematics!* But this is both surprising and unfortunate, since part of the great interest, for example, in Kripke's and Thomason's formal models in these areas is due precisely to their suggestive *metaphysical* implications. On this matter, Kaplan appears to be more willing to face the metaphysical consequences, with respect to individuals, to which his own work would appear to point. As we have just seen, he recognizes that past individuals do not exist and, reversing his course from 'Transworld Heir Lines' (1979), he now recognizes, in 'Demonstratives' (1989a), the transworld identity of individuals. But he goes further and correctly points out that since his position requires that individuals not be purely qualitatively individuated, it follows, "although I am uncomfortable with [it] . . . that the world might be in a state qualitatively exactly as it is, but with a permutation of individuals" (p. 505). I take this willingness to follow the idea of the irreducibility of individuals even to such, at first glance, strange conclusions to be a sign that one is now engaged in serious metaphysics.

Adopting, then, an ontological, as opposed to a merely biological, point of view, we pose the question: Where do we come from? (And where are we going?) That babies come from the womb is a familiar biological fact concerning our early *bodies*, but it is of no help with the present question. I thus lay down my third alarming proposition: (3) We don't really know *where* we (as babies) came from. And now something equally surprising begins to emerge. Gödel himself appears to be joining us on this Platonic journey. For in four long letters to his mother in 1961, he lays down some consequences, on the nature of the soul, of his 'theological worldview'—"the idea that the world and everything in it has meaning and reason, and in particular a good and indubitable meaning" (Wang 1987, p. 217). (Of course, one must bear in mind that these letters were not intended for publication.) To begin with, "[i]t follows immediately that our worldly existence, since it has in itself at most a very dubious meaning, can only be means to the end of another existence" (p. 217). Indeed, in connection with my proposition (3) Gödel writes that "[s]ince we

came into existence one day in this world *without knowing how-so and whence*, the same can happen again in the same way in another world" (p. 214; my emphasis). This is also clearly an echo of the *Phaedo*, where Socrates suggests that the correct picture is not 'living → death' but rather 'death' (i.e., prenatal nonexistence) → living → death. But this last picture, he argues, leads, by unavoidable symmetry, to the most complete account: 'death' → living → death → 'living'. (I put scare quotation marks around the outermost terms, since these represent at best analogues of the middle terms.) Thus, as Socrates says, "the living have come from the dead no less than the dead from the living" (Plato, *The Phaedo*, 71A–72B). For Plato then, as, it would seem, for Gödel, *birth and death are changes*—namely, the crossing of the border between nonexistence and existence. Plato makes this even more explicit in *The Parmenides:* "The non-existent one cannot move by shifting its position . . . and the non-existent cannot be in anything that exists" (1957, 162c). (Thus, the *unborn* nonexistent cannot 'be' in the *womb* or the *dead* nonexistent in the *grave.*) But "transition is motion," and "the nonexistent one has been shown to be a thing that moves, since it admits transition from being [nonexistent] to not-being [nonexistent]" (162b; my interpolations).

Birth and Death as Changes

Birth and death, then, are changes (with respect to existence), and as Plato makes clear in *The Phaedo* and as Aristotle affirms in a number of places, change requires a continuing substratum that underlies this 'motion'. Thus, it is the self-same individual, Socrates, before, during, and after life. Hence, we conclude that Socrates is not to be identified merely with the existing (hence, living) Socrates. And so we have our next thesis, (4) (The) 'Being' (of Socrates) ≠ (the) Existence (of Socrates). Since there must 'be' Socrates before birth in order for his birth to constitute a change in Socrates, from non-existence to existence, being Socrates cannot be the same thing as Socrates existent. Since intuitively, then, there is someone, Socrates, who did not exist but came to exist, I suggested in my 1987b that we let the formal existential quantifier express 'being'—that is, express the fact that there is such a person as Socrates (before and after birth)—and

also that we introduce a new, primitive, predicate for existence—namely, 'E!'. The statement, then, that Socrates is (now) dead—that is, nonexistent—continues to imply, by the principle of existential generalization, that there is someone who is nonexistent. This is now parsed as: $(\exists x)(\sim E!x)$. And Kaplan seems to agree with this when he writes, in 'Afterthoughts', that "[i]t would then be natural to add a narrow existence predicate to distinguish the robust being of true local existents, like you and me, from *the more attenuated being of the nonexistents*" (1989b, p. 608; my emphasis). Here, too, however, it is Plato who has set the stage: "[A one which does not exist] . . . must in some sense even possess being. For it must be in the state we are ascribing to it. Other-wise, we should not be speaking the truth in saying that the one does not exist" (1957, 161e).

But even having distinguished being from existence, and having recognized birth and death as motions or changes of the self-same being from the state of nonexistence to existence (or the reverse), we have not yet given the complete picture. For living, as we reminded ourselves earlier, is a process that takes place in (clearly, A-theoretic) time, and we have yet to stress the fact that birth obviously precedes death. And that is, of course, why we naturally *fear death* but *not* our *prenatal nonexistence*—a fact that must remain invisible or inexplicable to spatializers of time like Silverstein (1980) and Mellor (1981) (and recall here our discussion of Mellor's attempt to account for our different attitudes to present versus future pains and misfortunes). Putting to work our earlier distinction between the order and the direction of a series, then, we note that it is the A-series direction of our deaths as lying in our futures that accounts for the natural fear of dying, since from the point of view merely of B-theoretical temporal order, the positions occupied by pre- and postnatal nonexistence are symmetric. As with the direction of a potentially infinite mathematical series, the A-series direction, here, of living, pointed toward our deaths, is not reversible. And that is why even if all ends for us at death, it matters a great deal, as both Plato and Nietzsche insist, *how* we die, for the end is more important than the beginning. Indeed, in *The Phaedo*, Plato goes so far as to describe philosophy itself as the proper preparation for, and even cultivation of dying.

Since Gödel, however, seems to be in agreement here with Plato concerning the logic of individual human existence, with reference to our entrance (through embodiment) into and our exit from this world, represented by birth and death, it follows that Gödel's views on Einstein and time, in regard to this world, give us only half a picture of his philosophy. The theological worldview, it seems, must complement the space-time perspective. Once again we are called upon to view the world from two different points of view—from within and also *sub specie aeternitatis*. Yet, somehow, we, the individual selves, must be able to support *both* perspectives. Then what *are* we? "We do not know *what* we are (namely, in essence and seen eternally)" (Gödel, in Wang 1987, p. 215). But we do know *that* we can raise such questions and can choose to view this world (including our present embodiment in this world) from a higher (for Gödel, "theological") perspective. In *this* sense, then, we know that "[t]he mind is eternal in so far as it conceives things under the form of eternity" (Spinoza 1955, Book V, Proposition XXXI). Perhaps, then, we should consider Gödel's relativistic geometrization of space and time in the light of Plato's own cosmological geometrization in *The Timaeus* (in terms of fundamental geometrical Forms). For it appears at first glance that there can be, for Plato, no place for us in the phenomenal world except as merely one of those flickering images (in the Receptacle of Becoming) of the Fundamental Forms, and that our mode of being—namely, (temporal) becoming—is only a moving *image* of Eternity. Yet Plato recognizes *human-being* as somehow intermediate between merely temporal-phenomenal and genuinely Formal or Ideal being. Thus, as Cherniss puts it, for Plato, "both ideal being and phenomenal becoming are apprehended by a subject which is neither the one nor the other, but a mean between the two" (1962, p. 410).

Now no one, I believe, from Plato, to Aristotle (recall his proposal that the form of the mind is formlessness), to Kant (the phenomenal versus the transcendental ego), to Wittgenstein ("The subject does not belong to the world": 1974, 5.632), to Gödel, has succeeded in solving, or 'dissolving', this question of the intermediate existence of the self—that self that is somehow able to adopt both perspectives toward the world. But we can at least place Gödel, I think, with Plato, in discerning here a gen-

uine—indeed, a fundamental—clue to the nature of human being that is not dissolved by a more perspicuous view of language or resolved by a synthesis of the two perspectives. For Gödel, with Plato, views our embodied existence, in this world, as at best a confused and cloudy preparation for something more meaningful—in our postnatal nonexistence (i.e., nonexistence after death in this world). "Without a next life," he writes, "the potential of each person and the preparations of this life make no sense" (Wang 1987, p. 214), for "[w]hat would be the *point* of bringing forth an essence (the human being) that has so wide a range of possible (individual) developments . . . but is never allowed to realize one thousandth of them?" (p. 214). And perhaps the following remarks of Gödel on the non-reducibility of mind to machine point in the same direction of unlimited potential: "[M]ind, in its use, is not static but constantly developing . . . [and indeed] [t]here is no reason why the number of mind's states should not converge to infinity in the course of its development" (p. 197). Further, with Plato in *The Phaedo*, he insists that "[t]he greater part of learning will take place in the next world" (p. 214) and, moreover, that "we could very well be born [into the next world] with latent memories [of our experiences in this world]" (p. 214).

The Meaning of Eternity

It is not a question then, for Plato or for Gödel, of simply living longer, beyond death. Rather, as we saw earlier, eternity means for Plato (and, I would suggest, for Gödel) not 'long-lasting life' but rather 'genuine' ('Ideal') being. Thus, there is no force here to Wittgenstein's protest that "[n]ot only is there no guarantee of the temporal immortality of the human soul, that is to say of its eternal survival after death; but, in any case, this assumption completely fails to accomplish the purpose for which it has always been intended. Or is some riddle solved by my surviving forever?" (1974, 6.4312). In the first place, as Gödel suggests, it is rather death that closes off the unlimited possibilities of individual human development, death that introduces meaninglessness or the riddle of embodied existence. In the second place, it is a question not just of further existence but of development in a certain direction—the direction of (self) perfection, and so transfiguration.

The picture, I believe, is as follows: Since we are beings who are born with the greatest possible separation between what we are potentially and what we are actually (since neither God nor angel has room for improvement), it follows that the purpose of our lives consists not in perfecting any given stage of development, but rather in transcending it, of moving to the next, or higher, stage. As a perfect child is precisely a child successfully on the way to becoming an adult (and not, therefore, a kind of everlasting Peter Pan), a perfect adult points toward something beyond—something that has the same relation to adulthood as the latter has to childhood. "Man is called a baby by God, even as a child by a man" (Heraclitus, Fragment 97, in Burnet 1968, p. 140). Naturally, in both cases, the child in us clings to the stage at hand, fearing the darkness of the only dimly discernible future transfiguration, in which we—as we have come to know (and love) ourselves—will suffer the 'death' of unrecognizability.

Having emphasized, however, that, notwithstanding Wittgenstein's suggestions, there is no fallacy lurking behind the Platonic-Gödelian conception of the significance of death, I would like to try to cut a little deeper and to offer a possible means of reconciling what may appear to be two irreconcilable points of view. Gödel and Plato, then, appear to wish to transcend the limitations of temporal being by contemplating the possibility of crossing the barrier that death places in the way of our embodied existence. Wittgenstein, too, however, considers it essential to escape the confines of temporal being. However, he thinks of accomplishing this from within time: "For life in the present there is no death. If by eternity is understood not infinite temporal duration but non-temporality, then it can be said that a man lives eternally if he lives in the present" (1961, p. 75e). Compare Pascal: "We never keep to the present. . . . Thus we never actually live, but hope to live" (1966, *Pensée* 47). What Wittgenstein seems to have in mind here is not the merely negative attitude of ignoring the full temporal context of our lives, but rather just the reverse—that is, rendering the daily fabric of our existence of such significance that each moment approaches the ideal of becoming self-contained or 'an end in itself'. Far from wishing to neglect 'the whole', Wittgenstein wishes each part to reflect it, as a work of art may reflect a whole life:

The usual way of looking at things sees objects as it were from the midst of them, the view *sub specie aeternitatis* from outside. . . . The work of art is the object seen *sub specie aeternitatis*. (Wittgenstein 1961, p. 83e)

Wittgenstein, I suggest, has in mind, when he speaks of "life in the present," a distinction not unlike that of Aristotle's between *energeia* and *kinesis*. A *kinesis* is an essentially temporal activity that aims at some end external to the process itself (as when Glenn Gould *hunts* for his score of the Goldberg Variations), whereas an *energeia* is an activity (or state—see White 1980) that either is an end *(telos)* or in which an end is contained, and that is thus complete, perfect, or self-contained (as when Glenn Gould *contemplates* his score of the Goldberg Variations). Now the paradigm of an *energeia* is intellectual (aesthetic, loving) contemplation, and this concept has its home in Plato's philosophy. But now Plato seems to be aligned not with Gödel but with Wittgenstein! What has happened? The answer, clearly, is already before us. Gödel and Wittgenstein are at one with Plato that, in essence, temporal being is incomplete being, and that to fulfill our potential most completely as truly human beings we must seek somehow to 'cheat' time, to overcome the limitations of temporality. Gödel chooses to emphasize the partial nature of any such representation, or embodiment, of eternity from within the fabric of time (indeed, even Aristotle believes that only God-as-*noûs* could perfectly engage in the perfect *energeia* of contemplation). Wittgenstein, in contrast, wishes to emphasize the possibility of escaping (as much as is humanly possible) the tyranny of death by the incorporation into one's daily life of the perspective of eternity. If Plato can be cited on behalf of each of these attitudes to death and temporality, the reason for this, I believe, is that he himself adopted both.

E.N. Lee (1976) suggests, along these lines, that Plato maintained two points of view on the nature of *noûs* (and so, also, on the nature of the philosophical life and the question of dying). From the 'indwelling perspective' (*Timaeus,* and *Laws,* Book X), the model of *noûs* is the rotation of a sphere around a fixed and motionless center—an image of pure, perspectiveless cognition unconstrained by the necessity of adopting a limited point of view. Plato's use of the sphere, here, is surely not unrelated to

Parmenides's (1957, p. 44), and Lee remarks, correctly in my view, that for both thinkers this image marks "the real as perspectivally neutral" (p. 98). In contrast, from the 'threshold perspective' (roughly, *Phaedo, Phaedrus, Republic,* and *Symposium*), *noûs* represents the freeing of the *psyche* from its kinetic wanderings in this physical realm of fret and motion, releasing it into the company of the motionless, stable, and perfect Forms, with which it feels a deeper kinship. The guiding metaphor here is that of *noûs* as the culmination of the crossing over from the realm where one finds oneself—but where one is never really at home—to the next (and happier) realm. "It is essentially," says Lee, "the exile's view" (p. 91). But since there is no point in crossing the threshold into the happier realm unless one is prepared to dwell there, and since there is good reason to make our stay or dwelling in our present realm as much like that in the next as possible, it would appear that the two perspectives are complementary. So, too, then, would be the related points of view of Gödel and Wittgenstein.

Time and Eternity

What is not clear to me, however, is how Gödel can reconcile his Platonic conception of our this-worldly preparation (gradually, over time) for something more meaningful, beyond, with his strong doctrine of the ideality of time, which, though Kantian, is not Kant's, and is clearly other than Plato's. For time, it would seem, for Plato, does not entirely lack being (as it would appear to, for Parmenides—whom Gödel cites approvingly) but rather enjoys a kind of lesser or merely reflected being. Kant, as so often, appears to be a kind of halfway house here, yet it is not clear that Gödel is sympathetic to the idea of the Kantian transcendental self (echoed, to some extent, in the *Tractatus*—a book Gödel is known to have disliked). The resolution of this dilemma, for Gödel, may lie in his well-known affinity for the very different idealism of Leibniz. Yet, to date, we still have the fewest words from Gödel's pen on this, his most admired philosopher. For us, however, there remains *the dilemma of reconciling* these two bodies of phenomena—*the philosophical concomitants of A-theoretic time and the challenge Gödel has posed to incorporating this intuitive time within the framework of relativity theory.* Even more generally, there is the problem throughout of

reconciling the ideal (the perfect, completed, fully actual) with the *real* (the empirical, merely factual, given). This is, I believe, the fundamental problem in the Platonic philosophy, and reflection on it will enable us to draw a number of strands together, taking our lead from Chapter 6, on Frege's decontextualization of thought.

Decontextualization in a General Setting

What has emerged from our discussion so far is the Platonic point that the context of lived, human, temporal reality suggests or points to an ideal (or Idea, in Plato's sense), in the light of which alone we can *make sense* of this lived reality but that, *if actually realized*, would lead to paradox. For although Plato is famous precisely for having decontextualized, or '*separated*', these ideals, or ideas (Vlastos 1987)—and has been criticized on just this point by Aristotle and Kant—I believe that just as according to his philosophy this world is only seen correctly if viewed in the reflected light of the separated Ideas, these Ideas themselves cannot be grasped, or fully made sense of apart from their human, temporal, dialogical context, in which the need for them first arises. For Plato, of course, only writes philosophy in the form of dialogues, so that we never see the Ideas themselves except as they are seen by us. Indeed, it is *this*, I believe, and not simply a concern with ethics, in the narrow sense, that Plato takes as the Socratic 'turn' to the human. In contrast, for the speech of Parmenides,

> [t]ranscending human discourse as it does, its expounder transcends humanity and therefore speaks the language not of mortal men but of gods. . . Dialogue, for Plato, is an externalization of the process of thought. . . . [For Plato] genuine dialogue with another is impossible for anyone who will not engage his own soul in dialogue with itself, that dialogue of which the other is only the externalization and embodiment. (Cherniss 1977, p. 20)

(This provides, I believe, a hint, which I cannot here follow up, that the 'individualism' that Wang 1987 attributes to Gödel is not incompatible with the dialogical approach favored by Plato. See Yourgrau 1987c, pp. 112–14; 1989.) With this sense of dialogue or dialectic in mind, then, let us consider several specific contexts where it arises.

a. In geometry, although Plato insists that the idealized, pure, geometric forms are the true subject of the geometers, and even, in *The Timaeus*, that they constitute, in some sense, the very fabric of the material world, they are, paradoxically, themselves invisible. As in the Lewis Carroll story, if all that remains of the Cheshire cat is the pure geometrical crescent of its smile, then the cat will appear to vanish into thin air. Indeed, there is in general a great mystery, to put it mildly, in Plato's conception of the *visible* realm as a reflection and 'imitation' of the *invisible*.

b. Gödel, as we have seen, suggests, with Plato, that our this-worldly, embodied existence makes inadequate sense on its own if it is the final, ultimate, reality about the human—that is, if it remains forever incomplete. Indeed, as I put it elsewhere,

> just as in mathematics one 'sees' on the basis of limited but ever increasing iterations that the sequence of natural numbers will, if we adopt the 'arithmetical' point of view, never end, and similarly that two straight lines in Euclidean space drawn in even slight convergence must, 'in principle', meet, if we permit ourselves to take on a purely geometrical point of view and thus do not confine our attention to the properties of 'straight lines' in physical space, so in human affairs Gödel suggests, in effect, that the 'lines of convergence' from our brief and so imperfect but yet partially beautiful lives can be 'seen' (eventually) to complete themselves, if we do not limit our attention to the natural history of the 'type-human', but rather, allow ourselves to adopt the 'theological world-view', which seeks a broader understanding of a type only partially instantiated in the physical world. (Yourgrau 1989, p. 407)

Yet, paradoxically, as Plato suggests (for instance, in effect, in *The Symposium*), and as Gödel also seems to suggest (Wang 1987, p. 215), the actual *accomplishment* of perfection or completion here would render us kin to the lifeless, *un*thinking Ideas. In a word, the closer we approach the divine Ideas, the more the distinctively *human*, erotic drive for completion dies. Recall, again, as Plato says in *The Phaedo*, that "true philosophers make dying their profession" (1960, 67a).

c. Sentences, as we saw with Frege, are merely the bodies of thoughts, mere syntactic pictures of that which in essence is non-material—of what is semantic rather than syntactic. Yet a pure Fregean 'ideal' thought, though a necessary condition for the

possibility of using sentences to think, seems itself, if taken liter-
ally, paradoxical. Recalling the Platonic mystery in a., we note the
problem of how we could ever compare a (material) sentence with
an (immaterial) thought and learn to associate the one with the
other.

d. In the case of mathematics, Platonism postulates the sepa-
ration of the mathematical Forms, as if they had a life of their own
or a separate existence, as a necessary precondition for the fullest
comprehension of actual, lived, temporal, forever incomplete and
imperfect mathematical practice. This decontextualization of
mathematical practice, however, leads, at the cutting edge, to the
postulation of structures that keep eluding us, as with the quasi-
spatial Cantorian sets—for Cantor's Continuum Hypothesis
remains, after the consistency and independence results of Gödel
and Paul Cohen, undecided, even after Gödel's attempts to find
new axioms. Here, however, the dialectic is enriched by the pres-
ence also of a contextualized mathematics, the intuitionism of
Brouwer, where the temporal, human element is reintroduced in
the very foundations. With this dialectic, however, we come back
to our overarching theme concerning the temporal and the real,
and so we conclude with some observations about the relevance
of *contextualized mathematics* to the problem of the ideality of
time. We close this chapter with some thoughts on the question
of the temporalization of mathematics.

Temporal Mathematics

It will be recalled that although Plato attempted to banish all
traces of time and process from pure, 'formal' geometry, there
remained strong elements of the temporal, at a minimum in arith-
metic, in philosophers from Aristotle to Kant. Since Kant, how-
ever, there have been two developments in mathematics, pure and
applied, pointing in different directions. In pure mathematics, the
purification from all traces of the intuitive or the temporal
reached a climax toward the end of the nineteenth century when
Hilbert produced a formalization of geometry, Frege provided a
reconstruction of arithmetic on the basis of his powerful formal,
tenseless, quantificational logic (recall the tense-free definition of
'successor'), and Cantor provided a set-theoretic foundation for
his hierarchy of tenseless, completed, actual infinities.

To be sure, this purification was, as we have seen, not in all cases unproblematic—as in Parsons's suggestion of implicit temporality in certain attempts to provide an intuitive basis for the genetic-iterative conception of set, and as in our own suggestion to similar effect with respect to our attempt to intuitively ground Parsons's own conception of incomplete totalities. Yet, in spite of some possible exceptions, it is clear enough where developments in foundations, in this regard, are heading. Coordinate with this trend, however, is a movement in another direction—the increasing importation of the strictly mathematical into natural science, especially in physics and especially in the relativistic physics of (space-) time—that is, in Einstein's geometrization of the temporal. Thus, *whereas the mathematicians,* following Plato's lead, *were doing their best to take time out of mathematics*—or, in general, to decontextualize it—*the physicists were busy reintroducing this temporally purified mathematics into (theory of) time. Thus the physicists of time have been employing an instrument designed expressly,* by the mathematicians, *to be insensitive to the temporal!* Should we not, however, explore the possibility of a theory of time that employs a formalism less insensitive to its intended domain of application? (Recall the hint from Čapek we alluded to earlier: "Only when succession and change are incorporated into the very foundations of geometry is there a better chance of expressing the dynamic nature of becoming" [1961, p. 35].)

We have already attempted to provide a reconstruction of Frege's semantic framework that would reintroduce the element of context, including especially temporal context. And we have seen that there are prospects for coping with the threat of temporal determinism, raised first by Aristotle, if, with him, we permit certain modifications in our (meta-) logic and semantics. What, then, should we expect from an appropriate mathematical or formal model suitable to the expression of a theory of (A-theoretic) time? From what we have already seen, we can, I believe, set down the following desiderata: (1) Such a mathematics must employ, in its domain of application, incomplete totalities (such as the open future, potentially infinite series, and proper classes). (2) It must strictly disallow the employment of an insufficiently restricted universal quantifier (such as Parmenides's and Wittgenstein's "all that is the case" and Frege's absolute "all").

(3) This mathematics must contain a feature of directionality beyond order (as we have observed in the concept of potential infinity, and more specifically in the Aristotelian-Kantian succession of natural numbers). (4) Its logic, or metalogic, must be a modification or restriction of the classical (as in Aristotle's restriction of bivalence and his modification of the correspondence theory of truth—also advocated, as we saw, by Parsons for such incomplete totalities as proper classes). (5) Complete formalization, as an ideal, must be abandoned, and the construction of limit cases, in the sense introduced in this essay, must be, in principle, ruled out.

Brouwer: Putting Time Back into Mathematics

Now we have already seen traces of desiderata (1) to (5) in the philosophies of mathematics of Aristotle and Kant, but the approach to foundations in recent times that appears to satisfy in the most striking fashion *all five desiderata* is surely the intuitionism of L.E.J. Brouwer (which, as we have seen earlier, has strong ties with both Aristotle and Kant). Indeed, Brouwer writes explicitly that the First Act of intuitionism

> recognizes that intuitionistic mathematics is an essentially language-less activity of the mind having its origin in the perception of a move of time, i.e. of the falling apart of a life moment into two distinct things, one of which gives way to the other, but is retained by memory. (1952, p. 510)

He regards the "empty form" of the bare "two-ity" thus born in time to be, when stripped of all quality, what underlies all two-ities, and thereby to be what constitutes the "basic intuition of mathematics." Clearly, this is a temporal conception of mathematics. If we wish, then, to do justice not to the spatial but to the temporal mode of being, is it not more appropriate to turn to Brouwer than to classical, Platonistic mathematics, which is itself the very paradigm of spatiality (in the broad sense)? Of course, the direction of research in the present philosophical climate is clearly toward an increasing formalization of intuitionism itself, as in the seminal work of Arend Heyting, and some, like W.W. Tait, have argued explicitly that no real work is done by

Brouwer's invocation of the unfolding of time. ("These remarks are not intended to refute Brouwer so much as to cast doubt on whether his description of a move of time has any real content" [Tait 1983, p. 174].) It is intuitionism as Brouwer himself conceived it, however, that is my concern here, and I put forward the following suggestion: As Brouwerian intuitionism stands to its formalizations, so does intuitive, A-theoretic time stand to its spacelike projection into indeterministic, branching, tense logic, or, perhaps onto the world lines of Einstein-Minkowski space-time.

If Brouwer's is a temporal mathematics, however, is its temporal basis A- or B-theoretic? Surely, there can be no question but that *a B-theoretic intuitionism is an impossibility*. That intuitionism satisfies all five desiderata just given for an adequate mathematics of intuitive, A-theoretic time should help put the matter beyond doubt, if we make the case explicit, as follows. In the first place, Brouwer recognizes only incompletable, potential infinity, which is distinctive of the A-series. All B-theoretic structures, I have argued, are complete, and thus an infinity that has its basis in the B-series must be actual. This leads us, in turn, to the next fundamental point: that Brouwer clearly has in mind the successive unfolding of intuitive time, and, as has been argued at length in the preceding pages, there is no genuine succession of times in the B-series. The fact that Brouwer does not explicitly invoke the now, or refer to the past, present, and future, is thus not to the point. (It might be well to recall here that Gödel himself is absolutely clear on just this question: "The existence of an objective lapse of time, however, means (or, at least, is equivalent to the fact) that reality consists of an infinity of layers of the 'now' which come into existence successively" [1949a, p. 262].)

Added to these last considerations is the fact that there is an irreversible 'directionality', in the A-theoretic sense, in the temporal basis of intuitionism, in which a closed and determinate past gives way to a free, open, and not fully determinate future (reminiscent of Aristotle's model of time). Brouwer speaks, for example, of the Second Act of Intuitionism, "which recognizes the possibility of generating new mathematical entities: firstly in the form of infinitely proceeding sequences p_1, p_2, \ldots, whose terms are chosen more or less freely from mathematical entities *previously acquired*" (1952, p. 511; my emphasis). Moreover, these

free choices may be subject to restrictions that "at any stage may be made to depend on possible future mathematical experiences of the creating subject" (p. 511). Further, "in intuitionist mathematics a mathematical entity is not necessarily *predeterminate,* and may, in its state of free growth, at some time acquire a property which it did not possess before" (1955, p. 552; my emphasis).

Again, along these same lines, what about predictions about what will take place at future times? As Aristotle had before him, Brouwer appeals, in effect, to the A-theoretic intuition that since the future is not 'there' to be referred to, the coming-into-being in the future of a mathematical state of affairs (say, a proof) does not suffice to bring it about that a prediction of the possibility of such a proof in the past was true then. Rather, "expected experiences . . . are true only as anticipations and hypotheses; in their contents there is no truth" (1948, p. 488). Again, the mere linguistic representations of possible mathematical thoughts do not "convey truths before these truths have been experienced" (p. 488). (Whether or not, then, one agrees with Dummett that "it would be possible for a constructivist to agree with a platonist that a mathematical statement, if true, is timelessly true: when a statement is proved, then it is shown thereby to have been true all along" (1978b, p. 19), it is clear, I think, that this was not Brouwer's view.) This point of view, however, is derived only in part from the fact that, as with the A-theorist, Brouwer recognizes (in his case, mathematical) reality as itself coming into being successively. In addition, unlike Frege, he refuses to decontextualize mathematical thought. That is, he resists the crucial step by which Frege, the Platonist, separates, cleanly, thought content from the activity or experience of thinking, in order to then subject this truth-valuable content to the abstract manipulations of a formal logic. Brouwer, of course, is critical of classical logic—especially of the principle of the excluded middle (which, as we have seen, so vexed Aristotle). But the crucial point here is not that Brouwer proposed a revisionist logic. Rather, for him, mathematical truth cannot, without being destroyed, be torn away from its context—the experienced act of cognition. By Brouwer's lights, intuitionism recognized that "the criterion of truth or falsehood of a mathematical assertion was confined to mathematical activity itself, without appeal either to logic or to a hypothetical omniscient being. An immediate consequence was that in

mathematics no truths could be recognized which had not been experienced" (1955, p. 552). (For a nice discussion of this point, see Detlefsen 1990b.)

Complementarity

If, then, these suggestions are along the right lines, it would seem that the prospects for an adequate account of a temporalized mathematics like Brouwerian intuitionism are closely related to hopes for a successful elucidation of intuitive, A-theoretic time. It remains, however, that for a mathematical space, like that of Cantor's universe of sets, or for a "rigid four-dimensional space" (to use Einstein's phrase) like Einstein-Minkowski space-time, a more platonistic philosophy is indicated. Perhaps, then, the two perspectives, the intuitionistic and the Platonistic, can be seen to be, in some sense, complementary. Paul Bernays seems to have something like this in mind in his discussion of Gödel's ideas:

> Perhaps the methodological analogy [of Gödel's] between foundations of mathematics and of theoretical physics may go even farther, in this way, that just as in the new physical theories the rôle of the observer is an essential ingredient, for the interpretation of mathematics the rôle of mental activity cannot be fully abstracted from. . . . Also, then, the objective, theoretical (existential) standpoint on the one hand and the intuitionistic (constructive) one on the other hand could be regarded as 'complementary' aspects. (1946, pp. 78–79)

This still leaves us, however, with the unresolved problem of reconciling the two perspectives for the case of time, "that mysterious and seemingly self-contradictory being which, on the other hand, seems to form the basis of the world's and our own existence," as Gödel (1949a) puts it. For, as has become clear, I hope, from the preceding pages, *time seems at once to demand and to resist a reconciliation between its subjective, intuitive manifestations and its appearance in the best models that have been offered to date to incorporate its peculiar being into the fabric of the objective world.* It would seem, then, that in constructing the mathematical model of the Gödel Universe, Gödel has once again succeeded in raising a traditional, informal question to a new level

of clarity, waking us, thereby, from our dogmatic (relativistic) slumbers. For what Frege (1980, p. 111) observed about number can fairly, I think, be said about time: "The first prerequisite for learning anything is thus utterly lacking—I mean, the knowledge that we do not know."

Appendix A
Brouwer and the 'Revolution': The Philosophical Background of 'Temporal Mathematics'

Und Brouwer, das ist die Revolution!

H. Weyl

Unlike Plato, Brouwer held that perfection can be achieved without abandoning time.

W.P. van Stigt

Cantor himself, as we have seen, having proved Cantor's Theorem, cannot claim that the entire universe of his hierarchy of actually infinite sets constitutes a 'universal set'. He characterizes this 'universe', rather, as an 'inconsistent multiplicity'—what is known today as an 'improper class'—whose cardinal number is, in Cantor's words, "absolutely infinite." Absolute infinity, however, according to Cantor, is not a member of his hierarchy of transfinite cardinal numbers. It is for him not a properly mathematical conception at all, but rather 'theological'. The question arises, however, whether absolutely infinite collections are a species of Cantor's 'actual infinity'. We have argued (above, p. 179) that the *absolutely* infinite must be taken to be *actually* infinite: "How can sets themselves be [fully actual] platonic objects if their 'totality' is not? Those like Charles Parsons, however, who, as we have seen (pp. 177–185), maintain that proper classes are somehow 'potential', are obliged to provide us with a nontemporal account of this potentiality.[1] Parsons's 'modal' approach to absolute infinity, however, we have argued, is unsuccessful as a substitute for temporality. Shaughan Lavine (in *Understanding the Infinite*) argues, similarly, that Parsons's modal account of the

1. Nontemporal because one can hardly maintain that *actually* infinite collections are *generated in time*.

205

so-called 'iterative conception' of the Zermelo-Fraenkel axioms for (transfinite) set theory is unsuccessful as a substitute for temporal notions. In Lavine's words:

> Without the temporal notion of constructing some sets after others the iterative conception loses much of its appeal. Parsons has suggested that a modal interpretation of the iterative conception be given to avoid the reliance on time: a multiplicity of actual sets is a possible set. . . . It is not yet, however, clear how to interpret the necessary notion of possibility without relying on metaphors of time and construction. (1994, p. 149)

A similar situation arises when Ignacio Jané (1995) argues that Cantor in fact changed his position on the question of the actuality of absolutely infinite sets. According to Jané: "Before *Beiträge*, he [Cantor] repeatedly considered the absolute as a kind of the actual infinite, but in this letter . . . [h]e is taking the actuality away from the absolute." Thus, as Jané has it, "the absolute unboundedness of the aleph sequence [of transfinite numbers] is tantamount to its incompletability, to its existing only potentially." Later, however, Jané himself is forced to admit that, "[i]t is difficult to make sense of the potential infinite . . . without appealing to activities or processes taking place in some time-like medium" (p. 398). In the end, all he can say is that: "Cantor was, then, forced to deny the actuality of the absolute. But he remained silent about how to make sense of irreducible potentiality" (p. 400).

We have argued that not only is potential infinity[2] an essentially temporal notion, the kind of time sequence it presupposes is precisely that of McTaggart's A-series. It follows that Brouwer's rejection of Cantor and (all 'sizes' of) actual infinity in favor of the merely potential infinite presupposes something like A-theoretic time. From what philosophical perspective, however, did Brouwer approach the concept of time required by his philosophy of mathematics? Karl Popper, for one, has reflected on just this question. He notes correctly, in 'Epistemology Without a Knowing Subject' (1994), that Brouwer takes his cue from Kant's philosophy of mathematics, rejecting, however, Kant's reliance on space intuition to found geometry, in light of the emergence of non-Euclidean geometry (which contradicts the 'given' of geometrical intuition). Pointing, however, to the arithmetization of geometry, Brouwer believes he can found his intuitionist mathematics on the Kantian approach to arithmetic as relying on our basic intuition of *time*. Popper

2. Whether, as with Brouwer, introduced as a substitute for actual infinity, or as with Parsons, introduced as a 'more inclusive' infinity, intended to embrace the 'totality' of the hierarchy of Cantor's actual infinities, the 'Alephs'.

rejects this move of Brouwer's, however, much as we have in this study, remarking that: "If we say that Kant's theory of space is destroyed by non-Euclidean geometry, then we are bound to say that his theory of time is destroyed by special relativity" (p. 129).[3] Popper goes so far as to suggest that "Brouwer might not have developed his . . . philosophical ideas about intuitionist mathematics had he known at the time of the analogy between Einstein's relativization of time and non-Euclidean geometry." Nevertheless, according to Popper, Brouwer "could have retained his own theory of a *personal* time—of a time of our own intimate and immediate experience." "This," Popper continues, "is in no way affected by relativity, even though Kant's theory is affected" (pp. 129–130).

Whether or not, however, such an invocation of 'personal time' by Brouwer would render his mathematical philosophy unaffected by relativity theory depends on what exactly such 'personal time' amounts to. If all Brouwer has in mind is time as it appears in personal introspection, then his account would be subject to the investigations of empirical psychology, a discipline in no position to challenge the findings of relativity theory. It is clear, however, that this is not at all what Brouwer has in mind in attempting to found mathematics on "primordial temporal awareness". Rather, as van Stigt puts the matter, "Brouwer recognized the distinction between intuitive time and measurable time, to which he referred as 'scientific time' . . ." (1995, p. 152). Indeed, van Stigt stresses Brouwer's conviction of "the 'scientific', nonmathematical nature of the concept of 'measuring' and the notion of a metric" (p. 328), and quotes Brouwer: ". . . intuitive time, which must be distinguished from 'scientific time', which is definitely a posteriori, appears only in experience . . . [T]he Intuition of Time . . . is a measureless one-dimensional continuum." As van Stigt also points out, Brouwer shared Bergson's view that in science "a spatial frame [is] superimposed on time by the analytic intellect, [resulting in] a 'spatialization of time'" (p. 152), whereas 'real time' is "pure fluidity," "pure continuity," grasped by 'pure spirit' in immediate 'intuition'. The 'time', then, on which Brouwer hopes to found mathematics, and which underlies his conception of potential infinity, is *'disjoint' from the 'time' of physics*—that's to say, it is located in an aspect of reality that bears no internal relationship to the empirical world, which is the subject matter both of relativity theory and of empirical psychological science.

3. As noted in Chapter 5, 'From Kant to Star Trek: A Philosopher's Guide to Time Travel', Gödel does in fact argue forcefully that there is a sense in which special relativity 'verifies' Kant. The special sense Gödel has in mind, however, does not contradict the assertion Popper is making here.

Brouwer's conception of 'intuitive time' as just characterized clearly bears a strong resemblance to Husserl's idea of 'internal time consciousness' (discussed in Chapter 5). Thus, Husserl writes: "Inherent in this, as in any phenomenological analysis is the complete exclusion of every assumption, stipulation and conviction with respect to objective time . . ." (Husserl 1991, p. 4). Indeed: "One cannot discover the least thing about objective time through phenomenological analysis" (p. 6). Further, "[T]he ordered connections that are to be found in experiences as genuine immanencies cannot be met with in the empirical, objective order, *and do not fit into it*" (p. 6; emphasis mine). In regard to the last point, Husserl introduces a useful analogy from the phenomenology of space: "It makes no sense at all to say, for example, that a point of the visual field is one meter distant from the corner of this table here, or is next to it, above it, and so on . . . [T]he house appearance is not next to the house, above it, one meter away from it, etc." (pp. 5–6).

But if Husserl's account of time is to be placed alongside Brouwer's, then so too, perhaps, should Wittgenstein's discussion in *Philosophical Remarks* of the role of time in mathematics. ". . . [P]ossibility in mathematics," Wittgenstein remarks, "is precisely the same as it is in the case of time" (1975, p. 161). But what does the open-ended 'infinity' of time consist in? "We don't," says Wittgenstein, "think of time as an infinite reality, but as infinite in intension" (p. 163). In other words, "infinity is an internal quality of the form of time"[4] (p. 164). Again: ". . . here the infinity is only in the rule" (p. 167). These remarks help clarify the fact that, for thinkers who reject the actual infinite, potential infinity is not simply a weakened form of the actual infinite. This can be expressed by saying that an actually infinite series is to be viewed intensionally, not extensionally—i.e. not as a *collection of objects* to which one merely keeps adding another object, as time progresses.

Clearly, then, despite its Kantian overtones, the "form of time" does not refer, in Wittgenstein's discussion, to the temporal dimension of the (internal and) external world. This is further clarified when he goes on—in a related discussion which focuses on the role of memory in time-

4. What Wittgenstein seems to have in mind with this remark is that to characterize a 'collection' as potentially infinite is not to make a *prediction* that we (or God, or whoever) *could* in fact always, as time progresses, add another element (merely idealizing away from what Russell called 'medical' contingencies, like sickness or death, that might prevent being able to continue with this process). Instead, Wittgenstein has in the mind the fact it is part of the 'logic' or the 'grammar' or the 'rules of use' of what is meant here by 'time' that the modality of this temporal dimension in principle never admits 'completion'. Thus no refutable claim is being made here that '*in fact*' one really '*could*' in principle (whether 'in' our minds, or in empirical reality) keep adding to our collection 'forever'.

consciousness—to contrast time in the sense he is speaking of it with 'time' in physics: "Perhaps this whole difficulty stems from taking the time coordinate from time in physics and applying it to the course of immediate experience" (p. 81). Again,

> [i]f memory is no kind of seeing into the past, how do we know at all that it is to be taken as referring to the past? . . . Have we, say, learnt from experience to interpret these pictures as pictures of the past? . . . Yet it contradicts every concept of physical time that I should have perception into the past[5], and that again seems to mean nothing else than that the concept of time in the first system must be radically different from that in physics. (pp. 82–83, par. 50)

One should also bear in mind M.O'C. Drury's recollection that at the time Wittgenstein was writing *Philosophical Remarks* he commented to Drury: "You could say of my work that it is 'phenomenology'" (Rhees 1984, pp. 116, 220, Note 11).

Clearly, Wittgenstein's account of 'intuitive time' as just characterized bears a strong resemblance to Husserl's and Brouwer's. Each of these accounts in turn puts one in mind of Gödel's conception.[6] Gödel remarks, for example, that: "It is the role time plays in the description of the outer world which is similar in Kant and in relativity theory, while its relation to inner sensibility does not concern physics at all."[7] Further: "The four dimensions of space-time are natural for the physical world. But there is no such natural coordinate system for the mind; time is the only natural frame of reference" (Wang 1995, p. 228). Also: "What remains in Husserl's approach is the observation of the working of the mind: this is the way to make the concept of time, etc., clear—not by studying how [such concepts] work in science." Indeed, by Gödel's lights, "Time is no specific character of being. In relativity theory the temporal relation is like far and near is space. I do not believe in the objectivity of time. The concept of Now never occurs in science itself, and science is supposed to be concerned with the objective." Finally, "[A]n entity corresponding really in all essentials to the intuitive idea of

5. Compare van Stigt's characterization of Brouwer's 'Primordial [Temporal] Intuition': "the simultaneous presence in consciousness of two sensations, one recognized as past, the other as present" (p. 151).

6. Gödel, of course, is explicit that he has studied Husserl on time (with what degree of satisfaction, however, is not so clear).

7. These words occur in the xerox of ms [C] of Gödel's essay, 'Some Observations about the Relationship Between Theory of Relativity and Kantian Philosophy' provided to me by Princeton Univsersity's Firestone Library with the permission of Eliott Shore, Librarian, The Institute for Advanced Study. They appear not to have been included in either of the two versions of this essay reproduced as 1946/49 in Feferman et al. 1995.

time . . . in relativity theory . . . exists only in our imagination" (Gödel 1946/49 C1, p. 258, Note 28).

Gödel's conception of 'intuitive time' then, together with the similarly 'phenomenological' accounts of 'internal time-consciousness' of Husserl, Wittgenstein, and Brouwer, leaves it up in the air what the exact relationship is supposed to be between 'intuitive time' and the 'objective' time of Einstein's relativity theory. In general, however, it is sufficiently clear that Brouwer is indeed, as van Stigt points out, a philosophical 'idealist'[8]: "Brouwer's philosophy of the physical world can with some reservations be described as idealism. It shares many features with the anti-materialist tradition in its various forms from Platonism, Berkleyan solipsism to the idealism of Kant" (p. 171). Indeed, for Brouwer, "mathematics is conceived as an 'idealized' reality . . . [where t]he process of 'idealization' is an attempt at perfection, a reaching for the perfect reality . . . [But for Brouwer] a reality whose exclusive seat is to be found in the individual human mind. Unlike Plato he held that perfection can be achieved without abandoning time." What happens, then, to the vaunted objectivity claimed for mathematics, from Plato to Frege to Gödel? "No objectivity is claimed for mathematics by Brouwer. . . . Objectivity of knowledge presupposes the existence of objects external to the mind . . ." (p. 180). With Plato, then, Brouwer holds that the 'world of mathematics' is not a mere abstract shadow of, or blueprint for, the empirical world, but rather possesses 'a higher level of existence', consistent with its perfection.[9] What separates the two thinkers is, rather, the 'location' of this higher ontological realm. For Plato (and, of course, Gödel), it exists entirely on its own, timelessly, 'itself by itself' (as Plato likes to say), whereas for Brouwer its locus is in the individual, temporal, mathematical mind.

Ontological comparisons with the 'time' of physics aside, however, it is clear that the concept of time Brouwer is invoking here must share the essential features of McTaggart's A-series. "Existence in time", according to van Stigt in his account of Brouwer, "allows the [Mathematical] Subject to survey only past constructive events; he is

8. So too, of course, in some sense, is Gödel. But the question of Gödel's ultimate philosophical idealism is a very difficult one. As pointed out in Chapter 5, in one sense, or on one level, Gödel is an idealist in the sense of Kant concerning time, but contra Kant, a 'realist', concerning the reality of space or 'spacetime'. This assumes, however, Gödel's ultimate acceptance of the philosophical perspective of relativity theory, i.e. of empirical science. It is clear, however, that insofar as Gödel adopts, as he claims to in a number of contexts, the 'idealism'—specifically, the monadology—of Leibniz, he is ultimately rejecting the perspective of empirical science in the sense of Einstein.

9. Compare our epigraph from Gödel: "Projecting directly from the developed parts of mathematics to the entire world, Gödel concludes that it is also beautiful and perfect."

imprisoned in time, he . . . does not have the divine power of overseeing the whole of time from the outside . . ." (pp. 175–76). Indeed, "[w]hat . . . any formalization must fail to grasp," continues van Stigt—exactly as we have argued at length in this book—"is the dynamic aspect of the present and the special indeterminacy of the future." "The present", he goes on to say, "is the only real moment [T]he future . . . 'not having having been constructed' . . . lacks reality and existence. . . . The present is the dividing point between determinacy and freedom" (pp. 176–77). "The free future," moreover, "lacks the simple structure of the sequentially ordered past constructs; its 'dimension' transcends the denumerable" (p. 177).[10]

What remains, then, for Brouwer is the task of 'locating' the temporal dimension he is invoking as a foundation for potential infinity (and thus, for all of intuitionist mathematics) in its relationship to the 'time' dimension of the empirical world—i.e. to the temporal component of relativistic spacetime. This doesn't appear, however, to be a task with which Brouwer ever concerned himself in a systematic way. Nor does such a systematic study appear (Husserl notwithstanding) ever to have been undertaken by any other 'idealist' philosopher of Brouwer's stripe. Gödel, it is true, would appear (from his discussions with Wang and elsewhere) to have been interested, late in his life, in completing such a task. Death, however, sadly intervened and kept us from garnering the benefit of his much-needed insights.

10. Further, much as we argued in Chapter 2 (pp. 26–27) van Stigt goes on to remark that "in its time aspect mathematics may be compared to music: as harmonious sound it only exists in time . . . ; it is distinct from the musical score."

Appendix B
Zeno's Revenge: On the Mathematical Dogma of Infinite Divisibility

Where the nonsense starts is with our habit of thinking of a large number as closer to infinity than a small one.

<div align="right">Ludwig Wittgenstein</div>

In space intuition, a point is not a part of the continuum but a limit between two parts. . . . According to this concept, all the points do not add up to the line but only make up a scaffold (*Gerüsst*) or a collection of points of view.

<div align="right">Kurt Gödel</div>

We have been pursuing in this study Gödel's powerful argument that time, in the intuitive sense, cannot be captured by the mathematical formalism of relativity theory. More generally, we have followed up on Hao Wang's hint that Gödel is preoccupied with "the dialectic of the formal and the intuitive." Indeed, we have gone further than Wang in suggesting that there is an important sense in which Gödel's results on relativity theory follow the lead of his Incompleteness Theorem—in the one case establishing the *limits* of relativity theory in capturing *intuitive time*, in the other, uncovering the limits of formal proof theory in representing *intuitive arithmetic truth*. In a larger sense, however, one can see the history of western thought as engaged in a dialectic of the formal and the intuitive, employing these terms in their broadest senses. This historical dialectic can for our purposes be seen as beginning with Plato's *Euthyphro*, which illuminates the contrast between what one *chooses or loves* and *the good itself* (the inspiration for love)—i.e between *the beloved* and the *loveable*—which leads directly to the distinction between *law*

and *morality* (or the *letter* versus the *spirit* of the law).[1] In the *Republic*, in turn, Plato draws attention to the closely related contrast between the *majoritarianism* (the rule of the many, by counting votes) essential to democracy and the rule not of the popular but of *the good* in Plato's *Kallipolis*—the beautiful or just city. The dialectic continues with respect to war, where the relevant distinction is between *orders* and the *justification* of these orders. In capitalism, in turn, the young (Hegelian) Marx contrasts the *monetary value* of an item in the Market with its *human* value. And when the domain is science, we have seen that in relativity theory the dialectical contrast is between measurable *clock time* and the *intuitive time* of a subject's 'internal time-consciousness'. If, then, one reflects on these distinctions, what emerges is that the 'formal' component in this dialectic represents in many instances what is quantifiable or *mathematizable*. It is arguable that the increasing dominance of *mathematization* in the history of western thought and culture signals the increasing dominance of the formal over the intuitive in our dialectic, a dominance that reaches its high water mark, surely, in the twentieth century.

Indeed, *formalism*, in its broadest sense, is perhaps *the leitmotif of the twentieth century*, as pointed to by the overwhelming importance of the computer—bearing in mind Gödel's characterization of a computer as "a formal system made concrete." Other pointers are the ascendancy of 'structuralism' in linguistics (Chomsky), anthropology (Levi-Strauss), and literary criticism (Frye), as well as the rise of cubism in modern art and the twelve-tone musical scale championed by Schönberg. Significant, also, is the recorded heritage of the great pianist, Glenn Gould (himself an enthusiastic Schönbergian), whose performance of Bach fugues made concrete his preoccupation with musical structure.[2] We should not neglect here, of course, Einstein's relativistic geometrization of spacetime. It is *Gödel's Theorem*, however—*the* crucial (formal) result concerning 'formalism'—that is arguably *the most important theoretical result concerning the dominant theme of our century*.[3] W.V. Quine described Gödel's Theorem as "the most significant mathematical result of the century."

1. Plato's immediate concern is whether God (or any other 'authority') loves the good *because* it is good, or whether the good is good *because* God loves it. If the authority in question is taken to be the laws of the state, then the latter view amounts to *legal positivism*, a cousin of the 'logical positivism' against which Gödel's Theorem constitutes a direct assault. The *Euthypro* question constitutes, indeed, a kind of litmus test for all 'realisms'. Thus, mathematical *non-realists* like Wittgenstein maintain that 2 + 2 = 4 *because* we '*say so*', whereas mathematical *realists* like Gödel and Frege hold that we 'say' that 2 + 2 = 4 *because* 2 + 2 *really is* = 4.

2. There are deep and striking similarities between Gould and Gödel. There is, for example, something mystical behind the 'formal' endeavors of each. On a personal level,

Now, in addition to the large-scale cultural dialectic of the formal and the intuitive there is in the history of mathematics itself a related distinction between opposed philosophical perspectives.[4] Thus we find in mathematics itself a dialectic between *proof* and *truth*,[5] *algorithm* and *insight*, [6] *number* and *line* (or *arithmetic* and *geometry*), *straight* and *curved*, *discreteness* and *continuity*, the *finite* and the *infinite*, and the *potential* and the *actual* infinite. Periodically, however, this dialectic is challenged and a 'reduction' announced of one element of the dialectic to its 'complement' (which often signals a major advance in mathematics). In recent times, the so-called 'arithmetization of the continuum', which may be said to have reached its completion with Georg Cantor's theory of actually infinite sets (dubbed by Hilbert, "Cantor's Paradise"),

both were hermits and both could be seen bundled up in winter clothing in the dead of summer. And Gould even put together the sound track for the time-traveling film, *Slaughterhouse Five!*

3. It is a principal thesis of this book, of course, that with the discovery of the Gödel Universe, which constitutes a limit case for Einstein's relativistic geometrization of time, Gödel has achieved *another crucial result* with respect to the dominant theme of the twentieth century.

4. In his1961/?, Gödel brings up the fact that in our century mathematics itself has been drawn into one side of a 'dialectic', but here he is stressing his own distinction between basic philosophical worldviews. As we saw in Chapter 5 he calls these the 'leftward' direction—toward *skepticism, materialism,* and *positivism*—and the 'rightward' direction—toward *spiritualism, idealism,* and *metaphysics* (or *religion*). According to Gödel, mathematics belongs 'by its nature' on 'the right', but in accord with the spirit of the times in our century, it has been claimed by 'the left', as witnessed by Hilbert's Program (and logical positivism)—against which, of course, Gödel's Theorem constitutes a major blow.

5. Here, of course, Gödel's Theorem comes into play; but the situation is complex. The Theorem relates most directly to Hilbert's (*Formalist*) Program, the goal of which was to secure the *consistency* of mathematics. Gödel's Second Incompleteness Theorem constitutes a fatal blow to this program. But Hilbert's *Formalism* was a descendant of Frege's (and Russell's) *Logicism*, according to which all of mathematics (with the exception, for Frege, of geometry, where he followed Kant) was a definitional extension of a more general (indeed, *the* most general) science viz. *logic*. Frege, however, contra Hilbert (but in company with Gödel, who drew an analogy between mathematical logic and physics), considered logic to be a genuine *science*, which aimed not just at consistency but rather *truth*. (On this point, Gödel and Frege are at one with Brouwer—and against Wittgenstein.) And indeed Gödel considered himself to be—with Frege—a *logicist*, including (unlike most logicians) *set theory* under the heading of logic. He agreed with Frege, moreover, that the axioms of logic are 'analytic'—not in the sense of being 'true by definition' but rather 'true in virtue of the *content* of concepts'. Gödel invoked a faculty of 'mathematical intuition' of such concepts, and, as I argue in my 1996 and 1997, Frege should be taken to task for his skepticism of such 'intuition'. (As pointed out in Chapter 5, Frege harbored an exaggerated fear of 'psychologism', and this is surely one reason why Gödel turned to Husserl.) In Yourgrau 1997, pp. 161–62 I argue, indeed, that Gödel and Frege can be viewed as attempting to fulfill what I call "Plato's Program" (in the *Republic*) of going beyond mathematicians in seeking an "unhypothetical foundation" for mathematics. (Recall that Gödel indicated to Wang (1996, pp. 300–01) his approval of Plato's *Republic* , Bk VI, 510e–511c.)

6. Here, Church's Thesis constitutes an attempted 'reduction' of one element to the other. Specifically, his Thesis asserts that the *intuitive* idea of an algorithm or a purely mechanical procedure (requiring no insight) is fully captured by the *mathematical* concept

promised hope of just such a 'reduction'. Many saw this theory—and many, indeed most, still do—as finally resolving the age old question: *Can a finite quantity be infinitely divided?* Ancient wisdom denied this possibility. Zeno of Elea in particular, a follower of Parmenides (the same Parmenides that Gödel referred to, approvingly, as an early proponent of the ideality of time), advanced arguments in support of the thesis that *the sum of an infinite number of finite parts must be infinite.* It is a nearly universal assumption, however, that modern mathematics has finally refuted Zeno. In particular, it is widely believed that the development of the epsilon-delta definition of the 'sum' of a convergent infinite series in terms of the notion of '*limit*' and the emergence of the theory of *transfinite numbers* due to Cantor suffice to relegate Zeno's conundrum to the dustbin of philosophical history.

In opposition, however, to this mathematical-philosophical orthodoxy, I shall argue that the dialectic between potential and actual infinity has not thus been eliminated. In particular, I shall argue that: a) modern developments in the foundations of mathematics have not 'refuted' Zeno, but rather simply *evaded* the problem he raised; b) if we assume the actual existence of the infinite totality of rational (not to say, real) numbers, then it can be shown that Zeno was right, i.e. that $\sum_{n=1}^{\infty} 1/2^n$ is not only *not 1*, as is commonly supposed, but rather \aleph_0 (!) (\aleph_0 is Cantor's first transfinite cardinal number—the cardinal number of the set of finite numbers); and thus c) the skepticism of mathematical 'intuitionists' from Aristotle to Brouwer concerning the *actual infinity* of the set of rational (not to say real) numbers can be given unexpected support; and finally d) the 'size' of the first or 'smallest' transfinite number turns out to have been seriously underestimated—as others, like Paul Cohen, have emphasized that Cantor in effect underestimated the size of 2^{\aleph_0}, the cardinal number of the totality of real numbers, or equivalently, of the set of 'points' on the continuum—which Cantor 'hypothesized' was the 'second' transfinite number, \aleph_1, 'Aleph One' (Hallett 1984, p. 208).

A famous article on Zeno of Elea by the distinguished classicist Gregory Vlastos in *The Encyclopedia of Philosophy* (1967) sets the stage for our discussion. Vlastos asserts that Zeno must have made two assumptions:

> (c1) An infinitely divisible existent must contain a complete infinity of parts.
>
> (c2) If each member of an infinitely numerous set has some size (greater than zero), then the aggregate size of the set must be infinite. (p. 370)

of a recursive function. For Gödel's ambivalence concerning Church's Thesis see Martin Davis 1982, 'Why Gödel Didn't Have Church's Thesis'.

Why, however, did Zeno accept (c2)? "Simple arithmetic," Vlastos notes, "well within Zeno's reach would have shown him that any partial sum of this sequence (A/2 + A/4 or A/2 + A/4 + A/8 or . . .) would be less than A." Unfortunately, however, says Vlastos, Zeno "did [not] have, to rouse his suspicions against assumption (c2), the conception that the sum of an infinite series could be defined as the limit on which its successive partial sums converge" (p. 371). This orthodox view, that the modern conception of the limit of a convergent infinite series suffices to refute Zeno, is explicitly put forward by Tobias Dantzig, in his widely read *Number: The Language of Science:*

> The sum $1/2 + 1/4 + 1/8 + 1/16$. . . represents the finite number 1 in spite of the argument of Zeno that this sum is extended over an infinite number of terms. *The introduction of the concepts of convergence and limits may be objected to on one ground or another, but once accepted, the argument of Zeno, that a sum of an infinite series of numbers must by necessity be infinite, loses its force.* (Dantzig 1954, p. 145; emphasis added)

Now, what exactly is it to say that $\sum_{n=1}^{\infty} 1/2^n = 1$, in other words, that the 'sum' of the convergent infinite series $1/2$, $1/4$, $1/8$, . . . (Z, for short), interpreted as the 'limit' of the partial sums is $n = 1$? Roughly, it means that for any positive number, $\varepsilon > 0$, there will be an integer, δ, such that for the mth member of the series, for any $m > \delta$, the absolute value of the difference between 1 and the partial sum of the first m members of Z will be $< \varepsilon$. (See, for example, Courant and Robbins 1978, pp. 291–92.) More briefly, the later the member, m, of Z you choose, the closer will be the (partial) sum of the first m members of Z to 1. In what sense, however, can we take this fact to be a response to Zeno? Zeno wanted to know how one could add together *all* the (supposedly) *infinitely* many parts of a finite quantity without arriving at something infinite. What is the secret of Dantzig's (and Vlastos's) answer, via Cauchy and Weierstrass? Answer: we simply refuse to add together *all* the *infinitely* many parts! What has happened is that, rather than *answering* Zeno's question, a method has been found to *avoid* it. For the 'sum' of an infinite series, in the sense of a limit, is not really an infinite *sum* at all, in the sense in which $1/2 + 1/4$ is a finite sum. As Wittgenstein notes, ". . . the sum $1 + 1/2 + 1/4$. . . is of course a *limit* of a series of sums, and not a sum in the sense in which, e.g., $1 + 1/2 + 1/4$ is a sum" (*Philosophical Remarks*, p. 308). Again, ". . . a fallacy, which is common in the case of mathematics, e.g., the fallacy of supposing that $1 + 1 + 1$. . . is a sum, whereas it is only a *limit*" ('Wittgenstein's Lectures in 1930–33', by G.E. Moore; in Wittgenstein 1993, p. 89). In the last case, however, Wittgenstein brings in a

divergent series, while it is convergent series for which a limit is defined. (We will address divergent series below.)

Further, many mathematicians are perfectly clear-headed concerning what kind of sum the 'sum' of an infinite series is. Konrad Knopp, for example, in his compendious *Theory and Application of Infinite Series*, is quite clear on just this point:

> As regards the term *sum* the reader must be expressly cautioned about a possible misunderstanding: the number s [where $\sum_{n=1}^{\infty} a_n = s$] is *not* a sum in any sense previously in use, but only *the limit of an infinite sequence of sums.* . . . It would therefore seem more appropriate to speak not of the *sum* but of the *limit* or *value* of the series. (p. 102; emphases added)

The fallacy lies rather in the attempt by Dantzig (and Vlastos, Sainsbury, and many other philosophers) to put forward the theory of the limit of an infinite sequence of partial sums *as a solution to Zeno's challenge* to infinitely divide a finite quantity. If Cauchy and Weierstrass have successfully laid to rest Newton's "ghosts of departed quantities" (as Berkeley described the 'infinitesimals'), they have failed to silence the ghost of Zeno. For Zeno did not express any doubt that the sum of an 'arbitrarily large *finite*' number of parts, if the parts were small enough, could be finite; his concern was, rather, with summing up *all* the supposedly *infinitely many* parts, no matter how small, of a finite whole. Thus if Newton can be justifiably accused of equating 'indefinitely small' quantities with *zero*, Dantzig et al. can be charged with conflating the sum of an 'arbitrarily large finite' number of terms with an actually *infinite* addition.

Knopp, himself, however, is not immune to confusion when the relevance of limits of infinite series to Zeno is at issue. He comments, in this regard, that

> . . . it is really quite paradoxical that an infinite series, say $1/2^n$, should possess anything at all capable of being called its sum. Let us interpret it in fourth-form fashion by shillings and pence. I give someone first 1s., then $1/2$s., then $1/4$s., then $1/8$s., and so on. If now I *never come to an end* with these gifts, the question arises, whether the fortune of the recipient must thereby necessarily increase beyond all bounds or not. . . . [T]his is not so, since for every n
>
> $$s_n = 1 + 1/2 + 1/4 + \ldots 1/2^n = 2 - 1/2^n \text{ remains} < 2$$
>
> The *total gift* therefore never reaches even the amount of 2s. (Knopp 1990, p. 103; emphasis added)

What is wrong here is that Knopp speaks of "never coming to an end" with these gifts. If this is so, however, then I must give someone *all infinitely many* amounts of money, corresponding to *all* members of the infinite series. But then the recipient of this *largesse* will have acquired an 'actually-infinite' sum of finite quantities of money, the *meaning* of which is not touched on by the definition of the limit of *partial* sums. One cannot, then, have it both ways: if the 'sum' of this infinite series exists *only* in the sense of the 'limit' of the infinite sequence of partial sums, then it is meaningless for Knopp to simultaneously envision 'never coming to an end' with his gifts—i.e., to imagine giving someone *all* the (infinitely many) partial sums of money.

It is no wonder, however, that Knopp and Dantzig get into trouble relating Cauchy and Weierstrass to Zeno. The epsilon-delta method of defining 'sums' of infinite series as 'limits' is *finitary* in spirit, suggesting a way to *avoid* having to deal with *actual*, as opposed to merely *potential*, infinity. Abraham Robinson puts the matter cautiously: "[O]n the issue of the actual infinite versus the potential infinite, the epsilon-delta method, did not, as such force its proponents into a definite position" (Robinson 1969, p. 162). Joseph Dauben, in his 1988, is more blunt: ". . . [T]he epsilon-delta methods of Cauchy and Weierstrass re-established analysis on acceptably finite terms" (p. 186). Nevertheless, following Cauchy and Weierstrass, Cantor and others developed an explicit theory of actually infinite series and actually infinite numbers, in the light of which one may feel, as Michael White puts it, that "the idea of the 'sum' of an infinite series *implicitly* appeals to something like an *omega*-conception of the totality of the addenda of the series . . ." (White 1992, p. 172). (Cantor calls the first transfinite ordinal, 'Omega'; it has the same cardinal size as Aleph Null, \aleph_0.) The current position, then, on 'sums' of infinite series is that although the series of addenda is *actually* infinite—for example, there exist actually infinitely many rational numbers, or divisions of the 'rational number line'—one can only 'add together' *finite partial sums* of these. More briefly, although all the rationals between 0 and 1 *actually exist*, we somehow *cannot add together* all of them. This unstable position can be usefully compared with Aristotle's more coherent view. As is well known, Aristotle rejected the actual existence of infinitely many divisions of (what we would call) the 'rational number line'. The rationals, for Aristotle (which he viewed not as numbers but as ratios between numbers), only *potentially* exist. A line segment, in turn, for Aristotle, does not consist of 'points', but rather potentially consists of the (finitely many) sub-segments into which the original segment can potentially be divided. One can always divide a line segment further than any given finite limit, but the dividing process can never *actually* be completed. Distinguishing potential from actual infin-

ity, then, Aristotle did have a coherent reply to Zeno. Indeed, as Vlastos comments, "there is good reason to think that Aristotle himself would have approved [Zeno's assumption (c2)]" (Vlastos, p. 371). Aristotle's way out was simply to reject the actual existence of infinitely many divisions of a finite quantity—to assert, in effect, the mere potential infinity of the rational numbers. *For the contemporary (classical) mathematician, however, this Aristotelian path is blocked*, insofar as it is accepted that the rational numbers constitute an *actually* infinite series.[7]

Why is it inconsistent, however, one might ask, for a modern thinker to assert both that the set of rational numbers is actually infinite and also that the 'sum' of an infinite series of rationals is only a 'limit' of the series of partial sums? Why *must* it be possible to add together, in an 'actually-infinite sum', *all* the rationals, say, between 0 and 1? The situation is perhaps clearest from a geometrical point of view, but it is well to remind ourselves that the modern viewpoint assumes the 'arithmetization of the continuum', the beginning of which was no doubt the coordinatization of geometry, from Descartes onward. As Mary Tiles puts the matter, with regard to real numbers:

> the infinite sequences of rationals can be treated as *either actually or potentially infinite*. But when the definition of real numbers as the limits of converging sequences of rational numbers is given in the context of the intended geometrical interpretation it appears that *the actual infinite must be accepted* if the real numbers are to provide *an arithmetical model for the points in a line* in the manner which is implicit in coordinate geometry with its tacit assumption that every point on the x- and y-axes is indexed by a number. (Tiles 1989, pp. 93–94; emphases added)

What obtains in this context from a *geometrical* point of view, then, should be valid also *arithmetically*. Consider, then, the interval between 0 and 1 on the rational number line. If we divide it in half, we obtain two parts, $1/2$ and $1/2$, whose 'sum' constitutes the whole interval. Divide one of these parts in half, and we obtain again two parts, $1/4$ and $1/4$, whose 'sum', added to the first $1/2$, constitutes, again, the

7. Must the rational numbers be accepted as an actually infinite set if the natural numbers are? A colleague has suggested that if we assume the actual existence of all the infinitely many natural numbers (which we would presumably have to do if by chance there happened to exist infinitely many stars—a hypothesis, by the way, whose coherence is denied by Wittgenstein in *Philosophical Remarks*), then we could simply 'construct' the rationals from them—say by forming the set of all ordered pairs of natural numbers. If my reasoning is sound, however, these ordered pairs would not after all constitute *the rational numbers*, since we still could not coherently define an *arithmetic* for them. In particular, we could not coherently define all additions—including 'infinite' additions'—of these 'rational numbers'.

whole. If, then, *all* the rational numbers between 0 and 1 *actually* exist, then the interval can *actually* be 'divided' into infinitely many rational parts. But since this totality of parts *constitutes* the interval itself, from 0 to 1, it *must* be possible to 'add' together *all* the parts to *reconstitute* the entire interval. In a word: (1) *what can be actually infinitely decomposed can also, of necessity, be actually infinitely reconstituted.* If we can 'cut up' a finite interval of the rational number line into infinitely many parts, we must be able to 'glue' the parts back together again, to obtain that same interval.[8] (See, however, the remarks by Paul Bernays cited below.) But this actually infinite reconstitution is precisely what is ruled out by the theory of sums as limits, which declares senseless the attempt to form an actually infinite sum. (Again, I allow myself to slide between the geometric and the arithmetic concepts of a sum of parts.)

As a response to Zeno, then, Dantzig's invocation of the theory of limits fails, since it fails to address Zeno's question of how we can add together the actually 'infinite sum' of finite parts, obtained by infinitely dividing some finite quantity, without getting something infinite as a result. Worse, a close analysis of the theory of limits itself reveals a serious problem therein: given that one can obtain all the actually infinitely many rational numbers in the finite interval between 0 and 1 by an

8. In response to this disturbing argument a distinguished colleague has replied that: "Just because one has used partial sums to get to where one has a definition for an infinite sum does not mean the infinite sum is somehow still a kind of partial sum itself, or that one can only 'approach' the infinite sum but not ever actually 'have' it. Once it is defined, there it is." Now, as Frege has stressed, the issue of introducing new definitions for 'old concepts' in mathematics is a delicate one, but clearly we are not free simply to redefine a perfectly clear concept like 'all' to mean 'not all' (a point Gödel has in effect made elsewhere). In any case, a *limit*, as we have seen Wittgenstein—together with clear headed mathematicians—insisting, is simply *not* a *sum* in the classical sense. We are precisely *not* adding together, simultaneously, *all* (in the classical sense of 'all'!) the addenda when we take the limit of an infinite series. Indeed, that was precisely *the point* of the introduction of limits as a method of avoiding having to take an actually infinite sum, but nevertheless achieving, 'formally speaking', the needed results in the relevant mathematics.

This becomes even clearer with regard to my colleague's follow-up remark: "My coffee cup, if it is made of continuously divisible matter, could in principle fall apart into infinitely many pieces, each of which is of finite size, and could in principle be glued back together all at once with infinitely many simultaneous glueings." But this is precisely what *cannot* be done if what is meant here by an "infinite sum" is "taking the limit of the partial sums." Let the coffee cup fall apart into two pieces. Both halves must be glued together to fully reconstitute the cup. Let one of the halves itself fall apart into two pieces. Now all three pieces (one half, one fourth, and another fourth) must be reglued for the cup to be restored. And so on. If the cup literally falls apart into infinitely many pieces, it follows that *all* infinitely many pieces must literally be reglued if the cup is to be fully restored. But from the fact that the *limit* of all the partial sums or all the 'partial glueings' is represented by the complete cup, *nothing at all follows* about the result of literally *gluing together all the actually infinitely many pieces.* For as we have seen, the concept of the limit is designed precisely to *side step* the question of what happens when *all* the actually infinitely many addenda are *literally simultaneously 'added' together.*

infinite *division*, how can it *not* make sense—*pace* the theory of limits—to add together all the infinitely many parts obtained by this division? *Finitism and infinitism are here at odds with one another.* But the situation is even worse than this. For it will be argued shortly that, consistent with the modern point of view, which embraces actual infinity, one can make it plausible that for Zeno's series, Z, the idea of an 'actually infinite sum' is not senseless, and that, exactly as Zeno predicted, $\sum_{n=1}^{\infty} 1/2^n$ is not 1, but rather infinity!—more precisely, \aleph_0. Since Z is, or can be, obtained, however, by dividing up a *finite* interval, this consequence is unacceptable. Thus, again just as Zeno predicted, this suggests that we *cannot* infinitely divide a finite quantity, and hence that the set of rational numbers, viewed as indices to the points on the rational number line, is *not* after all *actually infinite.*

It may be doubted, however, whether these extreme results really do follow, even if it be granted that belief in the actual infinity of the rational numbers entails the meaningfulness of forming the 'actually infinite sum' of Z. For Z, after all, is a convergent series, whose members, as one says, become smaller 'without limit'. This consideration has weighed heavily, I dare say, with many thinkers. Mark Sainsbury, for example, in his well known study, *Paradoxes,* invokes it in his attempt to refute Zeno's thesis, which he characterizes thus: "If a whole contains infinitely many parts, each of some finite size, then the whole is infinitely large" (1988, p. 11). "To see that [this thesis] is false," writes Sainsbury, "we need to remember that it is essential to the idea of infinite divisibility that the parts get smaller without limit, as the imagined process of division proceeds." Again, "once we hold clearly in mind that there can be no lower limit on the size of the parts induced by the infinite series of envisaged divisions, there is no inclination to suppose that having infinitely many parts entails being infinitely large" (pp. 11–12). Note that Sainsbury does not invoke the notion of the 'limit' of a series of partial sums, nor assert that the very idea of an 'actually infinite sum' is senseless. Rather, he points to the fact that "the parts get smaller without limit."

What can be said about Sainsbury's response to Zeno? One notes, first, that it is highly implausible, on the face of it, that Zeno himself could have failed to notice the fact Sainsbury draws attention to. Is it really to be believed that Zeno could not see that the members of Z "get smaller without limit"? Amazingly, Vlastos *does* ask us to believe this! He is so unimpressed with Zeno's reasoning that he feels compelled to attribute to him an assumption Zeno himself never explicitly advanced—to wit, (c3): "An infinite sequence of terms of decreasing size must have a *smallest* term, e" (Vlastos, p. 370). Absent this assumption, Vlastos feels,

Zeno's argument is simply too implausible to have been advanced by him. This, in spite of the fact that, as Vlastos himself notes, ". . . (c3) unfortunately entails (c4): An infinite sequence of terms of decreasing size must have a *last* term, which contradicts the point made in Zeno's text that the sequence *has no last member*. . ." (pp. 370–71). Thus, Vlastos is willing to attribute to Zeno blatantly contradictory assumptions rather than admit any plausibility to (c2), given the fact, emphasized by Sainsbury, that the parts of Z become 'smaller without limit'.

Sainsbury, as we have seen, does not rule out the very idea of an 'actually infinite sum' as senseless. Since the fact that the members of Z become 'smaller without limit' is crucial for him, it seems to be presupposed that if an infinite series is *not convergent* but rather 'definite divergent' like $1/2, 1/2, 1/2, 1/2, \ldots$ (henceforth, Z_1), or $1, 1, 1, \ldots (Z_2)$, then its 'infinite sum' *would not be finite*. An indeed some mathematicians are willing to extend the notion of 'sum', in the sense of 'limit', to such series. Knopp writes, for example, that "in the case of definite divergence we can also, in an extended sense, speak of a sum of the series, which then has the 'value' positive-infinity or negative-infinity. Thus for instance the series, $\sum_{n=1}^{\infty} 1/n = 1 + 1/2 + 1/3 + 1/4 + \ldots$, is definitely divergent, and has the 'sum', positive-infinity, because, by 46, 3, its partial sums approach positive-infinity" (p. 103). This is not germane to our purposes here, however, since $\sum_{n=1}^{\infty} 1/n$, as so defined, is neither a limit nor an actually infinite sum. It is not a limit since the partial sums do not really become arbitrarily close to positive-infinity. Recall our epigraph from Wittgenstein: "Where the nonsense starts is with our habit of thinking of a large number as closer to infinity than a small one." And it is clearly not an 'actually infinite sum', since it is defined in terms only of finite partial sums.

Sainsbury, however, is responding to Zeno: If what makes the 'infinite sum' of Z *finite* is the fact that the members of Z diminish 'without limit', then it must be that for Z_1 and Z_2, whose members do *not* diminish, their 'infinite sums' *are infinite*. *Where can one turn, then, to make sense of the actually infinite sum of an infinite series of terms of constant finite size?* One should turn, surely, to Cantor's theory of transfinite numbers. A. Fraenkel, for example, writes in *Set Theory and Logic* (p. 58), that: "$1 + 2 + 3 + \ldots = \aleph_0$. This example shows the *proper addition of infinitely many numbers*, as opposed to the improper addition (by means of the limit concept) in the theory of infinite series and in the calculus." He continues: "$\aleph_0 \cdot 2 = \aleph_0$. And $\aleph_0 \cdot n = \aleph_0$, for any finite n." Further, ". . . any cardinal not $= 0$ can be represented as a finite or infinite sum in which each term is 1" (p. 59, note 3). Since $1 + 1 + 1 + \ldots$

= $1/2 + 1/2 + 1/2 \ldots$, it follows that any cardinal number can be represented as a finite or infinite sum of $1/2$ added to itself (or $1/4$ added to itself, or $1/8$ added to itself, etc.). If we accept, then, Cantor's theory of transfinite numbers, is it not reasonable to accept \aleph_0 as the 'actually infinite sum' of Z_2? (and also of Z_1, since Z_1 can be arranged thus: $(1/2 + 1/2) + (1/2 + 1/2) + \ldots$) The question that remains, then, is whether Sainsbury is correct that, unlike the case of Z_1 or Z_2, the 'actually infinite sum' of all the members of Z, which "get smaller without limit," is finite—in fact, is 1.

Sainsbury is not correct. It is possible to show, I believe, that: (2) *if the 'actually infinite' sum of (the divergent infinites series), Z_1 and Z_2, is infinite, then so is the 'actually infinite' sum of the convergent infinite series,* Z. This emerges from a close consideration of the following diagram:

	1)		2)		3)		
1)	$1/2$	+	$1/2$	+	$1/2$	+
2)	$1/4$	+	$1/4$	+	$1/4$	+
3)	$1/8$	+	$1/8$	+	$1/8$	+
.							
.							
.							
.							
n)	$1/2^n$	+	$1/2^n$	+	$1/2^n$	+

FIGURE 10

Note that each horizontal *row* has an actually 'infinite sum' which is infinite. The question, then, is: what is the infinite sum of each vertical *column*? But vertical column (1) is just our convergent infinite series, Z. Thus, according to Sainsbury its 'infinite sum' should be not \aleph_0 but 1. On what grounds, however, can he defend this asymmetric treatment of the horizontal rows and the vertical columns? There seem to be two possible lines of defense, one based on *cardinal* considerations, one on *ordinal.*

Cardinal. Since the successive addenda of vertical column (1) (= Z) become 'small without limit', no matter how large the number of addenda their sum will never exceed a finite amount.

We seem to have an echo, here, of Newton's "ghosts of departed quantities" (in Berkeley's phrase), since the idea seems to be that 'eventually' the addenda in vertical column (1), or Z, become 'vanishingly small'. Note, however, that all the members of infinite series Z remain discrete *finite* quantities; none of them is an *'infinitesimal'* (either in Newton's sense—whatever that was—or in Robinson's, in his 'nonstandard analysis'). Indeed, it is obvious that no matter how *'small'* the successive addenda in column (1) become, *there will always be, for every member m of vertical column (1), a horizontal row consisting entirely of addenda the size of m, whose sum is* \aleph_0. But if *each individual member* of column (1) is such that the result of adding *it* to itself infinitely many times is \aleph_0, why should the result of adding *the combination* of all the different individual members be *less* than \aleph_0? Indeed, still more simply, how could the mere 'smallness' of the addenda in column (1) speak to the size of their *infinite* sum? Obviously, Sainsbury would be unconvinced by the suggestion that, since each successive horizontal row has smaller addenda than its predecessor, eventually, 'at the limit', the addenda become 'vanishingly small', so that a horizontal row consisting of these 'small' addenda no longer has an infinite sum whose value is \aleph_0. How, then, is the case different with column (1)? The only difference is that the addenda themselves in that column become 'ever smaller'; yet, as we have just seen, *with a truly infinite addition, the 'small' size of each addendum (as long as it is still finite) is strictly irrelevant.*

Perhaps, however, Sainsbury et al. are relying on an ordinal argument.

> *Ordinal.* Column (1) is our convergent infinite series, Z. The limit, therefore, of the successive partial sums of column (1) is 1. We 'project', therefore, that even the truly 'infinite sum' of all the members of column (1), i.e. Z, cannot exceed 1.

The reasoning here seems to be as follows. No matter *how many* terms in Z we add, *the greater* number of terms added is offset by a corresponding *decrease* in the *size* of the terms added, a decrease by a factor of $1/2^n$. What one hand *gives* (more terms added) the other *takes away* (proportional decrease in the size of the terms added). This, then, is to be contrasted with a 'definite divergent' series like horizontal row (1) (i.e., Z_2). As we have seen, Knopp says that we may speak of the 'limit' of such a series as infinite, since the successive partial sums of such a series grow big 'without limit', and thus 'approach infinity'. That is why, it may be thought, if we go beyond Knopp and form the 'actually infinite sum' of Z_2, its value will *be* infinity. In sum, the reasoning here seems to be that whereas the successive partial sums of the 'definite

divergent' series Z_2 approach, arbitrarily closely, infinity, the partial sums of the convergent series Z_1 do not 'approach infinity', but rather 'converge' on 1.

This contrast, however is founded precisely on a false assimilation of the infinite with the finite. For the fact that the successive partial sums of Z 'converge' on 1 as their 'limit' is a *'finitary'* fact about this series. Each partial sum consists always of only finitely many members. That is *why* the sums do not become 'arbitrarily large', or 'large without limit'. The number of terms added is, as we saw, offset by a corresponding and proportional diminution in the size of the addenda. When we move to an *actually infinite* sum, however, the *proportionality* of the offsetting size of the addenda *disappears*. For although we now have *an actual infinity of addenda*, the size of the individual addenda *has not decreased by an infinite amount;* the addenda do *not* shrink, proportionately, to *'infinitesimal'* size, but remain *finite*. Thus, an asymmetry has emerged between the successive finite and the 'actually infinite' sums; that is why *it is true both that the limit of the successive partial sums of Z is 1 and also that the actually infinite sum of all the members of Z, should it exist , would be infinite.*

What has happened, then, is that the size of the first infinite number, \aleph_0, has been underestimated, and that in two senses. First, the fact that the successive terms in Z get 'smaller without limit' has led people to forget that when the additions are truly infinite in number, the 'smallness' of the addenda (if still *finite*—i.e. *not infinitesimal*) is 'cancelled', as it were, by the (actual) *infinity* of the number of additions. Second, there is the confused idea that, by contrast, for a 'definite divergent' series like Z_2 the successive partial sums 'approach infinity' (Knopp). Yet each successive partial sum, no matter how big, remains *qua* finite, *as far from infinity as every other partial sum!* Recall Wittgenstein: "Where the nonsense starts is with our habit of thinking of a large number as closer to infinity than a small one." In spite of the fact that since Cantor it is known that $\aleph_0 - n = \aleph_0$, for all finite n, no matter how big, the 'size' of Aleph Null continues to be underestimated. It cannot be approached stepwise, 'from below'. Again, Wittgenstein: ". . . but if I only advance along the infinite stretch step by step, then I can't grasp the infinite stretch at all. . . . No: it can only be verified by *one* stride, just as we can only grasp the totality of numbers at *one* stroke" (p. 146). Similarly, Gödel speaks of "the first infinite jump": "What are taken as the big jumps relative to the degrees of certainty, such as the use of impredicative definitions . . . are small compared with *the first infinite jump* to the totality of natural numbers" (Wang 1987, p. 189; emphasis added).

Gödel, then, seems to be emphasizing the greatness of the 'jump' to the first transfinite number, \aleph_0, whereas many thinkers have focused, rather, on the greatness of 2^{\aleph_0} and beyond. Both Wittgenstein and Gödel, however, are emphasizing, from different perspectives, the fact that there is no gradual, stepwise, approach to the infinite. One must therefore take exception to Shaughan Lavine, who speaks, in *Understanding the Infinite* (p. 168), of the "experience of potential infinity," and suggests that the ideal cognizer of potential infinity would be "an immortal mathematician," who keeps on counting forever. For even Lavine's deathless mathematician would only acquire a *stepwise* knowledge of infinity, which is, as Wittgenstein points out, no knowledge of the infinite at all. Rather, one must somehow gain epistemological access to the *modal* fact of the permanent *possibility* of adding one more number, or dividing one more time, and this must be, as Wittgenstein says, "grasped at one stroke." Gödel puts the matter this way, in conversation with Wang (1996, p. 220): "We idealize the integers . . . to the possibility of an infinite totality . . . What this idealization—realization of a possibility—means is that we conceive and realize the possiblity of a mind which can do it. *We recognize possibilities in our minds in the same way we see objects with our senses*" (emphasis added).

If Gödel and Wittgenstein are right, then, it follows that the successive partial sums of Z_2, though they do become—while always finite—arbitrarily large, do not in virtue of that fact *'approach infinity'.*[9] The different 'finitary' behavior, then, of the successive partial sums of Z and Z_2 does not constitute evidence against our argument that the 'infinite sums' of all the members of each series are, in both cases, infinite. Neither the cardinal nor the ordinal arguments, then, that we have introduced constitute successful defenses of Sainsbury's claim that since the members of Z become "small without limit", the *actually infinite* sum of all the members of Z is not *infinite*.

Zeno, then, has not after all been 'refuted' along the lines proposed by Dantzig, Sainsbury, et al. It has not been shown that a finite quantity can be (actually) infinitely divided. Further, if we accept the modern 'coordinatization of geometry' and the 'arithmetization of the continuum', then *there is an unacceptable tension between the classical assumption of the actual infinity of all the rational numbers* contained in a finite

9. *Exercise for the reader:* given the fact that "the nonsense starts with our habit of thinking of a large [finite] number as closer to infinity than a small one," how can it be true nevertheless both that children do in fact learn to grasp infinity by consideration of large numbers, and that, mathematically speaking, one can for many purposes 'simulate' the role played by the infinite by employing only very large finite numbers (by means of what Lavine (1994) calls "the theory of zillions")?

interval—arrived at (contra Zeno) by a *pointwise decomposition* of the interval of the rational number line—and *the classical theory of limits*[10], which denies the meaningfulness of actually *reconstituting* the finite interval by means of an actually infinite addition of all the infinitely many divisions. If one wishes to maintain that the set of rational (not to say real) numbers constitutes an actually infinite totality, then this *tension* leads to an outright *contradiction* if our reasoning has been sound that the 'actually infinite sum' of all the rational numbers within a finite interval is infinite. *Something has to give.* Our argument, itself, however, leaves open the choice of where the changes should come. One could follow Brouwer or other constructivists (Wittgenstein?), in the tradition of Aristotle, and reject the classical, definite, completed, actually infinite, point-wise decomposable continuum in favor of Brouwer's 'fluid', 'free-choice', never-fully-completed continuum.[11] One could, as Gödel puts it, introduce a separation between the geometric continuum itself and the 'points' which constitute a mere 'scaffold' on the line. "In space intuition," Hao Wang records Gödel as saying, "a point is not a part of the

10. Of course as a piece of 'mathematical engineering', i.e. as a calculating device, the theory of limits of convergent infinite series is untouched by our reasoning. It is its status as a proposed *theory* of line and number—in effect, a *metaphysics* of the calculus—that we have called into question. It's necessary to stress this point since a distinguished colleague has reacted rather strongly to my line of reasoning: "By casting doubt on infinite sums you cast doubt on the intelligibility of limits, . . . not to mention that common-or-garden decimal expansions of real numbers are not above suspicion since they too are infinite sums. In short, you have cast doubt on the intelligibility or well foundedness of most mathematics." In point of fact, however, I have neither cast doubt on infinite sums nor suggested the unintelligibility of limits. Concerning the former, I have precisely argued that we *can* make sense of actually infinite sums, given Cantor's transfinite arithmetic. What I have drawn attention to, rather, is the *tension* that arises from the tendency of mathematicians and mathematical philosophers simultaneously to accept Cantor's *transfinite arithmetic* and *also* to accept the theory of *limits* as *the solution* to the problem of how to 'reconstitute' the real (or rational) continuum after decomposing it into the actual infinity of real (or rational) numbers.

Further, I have of course nowhere asserted "the unintelligibility of limits." Indeed, I insisted, above, that: "*it is true both that the limit of the successive partial sums of Z is 1 and also that the actually infinite sum of all the members of Z, should it exist, would be infinite.*" And I have of course also not proposed or implied "the unintellibility of most mathematics"(!), nor cast doubt on the intelligibility of defining infinite decimal expansions of real numbers in terms of limits. A famous 'proof', however, that .999 . . . = 1 fails once we reject the assumption that .999 . . . is the *limit* of the sequence of partial sums, $\frac{9}{10} + \frac{9}{100} + \frac{9}{1,000} + \cdots$

11. W.P. van Stigt (1990) describes Brouwer's continuum thus: "Unlike Cantor's continuum, conceived as a given totality of points, Brouwer's intuitive continuum is a medium in which points can be inserted, a potential for 'cutting'. . . . The construction of a suitable point-grid on the continuum [can be] described as 'making the continuum measurable'. . . . Although operations and functions are defined in terms of the points of the grid, the scale is not the continuum itself" (pp. 329–330). Further, "his [Brouwer's] mathematical continuum shares the dynamic character of the 'time continuum'" (p. 152).

continuum but a limit between two parts. . . . According to this concept, all the points do not add up to the line but only make up a scaffold (*Gerüst*) or a collection of points of view" (1996, p. 236). This approach too has an Aristotelian flavor (see above, p. 28).[12] What is not acceptable, however, is a simple identification (or even a proposed one-one correspondence) of the (actually infinite totality of) rational (not to say the real) numbers with the 'points' on the 'rational number line' (respectively, the continuum). Indeed, Paul Bernays has made some remarks that point in the same direction (in correspondence with Wang, as recorded in *A Logical Journey*): "[O]ne should not overestimate the philosophical relevance of the possibility of embodying classical mathematics in set theory . . . [F]or considering the intuitive sources of mathematics *we have to keep to the old dualism of arithmetic and geometry* . . . [W]e cannot require a strict *arithmetization [of geometric concepts]* but in many cases must content ourselves with a kind of compromise. . . . [E]ven the concept of the number series is geometrically motivated. From the strictly arithmetical point of view the progress of numbers is only a *progressus in indefinitum*" (emphasis added).[13] The considerations advanced above, I believe, give fresh support to these pregnant observations of Bernays's. Whatever the successes, then, of the so-called 'arithmetization of the continuum' from the point of view of the practicing mathematician, its philosophical significance remains in question. In particular, the dialectic of potential versus actual infinity, as well as that between number and line (or arithmetic and geometry), has not—despite all the advertisements to the contrary—with the advent of modern mathematics, disappeared. Given, moreover, the arguments advanced elsewhere in this book, that *potential infinity* seems to be ineluctably tied to the concept of *time*[14], and given also the arguments we have advanced that even after Einstein (Husserl notwithstanding), time itself remains an enigma (perhaps even, as Gödel himself hints, *the* enigma), it follows that even after the great achievements of Cauchy, Weierstrass, Cantor, Dedekind, and Frege the infinite is far from having yielded to us its fondest secrets.

12. Compare the discussion of the continuum in terms of "wholes given before" and "wholes constructed out of" their parts, in Tiles 1989, pp. 92–94, 220–23.

13. See also Bernays's famous essay, 'On Platonism in Mathematics', for similar sentiments.

14. Elsewhere in this study (p. 199) I have drawn attention to the fact that it was Plato, in *The Republic*, who first attempted to drive time out of the realm of mathematics, a task seemingly brought to completion in the nineteeth century with the achievements of Cauchy, Weierstrass, Cantor, Dedekind, and Frege. Indeed, in 'What is Frege's Relativity Argument?', I argue that Frege and Gödel can be seen as bringing to fruition (or at least, coming close to doing so) what I describe there as "Plato's Program" for mathematics, as presented in *The Republic*.

Recapitulation

From modern analysis: $1/2 + 1/4 + 1/8 + \ldots = \sum_{n=1}^{\infty} 1/2^n = \lim (3/4,$ $7/8, 15/16, \ldots = 1$. This is an 'improper' infinite 'sum' of a convergent infinite series. *From Cantor and transfinite arithmetic:* $\aleph_0 \cdot n = \aleph_0$, for all finite n. Hence, $\aleph_0 \cdot 1 = \aleph_0$. But $\aleph_0 \cdot 1 = 1 + 1 + 1 + \ldots = ([1/2 + 1/2] + [1/2 + 1/2] + \ldots) = (1/2 + 1/2 + 1/2 + \ldots) = \aleph_0$. This is a 'proper' infinite sum of a divergent infinite series. So, *two different representations of the 'sum' of an infinite series—depending on whether the series is convergent or divergent?*

Since Cantor we accept actually infinite sets.[15] In particular, we say that the set of all rational (and all real) numbers is actually infinite, and that it corresponds one-one with the 'points' on the 'rational line' (respectively, the real number line—i.e. the continuum). Since Cantor (and Dedekind et al.), each member of the actually infinite set of real numbers is itself defined using the notion of an improper 'sum', i.e. a limit (viz. of an actually infinite convergent sequence of rational numbers). Thus Cantor in fact employs both '*infinitary*' concepts (viz., *actually infinite sets*) and '*finitary*' concepts (viz., *limits*).

Thesis [1]: **Since the parts constitute the whole, if the rational (or real) interval, [0, 1], can be actually infinitely divided or 'decomposed' into the totality of rational numbers (or 'points') in the interval, it follows that it can also be actually infinitely 'reconstituted' (via an actually infinite 'addition').** Yet when a convergent infinite series is at issue, even Cantor will not admit the proper, actually infinite sum of the infinite addition, $1/2 + 1/4 + 1/8 + \ldots$, but rather defines this 'sum' as the limit of successive partial (finite) sums. If Thesis [1] is correct, however, and $<0,1>$ does 'fall apart' into the totality of all rational numbers in the interval, we must be able to constitute the proper actually infinite addition of this convergent infinite series. *What could this actually infinite sum be?*

Appearances to the contrary, from the fact that the *limit* of the successive partial sums of this series is 1, *nothing at all follows* concerning the proper, actually infinite sum of all the members in the actually infinite series, $1/2 + 1/4 + 1/8 \ldots$. After all, the limit concept was designed by Cauchy and Weierstrass precisely to *avoid* the question of what the proper, actually infinite sum of this convergent series might be.

Thesis [2]: **The proper, actually infinite sum of the series, $1/2 + 1/4 + 1/8 + \ldots = \aleph_0$ (whereas the limit of this series is 1).** The following diagram conveys the backbone of the reasoning:

15. Why? See Lavine 1994, p. 159, for one answer.

(A) $+1/2 + 1/2 + \ldots = \aleph_0$ $+1/4 + 1/4 + \ldots = \aleph_0$ $+1/8 + 1/8 + \ldots = \aleph_0$ $+1/2^n + 1/2^n + \ldots = \aleph_0$

(B) $1/2$ $+$ $1/4$ $+$ $1/8$ $+$ $1/2^n$ $=$?

FIGURE 11

Note that there is no term in the convergent sequence, (B), so 'small' that its size prevents the proper, actually infinite addition of it to itself—as represented by the corresponding divergent sequence above, in (A)—from yielding \aleph_0. (NB: the addenda in (B), though increasingly 'small', remain finite; they do not become 'infinitesimal'.)

So, why the *illusion* that the proper, actually infinite sum of the addenda in (B) is, not Aleph Null, but rather 1? Answer: accustomed to taking the limit of successive finite partial sums, we are familiar with the fact that for *finite* sequences of addenda, the *larger* the number of addenda, the *smaller* the increment in the sum. We then *falsely extrapolate* this familiar inverse relationship from the *finite* to the *infinite* case. With a proper actually infinite addition, by contrast, while the total number of addenda is now *actually infinite*, the size of each individual addendum has *not* shrunk to the *infinitesimal*; it remains finite.

Thesis [3]: **Since the implications of Thesis [2] are clearly unacceptable (the sum of the parts of a finite interval cannot be infinite), it follows that the set of rational (not to say real) numbers (or 'points') is not actually infinite, but at most potentially infinite.**

Thus, if the set of rational (respectively, real) numbers is taken to model the rational (respectively, real) number line, it follows that the rational number line (respectively, the real continuum) cannot be (actually) infinitely decomposed. Brouwer's intuitionistic continuum (or a similar construction) receives here unexpected support—surprising, in particular, insofar as it derives not from the already intuitionistically suspect domain of the classical real numbers, but rather from the seemingly 'safe' domain of the rationals. Zeno's famous thesis that the finite cannot be infinitely decomposed is also confirmed.

Cantor himself, it should be recalled, was always actively hostile to the idea of the infinitely small—insisting, in particular, that his doctrine of the infinitely big (the transfinite numbers) does not imply, by taking the reciprocal, the existence of the "infinitesimal". (Clearly, what is meant by Abraham Robinson as the 'infinitesimal' of his Nonstandard Analysis is an entirely different notion,[16] based on concepts and results from modern logic—in particular, the Compactness Theorem of Gödel.[17]) Nevertheless, *Cantor wanted to have it both ways.*

16. See Dauben 1988, e.g. p. 179, where he rejects Lakatos's claim that "Robinson's work . . . offers a rational reconstruction of the discredited [historical] infinitesimal theory which satisfies modern requirements of rigour . . ." (brackets added).

17. For a brief, clear account of Nonstandard Analysis in its relation to Gödel's Compactness Theorem see Davis 1996.

He maintained simultaneously that the set of rational (and real) numbers (or 'points') exists as an *actually infinite totality* 'within' the finite interval, $[0,1]$,[18] but he also maintained that the 'sum' of the rational (or real) numbers within this interval is to be taken merely as an *improper 'sum'*, a *limit*. But the limit of a convergent infinite sequence is a notion, as we have seen, that precisely does *not* involve the *actually infinite addition* of the *actually infinite sequence* of addenda, whereas elsewhere Cantor *does* recognize the existence of actually infinite additions, viz. of divergent infinite sequences, such as $1/2 + 1/2 + 1/2 + \ldots$, and in fact sets this sum as $= \aleph_0$.

18. Again, we regard the interval, $[0,1]$, indifferently as geometric or arithmetic, since Cantor, of course, is precisely proposing the 'arithmetization of the continuum'.

References

Almog, J., et al., eds. 1989. *Themes from Kaplan*. New York: Oxford University Press.

Anderson, Anthony. 1998. Alonzo Church's Contributions to Philosophy and Intensional Logic. *Bulletin of Symbolic Logic*, Vol 4, No. 2 (June), pp. 129–171.

Aristotle. 1979 [1963]. *Categories* and *De Interpretatione*. Trans. J.L. Ackrill. Oxford: Oxford University Press.

———. 1983. *De Anima*. Trans. D.W. Hamlyn. Oxford: Clarendon.

Barrow, John. 1998. *Impossibility: The Limits of Science and the Science of Limits*. Oxford: Oxford University Press.

Bealer, George. 1987. The Philosophical Limits of Scientific Essentialism. *Philosophical Perspectives* 1 (Metaphysics), pp. 289–365.

———. 1994. The Incoherence of Empiricism. *Proceedings of the Aristotelian Society*, pp. 99–138.

Benacerraf, P. 1965. What Numbers Could Not Be. In Benacerraf and Putnam 1983, pp. 272–294.

———. 1985. Skolem and the Skeptic. *Proceedings of the Aristotelian Society*, suppl. LIX, pp. 85–115.

Benacerraf, P., and H. Putnam, eds. 1983. *Readings in the Philosophy of Mathematics*. Cambridge: Cambridge University Press.

Benardete, José. 1964. *Infinity: An Essay in Metaphysics*. Oxford: Clarendon.

Bernays, P. 1946. Review essay: Kurt Gödel, 'Russell's Mathematical Logic'. *Journal of Symbolic Logic* 11, No. 3: 75–79.

———. 1983. On Platonism in Mathematics. In Benacerraf and Putnam 1983.

Bernstein, Jeremy. 1991. Besso. In Bernstein, *Quantum Profiles* (Princeton: Princeton University Press), pp. 143–165.

Boolos, G. 1984. To Be Is to Be a Value of a Variable (Or to Be Some Values of Some Variables). *Journal of Philosophy* 81, pp. 430–349.

Brouwer, L.E.J. 1948. Consciousness, Philosophy, and Mathematics. In Heyting 1975, pp. 480–494.

———. 1952. Historical Background, Principles, and Methods of Intuitionism. In Heyting 1975, pp. 508–515.

———. 1955. The Effect of Intuitionism on Classical Algebra of Logic. In Heyting 1975, pp. 551–554.

Burgess, J. 1978. The Unreal Future. *Theoria* XLIV, pp. 157–174.

————. 1979. Logic and Time. *Journal of Symbolic Logic* 44, pp. 566–582.

Burnet, J. 1968. *Early Greek Philosophy*. Cleveland: Meridian/World.

Capek, Milič. 1961.*The Philosophical Impact of Contemporary Physics*. New York: Van Nostrand.

————. 1976 [1966]. The Inclusion of Becoming in the Physical World. In Capek, Milič, ed., *The Concepts of Space and Time* (Dordrecht: Reidel).

————. 1991[1983]. Time-Space Rather than Space-Time. In Capek, *The New Aspects of Time* (Dordrecht, Kluwer).

Carnap, Rudolf. 1963. Intellectual Autobiography. In Schilpp 1963, pp. 37–63.

Cherniss, H. 1962. *Aristotle's Criticism of Plato and the Academy*. New York: Russell and Russell.

————. 1977. *Selected Papers*. Ed. L. Tarán. Leiden: Brill.

Chihara, C. 1982. A Gödelian Thesis regarding Mathematical Objects: Do They Exist? And Can We Perceive Them? *Philosophical Review* XCI: 211–222.

Church, A. 1951. A Formulation of the Logic of Sense and Denotation. In P. Henle et al., eds., *Structure, Method, and Meaning: Essays in Honor of Henry M. Sheffer* (New York: Liberal Arts Press), pp. 3–24.

————. 1956. *Introduction to Mathematical Logic*. Princeton: Princeton University Press.

————. 1973. Outline of a Revised Formulation of the Logic of Sense and Denotation, Pt. I. *Noûs* 7, pp. 24–33; Pt. II, *Noûs* 8, pp. 135–156.

Courant, Richard and Herbert Robbins. 1978 [1941]. *What is Mathematics?* Oxford: Oxford University Press.

Craig, William L. 1979. The Infinite Past Regained: A Reply to Whitrow. *British Journal for the Philosophy of Science* 30, pp. 161–172.

————. 1990. 'What Place, then, for a Creator?': Hawking on God and Creation. *British Journal for the Philosophy of Science* 41, pp. 473–491.

Dantzig, Tobias. 1954. *Number: The Language of Science*. 4th ed. New York: The Free Press.

Dauben, Joseph W. 1979. *Georg Cantor: His Mathematics and Philosophy of the Infinite*. Cambridge, Massachusetts: Harvard University Press.

————. 1988. Abraham Robinson and Nonstandard Analysis. In W. Aspray and P. Kitcher, eds., *History and Philosophy of Modern Mathematics* (Minneapolis: University of Minnesota Press).

Davidson, Donald. 1984 [1968]. On Saying That. In Davidson, *Inquiries into Truth and Interpretation* (Oxford: Clarendon), pp. 93–108.

Davies, P.C.W. 1995. *About Time: Einstein's Unfinished Revolution*. New York: Simon and Schuster.

Davies, P.C.W., and J.R. Brown, eds. 1989 [1986]. *The Ghost in the Atom*. Cambridge: Cambridge University Press.

Davis, Martin. 1982. Why Gödel Didn't Have Church's Thesis. *Information and Control* 54, pp. 3–24.

————. 1996. Nonstandard Analysis. In M. Borchert, ed., *The Encyclopedia of Philosophy: Supplement* (New York: Macmillan).

Dawson, John. 1995. *Logical Dilemmas: The Life and Work of Kurt Gödel*. Wellesley: Peters.

DeBroglie, Louis. 1982. A General Survey of the Scientific Work of Albert Einstein. In Schilpp 1982.

Detlefsen, Michael. 1979. On Interpreting Gödel's Second Theorem. *Journal of Philosophical Logic* 8, pp. 297–313.

———. 1986. *Hilbert's Program: An Essay on Mathematical Instrumentalism.* Dordrecht: Reidel.

———. 1990a. On an Alleged Refutation of Hilbert's Program Using Gödel's First Incompleteness Theorem. *Journal of Philosophical Logic* 19, pp. 343–377.

———. 1990b. Brouwerian Intuitionism. *Mind* 99, pp. 501–534.

Dipert, R. 1982. Set Theoretical Representations of Ordered Pairs and Their Adequacy for the Logic of Relations. *Canadian Journal of Philosophy* XII, pp. 353–374.

Dipert, R., and R. Weldon. 1976–77. Set-theoretical Music Analysis. *Journal of Aesthetics and Art Criticism* 35, pp. 15–22.

Dreben, Burton, and Jean van Heijenoort. 1986. Introductory Note to Gödel 1929; 1930; and 1930a. In Feferman et al. 1986, pp. 44–59.

Dummett, M. 1967. Truth. In Strawson 1967.

———. 1978a. *Truth and Other Enigmas.* Cambridge, Massachusetts: Harvard University Press.

———. 1978b. *Elements of Intuitionism.* Oxford: Clarendon.

———. 1978c [1960]. A Defense of McTaggart's Proof for the Unreality of Time. In Dummett 1978a, pp. 351–57.

———. 1978d [1969]. The Reality of the Past. In Dummett 1978a, pp. 358–374.

———. 1978e [1973]. The Philosophical Basis of Intuitionistic Logic. In Dummett 1978a, pp. 215–470.

Earman, J. 1967. On Going Backward in Time. *Philosophy of Science* 34, pp. 211–222.

———. 1995. *Bangs, Crunches, Whimpers, and Shrieks: Singularities and Acausalities in Relativistic Spacetimes.* New York: Oxford University Press.

Eddington, A. 1958. *The Nature of the Physical World.* Ann Arbor: University of Michigan Press.

Einstein, Albert. 1949. Reply to Criticisms. In Schilpp 1969, pp. 663–688.

———. 1961 [1916]. *Relativity: The Special and General Theory.* New York: Crown.

———. 1976 [1928]. Comment on Meyerson's 'La Deduction Relativiste'. In Čapek 1976, pp. 363–67.

Evans, G. 1985. Understanding Demonstratives. In Yourgrau 1990, pp. 71–96.

Feferman, Solomon. Introductory Note to Gödel 1931c. In Feferman et al. 1986, pp. 208–213.

———. 1984. Kurt Gödel: Conviction and Caution. *Philosphia Naturalis* 21, pp. 546–562.

Feferman, Solomon, et al., eds. 1986, 1990, 1995. *Kurt Gödel: Collected Works, Volumes I–III.* New York: Oxford University Press.

Furth, M. 1988. *Substance, Form, and Psyche: An Aristotelian Metaphysics.* Cambridge: Cambridge University Press.

Fraenkel, A.A. 1966. *Set Theory and Logic.* Reading, Massachusetts: Addison-Wesley.

Frank, Philipp G. 1982 [1949]. Einstein, Mach, and Logical Positivism. In Schilpp 1982.

Frege, Gottlob. 1892. On Sense and Meaning. Formerly translated as 'On Sense and Reference'. In P. Geach and M. Black, eds., *Translations from the Philosophical Writings of Gottlob Frege.* 3rd ed. (Totowa: Rowman and Littlefield), pp. 56–78.

———. 1967a. The Thought: A Logical Inquiry. In Strawson 1967, pp. 17–38.

———. 1967b. *Grundgesetze (The Basic Laws of Arithmetic).* Trans. M. Forth. Berkeley: University of California Press.

———. 1970. *Begriffsschrift: A Formula Language Modeled upon That of Arithmetic, for Pure Thought.* In J. van Heijenoort, ed., *Frege and Gödel: Two Fundamental Texts in Mathematical Logic* (Cambridge, Massachusetts: Harvard University Press), pp. 5–82.

———. 1979. *Posthumous Writings.* Ed. H. Hermes et al. Chicago: University of Chicago Press.

———. 1980. *The Foundations of Arithmetic: A Logico-Mathematical Enquiry into the Concept of Number.* Trans. J.L. Austin. Evanston: Northwestern University Press.

Friedman, Michael. 1983a. Form and Content. In Yourgrau 1990, pp. 215–231.

———. 1983b. *Foundations of Space-Time Theories.* Princeton: Princeton University Press.

———. 1985. Kant's Theory of Geometry. *Philosophical Review* XCIV, pp. 455–506.

———. 1990. Kant on Concepts and Intuitions in the Mathematical Sciences. *Synthese* 84, 213–257.

———. 1991. The Re-evaluation of Logical Positivism. *Journal of Philosophy,* Vol LXXXVIII, No. 10 (October), 505–519.

Geach, Peter. 1972 [1965]. Some Problems about Time. In P. Geach, *Logic Matters* (Berkeley: University of California Press, 1972).

Gillies, D. 1988. *Frege, Dedekind, and Peano on the Foundations of Arithmetic.* Assen, The Netherlands: Van Gorcum.

Gödel, Kurt. 1930. The Completeness of the Axioms of the Functional Calculus of Logic. In Feferman et al. 1986, pp. 103–123.

———. 1931a. On Formally Undecidable Propositions of 'Principia Mathematica' and Related Systems I. In Feferman et al. 1986, pp. 145–195.

———. 1931b. Review of Hilbert 1931. In Feferman et al. 1986, pp. 213–15.

———. 1944. Russell's Mathematical Logic. In Feferman et al. 1990, pp. 119–141.

———. 1946/49: A, B2, C1. Some Observations about the Relationship Between Theory of Relativity and Kantian Philosophy. In Feferman et al. 1995.

———. 1949. An Example of a New Type of Cosmological Solution of Einstein's Field Equations of Gravitation. In Feferman et al. 1990.

————. 1949a. A Remark about the Relationship between Relativity Theory and Idealistic Philosophy. In Feferman et al. 1990. (Also in Yourgrau 1990.)

————. 1949b. Lecture on Rotating Universes. In Feferman et al. 1995.

————. 1961/?. The Modern Development of the Foundations of Mathematics in the Light of Philosophy. In Feferman et al. 1995.

————. 1964. What Is Cantor's Continuum Problem? In Feferman et al. 1990, pp. 254–270.

Goldfarb, Warren D. 1979. Logic in the Twenties: The Nature of the Quantifier. *Journal of Symbolic Logic* 44, pp. 351–368.

————. Forthcoming. Gödel's Philosophy. *Synthese*.

Goldman, Robert. 1997. *Einstein's God*. Northvale: Jason Aronson.

Hacker, P.M.S. 1972. Frege and the Private Language Argument. *Idealistic Studies* 2, pp. 265–281.

Hahn, Hans. 1980 [1933]. The Crisis in Intuition. In Hans Hahn, *Empiricism, Logic, and Mathematics: Philosophical Papers* (Dordrecht: Reidel).

Hallett, M. 1984. *Cantorian Set Theory and Limitation of Size*. Oxford: Clarendon.

Hawking, Stephen. 1992. Chronology Protection Conjecture. *Physical Review* D.46, pp. 603–611.

————. 1996 [1988]. *A Brief History of Time: From the Big Bang to Black Holes*. Tenth Anniversary Edition. New York: Bantam.

Healey, Richard. 1981. Statistical Theories, Quantum Mechanics, and the Directedness of Time. In R. Healey, ed., *Reduction, Time, and Reality* (Cambridge: Cambridge University Press).

Heisenberg, Werner. 1989 [1983]. Encounters and Conversations with Albert Einstein. In Heisenberg, *Encounters with Einstein* (Princeton: Princeton University Press).

Heyting, A., ed. 1975. *L.E.J. Brouwer: Collected Works, Vol. I*. Amsterdam: North-Holland.

Hilbert, D. 1902. *The Foundations of Geometry*. Trans. F.J. Townsend. Chicago: Open Court.

————. 1931. Die Grundlegung der elementaren Zahlenlehre. *Mathematische Annalen*. 104, pp. 485–494.

Hon, Giora. 1996. Did Gödel Surprise Einstein with a Rotating Universe and Time Travel? *Foundations of Physics* 26(4).

Horwich, Paul. 1987. *Asymmetries in Time: Problems in the Philosophy of Science*. Cambridge, Massachusetts: MIT Press.

————. 1990. The Growth of Now. Review of J.R. Lucus, 'The Future'. *Times Literary Supplement* (June 22–28), p. 672.

Huby, P. 1971. Kant or Cantor? That the Universe, if Real, Must Be Finite in Both Space and Time. *Philosophy* 46, pp. 121–132.

Husserl, Edmund. 1991 [1893-1917]. *On the Phenomenology of the Consciousness of Internal Time*. Trans. J.B. Brough. Dordrecht: Kluwer.

Ishiguro, H. 1972. *Leibniz's Philosophy of Logic and Language*. London: Duckworth.

James, E.P. 1992. Review of Chihara, *Constructability and Mathematical Existence*. *Philosophical Books*, Vol. 33, No. 3 (July).

Jeans, James. 1936. Man and the Universe. Sir Halley Stewart Lecture, 1935. In Jeans et al., *Scientific Progress* (London: Allen and Unwin), pp. 11–38.

Jeffrey, R. 1980. Coming True. In C. Diamond and J. Teichman, eds., *Intention and Intentionality* (Ithaca: Cornell University Press), pp. 251–260.

Kant, Immanuel. 1902. *Gesammelte Schriften*. Akademie Edition. Berlin: De Gruyter.

———. 1950. *Prolegomena*. Trans. P. Carus; revised L. Beck. Indianapolis: Bobbs-Merrill.

———. 1965 [1781]. *Critique of Pure Reason*. Trans. N.K. Smith. New York: St. Martin's Press.

Kaplan, D. 1978. Dthat. In Yourgrau 1990.

———. 1979. Transworld Heir Lines. In M.J. Loux, ed., *The Possible and the Actual* (Ithaca: Cornell University Press).

———. 1989a. Demonstratives. In Almog 1989, pp. 481–563.

———. 1989b. Afterthoughts. In Almog 1989, pp. 565–614.

———. 1990. Thoughts on Demonstratives. In Yourgrau 1990, pp. 34–49.

Katz, J.J. 1988. The Refutation of Indeterminacy. *Journal of Philosophy* LXXXV, pp. 227–252.

Kitcher, P. 1978. The Plight of the Platonist. *Noûs* 12, pp. 119–136.

Kleene, S.C. 1962. *Introduction to Metamathematics*. Amsterdam: North-Holland.

Knopp, Konrad. 1990 [1921]. *Theory and Application of Infinite Series*. New York: Dover.

Kosman, A. 1969. Aristotle's Definition of Motion, *Phronesis* 14, pp. 40–62.

Kreisel, Georg. 1980. Kurt Gödel. *Biographical Memoirs of Fellows of the Royal Society* 26, pp. 149–224.

Kripke, Saul. 1963. Semantical Considerations on Modal Logic. In L. Linsky, ed., *Reference and Modality*. Oxford Readings in Philosophy (Oxford: Oxford University Press).

———. 1980. *Naming and Necessity*. Cambridge, Massachusetts: Harvard University Press.

Lachterman, D. 1989. *The Ethics of Geometry*. New York: Routledge.

Lakatos, Imre. 1987. *Mathematics, Science, and Epistemology: Philosophical Papers*, Vol. II, ed. J. Worrall and G. Currie. Cambridge: Cambridge University Press.

Lavine, Shaughan. 1994. *Understanding the Infinite*. Cambridge, Massachusetts: Harvard University Press.

Lear, Jonathan. 1980. Aristotelian Infinity. *Proceedings of the Aristotelian Society* 29, pp. 187–210.

———. 1982. Aristotle's Philosophy of Mathematics. *Philosophical Review* XCI, pp. 161–192.

Lee, E.N. 1976. Reason and Rotation: Circular Movement as the Model of Mind (noûs) in Later Plato. In W.H. Werkmeister, ed., *Facets of Plato's Philosophy* (Assen: Van Gorcum), pp. 70–102.

Lewis, D. 1973. *Counterfactuals*. Cambridge, Massachusetts: Harvard University Press.

Lightman, Alan. 1993. *Einstein's Dreams*. New York: Pantheon.

Malament, David. 1976. Review: L. Sklar, *Space, Time, and Space-Time*. *The Journal of Philosophy*, Vol. LXXIII, No. 11 (June 10), pp. 306–323.

———. 1984. 'Time-Travel' in the Gödel-Universe. *Proceedings of the Philosophy of Science Association* 2, pp. 91–100.

———. 1995. Introduction to Gödel 1949b. In Feferman et al. 1995.

Mates, Benson. 1986. *The Philosophy of Leibniz: Metaphysics and Language*. New York: Oxford University Press.

McTaggart, J.M.E. 1908. The Unreality of Time. *Mind* 17, pp. 457–484.

———. 1927. *The Nature of Existence*, Vol.2. Cambridge: Cambridge University Press.

Mellor, D.H. 1981. *Real Time*. Cambridge: Cambridge University Press.

Miller, Izchak. 1984. *Husserl: Perception and Temporal Awareness*. Cambridge, Massachusetts: MIT Press.

Mohanty, J.N. 1984. Husserl, Frege, and the Overcoming of Psychologism. In K.K. Cho, ed., *Philosophy and Science in Phenomenological Perspective* (Dordrecht: Nijhoff), pp.143–152.

Moore, W. 1989. *Schrödinger: Life and Thought*. Cambridge: Cambridge University Press.

Moravcsik, J. 1973. Recollecting the Theory of Forms. In Werkmeister 1976, pp. 1–20.

Murdoch, I. 1978. *The Fire and the Sun: Why Plato Banished the Artists*. New York: Oxford University Press.

Myhill, J. 1951. On the Ontological Significance of the Löwenheim-Skolem Theorem. In M. White, ed., *Academic Freedom, Logic, and Religion* (Philadelphia: University of Pennsylvania Press), pp. 57–70.

———. 1952. Some Philosophical Implications of Mathematical Logic. *Review of Metaphysics*, Vol. VI, No. 2 (December), pp. 165–198.

Nerlich, Graham. 1996. Review of Yourgrau 1991. *Philosophical Quarterly*, Vol. 46, No. 183 (April).

Newton-Smith, William. 1984 [1980]. *The Structure of Time*. London: Routledge.

Nietzsche, F. 1968. *Twilight of the Idols*. Trans. R.J. Hollingdale. Baltimore: Penguin.

Oaklander, Nathan. 1994. Review of Yourgrau 1991. *Philosophy and Phenomenological Research*, Vol. LIV, No. 3 (September).

Palma, Adriano. 1992. An Ontology of Suspicion. Review of Yourgrau 1991. *Philosophy and the History of Science* 1 (October), pp. 115–121.

Parmenides. 1957. *The Way of Truth*. Trans. F.M. Cornford. In *Plato and Parmenides* (Indianapolis: Bobbs-Merrill).

Parsons, Charles. 1968. Review Essay: Jose A. Benardete, 'Infinity'. *Journal of Philosophy* LXV, pp. 431–37.

———. 1980. Mathematical Intuition. In Yourgrau 1990, pp. 195–214.

———. 1983a. *Mathematics in Philosophy*. Ithaca: Cornell University Press.

———. 1983b. Ontology and Mathematics. In Parsons 1983a, pp. 37–62.

———. 1983c. The Liar Paradox. In Parsons 1983a, pp. 221-67.

———. 1983d. What is the Iterative Conception of Set? In Parsons 1983a, pp. 268–297.

————. 1983e. Sets and Modality. In Parsons 1983a, pp. 298–344.

————. 1992. The Transcendental Aesthetic, in P. Guyer, ed., *The Cambridge Companion to Kant* (Cambridge: Cambridge University Press), pp. 62–100.

————. 1995. Platonism and Mathematical Intuition in Kurt Gödel's Thought. In P. Leonardi et al., ed., *On Quine: New Essays* (Cambridge: Cambridge University Press).

Pascal, Blaise. 1966. *Pensées*. Trans. A.J. Krailsheimer. London: Penguin.

Penrose, Roger. 1989. *The Emperor's New Mind*. Oxford: Oxford University Press.

————. 1997. *The Large, The Small, and the Human Mind*. Cambridge: Cambridge University Press.

Perry, J. 1977. Frege on Demonstratives. In Yourgrau 1990, pp. 50–70.

Plato. 1957. *The Parmenides*. Trans. F.M. Cornford. Indianapolis: Bobbs-Merrill.

————. 1960. *The Phaedo*. In *The Last Days of Socrates*. Trans. H. Tredennick (Harmondsworth: Penguin).

————. 1971. *The Timaeus and the Critias*. Trans. D. Lee. Harmondsworth: Penguin.

————. 1973a. *The Sophist*. Trans. F.M. Cornford. In *Plato: Collected Dialogues*. Ed. E. Hamilton and H. Cairns. Bollingen Series LXXI (Princeton: Princeton University Press).

————. 1973b. *The Theaetetus*. Trans. J. McDowell. Oxford: Clarendon.

Popper, Karl R. 1982. *The Open Universe: An Argument for Indeterminism*. Totowa: Rowman and Littlefield.

————. 1984. A Critical Note on the Greatest Days of Quantum Theory. In A.O. Barut et al., eds., *Quantum, Space, and Time: The Quest Continues* (Cambridge: Cambridge University Press), pp. 49–54.

————. 1994 [1972]. *Objective Knowledge: An Evolutionary Approach*. Oxford: Clarendon.

Prior, A.N. 1959. Thank Goodness That's Over. *Philosophy* 34, pp. 12–17.

————. 1967. Time and Determinism. In Prior, *Past, Present, and Future*. New York: Oxford University Press.

————. 1970. The Notion of the Present. *Studium Generale* 23, pp. 245–48.

Putnam, H. 1979. Time and Physical Geometry. In H. Putnam, *Mathematics, Matter, and Method: Philosophical Papers, Vol. 1* (Cambridge: Cambridge University Press), pp. 198–205.

————. 1985. Models and Reality. In Putnam, *Realism and Reason: Philosophical Papers, Vol. 3* (Cambridge: Cambridge University Press), pp. 1–25.

Quine, Willard Van Orman. 1969. Existence and Quantification. In Quine, *Ontological Relativity and Other Essays* (New York: Columbia University Press).

————. 1979 [1960]. *Word and Object*. Cambridge, Massachusetts: MIT Press.

————. 1987. Space-Time. In Quine, *Quiddities* (Cambridge, Massachusetts: Belknap/Harvard University Press).

Reichenbach, Hans. 1956. *The Direction of Time*. Berkeley: University of California Press.

————. 1958. *The Philosophy of Space and Time.* New York: Dover.

Rhees, Rush. 1984 [1981]. *Recollections of Wittgenstein.* Oxford: Oxford University Press.

Rietdijk, C.W. 1966. A Rigorous Proof of Determinism Derived from the Special Theory of Relativity. *Philosophy of Science* 33, pp. 341–44.

Robinson, Abraham. 1969. The Metaphysics of the Calculus. In J. Hintikka, ed., *The Philosophy of Mathematics* (Oxford: Oxford University Press), pp. 153–163.

Rosen, S. 1961. Thought and Touch: A Note on Aristotle's 'De Anima'. In Yourgrau 1990, pp. 185–194.

————. 1988. Heidegger's Interpretation of Plato. In Rosen, *The Quarrel Between Philosophy and Poetry* (New York: Routledge), pp. 127–147.

Rucker, Rudy. 1983. *Infinity and the Mind.* Toronto: Bantam.

Russell, Bertrand. nd [1903]. *The Principles of Mathematics.* Cambridge: Cambridge University Press. 2nd ed. New York: Norton.

————. 1915. On the Experience of Time. *Monist* 25, pp. 212–233.

————. 1956. Mathematics and the Metaphysicians. In J.R. Newman, ed., *The World of Mathematics*, Vol. III (New York: Simon and Schuster), pp. 1576–590.

————. 1993 [1919]. *Introduction to Mathematical Philosophy.* New York: Dover.

Sainsbury, Mark. 1988. *Paradoxes.* Cambridge: Cambridge University Press.

Savitt, Steven. 1994. The Replacement of Time. *Australasian Journal of Philosophy* 72(4), pp. 463–474.

Schilpp, Paul A., ed. 1963. *The Philosophy of Rudolf Carnap.* La Salle: Open Court.

————., ed. 1970 [1949]. *Albert Einstein: Philosopher-Scientist.* La Salle: Open Court.

Schlesinger, George. 1993. Review of Yourgrau 1991. *Philosophical Review*, Vol 102, No. 4, pp. 602–04.

Sharvy, R. 1980. A More General Theory of Definite Descriptions. *Philosophical Review* 89, pp. 607–624.

Shimony, Abner. 1993. The Transient Now. In Shimony, *Search for a Naturalistic World View*, Vol. II (Cambridge: Cambridge University Press), pp. 271–287.

Silverstein, H. 1980. The Evil of Death. *Journal of Philosophy* LXXVII, pp. 401–423.

Simons, Peter. 1982a. Three Essays in Formal Ontology. II. Number and Manifolds. In Smith 1982.

————. 1982b. Three Essays in Formal Ontology. III. Plural Reference and Set Theory. In Smith 1982.

Sklar, L. 1974. *Space, Time, and Space-Time.* Berkeley: University of California Press.

————. 1981. Time, Reality and Relativity. In Yourgrau 1990, pp. 247–260.

————. 1984. Comments on Malament's '"Time-Travel" in the Gödel-Universe'. *Proceedings of the Philosophy of Science Association* 2, pp. 106–110.

———. 1985. *Philosophy and Spacetime Physics*. Berkeley: University of California Press.

Skolem, Thoralf. 1967 [1922]. Some Remarks on Axiomatized Set Theory. In J. van Heijenoort, ed., *From Frege to Gödel* (Cambridge, Massachusetts: Harvard University Press), pp. 290-301.

Smith, Barry, ed. 1982. *Parts and Moments: Studies in Logic and Formal Ontology*. Munich: Philosophia.

Smith, Quentin, and Nathan Oaklander. 1995. *Time, Change, and Freedom: An Introduction to Metaphysics*. London: Routledge.

Solovay, R.M. 1965. 2^{\aleph_0} Can Be Anything It Ought to Be. In J.W. Addison et al., eds, *The Theory of Models: Proceedings of the 1963 International Symposium at Berkeley*. Amsterdam: North Holland.

Sorabji, R. 1986. Closed Space and Closed Time. In M. Woods, ed., *Oxford Studies in Ancient Philosophy*, Vol. IV (Oxford: Clarendon), pp. 215-231.

Spinoza, B. 1955. On the Improvement of the Understanding. In *The Ethics and Correspondence*. Trans. R.H.M. Fiwes. (New York: Dover).

Stalnaker, R. 1976. Possible Worlds. *Noûs* 10, pp. 65-75.

Stein, Howard. 1968. On Einstein-Minkowski Space-Time. *Journal of Philosophy* 65, pp. 5-23.

———. 1970. On the Paradoxical Time-structures of Kurt Gödel. *Philosophy of Science* 37, pp. 589-601.

———. 1990. Introductory Note to Gödel 1949. In Feferman et al. 1990, pp. 199-201.

———. 1991. On Relativity Theory and Openness of the Future. *Philosophy of Science* 58, pp. 147-167.

———. 1995. Introduction to Gödel 1946/49. In Feferman et al. 1995.

Strawson, P.F. 1963. *Individuals*. Garden City: Anchor Books.

———., ed. 1967. *Philosophical Logic*, Oxford Readings in Philosophy. Oxford: Oxford University Press.

———. 1985. *The Bounds of Sense: An Essay on Kant's 'Critique of Pure Reason'*. London: Methuen.

Tait, W.W. 1983. Against Intuitionism: Constructive Mathematics is Part of Classical Mathematics. *Journal of Philosophical Logic* 12, pp. 173-195.

Thom, R. 1985 [1971]. 'Modern' Mathematics: An Educational and Philosophic Error? In T. Tymoczko, ed., *New Directions in the Philosophy of Mathematics* (Boston: Birkhäuser), pp. 67-78.

Thomason, Richmond. 1970. Indeterminist Time and Truth-Value Gaps. *Theoria* XXXVI, pp. 264-281.

Tiles, Mary. 1989a. Philosophy and the Analogies of Time. *Philosophical Forum* XX, pp. 182-194.

———. 1989b. *The Philosophy of Set Theory: An Historical Introduction to Cantor's Paradise*. Oxford: Blackwell.

Tragesser, R. 1984. *Husserl and Realism in Logic and Mathematics*. Cambridge: Cambridge University Press.

Van Fraassen, B. 1985. *An Introduction to the Philosophy of Time and Space*. New York: Columbia University Press.

Van Stigt, Walter P. 1990. *Brouwer's Intuitionism*. Amsterdam: North Holland.

Vlastos, Gregory. 1962. Zeno of Elea. In *The Encyclopedia of Philosophy* (New York: Macmillan), pp. 369–379.

———. 1987. 'Separation' in Plato. In J. Annas, ed., *Oxford Studies in Ancient Philosophy* V. Oxford: Clarendon.

Wang, Hao. 1961. Process and Existence in Mathematics. In Y. Bar-Hillel et al., eds., *Essays on the Foundations of Mathematics, Dedicated to A.A. Fraenkel on His Seventieth Anniversary*. Jerusalem: Magnes Press, Hebrew University, pp. 328–351.

———. 1970. A Survey of Skolem's Work in Logic, in J.E. Fenstad, ed., *T. Skolem: Selected Works in Logic*, pp. 22–26.

———. 1974. *From Mathematics to Philosophy*. London: Routledge.

———. 1977. Large Sets. In R.F. Butts and J. Hintikka, eds., *Logic, Foundations of Mathematics, and Computability Theory* (Dordrecht: Reidel), pp. 309–333.

———. 1987. *Reflections on Kurt Gödel*. Cambridge, Massachusetts: MIT Press.

———. 1991. To and from Philosophy. *Synthese* 88, pp. 229–277.

———. 1995. Time in Philosophy and Physics. *Synthese* 102, pp. 215–234.

———. 1996. *A Logical Journey: From Gödel to Philosophy*. Cambridge, Massachusetts: MIT Press.

Waxman, Wayne. 1991. *Kant's Model of the Mind: A New Interpretation of Transcendental Idealism*. New York: Oxford University Press.

———. 1992. Time and Change in Kant and McTaggart. *Graduate Faculty Philosophy Journal*, Vol. 16, No. 1.

Webb, J. 1980. *Mechanism, Mentalism, and Meta-Mathematics*. Dordrecht: Reidel.

Werkmeister, K., ed. 1976. *Facets of Plato's Philosophy*. *Phronesis*, Suppl. Vol. 2, pp. 1–20.

Weyl, H. 1949. *Philosophy of Mathematics and Natural Science*. Princeton: Princeton University Press.

Wheeler, John. 1998. *Aeons, Black Holes, and Quantum Foam: A Life in Physics*. New York: Norton.

White, Michael J. 1980a. Necessity and Unactualized Possibilities in Aristotle. *Philosophical Studies* 38, pp. 287–298.

———. 1980b. Aristotle's Concept of Θεωρια and the 'Ενεργεια–Κινησις Distinction. *Journal of the History of Philosophy* 18, pp. 253–263.

———. 1981. Fatalism and Causal Determinism: An Aristotelian Essay. *Philosophical Quarterly* 31, pp. 231–241.

———. 1985. *Agency and Integrality*. Dordrecht: Reidel.

———. 1989. Aristotle on 'Time' and 'A Time'. *Apeiron* XXII, pp. 207–224.

———. 1992. *The Continuous and the Discrete: Ancient Physical Theories from a Contemporary Perspective*. Oxford: Clarendon.

Whitrow, G.J. 1976 [1961]. 'Becoming' and the Nature of Time. In Čapek 1976, pp. 525–532.

———. 1978. On the Impossibility of an Infinite Past. *British Journal for the Philosophy of Science* 29, pp. 39–45.

————. 1980 [1961]. *The Natural Philosophy of Time*. Oxford: Clarendon.

Wilson, M. 1984. The 'Phenomenalisms' of Berkeley and Kant. In A. Wood, ed., *Self and Nature in Kant's Philosophy* (Ithaca: Cornell University Press), pp. 157–173.

Wittgenstein, Ludwig. 1960 [1958]. *The Blue and Brown Books*. New York: Harper and Row

————. 1961. *Notebooks 1914–1916*. New York: Harper and Row.

————. 1974 [1921]. *Tractatus Logico-Philosophicus*. Tr. D.F. Pears and B.F. McGuinness. London: Routledge.

————. 1975 [1964]. *Philosophical Remarks*. Ed. R. Rhees. Trans. R. Hargreaves and R. White. Chicago: University of Chicago Press.

————. 1978. *Remarks on the Foundations of Mathematics*. ed. G.H. von Wright et al., 3rd ed. Oxford: Blackwell.

————. 1980. *Culture and Value*. Ed. G.H. von Wright, tr. P. Winch. Chicago: University of Chicago Press.

————. 1993. *Philosophical Occasions: 1912–1951*. Eds. J. Klagge and A. Nordmann. Indianapolis: Hackett.

Wood, Allen. 1984. Kant's Compatibilism. In Wood, ed., *Self and Nature in Kant's Philosophy* (Ithaca: Cornell University Press), pp. 73–101.

Yourgrau, Palle. 1982. Frege, Perry, and Demonstratives. *Canadian Journal of Philosophy* 12, pp. 725–752.

————. 1983. Knowledge and Relevant Alternatives. *Synthese* 55, pp. 175–190.

————. 1985a. Sets, Aggregates, and Numbers. *Canadian Journal of Philosophy* 15, no. 4, pp. 581–592.

————. 1985b. Russell and Kaplan on Denoting. *Philosophy and Phenomenological Research* XLVI, pp. 31–321.

————. 1985c. On the Logic of Indeterminist Time. *Journal of Philosophy* 82, no.10, pp. 548–559.

————. 1986. On Time and Actuality: The Dilemma of Privileged Position. *British Journal for the Philosophy of Science* 37, pp. 405–417.

————. 1987a. Frege on Truth and Reference. *Notre Dame Journal of Formal Logic* 28, pp. 132–38.

————. 1987b. The Dead. *Journal of Philosophy* 84, No. 2, pp. 84–101. Also in J.M. Fischer, ed., The Metaphysics of Death (Stanford: Stanford University Press).

————. 1987c. The Path Back to Frege. In Yourgrau 1990, pp. 97–132.

————. 1989. Review Essay: Hao Wang, 'Reflections on Kurt Godel'. *Philosophy and Phenomenological Research* 50, No. 2, pp. 391–408.

————. ed., 1990. *Demonstratives*. Oxford Readings in Philosophy. Oxford: Oxford University Press.

————. 1991. *The Disappearance of Time: Kurt Gödel and the Idealistic Tradition in Philosophy*. Cambridge: Cambridge University Press.

————. 1996. Gödel, Kurt. *Encyclopedia of Philosophy: Supplement* , ed. Borchert. New York: MacMillan.

————. 1997. What Is Frege's Relativity Argument? *Canadian Journal of Philosophy*, Vol. 27, No. 1 (June), pp. 137–171.

————. 1998. Comments on 'Did Gödel Surprise Einstein with a Rotating Universe and Time Travel?', by Giora Hon. *Foundations of Physics*, Vol. 28, No. 11, pp. 1719–1727.

————. Forthcoming. Philosophische Betrachtungen zu Gödels Kosmologie, in W. Schimanovich, B. Buldt, E. Köhler, and P. Weibel, eds., *Wahrheit und Beweisbarkeit: Leben und Werk Kurt Gödels* (Vienna: Hölder-Pichler-Tempsky).

Index

Printed in the USA
CPSIA information can be obtained
at www.ICGtesting.com
JSHW081928301024
72691JS00001B/2

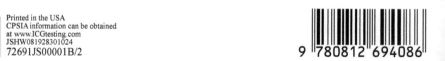